THE
UNITED STATES
of
AMERICA
laid down
From the best Authorities,
Agreeable to the Peace of
1783.
Published, April 3ᵈ 1783,
by the Proprietor
JOHN WALLIS,
at his Map-Warehouse,
Ludgate Street
LONDON

SCALES.
Sea Leagues 20 to a Degree.
English Miles 69 2 to a Degree.

Success to America
CREAMWARE FOR THE AMERICAN MARKET

featuring the S. Robert Teitelman Collection at Winterthur

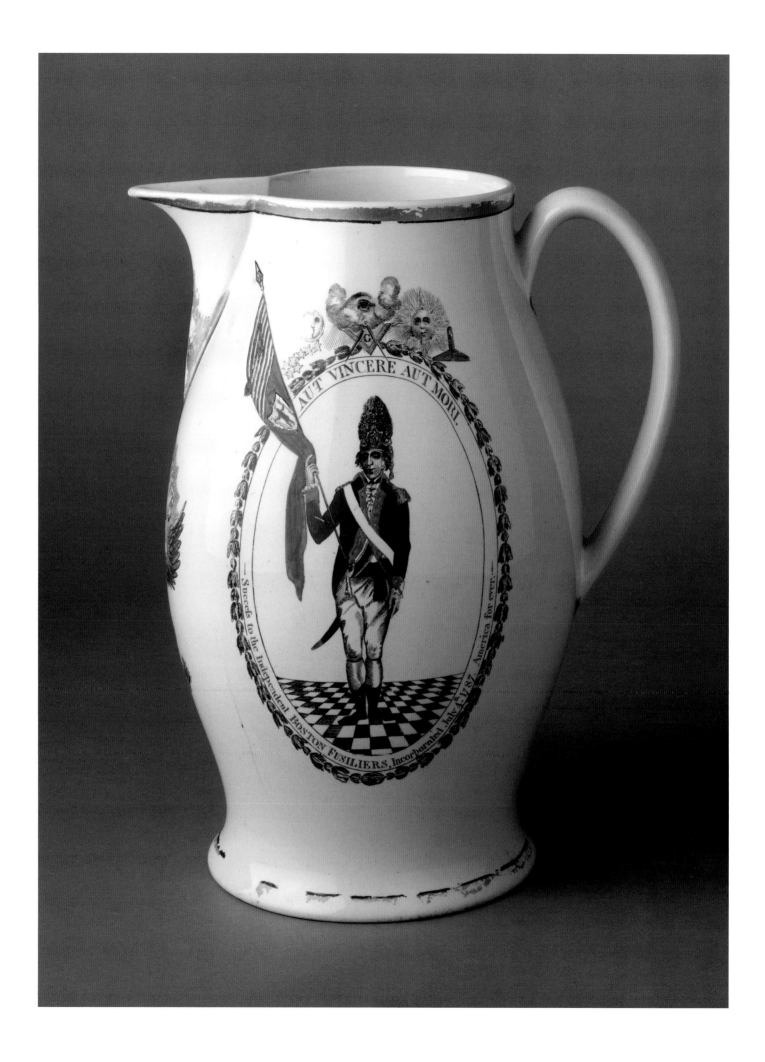

Success to America

CREAMWARE FOR THE AMERICAN MARKET

featuring the S. Robert Teitelman Collection at Winterthur

S. Robert Teitelman Patricia A. Halfpenny Ronald W. Fuchs II
with essays by **Wendell D. Garrett and Robin Emmerson**

ANTIQUE COLLECTORS' CLUB

ISBN 978-1-85149-631-0

British Library Cataloguing-in-Publication Data
A catalogue record for this book is available from the British Library

Frontispiece: Boston Fusilier, see cat. no. 33

Printed in China
for the Antique Collectors' Club Ltd, Woodbridge, Suffolk

CONTENTS

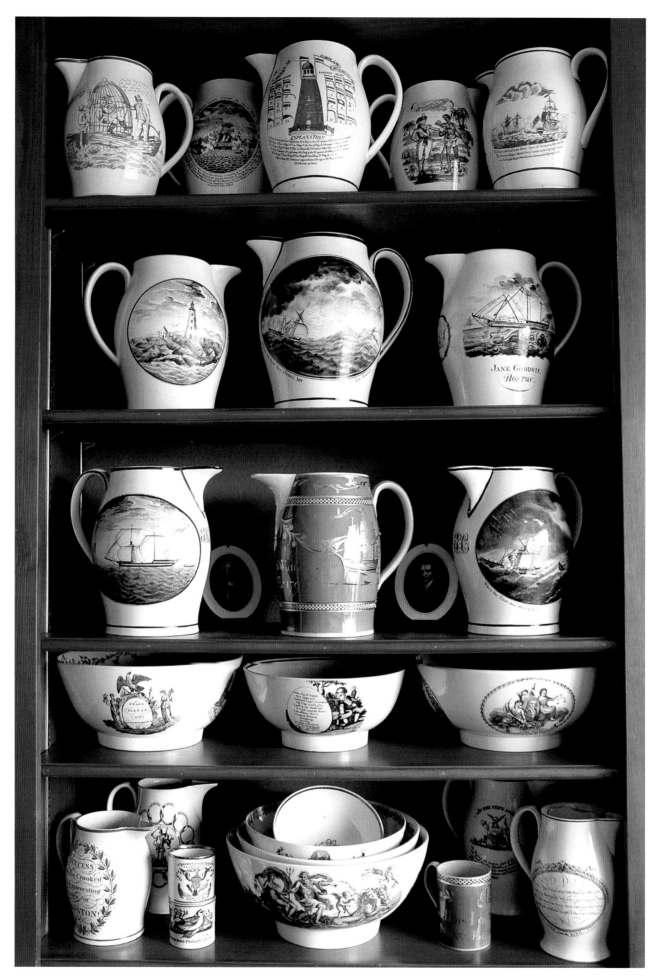

Display in the home of S. Robert Teitelman. ©Jerry Millevoi Photography Inc.

FOREWORD

The study of American history and its relationship to the decorative arts is an integral component of the institutional mission at Winterthur Museum & Country Estate. From the founding of the museum by Henry Francis du Pont in 1951 and the establishment of the graduate program in American material culture, research by curators, students, and scholars in the field has increased our understanding of life in early America and how that life helped shape, or was shaped by, the decorative arts. In this volume, those pursuits merge. There is created a new visual and documentary interpretation of the early years of the United States through the study of ceramics made in Britain expressly for the American market. The authors present us with new research and insight into the American experience of the late eighteenth and early nineteenth centuries.

It seems counterintuitive, but from the mid-1700s onward, British potters appear to have reveled in the opportunity to create ceramics that were decorated specifically to appeal to rebellious colonials and then to the victorious American citizens. Patriotic images and sentiments such as "No Stamp Act," "Sailor's Rights," and "Glory to Washington" in addition to the names and images of merchant vessels plying the waters between the two continents were all being memorialized.

The world's finest collection of such ceramic wares was assembled by S. Robert Teitelman and is fully illustrated in this volume. Of the 200 or so pieces in the collection, 50 have been generously gifted to Winterthur by Mr. Teitelman and his heirs, Roy T. Lefkoe and Sydney Ann Lefkoe. Known as the S. Robert Teitelman Collection at Winterthur, that group includes some of the finest examples of English pottery made specifically for the American market.

Winterthur curator Pat Halfpenny and Washington and Lee curator Ron Fuchs have created a book that tells a historical narrative, and they have done so in a manner that should please their fellow ceramicists as well as the general public. They look beyond the surface imagery to understand the individuals and society for whom the pottery was made. From the national records of presidential decrees to personal histories of ordinary citizens, we see America from new perspectives. In this merging of decorative arts and material culture, the sum is greater than its parts.

The combination of expertise contributing to this work is remarkable. Wendell Garrett's acclaimed writings on early America, Robin Emmerson's intimate and scholarly knowledge of Liverpool, and S. Robert Teitelman's focused research on his own collection allowed Pat Halfpenny and Ron Fuchs to develop the individual stories of each object. The internationally recognized ceramic skills of the authors blended flawlessly in a partnership that guided the project from aspiration to fruition.

The authors and I regret that the death of S. Robert Teitelman preceded the publication of this volume. No doubt he would have been as proud as we are that his collection and Winterthur's commitment to scholarship have converged in the creation of this outstanding contribution to the field he so loved.

David P. Roselle
Director
Winterthur Museum & Country Estate

PREFACE

This book owes everything to S. Robert Teitelman (1917–2008). Bob was a man of passion, bringing energy and dedication to all aspects of his life. He loved his family, friends, travel, Philadelphia, and music, singing, and telling jokes. He also loved his ceramics, his "Liverpool jugs," and through this passion created a world-class collection.

A lifelong acquisitor, as a boy Bob commanded a flotilla of boats. He had a great affinity for the sea and served as a naval officer in the Judge Advocate General's office in China, where he developed an appreciation for beautiful jades and, of course, formed a collection. With this nautical background, it is not surprising that he was attracted to pottery with naval and maritime themes. Having acquired five such examples, his research on those pieces introduced him to Robert H. McCauley's *Liverpool Transfer Designs on Anglo-American Pottery*. The book had a profound influence on Bob. It captured his imagination, showed him a way to celebrate his deeply felt patriotism, and set the standard for his future collecting. Guided by McCauley's book, Bob made the decision to acquire the prized example seen in the frontispiece, a jug decorated with the Boston Fusilier: "That was the jug that made me a collector of the ware." He saw a similar example in a New York auction and determined to buy it (see cat. no. 33). Prices were surprisingly low, and Bob acquired five jugs in all, doubling his collection. He never looked back. His compass was set, and during the next fifty years he purchased more than 200 additional pieces.

Not content just to acquire, Bob painstakingly catalogued each new piece. He doggedly researched and joyously celebrated every find. His love for America, its history and people, was demonstrated by the delight he exhibited in the story each jug had to tell. In ringing tones he would recite the patriotic verses; with pride he would tell of the naval victories; and with a deep and abiding admiration he would record the tales of Americans making their way in the newly established United States.

As his co-authors, we worked with Bob for many years on researching and cataloguing the ever-growing collection. Although he desperately wanted to write a book, he could scarcely find time to undertake the task of collating and reviewing the vast amount of information he had amassed. After all, there were more jugs to be found, friends to visit, lectures to give, and family to enjoy. The search for, and acquisition of, a new piece was part of his pleasure in collecting, and he was proud of his tenacity. He often told the story of how he acquired what he considered to be one of the finest Liverpool-type jugs made for the American market (see cat. no. 49). This jug was featured in the December 1901 issue of *Old China Magazine*, where the owner was noted as Charles Arthur Carlisle of South Bend, Indiana. It was some sixty years later when Bob saw the magazine article, but undaunted by the passage of time he called directory assistance in South Bend for the telephone number of every Carlisle in the city. He eventually found someone who remembered Charles Arthur Carlisle and was redirected to a descendant living in Texas who had the jug. The owner did not want to sell, but Bob maintained contact with her during the next fifteen years, calling and sending Christmas cards until she conceded and the jug became his.

Following a lead, waiting, and courting a prospective seller were all part of the game. There were many tales of searching and tracking—sometimes it was the jugs, sometimes it was the information. No library, historical society, or maritime museum was left unvisited. Bob even found the actual houses depicted on his jugs and often startled the home owners with a sharp knock on the door and a barrage of questions about the history of the building and its occupants. He rarely seemed to have been turned away; his obvious scholarship, friendliness, and determination won everyone over.

Bob had his own set of measures for evaluating pieces. He specifically liked those that were personalized with names, inscriptions, and traceable images. In preparation for this book he wrote:

> A collector is happy to acquire a piece with the name of a known ship. If the name of the vessel's home port or its master is added, so much the better. The epitome, however, is to have all three names—the ship, its home port, and master.
>
> In judging the relative value, other factors must be considered, such as the combination of designs and inscriptions, their rarity, whether they are transfer-printed or painted, the amount of extra decoration, color, gilding, borders, garlands and nosegays, and the size and condition of the piece. Generally large pieces are more desirable.

Bob acquired an extraordinary number of the more rare and highly desirable examples. To see him amid his collection in Collingswood, New Jersey, was an unforgettable experience. His apartment was furnished in impeccable taste, and his pieces were displayed massed

together in various rooms. It was an overwhelming assemblage of the finest examples of English pottery decorated with American patriotic imagery. A short visit was impossible; there were pieces to be handled, attributions to confer about, and research trips to be planned. Undoubtedly the Teitelman collection was the finest of its kind in the world and absolutely deserved to be published. The hand-painted scenes and transfer-printed images offered a magnificent illustrated history of early America. The collection celebrated the emergence and triumph of the young United States: from the rebellion against unjust taxation to portraits of the Founding Fathers; from early nineteenth-century firefighters to fabled merchant-princes of Salem; from the struggle for liberty to the battle to end slavery; and from U.S. naval vessels to the sloops and schooners that sailed from the country's numerous ports. When asked by a visiting collector how long he might go on acquiring, Bob replied, "I will buy my last jug the day before I die." He was then astonished, but amused, by the collector's next query: "Have you bought it yet?"

In the last year of his life Bob realized that perhaps he had delayed too long, that he would never produce his own book. He subsequently came to an agreement with Winterthur; in exchange for a gift of 50 objects and some funds toward the cost, the museum would undertake the publication he had so longed for. After his death, his family honored this commitment.

The idea of a catalogue of more than 200 fully researched pieces, however, was not viable. So the decision was made to use ceramics to tell the story of America from the Revolution through the early precarious years of nationhood to the final affirmation of independence signified by the War of 1812. The focus of the book would be the 50 gifts of the S. Robert Teitelman Collection at Winterthur. Where necessary, the story would be supported by additional pieces, mainly from the Winterthur collections. Bob was thrilled to see how, through this broad historical interpretation, his beloved pots could reach a wider appreciative audience. Should enough funding be raised to produce a larger volume, he desperately wanted to see his complete collection published. He felt strongly that the combination of images on each piece contributed to the overall aesthetic, and he expressed the hope that a series of photographs accompanied by brief details might be possible. This wish has been achieved with the addition of Appendix II and was made possible through the generosity of friends and family identified with our grateful thanks in the Acknowledgments.

This preface cannot close without Bob's co-authors expressing their gratitude for the opportunity to work with

S. Robert Teitelman, 2006. ©Jerry Millevoi Photography Inc.

a world-class collection and an extraordinary collector. Discussing whether "Liverpool jugs" were made in Liverpool or merely shipped from the port of Liverpool afforded us all an opportunity to engage in debates that ranged from speculative to factual. In learning about American history we began to understand the maritime contribution to the success of the country by ships with names as varied as the *Grand Turk*, the *Washington*, the *Columbia*, and the *Happy Couple of Savannah*. Bob conveyed to us his respect for the fearless mariners who commissioned English pottery to celebrate their dangerous, sometimes disastrous, voyages between Liverpool and ports such as Newburyport, Salem, and Penobscot Bay.

The days we spent with Bob discussing and disputing the pieces were always filled with laughter; the companionship was as sincere as the scholarship. As we worked through the collection we came to fully appreciate his discriminating eye, to respect his devotion to American history, and to comprehend the significance of his collection.

In honor of his scholarship, his love of America, and his fabulous collection and, most of all, because he was such a remarkable human being, his co-authors humbly submit this book as a fitting tribute to S. Robert Teitelman, as his jugs proclaim: A man without example, A patriot without reproach.

Pat Halfpenny
Ronald W. Fuchs II

ACKNOWLEDGMENTS

During this project we have enjoyed the support and assistance of a great number of people. Those donors whose generosity made the publication possible deserve a special note of gratitude. We first thank S. Robert Teitelman, whose wonderful gift of objects to Winterthur is surpassed only by his gift of scholarship and friendship. S. Robert Teitelman's nephew and niece, Roy T. Lefkoe and Sydney Ann Lefkoe, were incredibly generous in honoring their uncle's wishes and intent after his death and presented both objects and funds to secure the publication. We also thank Mrs. Roy T. (Nancy) Lefkoe for her patience and understanding. Others who made donations in support of the project include Mr. and Mrs. P. Coleman Townsend, Mr. and Mrs. Cummins Catherwood Jr., Mrs. Frances H. Colburn, Mr. and Mrs. John A. Herdeg, Mr. and Mrs. John L. McGraw, and The Shoreland Foundation.

We thank contributing authors Wendell Garrett and Robin Emmerson, whose essays exhibit an expertise that so wonderfully sets the scene for the descriptive catalogue entries. In telling the story of the evolution of America from a colony to an independent nation, we discover the historical context within which the decorative prints and paintings on the English pottery were conceived. In understanding Liverpool and Liverpool commerce, we discover how American merchants and mariners used their trading contacts in England to secure tangible evidence of their patriotism and devotion to their new nation. Blending those stories with the objects, this publication offers a unique insight into that late eighteenth-, early nineteenth-century world.

Bob Teitelman was well known in the field of decorative arts in both England and America, and many colleagues in museums, auction houses, and the antiques profession were eager to help complete his life's work. For their collegial support we thank Karin Walton, Curator of Applied Art, Bristol Museums & Art Gallery; Alan Granby and Janice Hyland of Hyland Granby; Robin Emmerson, Head of Decorative Arts, National Museums Liverpool; Peter Hyland, independent scholar, author, and collector; Craig Bruns, Curator, Independence Seaport Museum; Christina Keyser, Assistant Curator, George Washington's Mount Vernon Estate & Gardens; and Peter Grover, Director, University Collections, Washington and Lee University. For his review of maritime text, we thank Daniel Finamore, Russell W. Knight Curator of Maritime Art and History, Peabody Essex Museum. Our sincere appreciation also extends to Ronald Bourgeault, Northeast Auctions, and to his photographer, Andrew Davis, for supplying the images that appear in Appendix II. Without Ron's support and Andrew's skill, the illustrated supplement of the Teitelman collection would not have been possible.

This book comprises the S. Robert Teitelman Collection at Winterthur as well as the remainder of his personal collection. We have supplemented the discussion with pieces from the Winterthur collection donated by Henry Francis du Pont and Mr. B. Thatcher Feustman in addition to a privately owned teapot much coveted by both S. Robert Teitelman and Winterthur. We thank the lender for permission to publish.

We owe colleagues and staff at Winterthur Museum & Country Estate a deep debt of gratitude. The project would not have been possible without the encouragement of Leslie Greene Bowman, former director; the organizational and research skills of Curator of Ceramics & Glass Leslie Brown Grigsby; and the gracious assistance of Coordinator of Museum Affairs Cheryl Payne, whose skills are many and varied. The registrars and art handlers who documented and transported objects with consummate professionalism include Beth Parker Miller, Kathleen Orr, Paula de Stefano, Kathan Lynch, and William Donnelly. For maintaining the complicated objects lists, we appreciate the perseverance of Laura Johnson, who also assisted with the logistics of photographic sessions. For the marvelous photography, we are extremely grateful to Laszlo Bodo, who, with care and patience, navigated the waters of pleasing curators with impossible demands. I know that after several hundred shots, it seemed there could be no more "Liverpool ship jugs" in the universe, and yet one more would be found needing a special image or detail photograph; thank you, Laszlo. Susan Newton painstakingly indexed and sorted the photos. Without her positive attitude and can-do spirit, the organization of images would have been impossible to contemplate. Finally, with enormous respect and admiration, we thank Onie Rollins, our editor. This project might still be in the research stage were it not for

her meticulous attention to detail, sensitivity to the material, and willingness to work with the authors and publisher to bring the work to completion.

Other colleagues who were extremely supportive include J. Thomas Savage, Robert Davis, Jeff Groff, Linda Eaton, Wendy Cooper, Ann Wagner, Anne Verplanck, Sarah Beyer, and J. Ritchie Garrison. Thanks also to the library staff at Winterthur; at Independence Seaport Museum, Philadelphia; and at Peabody Essex Museum, Salem, Massachusetts. We are indebted as well to the now-unknown workers of the WPA who transcribed shipping records in the 1930s, providing information that was crucial to our study.

Over a period of many years, S. Robert Teitelman visited most, if not all, the research establishments along the New England and Mid-Atlantic seaboard. I know he would have wanted to acknowledge the numerous librarians, curators, collectors, and friends who helped him in his endeavor. In England he was a regular researcher in Liverpool and Stoke-on-Trent and always remembered the assistance and friendship of Tony Tibbles, Director of Merseyside Maritime Museum; Professor Alan Smith, former Keeper of Ceramics and Applied Art at Liverpool Museums; and Paul Holdway, master engraver, ceramic historian, and collector. We thank them all.

Finally, we extend special thanks, as always, to Geoffrey Halfpenny and to Michael Wedlock.

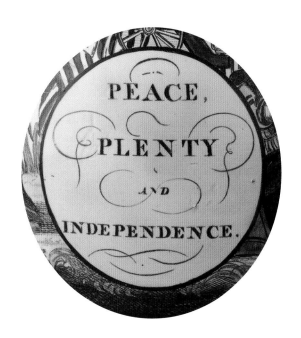

Authors and Contributors

S. Robert Teitelman, a graduate of Pennsylvania State University, earned his law degree from the University of Pennsylvania. After serving in the Navy during World War II, he became a partner in his father's law firm, specializing in real estate law, and was an active member of numerous cultural and professional organizations. He served as past Chairman of the Board of the Independence Seaport Museum and was closely associated with the University of Pennsylvania libraries, the Historical Society of Pennsylvania, the Library Company of Philadelphia, and the Rosenbach Museum and Library. In 1960 and again in 1980, he photographed the views of Philadelphia that had first been captured in prints published by William Birch in 1800. Those prints and Mr. Teitelman's photos were compiled and published as *Birch's Views of Philadelphia: A reduced facsimile of The City of Philadelphia as it appeared in the Year 1800* (Free Library of Philadelphia, 1982, and University of Pennsylvania Press, 1983). In 2003 the book was updated with new Teitelman images.

In 1950 S. Robert Teitelman purchased his first piece of patriotic pottery made in England for the American market and over the next fifty years formed a world-class collection. He wrote and lectured throughout America and England, and his scholarship and enthusiasm earned him an international reputation. His relationship with Winterthur Museum was longstanding, and part of his collection now forms the S. Robert Teitelman Collection at Winterthur. He died in February 2008 at the age of 91.

Patricia A. Halfpenny began her career in 1967 at City Museum & Art Gallery, Stoke-on-Trent, where she served as Keeper of Ceramics from 1980 to 1995. Her research, lectures, and publications have established her as a recognized authority on Staffordshire pottery, particularly that of the eighteenth century. In 1995 she left England to become Curator of Ceramics & Glass at Winterthur Museum & Country Estate. Since that time she has co-authored the *Campbell Collection of Soup Tureens at Winterthur* (with Donald Fennimore) and *Passion for Pottery: Further Selections from the Henry H. Weldon Collection* (with Peter Williams). In 1998 she was appointed Director of Museum Collections, and in 2009 she retired from Winterthur.

Ronald W. Fuchs II, Curator of the Reeves Collection of Ceramics at Washington and Lee University, graduated from the College of William & Mary and received his masters degree from the University of Delaware/Winterthur Program in American Material Culture. As former Associate Curator of Ceramics for the Leo and Doris Hodroff Collection at Winterthur, he co-authored (with David Sanctuary Howard) the publication *Made in China: Export Porcelain from the Leo and Doris Hodroff Collection at Winterthur*. He has worked with the Teitelman collection for many years, first compiling a computerized catalogue, then researching and writing for this volume. He currently serves as a Board Member of the American Ceramic Circle and has lectured widely in America and Europe.

Wendell D. Garrett is a Consultant to the Americana Department at Sotheby's and Editor-at-Large, *The Magazine Antiques*. An established authority on both the decorative arts and American history, he was Assistant Editor of the *Diary and Autobiography of John Adams* (4 vols.), Associate Editor of the first two volumes of *Adams Family Correspondence*, and Editor of the earliest diary of John Adams. Mr. Garrett joined the staff at *The Magazine Antiques* in 1966, ultimately serving as Editor and Publisher. From 1987 to 1993 he held the position of Chairman of the Board of Trustees for the Thomas Jefferson Foundation (Monticello). He is the author of *Apthorp House, 1760–1960* and *Thomas Jefferson Redivivus* and co-author of *The Arts in Early American History, Monticello and the Legacy of Thomas Jefferson*, and *Classic America*, among others. In 1994 he was honored with the Henry Francis du Pont Award for his distinguished contribution to the American arts.

Robin Emmerson was educated at Oxford University, the Courtauld Institute of Art, and Manchester University, where he specialized in art museum management. He began his career as a graduate trainee in decorative arts at Leicestershire Museum, was subsequently appointed Curator of Decorative Arts at Norwich Castle Museum, and is currently Head of Decorative Arts at National Museums Liverpool. He has published on subjects ranging from medieval art to church silver and Wedgwood. His selective catalogue of the Norwich collection, *British Teapots and Tea Drinking, 1700–1850*, was published by Her Majesty's Stationery Office in 1992. Mr. Emmerson has lectured extensively on ceramics in England as well as America.

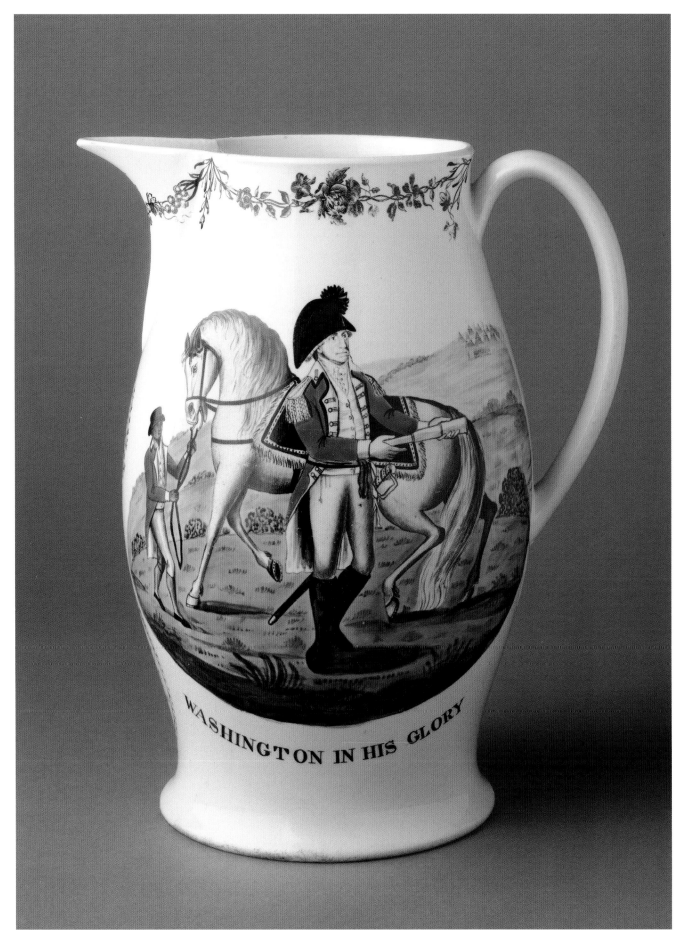

Figure 1.1. This creamware jug features an imposing George Washington as commander in chief of the Revolutionary War forces. For a complete description, see cat. no. 8.

Chapter 1

THE RISING GLORY OF AMERICA

Wendell D. Garrett

The United States was the first of the "new" nations. As the American colonies were the first to rebel against a European mother country, so the American states were the first to create—in Lincoln's term, to bring forth—a new nation. Modern nationalism was inaugurated by the American, not the French, Revolution. (Fig. 1.1)

It is unnecessary to emphasize anything as familiar as the importance of history, tradition, and memory in successful nationalism. It was the very core of Edmund Burke's philosophy: the nation—society itself—is a partnership of past, present, and future; we (the English) "derive all we possess as an inheritance from our forefathers."[1] But if an historical past and an historical memory are indeed essential ingredients for a viable nationalism, what was the new United States to do in 1776, or in 1789, or for that matter any time before the Civil War? How does a country without a past of her own acquire one, or how does she provide a substitute for it? Where could such a nation find the stuff for patriotism, sentiment, pride, memory, and collective character? It was a question that came up very early, for Americans have always been somewhat uncomfortable about their lack of history. More than a century before the Revolution, it had been observed of the Virginians that they had no need of ancestors, for they themselves were ancestors. The variations on this theme were infinite, but the theme itself was simple and familiar: Americans had no need of a past because they were so sure of a future.

Nothing in the history of American nationalism is more impressive than the speed and lavishness with which Americans provided themselves with a usable past. "Uncle Sam" was quite as good as John Bull, and certainly more democratic; the bald eagle did not compare badly with the British lion; the "Stars and Stripes" had one advantage over all other flags in that it provided an adjustable key to geography and a visible evidence of growth; and the Declaration of Independence was certainly easier to understand than the Magna Carta. In addition, there were

shrines: Plymouth Rock, Independence Hall, Bunker Hill, Mount Vernon, and Monticello.

These were some of the insignia, the insistent manifestations of the possession of an historical past. The stuff of that past was crowded and rich. The colonial era provided a remote past: Pocahontas saving John Smith; the Pilgrims landing on the sandy coast of Plymouth and celebrating the first Thanksgiving; William Penn negotiating with the Indians; and Benjamin Franklin walking the streets of Philadelphia. The Revolution as well proved to be a veritable cornucopia of heroic episodes and memories, and the War of 1812, for all its humiliations, made its own contributions to national pride. Americans conveniently forgot the humiliations and recalled the glories: Captain Lawrence off Boston Harbor: "Don't give up the ship"; the *Constitution* riddling the *Guerrière*; Francis Scott Key peering through the night and the smoke to see if the flag was still there; Perry declaring "We have met the enemy and they are ours." Certainly the speed and effectiveness with which Americans rallied their resources to supply themselves with an historical past cannot but excite astonishment. And what a past it was—splendid, varied, romantic, and all but blameless, in which there were heroes but no villains, victories but no defeats, a past that was all prologue to the rising glory of America.

Loyalties of one sort or another have always been powerful causal forces in human history. It was the personal loyalty of the vassal to his lord that gave medieval feudalism its cohesive force; it is individual and collective loyalty to the nation that, today, holds the national societies of the modern world together. But what is a nation? It has no tangible existence in the physical world. Its existence, therefore, while nonetheless real, is entirely metaphysical, or mental; the nation exists only as a concept held in common by many people. It is an emotional loyalty of men and women to this always-changing concept that constitutes nationalism. Without the concept of nation, loyalty and patriotism could not exist.

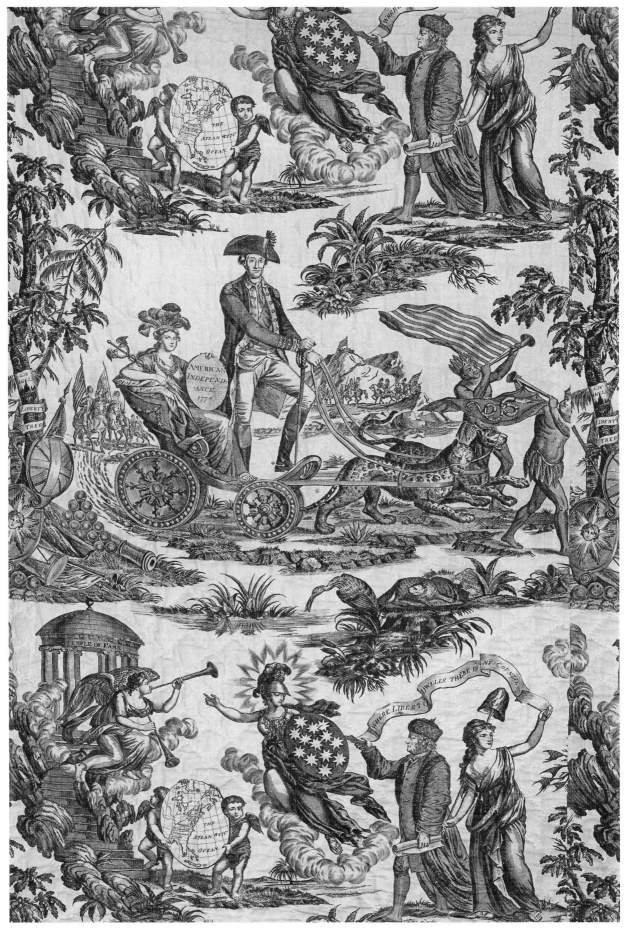

Figure 1.2. George Washington and numerous symbols of American independence are celebrated on this wholecloth quilt from the late 1700s. 1960.166 Winterthur Museum.

The concept of the nation appeared in the Western world apparently as a by-product of the emergence of the modern integral state. It is to be noted that the concept of the British nation and of loyalty to it was expressed in the term "Empire," which was also used by the Americans until 1776. It was borrowed, as the "American Empire," to indicate the American nation as that new concept grew in the minds of Americans after independence.

The Britons of Anglo-America gloried in the name, and they felt a genuine emotional identity with the concept of the British nation. Benjamin Franklin expressed this sense of common nationalism in January 1760: "No one Briton can more sincerely rejoice than I do, on the reduction of Canada; and this is not merely as I am a colonist, but as I am a Briton."[2] This feeling of affection for the mother country persisted in the years of crisis, right down to the eve of independence. Yet, Americans felt themselves to be distinctly different from the Britons. This consciousness of being a different sort of Briton living in a different "country" was apparently a strong germinal factor in the origin and, later, emergence of a self-conscious American nationalism. In the time following the Seven Years' War it enjoyed a new burst of enthusiastic, emotional expression. But this feeling for one's country (colony) and for America in a collective or pluralistic sense was focused upon the new land only within the larger context of the Empire. The colonial Americans were never less than loyal to their nation—the nation of Britons everywhere; their loyalties to America were always subservient to, and integrated with, their greater loyalty to the Empire and its ideals.

The history of loyalties in Anglo-America in the years between 1763 and 1775 is not one of divided loyalties, but, rather, a history of two separate, distinct, and rival series of efforts to preserve the old American loyalty to the British nation. The American Whigs stood for the maintenance of the old loyalty to the British national ideals, as they understood them, against the policies and actions of what they took to be a series of misguided ministries; the Tories clung to the old loyalty despite the policies of those same ministries, however misguided.

Samuel Adams, in his debate with Thomas Hutchinson, pointed out that all the American Whigs insisted upon was some sort of constitutional reform that would ensure to Americans the same constitutional guarantees that the Britons living in England enjoyed. Given this guarantee, he said, the loyalty of the Americans to the British imperial national ideal would remain true and undiminished. Persistent wrongheadedness by English ministers might destroy American loyalty to the Empire, but enlightened constitutional reform might be expected to preserve and encourage American loyalty to the national ideal indefinitely.

Yet the Americans' sense of differentness and their consciousness that they were a peculiar and specially favored segment of this imperial society were equally real and growing with intensity. It was this sense of a special destiny that inspired John Trumbull to predict a future glory and cultural leadership for America: "America hath a fair prospect in a few centuries of ruling both in arts and arms. It is universally allowed that we very much excel in the force of natural genius: and although but few among us are able to devote their whole lives to study, perhaps there is no nation in which a larger portion of learning is diffused through all ranks of people."[3] Philip Freneau and Hugh Henry Breckenridge sang of the same sort of glorious future for America in their "Rising Glory of America" poem at the Princeton commencement of 1771.

Americans were becoming conscious of their own heroic past and culture as well as the English traditions they had inherited. The birth of an American mythos, and of the consciousness of a native American culture, was one of the steps on the path toward a full national consciousness—a growing self-consciousness that began to demand cultural as well as political independence from Great Britain. Poets, publicists, and politicians exalted the pioneers who crossed the ocean. They lauded the American heroes, military exploits, the landscape, the epic struggle with the Indians, and so on. It is probably no accident that at least ten American-written narratives of Indian wars and captivities were published in the colonies and states between 1764 and 1780. Again and again, also, reference was made, by both Whig and Tory writers, to the English mythos of liberty inherited by Americans. As the war progressed, the heroic deeds and men of that struggle became part of the American mythos.

The concept of an American Empire-nation was the product of a slow intellectual and emotional growth. It began in the sort of patriotism toward the provinces expressed by colonial writers. But it was many years before the image of the British Empire-nation of the colonial era was fully and perfectly replaced in the minds of all Americans by the image of a genuine, integral American nation. The war years, 1776–1783, constituted what might be called the period of its gestation and, toward the end of the war, its birth.

The American Revolution gave rise to major symbols of public memory (Fig. 1.2). The struggle not only represented the origins of the nation-state but

produced a number of leaders, documents, and dates that served as important subjects for commemoration: George Washington, the Declaration of Independence, and the Fourth of July. National loyalty passed from the king of England, now a source of evil, to the new "king," Washington, who replaced George III as a symbol of leadership and civic authority (Fig. 1.3). By 1781 Washington's birthday was celebrated with special dinners and "demonstrations of joy." The man vividly impressed his contemporaries because he looked the part he played. Standing a full head taller than most of his soldiers, Washington repeatedly demonstrated his strength and stamina, moving with agility and dignity on foot and on horseback. His bearing bespoke authority; his demeanor inspired confidence.

The establishment of the Revolutionary era as a centerpiece for public memory in the early republic and the movement to generate loyalty to the new nation was furthered by the triumphant return visit of the Marquis de Lafayette in 1824 and 1825. While touring towns throughout the United States, Lafayette's appearance evoked much discussion about the past and the present as well as genuine public affection for the figures and events of the Revolution itself. His pilgrimages to Revolutionary War battlefields, his reunions with aged comrades, and the receptions arranged for him generated enthusiasm and interest. Lafayette was not only a symbol of patriotism but a representation of political liberty for ordinary citizens as well, many of whom worshiped him for having left family and wealth in France to fight for liberty in America.

Beginning in the late 1820s, however, a rise in regional and class divisions led to sharp exchanges in commemorative activities and to something of a decline in the single-minded focus on patriotism and national unity that had reached a peak in 1825. The exaltation of the origins of the nation-state, however, did not come entirely from vague expressions of emotions but was also consciously expedited by the actions of cultural leaders. This was exactly the case when men of "social influence" formed an association in Charlestown, Massachusetts, to erect a memorial to the Battle of Bunker Hill. These men were mostly from the class of entrepreneurs and professionals who were helping to make a new social order and appeared eager to associate themselves with the heroic makers of the new nation.

The central event of the groundbreaking ceremony was an oration by Daniel Webster. His speech contained powerful exhortations for patriotic loyalty and further reinforced the attempt of a rising professional and merchant class to place their pursuit of material

advancement and personal reward within the context of patriotic activity. Webster reasoned that his generation could win no laurels in a war for independence but could, in fact, accomplish other patriotic objectives. Specifically, they could preserve and defend what the Revolutionary generation had achieved. They could also improve upon the past by working toward material advancement. "Our proper business is improvement. Let us develop the resources of our land, call forth its powers, build up its institutions," Webster exclaimed. He insisted that the expansion of material progress must continue for "Our Country, Our Whole Country and Nothing But Our Country."[4] (Fig. 1.4)

Seventeen years later, in 1843, at the dedication of the monument, another elaborate celebration was held in Boston. President John Tyler and his cabinet attended and participated in a long parade that consisted of Revolutionary War veterans, military units, fraternal associations, and groups representing local educational institutions. The parade restated reality according to the desires of social and cultural leaders. It portrayed a highly ordered and unified society in which all citizens respected figures and institutions of authority. As Tyler, the veterans, and other prominent people moved along the line of march to the music of *The Union*, men and women cheered and waved handkerchiefs in a symbolic display of patriotic and social unity. In this public ritual and space, all were expected to honor leaders of the present structure of power and believe that these officials were the heirs of the Revolution itself.

A crowd reported to number about 100,000 gathered near the completed monument to hear Webster speak again. Passages from his 1826 oration were said to have gained wide circulation, becoming "household words throughout the nation." Webster again called for loyalty to the Union. To him the Bunker Hill monument stood for "patriotism and courage" and for "civil and religious liberty." But in his recounting of the past that led up to the Revolution and the monument to patriotism, he reserved a special place for his favored middling classes. He claimed that among the colonists of English America, liberty first manifested itself among the "middle, industrious, and already prosperous class" and the inhabitants of commercial and manufacturing cities. Several months later, in a speech before the New England Society of New York City, he again celebrated "eminent merchants" such as John Hancock and asserted that no class had shown "stronger and firmer devotion" to the preservation of the Union than the "great commercial masses of the country."[5]

Roughly from the Peace of 1815 to the death of Henry David Thoreau in 1862, America was engaged in

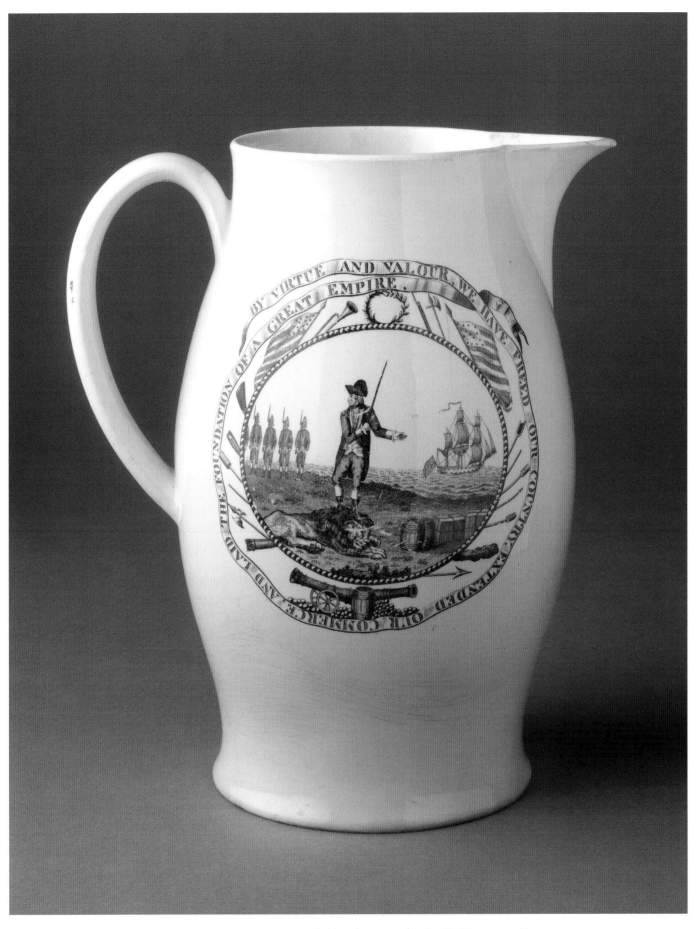

Figure 1.3. A triumphant George Washington is encircled by a banner exclaiming 'BY VIRTUE AND VALOUR, WE HAVE FREED OUR COUNTRY, EXTENDED OUR COMMERCE, AND LAID THE FOUNDATION OF A GREAT EMPIRE.' For a complete description, see cat. no. 5.

a quest for a definition of self that would give meaning to the American past, present, and future. James Monroe was the last incumbent president to have been an adult at the time of the Declaration of Independence. Henry Clay, John Calhoun, and Daniel Webster, men who "knew the Founders," passed from the scene around the middle of the century, having themselves contributed to the formulation of the American idea. Abraham Lincoln, a railroad lawyer born early in the nineteenth century, reaffirmed the outlines of a tradition on which he was prepared to stake the existence of the nation.

Whatever the implications to be drawn from it, the undoubted fact of American prosperity provided a handy vehicle for years of national self-evaluation. "We cannot open our eyes," said a speaker in 1822, "without beholding the most unequivocal monuments of the general success, which has crowned the industry and economy of our citizens."[6] The expansion of the national territory, the creation of new industries, and the development of a vast transportation network were a few of the "unequivocal monuments" that were to provide unfailing markers of "the general success" for decades to come. In a universe of providential order, virtue and prosperity were intertwined.

America as the site of a "New Heaven and a New Earth"—America as the first nation ever founded on the principles of natural rights and justice—was manifestly a spectacular assault against the efficacy of time as history.[7] Europe was doomed to go on in the old way, controlled by prescription and tradition, but America, structuring itself upon first principles, lived now upon her own time, henceforth to be the definitive time. Having been released from the past by a providential dispensation, it was not surprising that Americans should slight the values of that past, even deny their real status, in favor of an ever-present "present." "In a society which has no Past, the Past counts for nothing," Michel Chevalier noted thoughtfully.[8] America had inaugurated a new time scale, one that brought along with it its own set of values, and those were the sole values by which America would consent to be judged.

Shortly after the Declaration of Independence, Frenchman J. Hector St. John de Crèvecoeur expressed the conviction that the American was a "new man" for whom the categories of the Old World were inapplicable.[9] More than half a century after Crèvecoeur, his countryman Chevalier came to investigate the American spirit in Jacksonian time and hailed the American as "a new political and physiological phenomenon, a hitherto unknown variety of the human race."[10] While lagging behind the Frenchman and

Englishman in many respects, particularly in taste and philosophy, Chevalier's "homo Americanus" was superior to the rest of the human family by its extraordinary combination of sagacity, energy of will, and hardy enterprise; by its admirable aptitude for business; by its untiring devotion to work; and, above all, by its recognition and protection of the rights of the laboring classes, hitherto treated as the off-scourings of society. To Chevalier it was plain that "this people will become the founders of a new family."[11]

In thus cutting loose from the past, in disengaging themselves from the historical continuum, Americans had no intention of being considered a kind of sport of time, of high individual and particular interest but lacking in more general significance. Abandoning the doomed past to the Old World, Americans were convinced that they had pre-empted for themselves, and those who could muster the courage to follow their example, the most valuable of all temporal categories— the future. In the controversy between the Old World and the New, the argument from the past was answered by the argument for the future.

Americans cherished an uncritical and unquestioning conviction that theirs was the best of all countries. Nonetheless, missionary confidence was tempered by the shocks and the turbulence of the 1840s and 1850s in the United States—the Texas question, the Mexican War, acrimonious debates over slavery, and undeclared civil war in Kansas and Nebraska. Some even advocated self-examination. Ralph Waldo Emerson in 1822 had expressed uneasiness. "Will it not be dreadful," he wondered, "to discover that this experiment made by America, to ascertain if men can govern themselves, does not succeed?"[12]

The baffling process by which a transplanted European culture has been changed on this continent into something uniquely American eludes definition. The American character is the product of an interplay between inheritance and environment. That America was the offspring of Britain was acknowledged, but the roots of American culture and institutions can be traced back to ancient Greece, Rome, and the Holy Land. That so heterogeneous an inheritance should result in so homogeneous a character suggests that environment had a decisive role. The environment, to be sure, was scarcely less diverse than the inheritance, for the American continent was as complex as all of Europe. Yet disparate geography no more than amalgamations of races produced profound social diversity. What emerged was a combination that was distinctly national. In other words, the differences between a Yankee, a Southerner, and a

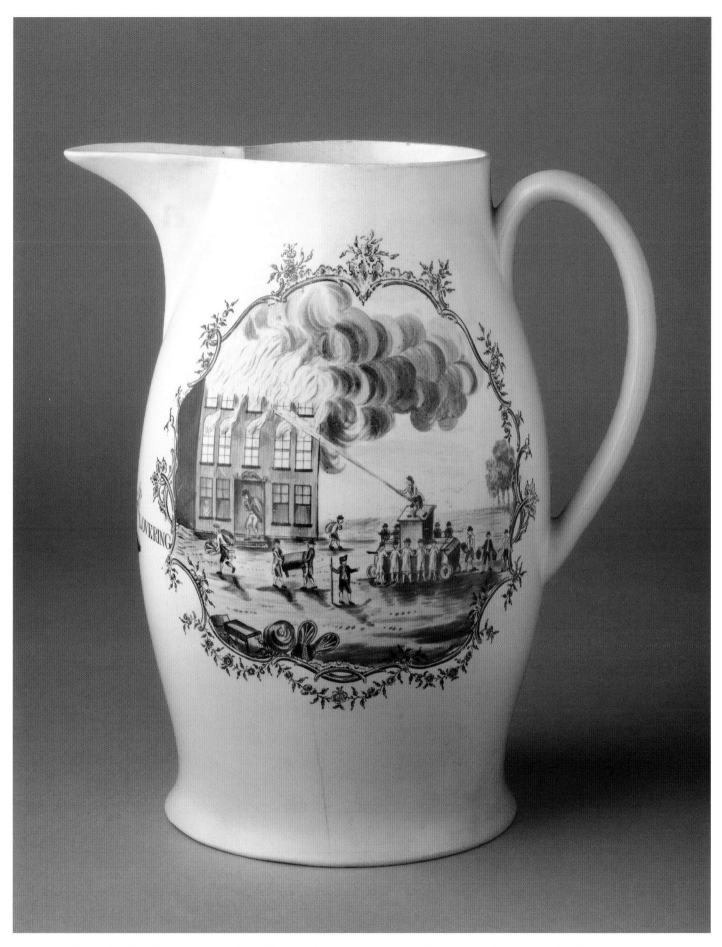

Figure 1.4. Merchant Joseph Lovering of Boston, whose name appears on this creamware jug, is honored for his service to the city, including his work as 'fireward.' For a complete description, see cat. no. 60.

plainsman were insignificant compared with the differences between a German, a Frenchman, and an Italian. For that matter Vermonters and Texans could understand each other's language better than Yorkshiremen and Cornishmen.

What created the American was the sense of spaciousness; the invitation to mobility; and the feeling of independence, enterprise, and optimism. With incurable optimism went a sense of power and vast resources of energy encompassing the continent. No project seemed too large in scale, and empire builders were both real and legendary. Daniel Boone, Davy Crockett, and Sam Houston belong to mythology as well as history. The realities of geography and history made Americans receptive to large plans and heroic speculations. They took pleasure in the sheer size of the Great Lakes, the Mississippi River, Niagara Falls, trusts, combines, and giant corporations. The Declaration of Independence, if it did not create a nation, made it clear that although there were thirteen colonies, they were united. "Our great title is Americans," wrote Thomas Paine.[13] (Fig. 1.5) Nor could the problems of independence and war be confronted and solved except in nationalistic terms. All the materials needed for a powerful nationalistic tradition came directly from the wartime experience, and American leaders agreed that a strong sense of national identity was vital to the new country's survival. Therefore, said Noah Webster, "Every engine should be employed to render the people of this country national . . . and to inspire them with the pride of national character."[14] Americans agreed that the United States was new, and that it was different—or as Crèvecoeur had summed it up in 1782: "The American is a new man, who acts upon new principles."[15]

At the conclusion of the Revolution, American chroniclers turned to the task of setting down and interpreting the history of the way of life—for the study of the history of one's own nation, as Voltaire had pointed out, made one a better citizen and a more loyal one. Wrote Webster, "As soon as he opens his lips, he should rehearse the history of his own country; he should lisp the praise of Liberty, and of those illustrious heroes and statesmen who have wrought a revolution in her favor."[16] Appraising their past, their present, their resources, and potentialities, Americans decided that the United States was blessed beyond all measure. America as "Nature's Nation," a second chance for mankind, was not lost on the president-philosopher from Monticello, who described the United States in his first inaugural address as "kindly separated by nature, and a wide ocean, from the exterminating havoc of one quarter of the globe . . . possessing a chosen country, with room enough to the thousandth and thousandth generation."[17] America was different from everything known in Europe; it was some monstrous anomaly of nature, too strange, too alien for the European imagination.

As the theory of the divine right of kings and the aristocratic ideal of society faded toward the end of the eighteenth century, the enthusiasm for classical Rome and Greece grew apace. Political rebels searching for a new form of government found their model in the republics of antiquity, while those seeking a new basis for society found it in the citizen, the responsible member of the "civitas," the city-state of the ancient world.

The Western mind was discovering the discipline of history and its companion, archaeology. The excavations at Pompeii and Herculaneum in the second quarter of the eighteenth century had resurrected the long-lost physical appearance of the vanished world of the Greeks and Romans, until then only known through the works of ancient poets and historians. At the same time the mental image of the past was transformed by writers like Gibbon and Voltaire, who made a comparison and critical study of sources to build a living portrait of the lost civilization.

The capital of this dream world was Rome. Neoclassicism—the cult of antiquity—was more than a nostalgic obsession with the past; the movement had a revolutionary character and serious purpose. Neoclassicism was a cerebral movement, as Johann Winckelmann declared, in which the "noble simplicity and calm grandeur" of antiquity were to be imitated, not copied.[18] Antiquity indeed haunted the imagination of the Founding Fathers, who saw Greece in the age of Pericles and the Augustan Age as the noble achievements of free men aspiring to govern themselves. In this conviction the first generation of the American nation adopted the terms Senate, Congress, Capitol, and Republic in describing its government. Even the Great Seal of the United States was created with three Latin inscriptions. In the nineteenth century, the personification of America was transformed from the dusky naked Indian girl, in feather ornaments accompanied by an alligator and holding a cornucopia, into Columbia and eventually Liberty herself—an allegorical figure as familiar in the repertory of motifs as the gods of classical mythology or personification of the virtues and vices. (Figs. 1.6, 1.7)

During the great experiment of Jacksonian democracy, when the United States lived very much to itself, it was viewed as the land of hope, an asylum, the "nation of futurity." But America was also maddingly pluralistic in this age of individualism, a mosaic of

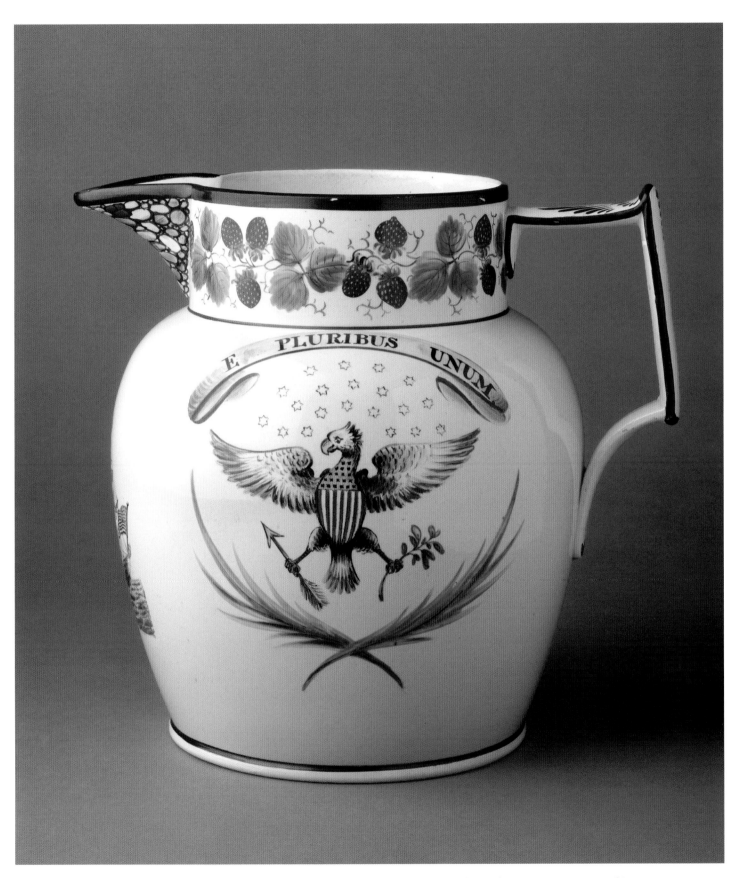

Figure 1.5. The motto on this pearlware jug, 'E Pluribus Unum', celebrates the melding of many into one Union of States. For a complete description, see cat. no. 66.

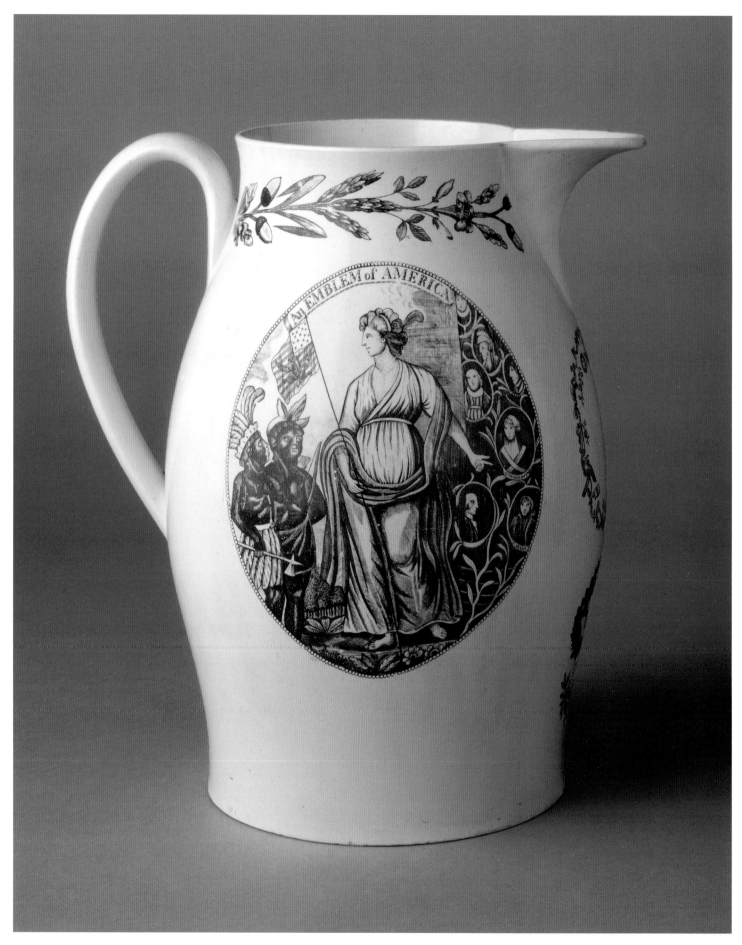

Figure 1.6. The classical figure of Columbia, the 'Emblem of America', was a familiar print on creamware made for the American market. For a complete description, see cat. no. 61.

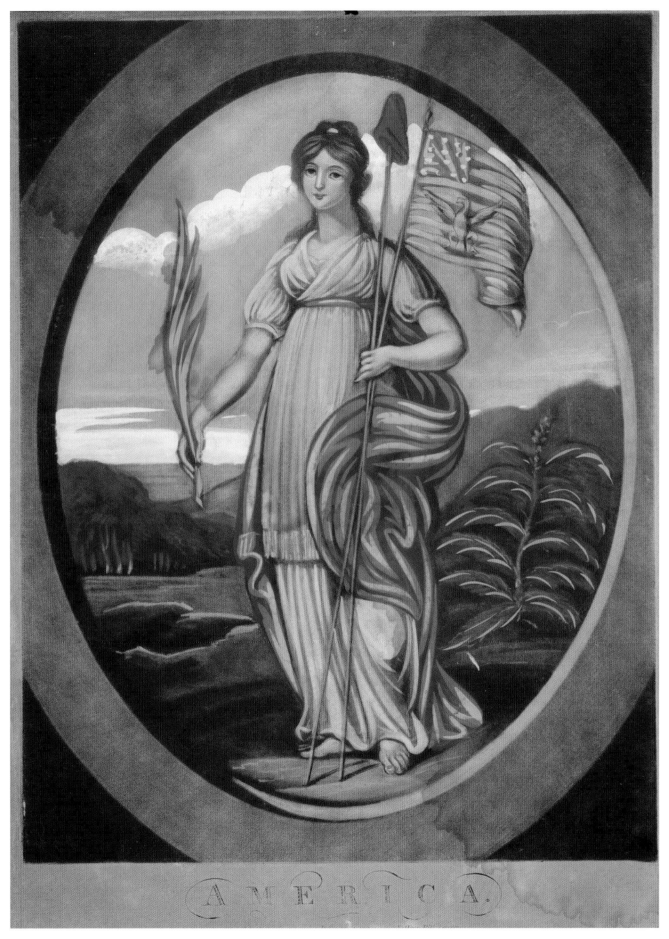

Figure 1.7. This reverse print on glass, an allegorical figure of America in classical dress, was made in England for the American market, 1801. 1960. 293 Winterthur Museum, bequest of Mrs. Waldron Phoenix Belknap.

sections subdivided into regions and localities with widely disparate economic pursuits. The economic revolutions that promoted massive migrations westward and from rural areas to industrial centers also resulted in the destruction of the self-sufficient farm economy, the collapse of the artisan and apprenticeship system, and the breakdown of traditional familial and communal ties. It also generated new areas of conflict—between capital and labor, wealth and poverty. Within this context, the nation's continental land mass of the fertile West was nothing if not an "appointed remedy" in Emerson's words,[19] or a "safety valve," in those of Horace Greeley,[20] which permitted the governing tenet of antebellum America to remain the doctrine of the harmony of interests. Such faith underscores the basic premise of Jacksonian democracy—an implicit trust in the common sense of the common man, an unshakable belief in the will of a virtuous and competent people.

In little more than a century after its discovery, America became an extension of Europe—in fact, not just allegorically. The first colonists of British North America strove to be Britons in this early Eden while living among indigenous Indian people whom they perceived to lack the rudiments of civility. But just as the motives for emigration detached many settlers from the civilization they left behind, the perils of the Atlantic crossing and the colonial experience in a new land profoundly affected the search for identity of these transplanted Englishmen, who soon began to see themselves in some ways as distinct and separate from the mother country. "Our ancestors sought a new continent," said Lowell: "What they found was a new condition of mind."[21]

Since independence is the first goal of nationhood, the United States got off to one of the fastest starts of any nation in history. It threw off the controls of its mother country abruptly, refused to look back in remorse, and never strayed from the path of self-reliance. It would be hard to imagine a nation more oblivious to the commands, or impervious to the influence, of men of power in other nations than the headstrong republic of the first half of the nineteenth century. The point about American independence was made with excessive clarity both at the beginning of this period, when the Treaty of Alliance of 1778 with France was repudiated, and at the end of the antebellum period, when Lord Palmerston found it impossible to respond favorably to the plea of the Confederacy for recognition. From Yorktown to Appomattox, the United States "went it alone" as few nations of the modern world had the good fortune and resources to do.

The American people had always had plenty of practice in going it alone politically. When the time finally came for the leaders of the mother country to assert their authority with vigor, they found themselves face to face with thirteen rebellious children who, while they might not always get along too happily with one another, now decided rather suddenly that they could get along rather well without their mother. Although the idea of independence may seem to have burst full grown from the bold minds of men like Paine, Jefferson, Franklin, the Adamses, and Washington, it had been in gestation since the first plantings in Virginia and Massachusetts.

In the early years of independence some doubt festered in less-resolute minds about the immunity of the United States against foreign influence in the political, economic, and cultural process. Few Americans gave a thought to the possibility that their country might lose independence by losing a war, not even if Britain, France, and Spain were to forget their antipathies, hire Hessians by the boatload, and plan a united effort to smash the upstart. More than a few were worried that intriguing men or disaffected sections might be bought for a good price, and enough Spanish gold flowed malevolently through the specie-starved Southwest to give substance to the worry. In the years of Aaron Burr's disgrace, Andrew Jackson's victory at New Orleans, and John Quincy Adams's purchase of Florida, however, this worry born of the knowledge of European practice and nourished on the time-honored conspiratorial theory of history began to decline and finally vanished. As the sun of American nationalism rose steadily higher, the confidence of Americans in an independent destiny grew steadily stronger. (Fig. 1.8)

This is not to say that Americans huddled or swaggered in isolation behind the great ocean. The ocean was a barrier, but it was also a highway, a broad and ever-more-passable channel of commerce in goods, money, skills, techniques, ideas, and men. From the very beginning, despite the attempts of a few austere souls to turn their backs on Europe, most Americans were hardly less thankful for the opportunity the Atlantic gave them to trade busily with other nations without submitting to their political dictates.

Cultural independence, however, lagged as far behind economic independence as did economic behind political. The most obvious example of continued American dependence on the Old World was to be found in the related fields of language and letters. The language of America was the language of England, even if many Englishmen claimed not to understand it.

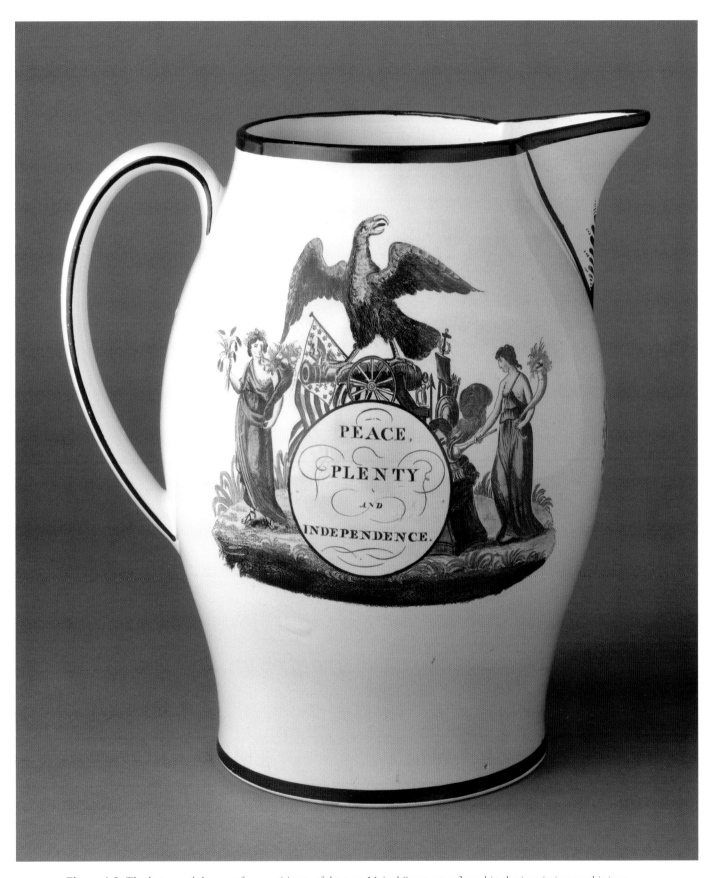

Figure 1.8. The hopes and dreams of many citizens of the new United States are reflected in the inscription on this jug: 'PEACE, PLENTY AND INDEPENDENCE.' For a complete description, see cat. no. 71.

England had been a bubbling fountain of literature in the common language for centuries, and the fountain continued to bubble lavishly and seductively. Most Americans saw no reason why they should not go right on drinking from it, and few Americans expected their own fountain to start bubbling on a competitive basis until more pressing tasks of national development had been accomplished. Yet patriotic Americans were outraged by Englishman John Bradbury's blast of 1818 at the pretensions of their literature, not least by his supposedly friendly prediction that when Americans had "got to the Pacific Ocean" they might "set down to amuse themselves" and produce "epic poems, plays, pleasures of memory, and all the elegant gratifications proper to an ancient people."[22]

One might argue plausibly that most citizens of the United States passed up the challenge of cultural independence by placing culture near the bottom of their list of national and personal aspirations. The argument, although plausible, does nothing to reverse the judgment that most of what was elevated and sophisticated about life in the midcentury American had been borrowed rather than created. The best one can do is to soften the judgment by noting that Americans of this period carried forward a tradition of the colonial years by picking and choosing freely among the intellectual and aesthetic offerings of the Old World, and that as time went by they turned increasingly to countries other than Britain for instruction and entertainment.

Through all the years from Washington to Lincoln, the American people were engaged in an industrious search for self-identification. The kind of nation most Americans hoped for in the future demanded a legacy that would liberate energy without paralyzing will. At the same time, the techniques of national devotion had to express the American character as something simple, sincere, zestful, and democratic. As to the legacy, one may well ask: Did a new nation ever have heroes quite so satisfying as the Pilgrim Fathers, the men of Jamestown, the Signers, the Framers, Benjamin Franklin, Daniel Boone, and the semidivine Cincinnatus of the West, George Washington? Are our hearts ever stirred today, as were those of our ancestors, with feelings of joyful patriotism by the oratory of thousands of ordinary men on the Fourth of July and of scores of larger-than-life men like Daniel Webster on occasions like the celebration at Plymouth in 1820 and the laying of the cornerstone at Bunker Hill in 1825?

Such feelings have gone out of fashion; yet in the days of our youth, they were the intellectual fertilizer of the flowering of American nationalism.

The pursuit of an American identity led many citizens to think and speak of a "nation singled out by the searching eye and sustained by the protecting arm of a kind and beneficent Providence."[23] For more than four centuries, the New World has been an object of curiosity to the Old, and for half that time the United States in particular has been called upon to point a moral or adorn a tale. Literally thousands of travelers have visited here and rushed home to transcribe their impressions, sometimes to compliment, at other times to criticize. By common consent, Alexis de Tocqueville's *Democracy in America* is the most illuminating commentary on American character and institutions ever penned by a foreigner. Tocqueville was thorough and indefatigable in his search for facts, patient and skillful in their organization, sympathetic and perspicacious in their interpretation, and luminous in their presentation. His purpose was lofty, his learning solid, his understanding profound. "I confess that in America, I saw more than America. I sought the image of democracy itself, with its inclinations, its character, its prejudices, and its passions, in order to learn what we have to fear or to hope from its progress." Then he added, "The question here discussed is interesting not only to the United States, but to the whole world; it concerns not a nation only, but all mankind."[24]

America, in short, was not the primary object of his investigation, but rather democracy. The inspiration of the inquiry was not so much curiosity about America as concern for France, especially, and for the Old World in general. America was, it seemed, merely the laboratory; the findings were designed for application abroad. His purpose was to prepare men everywhere for the "providential fact" of equality; to dissipate fears, quiet excessive hopes, encourage accommodation, and to lift men above narrow and selfish views. The young United States was both forerunner and archetype. For democracy, Tocqueville was persuaded, was inevitable and irresistible, its doctrines and practices destined to spread over the Western world. (Fig. 1.9) For that reason if for no other, their quest commands the respect of history. These Americans went in search of something to which all but a few men aspire; they found a larger portion of it than all but a few will ever know.

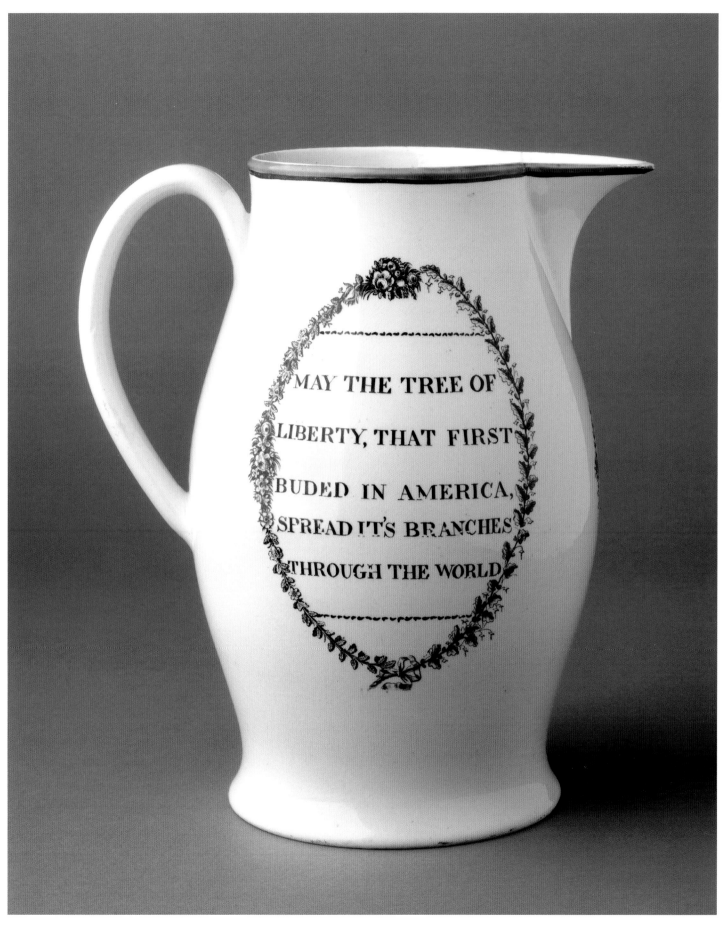

Figure 1.9. 'MAY THE TREE OF LIBERTY, THAT FIRST BUDED IN AMERICA, SPREAD IT'S BRANCHES THROUGH THE WORLD' mirrors the thoughts on democracy expressed by Alexis de Tocqueville. For a complete description, see cat. no. 73.

Chapter 2

CREAMWARE AND THE STAFFORDSHIRE POTTERIES

Patricia A. Halfpenny

In 1769 when George Washington sent an order to his English agent for a new set of dishes to use at his table and in his kitchen, he requested "ye most fashionable kind of Queen's Ware." He was ordering English creamware, the most elegant, refined, and stylish earthenware available. This purchase was made despite the troubled relationship between England and her American colony. The leaders of the Colony of Virginia had met in May 1769 and declared that they would purchase nothing of British manufacture after September of that year. Washington met the letter of the agreement by ordering his pottery in late July just weeks before the deadline.[1]

Queen's Ware was the earthenware of choice in the immediate post–Revolutionary War period. Its smooth, pale surface offered an ideal ground for both the monochrome printed and the polychrome painted inscriptions and imagery that were so popular in the expanding market. (Fig. 2.1) At its introduction in the 1740s, this new kind of pottery was called "cream colored," but following the approval of Queen Charlotte for Wedgwood's products, she allowed his pottery to be called Queen's Ware. After 1765 this became the general term for what collectors now call creamware.

Creamware: Composition
Creamware was developed in eighteenth-century Staffordshire, where progress in the pottery industry was usually the result of experimentation and refinement of existing bodies and glazes—innovation mixed with a dash of inspiration. So it was with the earliest creamware. The body was the same as that developed by John Dwight in the late seventeenth century for white salt-glazed stoneware and exploited to its fullest by the Staffordshire salt-glaze potters from the 1720s onward. The body is made principally from ball clay and flint. There was little white clay available in Staffordshire, so it had to be transported from Devon and Dorset. The journey was economically viable because the large coal fields of Staffordshire yielded fuel perfectly suited to

pottery making—a long flame that was hot burning, with few impurities. In pottery making, coal was needed in much larger quantities than clay.

Ball clay is formed from granite that was moved over time from its site of formation by the forces of nature. During that movement, the clays were subjected to pressure and heat. They picked up contaminants and were often carried by glaciers or rivers and deposited as beds of sedimentary clay. Ball clay is usually light in color and is sometimes stained blue-gray by the organic contaminants. Because of the pounding it received as it was moved and deposited, ball clay particles are finely ground, creating a smooth, malleable product. The clay received its name from the manner in which it was transported; dug from pits, it was made into balls weighing about twenty-six pounds and packed for transport by land, sea, river, and canal. When the clays arrived in Staffordshire, they were cleaned by mixing with water, and the liquid was passed through a series of fine mesh to ensure small particle size. These ball clays, when fired, produced a desirable white product, with the organic matter burning away in the high temperatures. Although fine and white, the clay was not perfectly suited to eighteenth-century pottery production methods, so flint was added to create a more workable mixture, tempering over-plasticity and preventing excessive and unequal contraction during the drying process.

Flint was gathered in the form of pebbles from the beaches around Norfolk and transported to Staffordshire. It was first calcined, or burned, turning the stones white and friable and allowing them to be ground more easily. Clay and powdered flint were then mixed in water. When the water evaporated, what remained was a moist, workable mixture that could be made into pots, either by throwing on the wheel or molding. (Fig. 2.2)

First used in the production of white saltglaze, the clay-flint body produced an incredibly fine, lightweight, strong stoneware. Although popular with customers, salt-glazed stoneware did have disadvantages. The single firing limited the range of decorative techniques, and

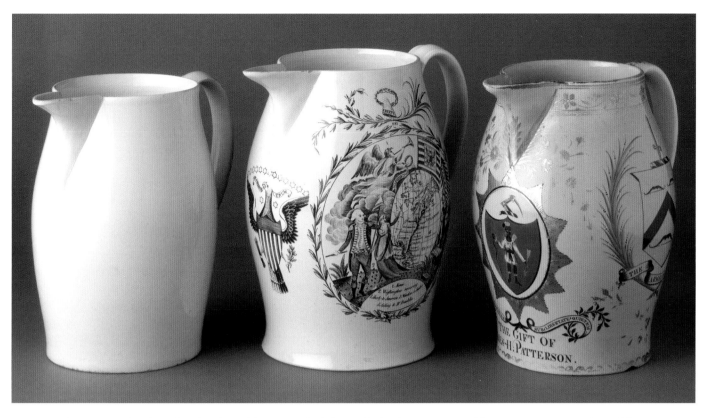

Figure 2.1. The plain, glazed surface of the jug on the left is ready for decoration. It could receive a print (as on the middle jug) or a painted design (as on the right).
From left: SRT 96.1 Winterthur Museum L2007.1036.127 Family loan, see cat. nos. 20, 21.

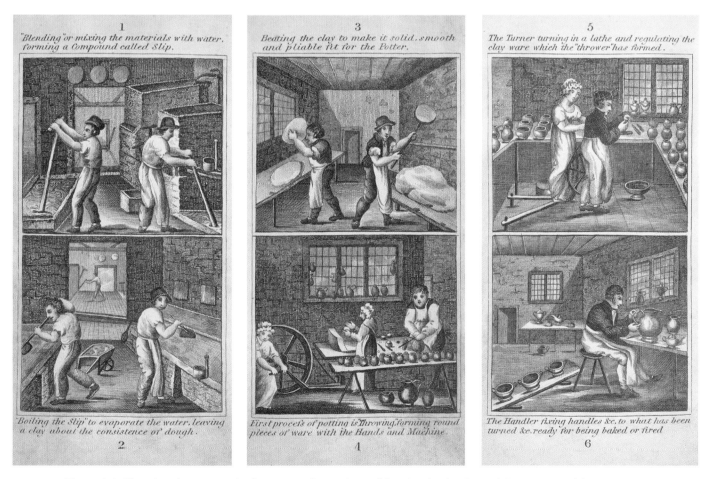

Figure 2.2. Plates 1–6 show potters in the process of preparing and forming the clay. From *A Representation of the Manufacturing of Earthenware* (London: Abrose Cuddon, 1830). Printed Book and Periodical Collection, Winterthur Library.

the pitted, orange-peel surface texture that is a characteristic of salt glazing was not always suitable for fine decoration. More detrimental than the technical problems, however, was the fierce competition between makers. This led to a price-cutting war that resulted in a downward spiral of prices, and in the early decades of the eighteenth century many potters were ruined. In response, experiments were carried out to develop a new kind of pottery that would fulfill consumer demand for inexpensive tableware but allow a margin of profit for the maker. The result was creamware, which came to dominate the industry, creating huge demands in Europe as well as in England and the colonies.

Creamware: Introduction

Enoch Booth of Tunstall, Staffordshire, is credited with being the first creamware potter. He made pottery from the clay-flint mixture first developed for saltglaze but coated it with the traditional lead glaze of simple Staffordshire earthenware, and adopted the separate biscuit and glaze firings of more sophisticated pottery such as delftware and refined red earthenware. The double firing cycle meant that the pieces were formed by wheel or by mold, dried, and then fired to a temperature of about 1100–1150°C. At this point the pottery, in "biscuit" state, was dense, brittle, and porous. Although biscuit earthenware could not hold liquids, a hard biscuit body allowed the piece to be more easily handled while

a range of underglaze colored decoration was applied, creating a more sophisticated end product. Sometimes the piece remained undecorated at this stage, and a creamware was produced that could be left plain or receive decoration after the glaze firing. (Fig. 2.3) For the second, or glaze, firing, the pots were dipped into a liquid lead-based glaze and fired again to about 1050–1100°C, fixing a shiny waterproof coating all over the pot.

The main component of the glaze used for eighteenth-century English earthenware was lead, a well-known glass-forming material that had been used in ceramic glazes from the medieval period. The lead available to eighteenth-century Staffordshire potters was seldom pure. It was found in deposits alongside iron ore, which contaminated it to various degrees. Depending on the amount of iron staining in the lead, the resulting creamware glazes were tinted in shades from pale primrose to deep honey. Creamware might have gradually lightened over time as progress was made in preparation techniques, but color cannot be used exclusively to determine the date, as factories not willing or able to adopt the latest improvements continued to make darker creamware alongside the lighter pieces produced by fellow potters. The story of creamware is the search for the means of removing iron impurities from the glaze with the ultimate goal of producing white earthenware.

Enoch Booth left evidence of his early manufacture of creamware with several examples dated 1743. As other potters began to make the new product, it gained an

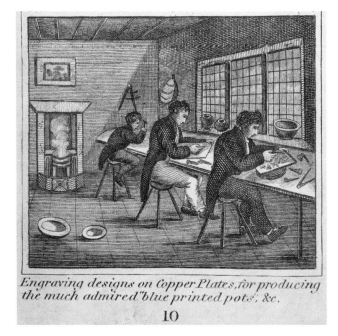
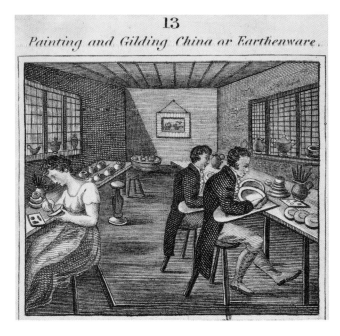

Figure 2.3. Plates 10 & 13 illustrate the process of engraving designs and painting over the glaze. From *A Representation of the Manufacturing of Earthenware* (London: Abrose Cuddon, 1830). Printed Book and Periodical Collection, Winterthur Library.

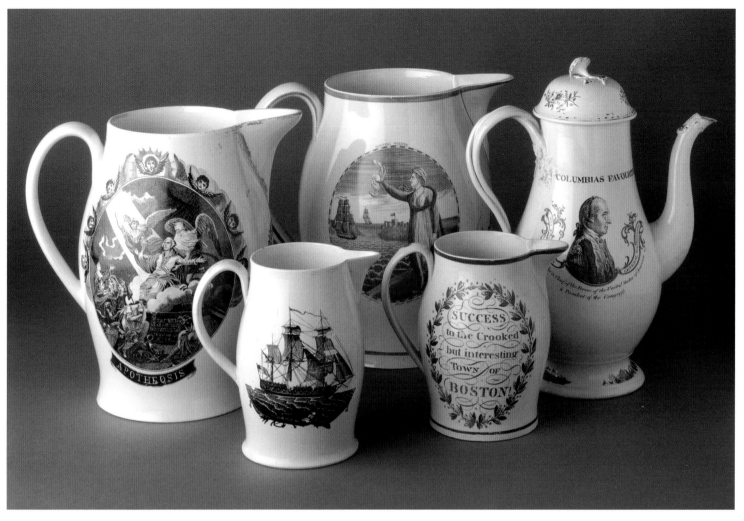

Figure 2.4. These pots illustrate the range of colors and types of printed designs available on creamware destined for the American market from 1778 to 1815. For complete descriptions, see *(from left)* cat. nos. 12, 4, 48, 37, 10.

increasing market share and was a well-established pottery body by the 1750s. It was extremely popular with American colonists. As early as 1751, the *Boston Evening Post* carried advertisements for the sale of "Cream colored…Tea-Pots, Sugar Dishes."[2] It did not take long for its popularity to spread. Plain creamware was the cheapest and most ubiquitous. The forms were stylish, and the pottery was elegant and hard wearing. Apart from rarely encountered underglaze painting in cobalt blue, manganese brown, or copper green, decorated creamware was usually printed or painted over the glaze. Printing offered complex scenes, realistic portraits, and recognizable events but was confined to monochrome colors, usually black, occasionally red, and, rarely, lilac. It was possible to enliven the print with touches of hand-painted color, but this was not normally successful over a large area of print. Perhaps the most commonly found supplementary colors are the reds and blues added to prints of ships, so that a flag could depict the Union Jack of Great Britain or the Stars and Stripes of America, customizing the design for a specific market.

Creamware: Printed Decoration

Printed decoration on creamware offered images similar to those printed on paper or published in books. (Fig. 2.4) Copying or adapting a design from an existing source was standard practice for engravers in the ceramic industry. It required fewer resources in creation, cost less to produce, and was completed more quickly than an original design engraved from scratch. The cost of engraving a copper plate to print a personalized inscription was rarely worth the expense, and so names, dates, places, and other personal details found on printed pottery were often added in hand-painted enamels.

The earliest known prints on creamware are those produced at the Liverpool firm of Sadler and Green. The techniques of printing are complex, as the production period for creamware spans the introduction of two major printing processes: bat printing and hot-press printing.[3] In the 1750s John Sadler and his assistant, Guy Green, swore an affidavit that they "did within the space of six hours . . . print upwards of Twelve hundred Earthenware Tiles of different patterns at Liverpool."[4]

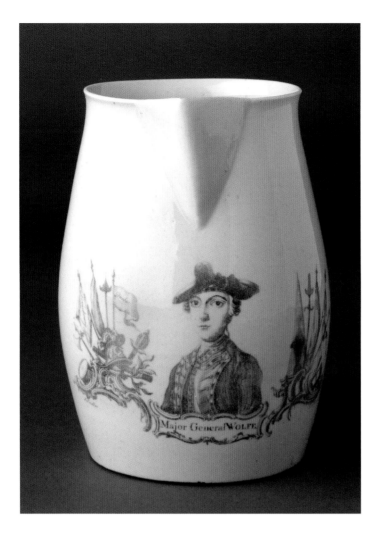

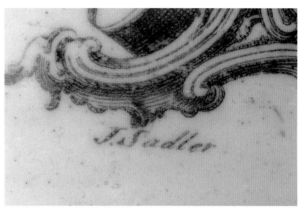

Figure 2.5. Porcelain jug made at Longton Hall, Staffordshire, with printed decoration by John Sadler, Liverpool, ca. 1760. Signed "J. Sadler" at bottom left of print. 1958.731 Winterthur Museum, bequest of Henry Francis du Pont.

Figure 2.5a. Detail of John Sadler's signature. 1958.731 Winterthur Museum, bequest of Henry Francis du Pont.

The earthenware tiles they used were tin-glaze, a product of the local Liverpool pottery industry. As printers, Sadler and Green did not undertake the production of the etched or engraved copper plates used to produce the designs; they engaged engravers to supply them. The growing city of Liverpool with its industry and maritime businesses offered engravers numerous opportunities. Bill heads, art works, newspapers, broad sheets, clock dials, the Lancashire textile industry, and the city's own potteries needed the skills of engravers. Some were employed in industry and worked for their masters; some worked for master engravers in a specialist business; others were freelance. Printers might employ one or two of their own engravers and job out extra or special work to the freelancers. This seems to have been the case with Sadler and Green. Prints are occasionally found with their signature and, more rarely, with the additional signature of the engraver, leading to the conclusion that in these cases the engraver was a significant artist commissioned to provide that particular design. Although Sadler and Green's signature is commonly found on Liverpool tin-glaze tiles and on porcelain, it also appears on Staffordshire earthenware, for in 1761 the printers entered into a series of restrictive agreements with Josiah Wedgwood.[5] (Figs. 2.5, 2.5a)

At the time, Wedgwood had been in business alone for about two years and was yet to have his cream-colored ware approved of, and named, by Queen Charlotte. However, he was obviously a rising star in the industry and an extraordinary potter with great business acumen. Within a few years he was already thinking of developing his market in America, writing, "What do you think of sending Mr. Pitt upon Crockery ware to America, A Quantity might certainly be sold there now & some advantage made of the American prejudice in favour of that great Man.—Lord Gower bro.t. his family to see my works the other day & asked me if I had not sent Mr. Pitt over in shoals to America."[6] The Wedgwood and Sadler and Green agreement was mutually exclusive: Wedgwood agreed not to use any other printer for his creamware, and Sadler and Green agreed not to print creamware for any other manufacture. This arrangement held for at least thirty years until the death of Wedgwood in 1795 and probably until the retirement of Guy Green, the surviving partner of the Liverpool printing company, in 1799. One can assume with a reasonable degree of certainty that Wedgwood-marked, printed creamware was decorated by Sadler and Green and that known Sadler and Green prints on creamware are on wares supplied by Wedgwood.[7]

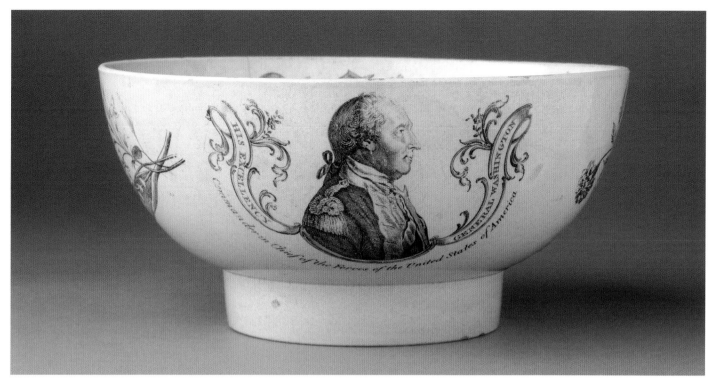

Figure 2.6. Based on an original of the early 1780s, this print of Washington's profile is done in the earlier style of engraving, with no frame or background. For a complete description, see cat. no. 7.

Creamware: Types of Printed Designs

The earliest designs on creamware were freely conceived and are rarely confined within a frame or cartouche. The foreground is usually defined by a band of rocks and foliage or a scrolling title, providing a lower boundary to the design. There is seldom any sky or distant view in the top half of the print; the figures and trees are profiled against the creamware body so that the printed picture sits as a "cut-out" on the surface of the pot. The printed portrait of George Washington is typical of this earlier style of engraving. (Fig. 2.6) Prints for the American market mostly date from the post–Revolutionary War period, however, and they exhibit features of a later style. From the 1780s, the main scenes in printed decorations were often depicted within circular or oval panels with additional details such as swags, foliage, or inscriptions arranged around the outside. The designs fill the whole panel. Skies with clouds, distant views, and complex foregrounds were etched and engraved and then often printed in an intense black that produced darker, busier designs than those in the earlier, simpler vignettes. (Fig. 2.7)

Every manufacturer with ambition for monetary success was looking to the overseas trade, and America, with its British taste and culture, was seen as a prime market. In the 1760s and 1770s Liverpool may have dominated the pottery printing trade, but eventually engravers and printers offered their services in Staffordshire, where there was a growing need for their work. The concentration of potteries in North

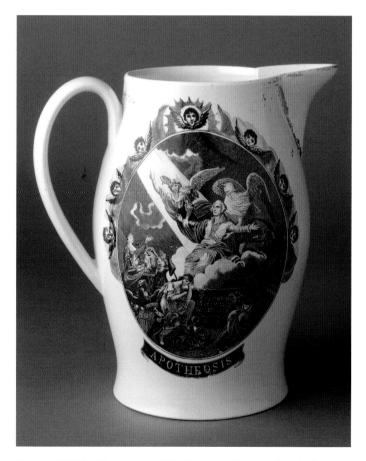

Figure 2.7. The "Apotheosis of Washington," after an original of 1802, shows a later style of engraving: it is framed, darker, and has a heavily engraved background. For a complete description, see cat. no. 12.

Staffordshire offered steady employment for skilled men, and it made commercial sense to have the decorators as close as possible to the site of production. From the closing years of the 1700s until 1818, more than sixty engravers were recorded in Staffordshire.[8] Some were self-employed, but others worked for engraving establishments and pottery manufacturers where they might have created designs for printing in underglaze blue on pottery as well as overglaze decoration such as those found on creamware made for the American market.

A number of printers working in this later style must have bought plain wares that they then decorated, for there are a number of prints with American-market

Figure 2.8. This jug, in purple, carries the printer's mark "F. Morris" "Shelton." For a complete description, see cat. no. 17.

Figure 2.9. The print on this jug carries the inscription "Bentley Wear & Bourne Engravers & Printers, Shelton Staffordshire." For a complete description, see cat. no. 31.

subjects that include signatures in the design. Prominent among these is Francis Morris, whose name appears in tiny letters within the print "F. Morris Shelton." It is not known whether Morris was trained as an engraver, but he first appears in 1800 as a black printer of Vale Pleasant in the Staffordshire potteries.[9] He may have employed engravers or purchased copper plates from independent engravers. The term "black printer" is used to describe a printer of overglaze decoration, although we know that Morris also used other colors. (Fig. 2.8) By 1809 the firm seems to have expanded and was listed as "Morris, Francis, gilder, enameller, & printer of earthenware, Shelton," but by 1818 the business was gone.[10]

A slightly later printing company was Bentley, Wear & Bourne. The partnership is thought to have begun in 1815. (Fig. 2.9) By 1816 they were occupying new premises in Shelton, Staffordshire. The firm was listed as engravers, printers, and enamelers in a notice announcing the resignation of Bourne in June 1818. The works was offered for sale or rent by Bentley & Wear in February 1820.[11] William Bentley and Simeon Bourne were both engravers living in Shelton, but there is no one by the name of Wear listed in any of the Staffordshire pottery towns, suggesting that he was an investor rather than an active partner in the concern.

Little is known of the trading practices of printers in the early nineteenth century, but it is reasonable to suppose that they not only purchased plain wares to decorate with their own designs but also worked on commission for manufacturers. A large number of Morris pieces exist in the S. Robert Teitelman Collection, suggesting that Morris specialized in prints for the American market and that he was not afraid to advertise his work.

The American Market: Patriotism & Commerce
By far the greatest number of printed designs for America are devoted to the military hero and first elected president, George Washington, celebrated in life and deeply mourned in death. Prints of Washington as commander in chief of the forces gave way to presidential imagery, but for decades following his untimely death memorials of all kinds continued to be popular. Sources for designs often emanated from America but were then copied and recopied in Europe. It is often possible to trace the original source of a print, particularly of Washington, but it is difficult to identify the specific version of a print that an engraver might have copied. Some pottery pieces are completely decorated with prints devoted to a single subject, and again Washington dominates. Frequently, however, prints on a single piece have no obvious relationship to one another. A bowl with two George Washington prints might also have

Figure 2.10. The printed patterns with touches of hand painting seen here illustrate the various colors and designs available on creamware made for the American market in the 1778–1815 period. For complete descriptions, see (*from left*) cat. nos. 71, 65, 33, 54, 45.

floral sprays, sailors, or Neptune interspersed. It is difficult to date Washington memorial prints because they continued to be popular for so long.

Expressions of respect and support for Washington are just one phenomenon of the exceptional outpouring of patriotism in the early years of the young American nation. Proud of their hard-won independence, concerned for their continued Union against the rest of the world, and eager to have visible symbols to express their sentiments publicly, Americans bought printed pottery with images and mottoes that were tangible tokens of their patriotism. Popular prints included national symbols such as the Great Seal of the United States. The symbolism of each element of the design was not always fully understood by the English engravers and so there are some interesting interpretations; nevertheless, the designs must have been acceptable to the consumer as the pots survive in great number. It is significant that the Liverpool pottery firm of Herculaneum created an adaptation of the Great Seal for its own mark, placing it prominently on jugs with the factory name below. "Peace, Plenty, and Independence" was a popular slogan; the print is occasionally hand painted with enamel colors and can make a very showy display. "Peace and Prosperity to America," "Success to American Trade," and "Free

Trade and Sailors Rights" all speak to the fight for a place on the world stage, as war with France threatened then receded, and the English navy continued to impress American seamen (Fig. 2.10). Perhaps the most moving of these patriotic messages is that found on a jug made for David Alden: "May the tree of Liberty that first buded in America spread its branches through the world."

In celebrating America's growing international commerce, the most commonly seen print is that of a sailing ship. Most of these were rarely, if ever, intended to depict particular vessels; they were "stock prints" that found favor with ship owners and masters who were willing to take any depiction of a ship and personalize the piece by paying for additional hand painting. Many of these personal pieces are jugs. When the name of a ship, ship's master, or home port is added, it elevates the level of interest and value for the modern-day collector; when all three details are added, the jug becomes exponentially important. A printed jug may be enjoyed as a wonderful piece of ceramic art, but when it carries personal details that reveal the name of the owner and his place in society or enables us to follow the ship's voyages through shipping wars and over dangerous oceans, then the jug becomes a more tangible, exciting link to America's past. The S. Robert Teitelman Collection is rich in such documentary pieces.

The American Market: Special Commissions

The most extraordinary decorations found on creamware are the specially commissioned designs hand painted in colors over the plain shiny glaze. (Fig. 2.11) Overglaze color is known as enamel color and is basically a colored glass fixed to the glazed surface of the pot. The specially prepared colored glass is crushed and sifted until it is a fine powder. The powder is then used by the enameler, who grinds it into a measure of oil to make it suitable for painting. During a subsequent firing, the oil evaporates, leaving the ground glass on the surface of the pot in the desired pattern. At the height of the temperature, the glass enamel and the glaze soften, and the glassy enamel reforms and becomes fused with the glaze, creating patches of translucent color. Different groups of colors mature at different temperatures between 800° and 1000°C. This means those colors requiring the highest temperature are applied first and fired, and those requiring a lower temperature are applied and fired next, until all the necessary colors are applied. Gilding, in which finely ground gold powder is used as the coloring agent, is applied last, as it will not survive at temperatures above 800°C. Once the pottery was made, it could be painted at the factory or sold to be decorated by specialist enamelers.

The S. Robert Teitelman Collection at Winterthur has a wealth of specially commissioned pieces. The most common form for a presentation or commissioned piece is the jug. Of varying sizes from half-pint to many pints, the jugs came with numerous decorative options. Most often they would have been commissioned in Liverpool. A visiting ship's captain could have one made for himself or order one for a customer in his home port. The jugs may have been made in Liverpool, Staffordshire, or any of the major pottery-making areas, but it seems reasonable to suppose that the final decorative touches would have been applied in Liverpool, where the customer could order directly from the factory, warehouse, or decorating establishments. Occasionally, special pieces may have been made in Bristol or Swansea (see cat. no. 22) and shipped from the port of Bristol, but research on the majority of named jugs suggests the trade was most frequently carried out in Liverpool.

In looking for an appropriate souvenir, a visiting American could buy a standard printed piece with a design made specifically to appeal to American buyers. If something special was wanted, it was possible to purchase a piece that had a reserve panel left blank, usually beneath the spout, for the addition of a painted name, initials, or monogram. An enameler could easily add a few letters or words and fire the piece and have it ready before the purchaser's return voyage to America. Other times a purchaser might be in too much of a hurry or unwilling to pay the price to have the extra decoration added, and the space would remain blank (see cat. no. 61).

The vast majority of painted creamware was decorated with generic designs, either at the pottery or by specialist decorators. Floral sprays, landscapes, ladies and gentlemen taking tea, and exotic Chinese gardens were all subjects with a wide appeal that could expect to find customers throughout England, Europe, and America. Designs made for a narrow, specific market were a much riskier business as trade could be, and frequently was, disrupted by war, economic downturns, or changes in customer preference. Some painted decoration could be calculated to have specific appeal to a certain group of people in more than one country. Early teapots, typically painted with black and red enamel decoration, had images and sentiments that spanned the political thinking in both England and colonial America. Images relating to the libertarian John Wilkes and inscriptions seeking "Freedom to the Slave" (see cat. nos. 2, 23) found a welcome place in homes of those who supported the cause. Pieces such as these could have been made and decorated in any of the pottery-making centers; Staffordshire was the largest, and therefore the most likely source for many.

To offer a convenient and relatively economical way to order a special piece, jugs might receive a print on one side only, leaving the other side blank for a more ambitious commission to be painted later. This trade relied on having good pottery artists available to paint the desired design, fire it, gild it if necessary, fire it again, and have it packed on board ship. Most likely many of the specially commissioned painted pieces were completed in Liverpool on jugs made there and elsewhere. The most expensive option for acquiring a jug was to order a completely hand-painted piece without any printed design. The most desirable pieces have details such as names, dates, or places that enable us to identify the owner and get a glimpse into the life of that person. The jug made for Joseph Lovering (cat. no. 60) not only depicts his experience as a firefighter in Boston but is a tangible link to a man who, as a young boy, was involved in the Boston Tea Party. When you look at this jug, when you hold it, you are experiencing history. Some painted scenes give us a glimpse of an America that no longer exists. The Cade Brothers rope works in Boston is depicted showing the long, low line of narrow sheds where the rope was drawn and twisted (see cat. no. 43). That land was sold in 1805 to a housing developer, and in the background of the scene you can see Beacon Hill and its monument to the heroes of the Revolutionary War. The monument was removed in 1811, and the earth was used to fill Mill Pond.

Figure 2.11. These pieces show the types and colors of hand-painted decoration available on creamware destined for the American market from 1765 to 1820. For complete descriptions, see (*from left*) cat. nos. 8, 23, 41, 2, 48.

To save time and money, many of the specially commissioned jugs were painted in monochrome, usually in shades of gray and black. A quick turnaround in port meant that there was limited time to commission a piece, negotiate a price, and have the painting and firings completed before it could be packed for the journey. Occasionally, however, more ambitious objects were produced. The charming piece made for Rachel Mackinet (see cat. no. 58) has an elegant, subtly colored painted portrait of Rachel and the name of her inn in Germantown, Pennsylvania. In contrast, the portrait of Mr. Scarff on the jug celebrating the art of the cooper is in hard, strong colors that dominate the front of an otherwise black-printed jug (see cat. no. 59). The survival of so many of these special purchases suggests that they held a special place in the families of the men who ordered them. They can be found in museums up and down the eastern seaboard of the United States. Some were presented to local history societies, particularly if the scenes portrayed an important event or activity. Proud descendants wanted to secure a safe harbor for their family heirloom.

From the early nineteenth-century firefighters of Boston to the fabled merchant-princes of Salem and U.S. Navy vessels, sloops, and schooners, numerous scenes of American life have been recorded in hand-painted and transfer-printed images on the smooth, shiny glaze of English creamware. These objects were purchased through the international commerce that was an essential part of establishing America as a "real and permanent country." The ability of the English potters to provide goods so desirable and so meaningful to the American market transcended the frequent hostilities. Political embargoes, declarations of war, and skirmishes on land and sea were all to take place as America won independence from Britain and fought to establish its position on the world stage. Remarkably, at every opportunity the sympathetic English potters celebrated and commemorated the American cause, eager to secure the business of this emerging nation. (Fig. 2.12)

Figure 2.12. "Success to America" is a sentiment frequently found on creamware made for the American market. For a complete description, see cat. no. 69.

POTTERY AND
THE LIVERPOOL TRADE

Robin Emmerson

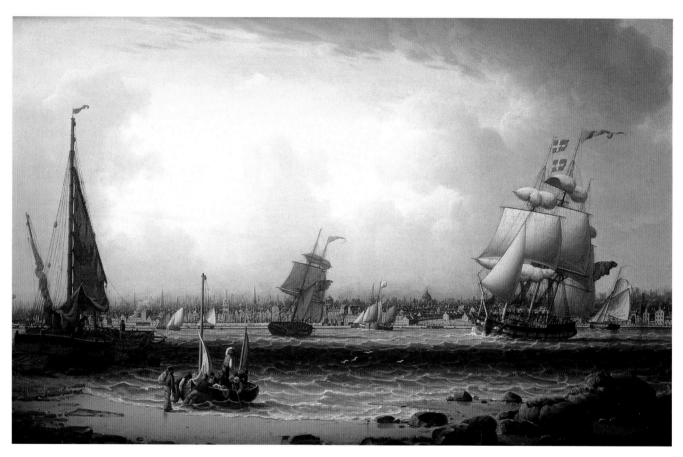

Figure 3.1. Robert Salmon, *View of Liverpool*, ca. 1825. Oil on wood panel; 15¼ x 25in. Inscribed on the reverse: "Painted by Robert Salmon, 1825." Courtesy Alan Granby and Janice Hyland.

In the eighteenth century, Liverpool took over from Bristol as the most important British port after London. Both were on the west coast, facing America, but while Bristol's access to the sea was gradually silting up, Liverpool had no such problem, situated just inside the mouth of a wide and deep river, the Mersey. As America's economy took off during the course of the eighteenth century, so did Liverpool's.

In 1715 the Corporation of Liverpool built the world's first enclosed dock, strikingly visible on early views and maps of the town. At the time the town consisted of only a few streets. When you compare a map of the 1790s, it is clear that the community had grown enormously (Fig. 3.1). There was now a row of enclosed docks lining the waterfront, dwarfing the original, known as the Old Dock. Behind the docks were lines of warehouses, stacked high with imported sugar, tobacco, and cotton as well as manufactured goods and raw materials for export. (Fig. 3.2)

Economic historians will no doubt continue to argue

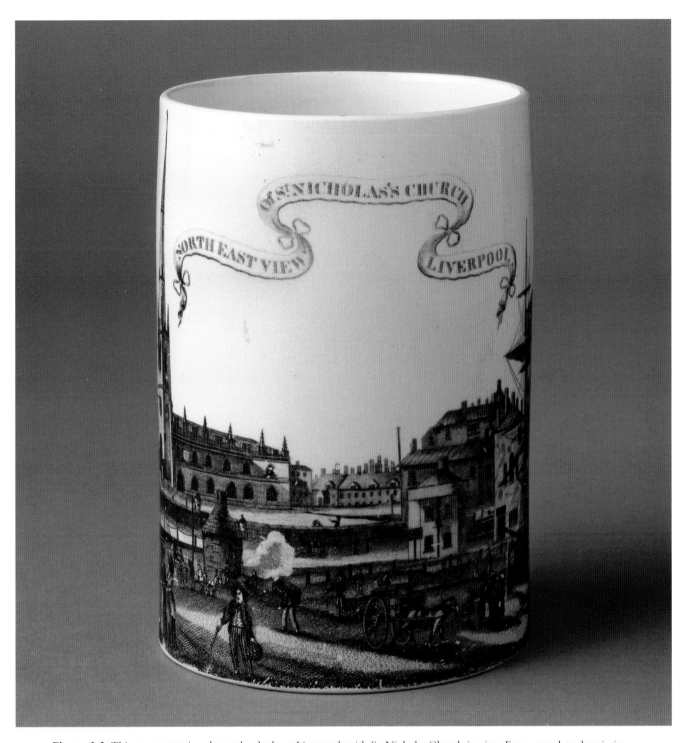

Figure 3.2. This creamware jug shows the docks at Liverpool, with St. Nicholas Church in view. For a complete description see cat. no. 36.

over the exact proportion of Liverpool's eighteenth-century wealth that came from the transatlantic slave trade. What no one disputes is that in the second half of the century Liverpool took over from Bristol as Britain's main slave-trading port. The responsibility for the trade did not, however, rest on the shoulders of a few wealthy businessmen. Many of the town's inhabitants took a small share in a ship in the "Africa trade," with no ethical misgivings. For them the horrors of the trade were out of sight and out of mind. The ships left Liverpool with cargoes of manufactured goods for West Africa. There the goods were sold and the ships packed with their human cargo of slaves, bound for the New World. In the New World the slaves were sold, and the ships were loaded with sugar, tobacco, and cotton, headed for Liverpool. This was the so-called "triangular trade," which yielded an unspectacular but steady profit to support many of Liverpool's other business ventures, including ceramics.

Liverpool: Delftware and Transfer Printing
The beginning of Liverpool's ceramics industry was marked by an advertisement in the *London Post Boy* on May 23, 1710: "The Corporation of Liverpool in Lancashire have encouraged there a Manufactory of all sorts of white and Painted pots and other vessels and Tiles in imitation of China, both for Inland and outland Trade, which will be speedily ready and sold at reasonable rates."[1]

These white pots were delftware—tin-glazed earthenware. The tin in the glaze made the pots white, concealing the buff color of the earthenware body in an attempt to look like Chinese porcelain. Unfortunately, delftware was not strong, and the glaze was especially prone to chipping, exposing the brownish body beneath and giving the game away. (Fig. 3.3) Its resistance to thermal shock was also poor. Relatively few teapots survive in comparison with other shapes, probably because of their tendency to crack when boiling water was poured into them. Despite these disadvantages, delftware continued to be made in large quantities through the middle years of the eighteenth century in Liverpool, London, Bristol, Glasgow, and Dublin.[2] The number of potteries grew tremendously in Liverpool because they could cash in on the booming export trade. When Americans at this time referred to "Liverpool ware," it was delftware that they meant.

Liverpool's other ceramic speciality was developed in the 1750s on the back of the delftware manufacture. In 1756 John Sadler and Guy Green in Harrington Street demonstrated the process of transfer printing on delftware tiles. (Fig. 3.4) Their tiles were the first mass-produced printed pottery in history.[3] They first printed from woodblocks, creating a rather handmade look. Woodblocks wore out quickly, however, so the firm changed to engraved copper plates, which lasted longer and gave a more precise and delicate print. The commercial success of their tiles can be judged from their presence around eighteenth-century fireplaces all along the eastern seaboard of the United States.[4]

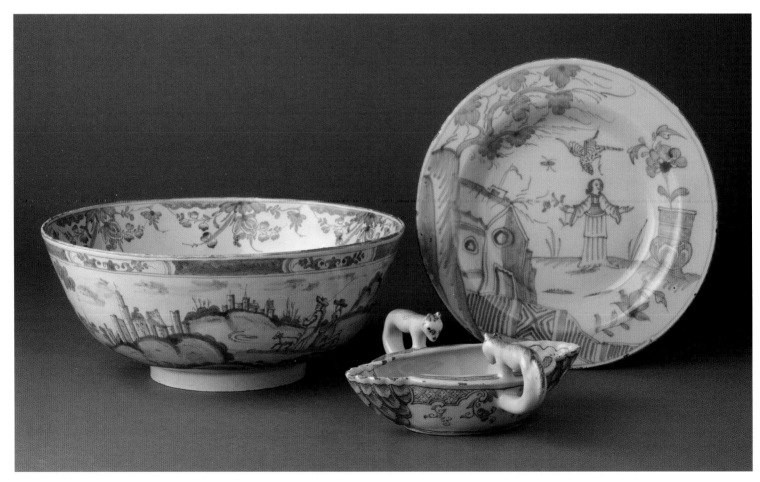

Figure 3.3. The bowl, sauceboat, and plate illustrate some of the disadvantages of delftware. Note the earthenware body showing through where the objects have chipped. *From left*: 1984.30 Winterthur Museum; 1962.596 Winterthur Museum, bequest of Henry Francis du Pont; 1974.47 Winterthur Museum, gift of Mr. and Mrs. Reginald P. Rose in memory of Mrs. Harry Horton Benkard.

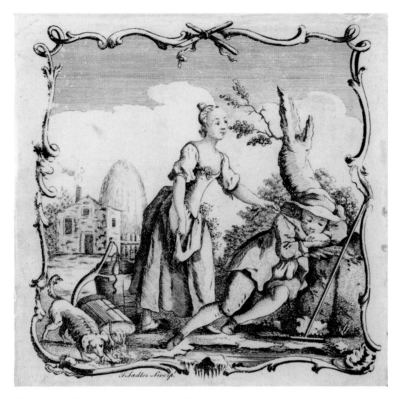

Figure 3.4. This transfer-printed delftware tile, which dates to 1757–61, is marked "J. Sadler Liverpl." 1969.3676 Winterthur Museum.

Staffordshire: Salt-glazed Stoneware

By 1760 the Liverpool potteries were losing ground against increasingly powerful competition from Staffordshire, where potters were making England's first hard, all-white pottery—salt-glazed stoneware. Staffordshire potteries initially had the disadvantage of being inland, with no navigable river to the coast. In the 1730s they remedied the situation by deepening the River Weaver, enabling them to transport pots from Winsford to Liverpool by water. A second impediment was their need to import the special clay for the stoneware from Devon and Dorset around the coast to Liverpool and then inland to Staffordshire.[5] The economics of this may seem to make no sense until one realizes that up to ten tons of coal were needed to fire one ton of clay. The Staffordshire potteries had the advantage of being built on an extensive coalfield, with many potters owning their own mine workings literally in the backyard of the pottery.

The white salt-glazed stonewares from Staffordshire were stronger than Liverpool delftware. You could pour boiling water into a teapot without fear of its cracking, and the stonewares were also less easily chipped. If they did chip, the body inside showed white, the same color as the outside. White stoneware soon commanded a premium in both the home and export markets, but delftware did not stop being made. It was simply pushed further down the market. This set a pattern that was repeated each time a technically improved new ware came out of Staffordshire: previous types did not go out of production but were pushed down the market. They ceased to be made only when even the poorest customers could afford something else.

Why did the technical innovations in ceramics come from the potters of Staffordshire rather than Liverpool? Coal was available cheaply enough in Liverpool, and it was exported from there to New England. The explanation lies in the concentration of skills in the two locations. In North Staffordshire the pottery and coal industries were the main potential source of wealth for young men on the make. In Liverpool the most lucrative opportunities centered around shipping and trading. There was plenty to attract the brightest minds away from a future in the pottery industry. The concentrated "skills pool" in Staffordshire, by contrast, gave its industry unbeatable strength.

Figure 3.5. White salt-glaze stoneware teapot made in Liverpool and incised "Henry Muskett 1760."
© Royal Institution of Cornwall.

Liverpool Responds

In the 1760s Liverpool potters responded to the competition from Staffordshire. First, they began to trade in Staffordshire stoneware in addition to their own products. Many potters followed the example of John Dunbibin, who made delftware in Liverpool but acquired warehouses in Liverpool and London for the sale of delftware as well as white stoneware and the brown stoneware made in Nottingham.[6] Next, Liverpool potters began to make what Staffordshire was making. Timber merchant John Okill was an important shipbuilder who diversified into other aspects of the import-export business. He owned the Flint Mug Works in Parliament Street. The name of his pottery advertised the fact that it made white stoneware, for calcined flint was a principal ingredient. There is not much doubt that the pottery was serving the export trade. Okill's half-brother George settled in Philadelphia, and in 1767 his

nephew John wrote from Jamaica about selling pottery.[7] Henry Muskit (Muskett) completed his apprenticeship with John Okill & Co., and a white salt-glazed stoneware teapot and tea canister of his survive, both with "Henry Muskett 1760" incised into the clay before firing.[8] (Fig. 3.5) If it were not for these inscriptions, both pieces would be ascribed to Staffordshire. Liverpool and Staffordshire saltglaze evidently look so much alike that it is nearly impossible to tell them apart.

At the same time in Liverpool, a new breed of entrepreneur was arising whose sole business was buying and selling. Called Liverpool merchants, the businessmen possessed a nose for fashion, a good sense of where market demand was moving, excellent communications skills, and the ability to maintain and develop business relationships at long range. Before long these Liverpool merchants would become merchant bankers, as a more sophisticated need to extend credit and maintain capital arose.

Figure 3.6. An impressed "WEDGWOOD" mark identifies this transfer-printed creamware stand, 1770–80, which would have formed part of a dinner service. 1969.936.62 Winterthur Museum, bequest of Henry Francis du Pont.

Staffordshire: Creamware

In the early 1760s creamware became a serious competitor to white salt-glazed stoneware. Its smooth, glossy glaze made it superior in appearance to the dimpled, "orange-peel" texture of saltglaze, and young Josiah Wedgwood saw it as the perfect surface for printed decoration. (Fig. 3.6) Printed decoration had already been used on porcelain, but porcelain was expensive. If the same process could be executed on creamware, the middle class would snap up the chance to copy this expensive look at an affordable price. Liverpool's Sadler and Green had the skills and were in exactly the right place to do the job for Wedgwood, who would send them undecorated pots. As soon as the pots were printed, they could be put straight on the ship in Liverpool for export. Wedgwood made an exclusive agreement that Sadler and Green would print on creamware for nobody but him, and he kept them well supplied. This meant that Wedgwood had a product his competitors in Staffordshire could not make, earning his creamware a unique reputation.[9]

Creamware now pushed white saltglaze down the market just as saltglaze had done to delftware. There was a clear pecking order in terms of price and desirability. Ebenezer Bridgham advertised his china shop in the *Boston Newsletter* on December 31, 1772, calling it the Staffordshire and Liverpool Warehouse, pointedly listing Staffordshire first and Liverpool second as places where desirable pots were made. The order of products listed in the ad itself reflects customer demand, with the best sellers noted first: "A beautiful variety of printed and gilt and plain cream-coloured plates, dishes, candlesticks, salvers . . . flummery moulds, and many other articles never before imported into this place. All sorts of Agate, Tortoise, Pineapple, Collyflower, Fruit pattern, enamelled, black, brown, white, blue and white and red ware." Printed creamware is at the top of the list, followed by gilt and plain creamware. After this come types more or less covered with colored pigments or glazes, which had been fashionable in the early days of creamware when its body was still a dull color that looked better covered. White saltglaze and delftware are probably taken for granted in the "white, blue and white" at the end. Fashionable customers would now be buying them only for the kitchen and the servants.

Liverpool: Creamware Too

Just as Liverpool potters had replicated white saltglaze, so they copied creamware in turn. When John Okill died and his Flint Mug Works was advertised for sale in 1773, the stock included a quantity of creamware that was specifically described as having been made on the premises.[10] We also have evidence of Liverpool creamware from printed decoration. Simeon Shaw's *History of the Staffordshire Potteries*, published in 1829, says of the year 1767: "About this time Thomas Rothwell possessed of great skill as an enameller, engraver and printer, was employed by Mr Palmer, at Hanley, and specimens yet remaining evince considerable ability but like all other attempts, they do not equal the productions

of S &G for Mr Wedgwood."

Rothwell was born and bred a Liverpool man and described himself as an enamel painter. It is clear from his history that he must have learned engraving and transfer printing with Sadler and Green before going freelance and exporting his skills to Wedgwood's competitor Humphrey Palmer in Staffordshire.[11] A teapot exists with a print of the Haymakers, a design that Sadler and Green printed for Wedgwood. In this instance, however, it is signed "T.Rothwell Delin. et Sculp." and is printed on a pot of a distinctive form, unlike those known to have been made by either Wedgwood or Palmer. (Fig. 3.7) Its deep cream color suggests a date in the 1760s. The signature indicates that Rothwell both

Figure 3.7. Creamware teapot with print signed by Thomas Rothwell. Courtesy National Museums Liverpool.

drew the design and engraved the copper plate, working freelance. But who made the pot? Others of this precise shape are known with similar-looking printed decoration. It seems possible that the teapots were made in Liverpool and the printed decoration added there before Rothwell left for Staffordshire.

Rothwell was perhaps Liverpool's first freelance engraver and pottery printer. Other pupils of Sadler and Green followed. The best documented is Richard Abbey, who apprenticed to them from 1767 until 1773, when, at the age of nineteen, he set up his own business and noted in the *Liverpool Advertiser* on December 10 of that year:

> RICHARD ABBEY Late Apprentice to Messrs. Sadler and Green Begs Leave to inform his FRIENDS and the PUBLIC That he has Open'd his SHOP, at NO.11, in Clieveland Square, Where he Manufactures and Sells all Sorts of QUEEN'S WARE, Printed in the neatest Manner, and in a Variety of Colours N.B. Orders for Exportation Also Crests, Coats of Arms, Tiles, or any other particular Device will be completed at the shortest Notice By their most obedient humble Servant RICHARD ABBEY.[12]

Abbey was stretching a point since he "manufactured" creamware only in the sense of printing on it. Other Liverpool pottery printers could, like him, complete "Orders for Exportation . . . at the shortest Notice" because there was a ready supply of every conceivable shape and size of piece filling the warehouses along the waterfront. Printing also enabled decoration to be done quickly, even on bespoke pieces that required personalized inscriptions. Standard images of ships of different kinds, floral swags for borders, scenes of agricultural contentment, sailors' farewells, and verses for every occasion were all available as prints. Special decoration could be added quickly, with the all-important names and dates painted by hand in the spaces left for them, along with any non-standard message if the customer required one.

Most of the creamware decorated by Liverpool printers was from Staffordshire, because that was what was filling the Liverpool warehouses. From 1777 it became much easier and cheaper for the Staffordshire potters to send their wares to Liverpool with the opening of the Trent and Mersey canal. The result was a huge boost to the Staffordshire industry and an increase in Liverpool's ceramic exports. The most enterprising Staffordshire potters also began to find it advantageous to employ their own staff in Liverpool: Thomas Wolfe of

Stoke employed young John Davenport from 1786, and Davenport is said to have greatly developed Wolfe's exports to both America and India.[13] Gore's *Liverpool Directory* notes that in 1790 Wolfe had warehouses at 35 and 45 Old Dock, and he boasted in an advertisement that "he keeps 500 crates ready packed, in his warehouse in Liverpool suitable for the West Indies or American markets, which may be shipped at a day's notice." A brief partnership developed between Wolfe and Davenport but was disbanded in 1794. Wolfe continued his business at the Old Dock. By 1796 he had added a "Staffordshire and China Warehouse" at no. 4 before moving to no. 42 and in 1805 to no. 44 "south east corner Old Dock" as Messrs. Wolfe and Hamilton.

John Davenport set up his own business a few yards away, as he announced in the Liverpool *General Advertiser* on September 25, 1794:

> The partnership concern heretofore carried on by Thomas Wolfe & Co. in Liverpool, in the Manufacturing and selling of earthenware and glass and conducted by the said John Davenport, being now dissolved by mutual consent, John Davenport begs leave to inform the public in general that he continues on his own account to carry on the business of Manufacturing and Selling Earthenware and glasses, in his warehouse on the south side of the old dock lately occupied by Mr Joseph Leay, where the orders of his friends and the public will be attended to and executed with punctuality and despatch.

The reference to manufacturing is rather misleading, since there is no evidence that Davenport made anything in Liverpool. He probably included it because in 1794 he had become a manufacturer by purchasing the Unicorn Pottery at Longport in Staffordshire. The export merchant had finally decided to control the whole business by taking over the production process itself.[14] Another Liverpool merchant connected to Staffordshire was William Pownall, who, as noted by Joseph Stringer, a clerk and cashier at Minton's, was involved with the beginnings of the firm in the 1790s under Thomas Minton: "He [Minton] was also fortunate in having the acquaintance of Mr Pownall, a merchant from Liverpool, who aided him with capital to extend his operations, and who was, for a few years, a sleeping partner in the business."[15]

The complex interplay between Liverpool and Staffordshire that we have observed in the export and financial side of the business is especially evident when

we look at the printed creamware pots of the years around 1790. It is difficult to determine not only where a particular piece of creamware was made, but even where it was printed. Many Liverpool ceramic printers were now following Thomas Rothwell's path to Staffordshire, setting up as freelance engravers and printers and printing pots from many different factories. One such man was Thomas Fletcher.[16] Born in Lancaster in 1762, by 1783 he was described as a pot painter of Shaw's Brow, Liverpool. In about 1789 he moved to Staffordshire and two years later insured a house and potworks adjoining in Hanley for £225. His signature is found on creamware printed by him in Staffordshire. In 1800 more than 450 of his copper plates were advertised for auction, with more being sold in 1807 after his death. Fletcher was described as an enameler, so this term, like pot painter, was evidently seen as including on-glaze printing. Only his signature enables pieces printed by him in Staffordshire to be distinguished from pieces printed by others at the same time in Liverpool.

Even a signature in a print, however, can be unreliable evidence. For example, Fletcher's copper plates, sold at auction, would have been bought and used by various printers and potters. These purchasers may not have removed Fletcher's signature from within the engraved design before using the plates; therefore, Fletcher's name on a pot does not necessarily mean that he printed it.

Perhaps the most mysterious of the printed signatures is that of Joseph Johnson.[17] His name is found on two teapots bearing prints signed "R. Abbey sculpt. Jph. [Josh] Johnson Liverpool."[18] In addition, a mug that bears a print of Bidston Hill Signals is signed "Printed by Joseph Johnson Liverpool" and dated 1789.[19] Despite this fact, Johnson cannot be traced in the Liverpool town records, and it seems most likely that he was actually a potter at Newburgh, some fifteen miles from Liverpool. An advertisement in Williamson's *Liverpool Advertiser* for January 21, 1793 reads: "CLAY Lately discovered within Parbold township sundry BEDS of CLAY, of excellent qualities which have been proved by Joseph Johnson, manufacturer of Earthenware, at NEWBURGH." Newburgh and Parbold were adjoining villages. It would make sense for an enterprising potter to give his address as Liverpool in a print, since in the event of enquiries from far afield he was probably known to the merchants in town. By contrast, no one beyond Liverpool would know where Newburgh was and which port served it. Johnson's signature is also found on a print on a jug bearing the impressed mark *Wedgwood & Co.* for Ralph Wedgwood of Burslem. (Fig. 3.8) It seems likely that Johnson printed only on creamware made by others.

Such examples should serve to demonstrate that those who refer to a piece of black-printed creamware as "a Liverpool jug" are ignoring the complex commercial setting in which these wares were created. Was the pot made in Liverpool or elsewhere; were the copper plates engraved in Liverpool or elsewhere; and was the piece printed in Liverpool or elsewhere? Any answer to one of these questions can be combined with any answer to either of the others. To make matters even worse, "elsewhere" does not just include Staffordshire, for Liverpool engravers and printers took their skills to potteries all over Britain. Most prints on creamware are unsigned, just as most creamware pots are unmarked. The reality is that for any particular creamware jug without an impressed maker's mark and decorated with an unsigned on-glaze print, the possibilities for attribution are legion.

New Ventures

In 1796 a new manufacturing venture in Liverpool was the most determined attempt of all to copy the successes of Staffordshire—the foundation of the Herculaneum Pottery at Toxteth just outside town beyond the Park Lane Pothouse.[20] (Fig. 3.9) The factory's classical name was a further imitation of Staffordshire, in this case of Wedgwood's famous Etruria factory. The archaeological discoveries of Herculaneum and Pompeii from beneath the volcanic ash of Vesuvius had been steadily published during the second half of the eighteenth century and continued to inspire the revival of ancient interior decorative styles.

The men behind Herculaneum were neither potters nor pottery dealers but businessmen with interests in shipping and ships' chandlery as well as the mining of slate in North Wales and its exportation from Liverpool. Why they decided to start an ambitious pottery when they did remains a mystery. We can, however, infer their view of Liverpool's pottery industry from their actions: they imported at least forty of their workforce, all the key technical staff, from Staffordshire. In the first decade of its life, Herculaneum was producing the same up-to-date range of pottery types as Staffordshire: creamware; blue-printed earthenware; unglazed stoneware in white, brown, and black; and bone china. The factory was on the bank of the River Mersey and had its own dock. From 1807 it also ran a showroom in Duke Street in central Liverpool, where fashionable interior designer George Bullock was paid for some decorative work in that year.[21]

It is arguable that Herculaneum was not so much a Liverpool pottery as a Staffordshire one on the Mersey. The factory put its mark on more of its pottery than most of its competitors did, but many of these pieces, if they

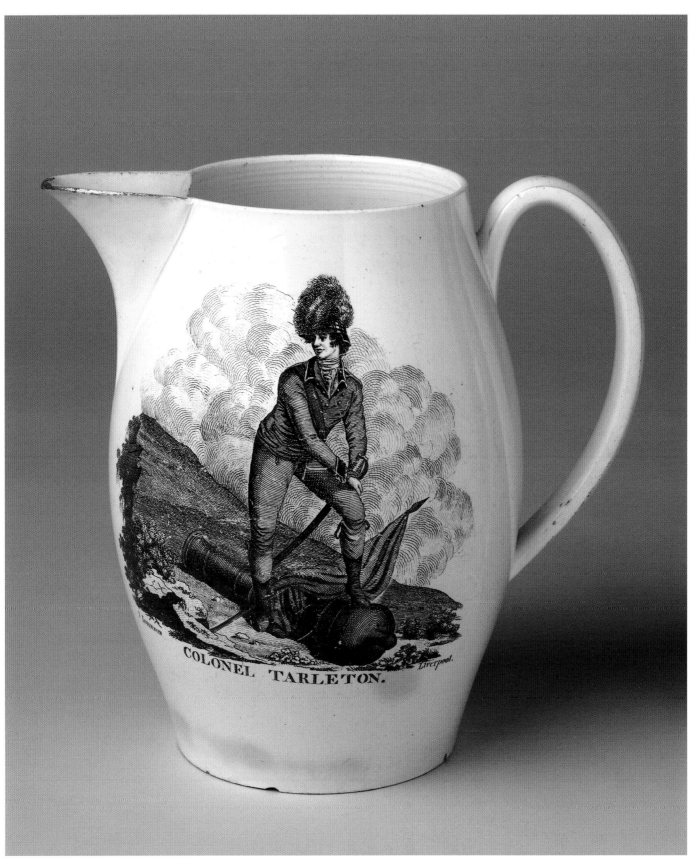

Figure 3.8. Creamware jug by Ralph Wedgwood of Burslem, Staffordshire, with print signed by Joseph Johnson, Liverpool. Courtesy National Museums Liverpool.

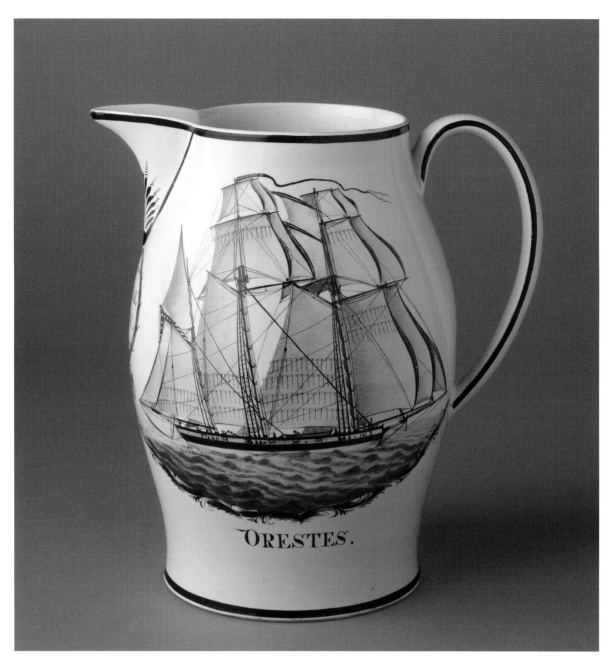

Figure 3.9. This creamware jug, with an impressed mark from the Herculaneum Pottery, Liverpool, features a rare, hand-painted portrait of the schooner *Orestes*. For a complete description, see cat. no. 47.

were not marked, would be assumed to be from Staffordshire. The one area of production in which continuity can be seen with earlier Liverpool work is on-glaze printing. A number of black prints found on marked Herculaneum creamware derive from copper plates from Guy Green or Richard Abbey, presumably because these older designs continued to be popular with customers.[22]

Black-printed and enameled creamware was the most decorative earthenware that Liverpool or Staffordshire produced in the late 1700s, and even after 1800. Up to the 1780s, however, the bulk of the pottery leaving Liverpool for America was creamware with no decoration at all. Decoration cost money, and there was a clear connection

between popularity and cheapness. The least-expensive form of decoration was a simple painted edge, followed by that produced by dipping the ware in liquid clay of another color, letting it dry, and then turning it on a lathe. Next came painted decoration in blue (before glazing) and, from 1784 onward, printed decoration in blue (before glazing). Ware with on-glaze decoration in the form of enamel painting or black printing required at least one additional firing, meaning that it was the most expensive earthenware to produce and the highest priced. When contemporaries referred to the types of ware in order of cost they tended to list them as plain, edged, dipped, painted, printed, enameled, and penciled or copperplate (black printed).

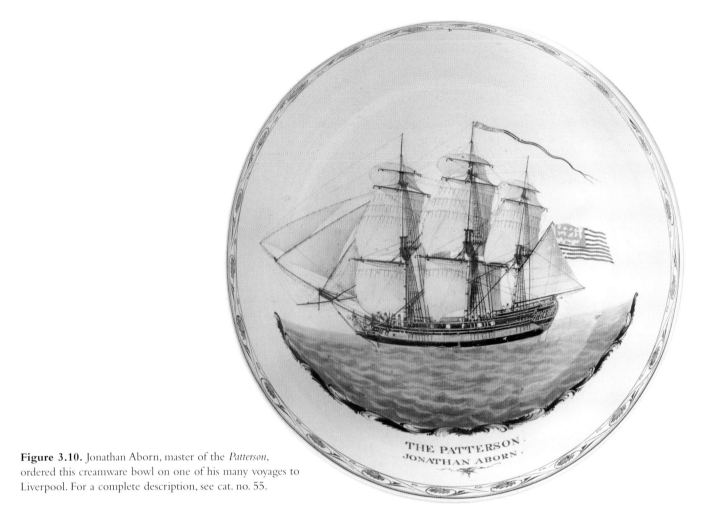

Figure 3.10. Jonathan Aborn, master of the *Patterson*, ordered this creamware bowl on one of his many voyages to Liverpool. For a complete description, see cat. no. 55.

The American Market

Up to 1820 the majority of the tableware—that is, dinnerware—exported to America was undecorated or, at the most, had painted edges.[23] Jugs, mugs, and chamber pots, the so-called hollowwares, did not generally have anything more than dipped decoration. Teawares were the item on which the most expense was afforded, but even these in 1780 were generally plain. Around 1790 painted wares (that is, painted before glazing) seem to have become the most popular type on the tea table and remained so for more than half a century. Ware with on-glaze prints was too costly to occupy more than a small slice of the market. For most consumers, then, a black-printed beer jug or mug was probably a bit special, to be brought out only when they were entertaining friends. It should not be surprising therefore that the producers of these wares chose the decoration carefully for its social resonance, especially with an eye to popular toasts.

From a study of invoices from New York merchants, it has been shown that the prices of earthenware fell over time.[24] In 1796 painted teaware cost almost twice as much as the same thing in plain creamware; by 1814 it cost only one and a half times as much. In 1796 printed teaware cost almost four times as much as plain creamware; by 1814 it was only three times as much. The deflation that

followed the Napoleonic Wars caused a decline in the price of British manufactured goods, corresponding with the reopening of trade with America after the Trade Embargo of 1807 and the War of 1812. These events caused the prices of earthenware to fall dramatically after 1814, reducing the difference between the cost of various types of decoration and compelling manufacturers to simplify the decoration of the cheaper types.

An invoice of September 1802 lists "sundry Merchandise shipped on board the Patterson, Jonathan Aborn Master, bound for New York, by order and on account and risk of John Innes Clark Esq & to him consigned by Michael Richardson & Co., Merchants, Liverpool."[25] The ship was loaded with 150 tons of coal, but in terms of value its principal cargo was 200 crates of earthenware bought by Richardson from the Herculaneum Pottery Company. (Fig. 3.10) The pottery is listed crate by crate, which makes it possible to count and analyze the contents (see Appendix I).

The Aborn invoice reflects the usual pattern of transatlantic trade, where an American merchant house places an order with a Liverpool merchant house. Merchants tended to specialize in particular markets but dealt in the whole range of goods that the market supplied or demanded. Merchant houses had the capital to order large volumes of goods, and they developed relationships

Figure 3.11. Potsherds built into a dock wall at Liverpool, ca. 1805–7: plain, edged, dipped, painted, printed, and enameled. Courtesy National Museums Liverpool.

of trust with merchant houses on the opposite side of the Atlantic. This was crucially important, since the commonest cause of failure was the inability to call in debts from overseas. Many potters in England, and many crockery dealers in America, preferred to let the merchants take the risk—and a profit—rather than run the possibility of receiving broken goods or of not being paid.

This was not the only trade pattern, however, for others were evidently prepared to take more risk for the chance of more profit. For those potteries that decided to sell directly to America, a personal visit might be necessary to establish the relationship. The best guarantee of reliability was a family link. On March 23, 1784, the *Grange* sailed from Liverpool to Philadelphia carrying fifty-three crates of pottery from Wedgwood to John Vaughan, an arrangement made by Samuel Vaughan & Son in London. The vessel was not unloaded in Philadelphia until May, which delayed payment to Wedgwood.[26] It was only the larger factories that could afford such an agreement. Most potteries were fairly small and needed to maintain their cash flow. They were obliged to sell to whomever could pay them quickly, and that was always the Liverpool merchant. A potter's dream, of course, was to establish his own agent on American soil, cutting out the American as well as the Liverpool merchant. The 1807 Trade Embargo and the War of 1812 probably delayed such an arrangement by the larger potteries. The situation did change after the war, and 1815

was a bumper year for orders. Although the old pattern of trade continued, the years around 1820 saw the beginnings of a change, with major potteries such as Enoch Wood establishing direct agents on the East Coast of America.

Recent excavations at the Liverpool docks have uncovered a cache of pottery that was dumped deliberately. (Fig. 3.11) It was used as part of the filling

Figure 3.13. Potsherd built into the dock wall at Liverpool, ca. 1805–7, showing the American flag. Courtesy National Museums Liverpool.

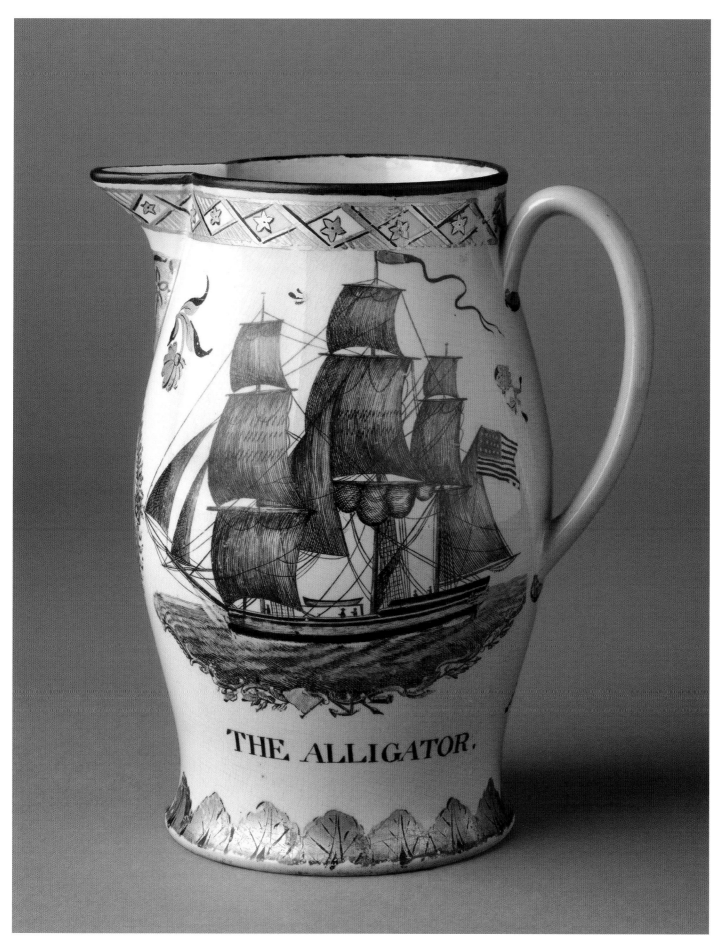

THE ALLIGATOR.

Figure 3.12a. The flag with fifteen stars marks this jug as being destined for the American market. For a complete description, see cat. no. 64.

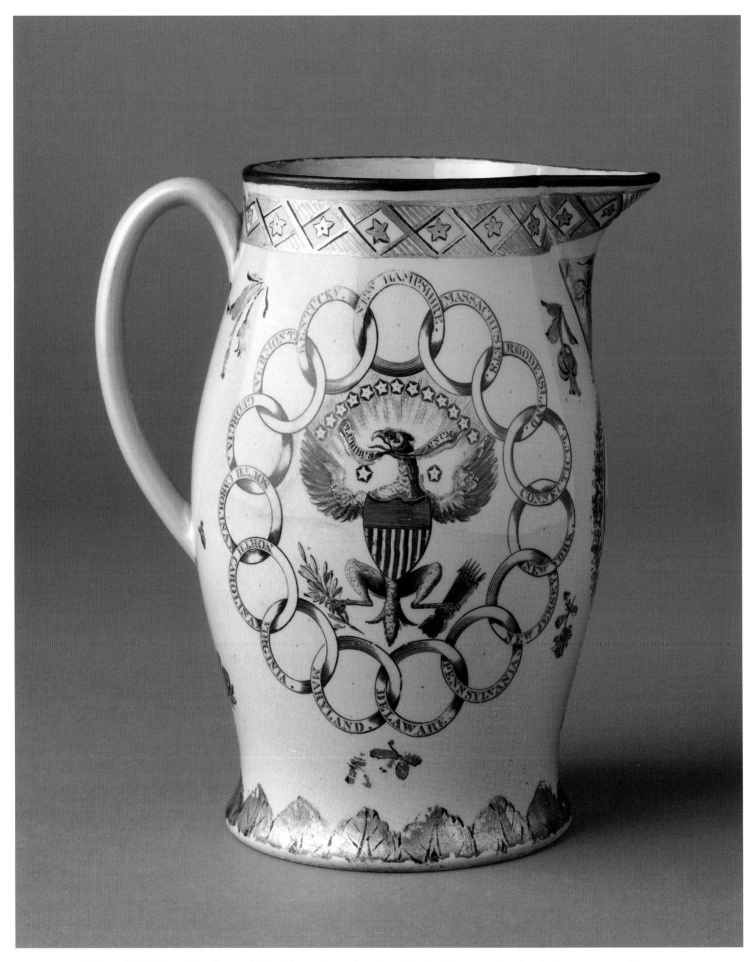

Figure 3.12b. The chain of states design is featured prominently on this jug. For a complete description, see cat. no. 64.

of a dock wall dating probably from 1805–7.[27] Whether the wares were damaged stock or otherwise unsalable is not clear. The number of pieces decorated with identically rendered designs suggests that much of the deposit came from a single warehouse. As one would expect, undecorated creamware is in the majority, followed by wares painted with a blue or green edge. There is a large quantity of dipped ware decorated with many complex lathe-turned designs—colored ware, as the Aborn invoice calls it. There is plenty of underglaze-decorated ware, more of it painted than printed; some is painted only in blue and some in multicolour. There is a smaller quantity of on-glaze printed ware and a still smaller quantity of enameled ware. The on-glaze prints show that some of the ware was destined for America. There is a ship flying the American flag, with fifteen stars, and a portion of the chain border from the print entitled "Washington crown'd with laurels by Liberty," showing the two links inscribed "Rhode Island" and "Connecticut." (Figs. 3.12a,b, 3.13, 3.14) Another print features the Bidston Hill Signals, the last in a chain of signal stations stretching to Holyhead that sent news of

arriving ships in Liverpool by a system of flags. (Figs. 3.15, 3.16) Mugs and jugs printed with the Bidston Hill Signals may also have been destined for America. Captain Robert Lund lived in Portsmouth, New Hampshire, and was master of the *Lydia* between 1792 and 1810. He is known to have sailed home from Liverpool in 1795 with a cargo of Cheshire salt, and pieces of a mug printed with the Bidston Hill Signals have been excavated from outside his house.[28]

The Bidston Hill Signals gave Liverpool merchants important advance information that influenced prices on the Liverpool Exchange, depending on what goods the ship was likely to be carrying. This information traveled only within Britain; communication across the Atlantic was much more difficult. A direct conversation with a recalcitrant customer could only take place through a trusted third party on the spot. It was in the interest of businesses to help one another in this way since it was likely that sooner or later everyone would need to ask for a favor. George Gilchrest of Liverpool wrote on February 20, 1807, to New York merchants Ferguson & Day, who were helping him extract

Figure 3.14. Potsherd built into the dock wall at Liverpool, ca. 1805–7, showing a fragment of the chain of states design. Courtesy National Museums Liverpool.

payment from local china dealer Ebbets & Gale, who had made a large deduction from their payment to him because of pots that had been broken in transit:

> I doubt not you have used every exertion to terminate this business as favourably as possible, but the abatement made by Ebetts and Gale is a very serious one indeed & from the enclosed letter I received from Messrs. J.& J.Davenport on the subject . . . you will perceive they will allow nothing whatever for breakage . . . you will therefore perceive that I shall lose the abatement of upwards £80 Sterling instead of a profit unless you are enabled to recover something from Ebetts & Gale.[29]

Manufacturer John Davenport, who had learned his business in Thomas Wolfe's Liverpool warehouse, understood well the balance of risk and judgement in doing business at long range. What he wrote in old age serves to sum up the skills of the Liverpool merchant as well as of the master potter:

Making goods . . . is but a small part of the duty of a master, perhaps the least, for the gains there come by small matters, while the property, by sales and consignments, is put at risque in heavy sums, and requires the exercise of a sound judgment & clear understanding with the parties, who are intrusted with it . . . a foreign trade can never be conducted with success unless the most minute and continual attention is paid to what is going on in the sales, & in the collection of the monies at the periods when they become due.[30]

In contrast, the lucrative Liverpool pottery industry presented quite another story. Any American ship's captain who docked in port would have found it easy to order whatever type jug he desired, have it decorated to his specifications, and ask that it be readied for pickup by the time he set sail. Indeed, eighteenth-century Liverpool played an important role for businesses on both sides of the Atlantic.

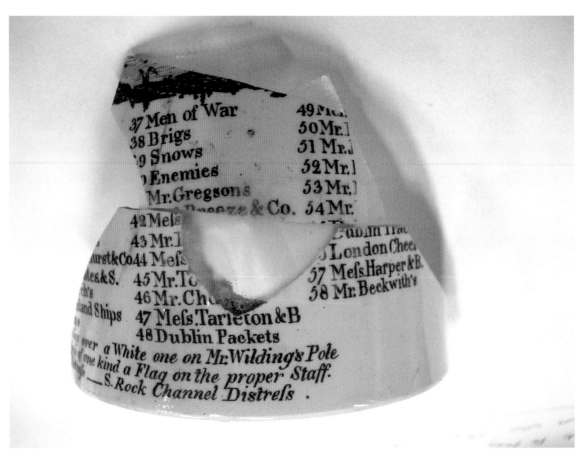

Figure 3.15. Potsherd built into the dock wall at Liverpool, ca. 1805–7, with details from the Bidston Hill ship listings. Courtesy National Museums Liverpool.

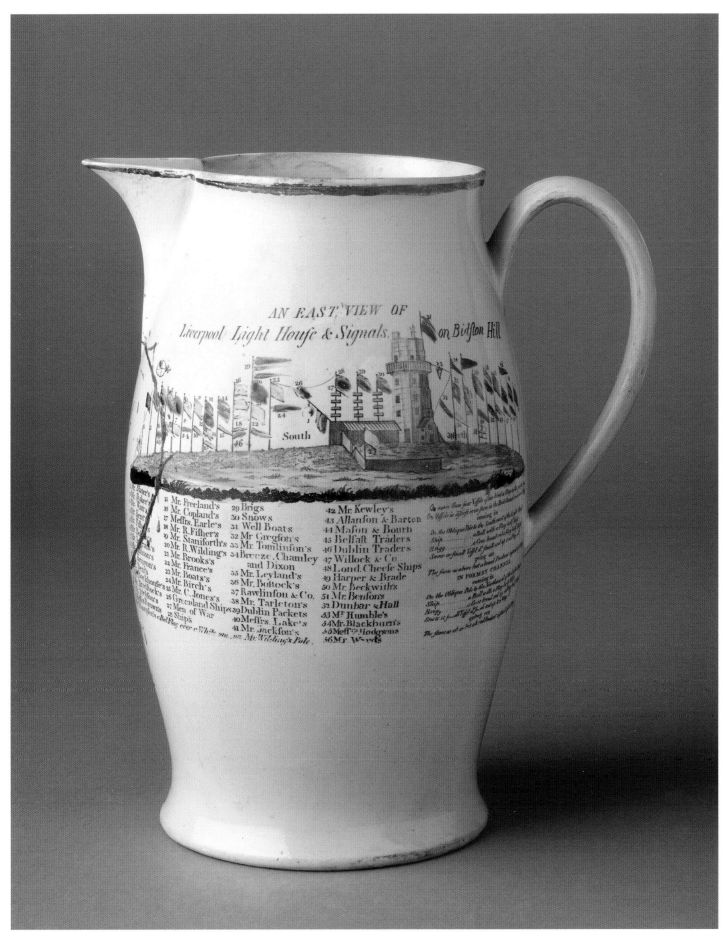

Figure 3.16. The Bidston Hill lighthouse and signals are prominently displayed on this creamware jug made in Liverpool. For a complete description, see cat. no. 35.

AUTHORS' NOTES

This project originated with S. Robert Teitelman—a consummate collector and researcher and the principal author of this book. Since his death in February 2008, Pat Halfpenny and Ron Fuchs have continued the work he began. It is the latter two authors whose notes you will find here.

In thinking of the S. Robert Teitelman Collection at Winterthur as an illustrated history of early America as told on pottery, our wish was to create a story line that would appeal to the widest possible audience. To deliver a comprehensive narrative, we chose to include additional pieces from the Winterthur collection and a rare example from a private collection. We are most grateful to Wendell Garrett and Robin Emmerson, whose introductory essays set the stage for what is presented in the catalogue entries.

The organization of the entries is outlined in the table of contents, where subject headings follow a loose chronological order and mirror events of the formative years of the young United States. **Rebellion and Revolution** celebrates the fight for liberty and independence; **Roots of a New Nation** highlights leaders of the new democracy, the battles against the injustices of slavery, and the defense of the new nation by its naval fleet; **Navigating the Commercial Waters** features images of shipbuilding, ports of call, and maritime activities—all essential components of American independence; **Commerce on Land** focuses on the trades and professions that expanded as America sought to create its own industrial base; and in **Patriotism** Americans proclaim their freedom and exhibit their national symbols.

S. Robert Teitelman was meticulous in keeping records as he acquired new pieces and dedicated himself to discovering as much information as possible about each and every purchase. The general consensus of American collectors was that he collected "Liverpool wares." One of the major questions facing the authors was "What did 'Liverpool wares' mean?" A term rarely if ever used in England, "Liverpool wares" or "Liverpool jugs" is essentially an American collectors' term and carries with it the perception that all these wares were made in Liverpool. The truth, however, is more complicated.

As research for the book became more focused, discussions took place with specialists on the city and ceramics of Liverpool. We are grateful for contributions to those discussions by Robin Emmerson and Peter Hyland. In the most general terms, we agreed that the majority of these ceramics had at least been shipped from Liverpool, notwithstanding that pieces marked Bristol or identified as Swansea were most likely exported from the port of Bristol.

Although Liverpool was a center for ceramic manufacture, it is not possible to definitively identify creamware made there prior to the establishment of the Herculaneum Pottery in 1796. For in addition to warehousing, selling, and shipping locally made products, Liverpool merchants offered the same services to any English potters wishing to export their wares. In the late 1700s, Liverpool was the port of choice for most Staffordshire potteries, which, because of the overwhelming number of individual factories, must have been responsible for the majority of pottery passing through the city in the 1765–1820 period. Other potting centers in Yorkshire and the northeast of England may also have used the port.

Attribution is complicated by the growth of independent painters and printers in Liverpool and Staffordshire. The majority of English creamware made for export was undecorated, and pieces could be purchased by specialists who then added printed and painted designs from stock patterns or created specific designs to meet special orders. The independent workshops in Liverpool could have obtained their blanks from a local pottery or through merchants who handled the products of a number of factories. Many of the engravers, printers, and enamelers are recorded in Liverpool street directories between 1780 and 1800; few are listed after that date, and none at all appear after 1810. In Staffordshire the major factories usually had their own decorating workshops, and the rise of independent decorators there almost coincides with their decline in Liverpool—beginning in the 1790s and expanding through the first decades of the 1800s. It is not difficult to deduce that for unmarked pieces of pottery, determining the origins and the place of decoration is a difficult task.

Using the S. Robert Teitelman Collection as a basis for understanding these challenges complicates the issue even further, for his pieces do not represent the vast majority of pottery shipped to America. His collection focuses on examples with American patriotic imagery and is disproportionately strong in pieces made expressly for American merchants and ship captains with Liverpool connections. These transatlantic customers with specific design and inscription requests would have been most ably served by potteries and independent decorators in the port city of Liverpool, particularly for hand-painted designs. Therefore, despite the authors' early misgivings about the relationship between Liverpool and the objects in the Teitelman collection, the majority of pieces do appear to have a strong Liverpool connection.

The substance of the discussions above has informed the authors' opinions on the origin of the pottery and the decoration. We are grateful for the help and guidance of our colleagues but accept that any fault in reasoning is our own.

1. Where objects carry a factory mark, we have generally accepted them as products of that factory.

2. Where objects carry a printer's or engraver's mark, we have given consideration to their location. It is thought unlikely that independent decorators in Staffordshire purchased wares from other districts. Staffordshire engravers and printers most likely decorated Staffordshire-made wares. Objects decorated by Liverpool engravers could have originated from any pottery center.

3. If an object is marked Herculaneum, we consider it to be entirely the product of that factory. Whether the factory employed full-time decorators or subcontracted the work, we believe it to be unlikely that a Herculaneum piece would have been decorated independently. Not impossible, but unlikely.

4. If a piece of pottery has a combination of printed decorations also seen on marked Herculaneum pieces, and a line-by-line comparison has been made showing the decoration to be identical, then that piece, too, has been catalogued as Herculaneum. The authors believe that Herculaneum copperplate engravings would generally have been confined to factory products. Not exclusively, but in most cases.

5. If a piece of pottery has printed decoration that is seen as a companion print to known Herculaneum prints, the object has been catalogued as "probably Herculaneum." These attributions are particularly convincing if other Herculaneum features such as the black-painted feathered spout decoration or printed or painted border patterns characteristic of Herculaneum are also present. We have used the "preponderance of evidence" as a guide; less evidence would lead us to a less-positive attribution such as "possibly Herculaneum."

6. Where characteristics associated with Liverpool printers such as Sadler & Green are observed, a general Liverpool attribution may be suggested. However, with the statistically dominant Staffordshire industry, sometimes both centers of production may have convincing claims for the pottery, even if Liverpool decorators were responsible for the final surface patterns. In this case, the first named location in the catalogue entry is that which the authors believe to be the more likely origin.

7. Finally, there is the matter of hand-painted decoration. The S. Robert Teitelman Collection at Winterthur is strong in enamel-painted decoration, from simple inscriptions to complex and specific imagery. Given the nature of such commissions, the authors have come to believe that no matter where the pottery was made, the majority of hand painting was applied in Liverpool, where customers could interact directly with the craftsmen and artists. Prior to the early decades of the 1800s, these pieces could have been made at any potting center before being acquired by independent Liverpool decorators. Those known to have been made at the Herculaneum factory were almost certainly decorated by artists employed by the factory. With the decline in freelance ceramic artists in Liverpool from 1800 onward, it is not unreasonable to assume that the Herculaneum Pottery became the primary supplier of creamwares with American patriotic hand-painted decoration.

Thus, after many years of friendly dispute, S. Robert Teitelman would have been delighted to learn that his collection, if not typical of the vast amount of English pottery imported into America, can legitimately claim the name of "Liverpool ware"—even if his co-authors prefer that this misleading soubriquet be consigned to the transatlantic ocean depths.

THE CATALOGUE

1. Jug

Herculaneum Pottery
Liverpool, England; 1810
Creamware printed in black
Signed by the engraver "T. Dixon Sculpt 1803"
H. 16⅝ in. (423 mm)
2009.23.18 Gift of S. Robert Teitelman, Roy T. Lefkoe, and Sydney Ann Lefkoe in memory of S. Robert Teitelman

This unusually large jug was made to commemorate the jubilee of King George III in 1809. It has no specific American imagery but represents the monarch under whose rule America fought for, and won, independence. Beneath the lip is a central print of the royal coat of arms of the king. This version was introduced in 1801, when the Act of Union united the kingdom of Great Britain with Ireland, and George III renounced the monarch's ancient claim to the throne of France.[1] The engraving is signed in reverse "T. Dixon Scupt 1803." Thomas Dixon was an engraver known to have been working in Liverpool from 1806 to 1816.[2] This may be the first documentary evidence of his working there somewhat earlier.

To the right of the royal arms is a small oval medallion inscribed "KING AND CONSTITUTION," and further to the right are a suite of prints celebrating the jubilee. The topmost image is a portrait entitled "GEORGE the THIRD in the 51st Year of his Reign." A later portrait with a similar crowned and radiant portrait is "Engraved by S. Freeman from Mr. Chalon's miniature."[3] It seems likely that this image also derived from the Chalon portrait. Below the portrait Faith and Britannia ride on a cloud holding a scroll inscribed

"Happy would England be, Could George but live to see, Another JUBILEE," together with George III's cypher and the number "50." A scene below is inscribed "Let the Prisoners go Free Give God Praise Jubilee 25 Octr. 1809" and shows a large group of prisoners being freed from the old Tower of Liverpool. In the background is an equestrian figure of George III that was erected to celebrate this occasion. Royal jubilees were traditionally times when certain prisoners, especially debtors, were freed, a practice widely observed in 1809.

On the reverse of the jug is an oval portrait inscribed "The RT. HBLE. LORD VISCT. WELLINGTON. K.B. &c. &c." supported by naval trophies. Below the portrait is a scene of two fighting ships. Arthur Wellesley was ennobled as Viscount Wellington in 1809 for his successful command of the British forces in Portugal during the early years of the Peninsular War in which Britain united with Portugal as well as Spanish guerilla forces to defeat the French, first in Portugal and then in Spain. This portrait shows Wellington as a young British hero wearing the star of the Grand Cross of the Order of the Bath, to which he was admitted in 1803. He continued to rise in the peerage to become the 1st Marquis of Wellington in 1812 and 1st Duke of Wellington in 1814.[4]

Other printed images on this piece include a traditional swagged floral border; vignettes of faith, hope, and charity; sailing ships; and various generic prints that would appeal to the English patriotic market. The importance of the king and his great general, however, could not have been overlooked by Americans who remembered the days of the Revolution and felt the instability of Europe as Britain and France continued to engage in war.

The engraving is signed in reverse.

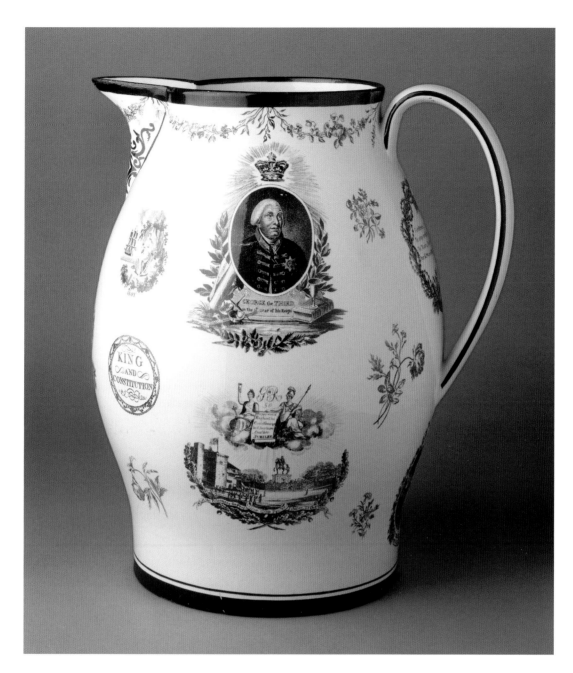

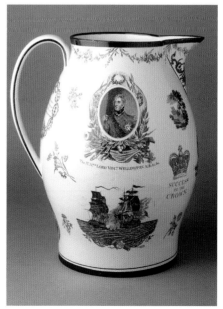

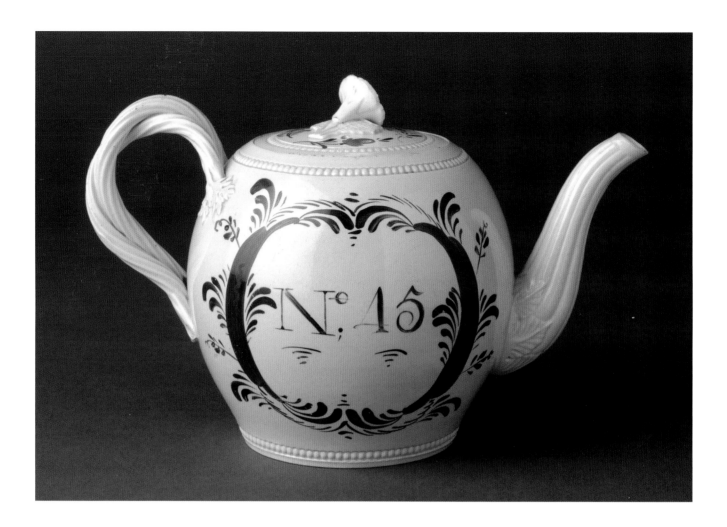

2. Teapot

Probably Staffordshire, possibly Yorkshire, England;
1765–70
Creamware painted in enamels
Diam. 4½ in. (114 mm), H. 4¹¹⁄₁₆ in. (120 mm)
2009.21.12 Gift of S. Robert Teitelman

The painted bust portrait of John Wilkes on one side of this teapot is inscribed "Wilkes & Liberty" and is related to the enigmatic inscription "No. 45" painted on the reverse. A champion of civil liberties and an ardent defender of the American colonists' cause, Wilkes, an Englishman, became an inspiration for American freedom. In 1762, when the new king, George III, arranged for his close friend and Scottish nobleman the Earl of Bute to become prime minister, there was an outcry at his inexperience and incompetence. In opposition to *The Briton*, a journal that supported Bute's administration, Wilkes established a weekly newspaper in June 1762. Its title, *The North Briton*, mimicked the offending journal and made satirical reference to Scottish Lord Bute.[1] For the next forty-five weeks, *The North Briton* severely attacked the king and his prime minister. Issue No. 45 accused the king of uttering falsehoods in his speech praising the Treaty of Paris, which ended the Seven Years' War. Angered by the attack, George III had Wilkes arrested on a general warrant and imprisoned

in the Tower of London. Wilkes challenged the warrant, claiming parliamentary privilege and was released. In 1764, however, he was expelled from Parliament and became vulnerable to legal action. After he was elected Lord Mayor of London, in 1774, he was finally allowed to return to Parliament, where he vigorously fought for reforms.

Wilkes became a symbol of liberty and opposition to tyranny. On the streets of Boston and London alike the rallying cries of "Wilkes & Liberty" and "No. 45" were heard. The newspapers of the American colonies, including the *Providence Gazette and Country Journal* (August 13, 1768), carried news of Wilkes's exploits and published details of Boston silversmith and patriot Paul Revere's much-venerated punch bowl, known today as the "Sons of Liberty Bowl."[2] It prominently displays the inscription "No. 45" and "Wilkes & Liberty" and celebrates the ninety-two rebellious members of the Massachusetts Assembly who refused to rescind a letter they had sent to other colonies protesting the Townshend Acts of 1767.[3] Although this teapot may have been made to appeal to those who sympathized with Wilkes in England, it would also have resonated with many colonial Americans chafing under the yoke of British rule.

No direct source has been identified for this portrait of Wilkes, although many of his likenesses were published during the 1760s,[4] including a satirical portrait by William

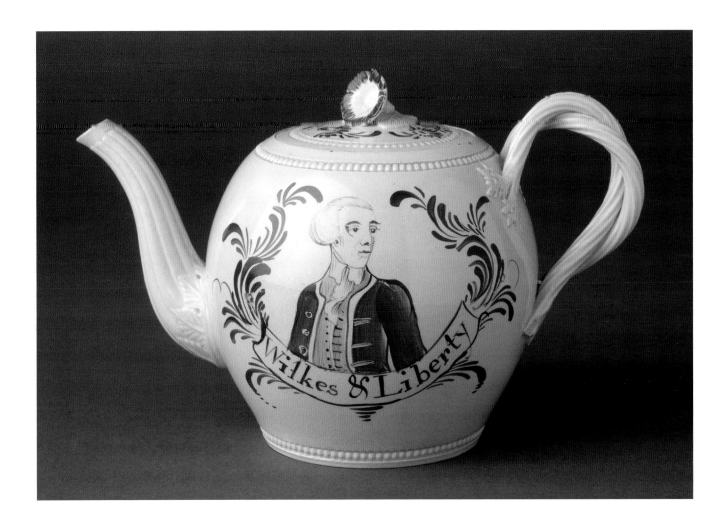

Hogarth in 1763. In the Hogarth print, Wilkes holds a staff with a liberty cap. This image has been discussed as "the earliest use of a liberty cap within the context of eighteenth-century revolutions," noting that the "cap representing liberty first appeared in America, and from there it spread to France."[5] Appearing on the Revere bowl previously discussed, the staff and liberty cap represent symbols of resistance to tyranny and became part of the iconography of the American Revolution.

This teapot is one of the earliest pieces in the S. Robert Teitelman Collection at Winterthur. Features include the relatively small size, reflecting the expense of filling it with costly tea; the decorative rouletted bands of "pearl beading" at the foot and rim of the pot and cover; a molded, reeded spout with acanthus leaves at the base; a floral knob; and a grooved, twisted handle with foliate terminals to the top. All these are decorative features associated with the first phase of refined creamware. The terminals at the base of the handles are distinctive but as yet cannot be identified to a specific pottery-making region or individual factory. It is details such as this that, combined with archaeological and other research, may one day lead to a more precise attribution.

This teapot, like those printed with a portrait of William Pitt, may have been made for an American or British market.[6] It earns inclusion in the S. Robert

Teitelman Collection at Winterthur because Wilkes was so influential in promoting America's cause and inspiring its independence. Wilkes-Barre, Pennsylvania, and Wilkesboro, North Carolina, are just two of the towns named after John Wilkes.

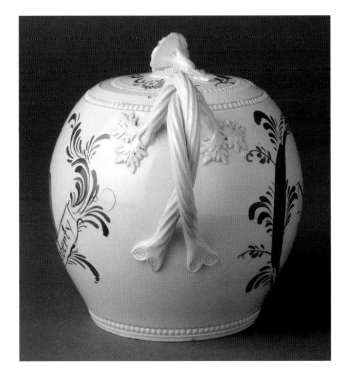

3. Teapot

Probably Staffordshire, England; 1766–70
Creamware painted in enamels
H. 5 in. (127 mm), OW. 7½ in. (191mm)
Private collection

The small size of this modest teapot belies the enormity of the message it conveys. Hand painted in red enamel, the emotive inscriptions read "No Stamp Act" and "American Liberty Restored." These declarations heralded the American Revolution.

In 1763 Britain emerged from the Seven Years' War as the dominant colonial power in Europe, but the cost of conflict plunged the country into debt. Faced with maintaining a significant military presence to defend their vast new territories in North America, King George III's ministers initiated legislation to raise revenue from taxes. The British government felt that the colonies were the primary beneficiaries of these military preparations and should pay for at least a portion of the current and future expenses expressly incurred in North America. The Stamp Act introduced direct taxation of all colonial commercial and legal papers, including newspapers, pamphlets, playing cards, and almanacs. Each piece of paper had to be officially stamped, with charges varying depending on the type of document.

Expecting some opposition but not envisaging the intensity of the protests, the British parliament passed the Stamp Act by a large majority on March 22, 1765, effective from November 1. The tax immediately met with great resistance. Colonists demanded their rights as Englishmen to be taxed only by their own consent through their own representative assemblies and refused to pay the stamp duty; merchants banded together and vowed not to import British goods, and a "Stamp Act Congress" was convened in New York to petition the king and Parliament for repeal of the detested act. Joining colonial opposition, British merchants and manufacturers, whose exports to the colonies were threatened, also pressed for repeal. Seeing an opportunity to advance his political career and express his American sympathies, William Pitt rose in the House of Commons on January 14, 1766, to "deliver my mind and heart upon the state of America."[1] His rousing speech secured the repeal of the act and the resignation of his rival, Lord Rockingham; Pitt was then asked by the king to form the next government. The Stamp Act was formally repealed on March 18, 1766, and by May of that year festivities were under way. In the *New Hampshire Gazette* of May 30 there was a report of one such celebration.

EXETER, May 19. In consequence of receiving the late happy News of the Total Repeal of the *Stamp-Act,* the Sons of Liberty belonging to this Town at Two o'Clock this Morning assembled on Liberty Square, *universal* Joy appeared in every true hearted Son–The Morning was ushered in with Ringing of Bells, Firing of Cannon, with the display of Colours in several Parts of the Town; a Monument was also erected on Liberty Square in Loyalty to our Royal King, and in Remembrance of our never to be forgotten Friend and Deliverer Mr. PITT, upon which was inscribed on one side GEORGE the Third and Patriot PITT forever; on the other side LIBERTY Restored March 18, 1766. . . . in the Evening the Town was Ornamented with the Display of Rockets and other Fireworks, Illuminations and Bonfires, concluded the whole.

No doubt the manufacturers in England who made this teapot were eager to avoid an American boycott of their goods and were equally relieved at the repeal. The teapot was likely made in Staffordshire, the center of the English pottery industry where about 150 different potworks were in operation by the mid-eighteenth century. The design of this piece, with its small globular body and crabstock handle and spout molded to represent gnarled tree branches, was a standard form made by many manufacturers. The overglaze hand-painted decoration was probably applied by a specialist decorator, as few potteries at this time employed their own experienced artists. Although it might have been made for English supporters of the American cause, it was most likely intended for export, for this small teapot represents the strong sense of achievement felt by the colonists in their victory. It would have served as a permanent reminder of the struggle that was just beginning—a tangible survivor of passions that were ignited and kindled into the blazing fire of the American Revolution.

Opposite below: *THE REPEAL. Or the Funeral Procession of MISS AMERIC-STAMP*, England, 1766–70. This etching with watercolor is the work of an unknown engraver, after Benjamin Wilson. It was probably published in London after the repeal of the Stamp Act on March 21, 1766. With its allusions to British-American trade, the image would have been popular on both sides of the Atlantic. 1957.1262 Winterthur Museum, bequest of Henry Francis du Pont.

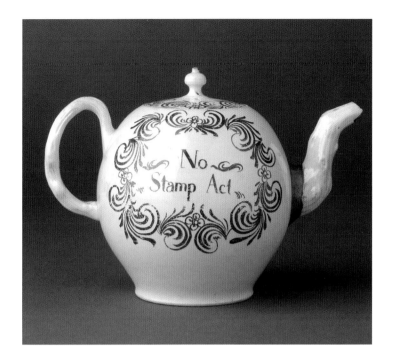

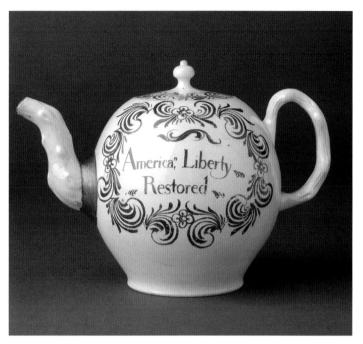

4. Jug

Probably made in Staffordshire and decorated in
Liverpool, England; ca. 1778
Creamware printed in red
H. 6½ in. (165 mm)
2009.21.21 Gift of S. Robert Teitelman

The peculiar scene printed in red on this jug is based on a satirical cartoon entitled "A Picturesque View of the State of the Nation for February 1778" and published in London's *Westminster Magazine* on March 1, 1778. It is a commentary on the British perception of Admiral Lord Howe's activities as commander in chief of the British forces in America, from 1776 to 1778. As E. McSherry Fowble writes of this image, "Of all the engravings published by satirical authors during the confrontation between England and America, none was reproduced more widely."[1]

In June 1777 his brother, General Howe, had moved his troops to the south bank of the Delaware River and won two successive victories over the Americans at the Battle of Brandywine and the Battle of Germantown.[2] He did not pursue the retreating American soldiers but settled down in Philadelphia for the winter with his army. It is said that while other British troops were fighting and experiencing defeat, Howe and his men were enjoying the social life of Philadelphia. Howe, his mistress, and his staff spent most of their time on entertainment: the theatre, dancing, and gambling being the primary forms of distraction.[3]

The source print for this engraving was published just before Howe resigned his commission and returned home to face an investigation of his conduct, which later found him to be innocent of wrongdoing. Certainly the mood of England is reflected in the cartoon's many symbolic references. A passive cow representing British commerce has her horns removed by America (a man with feathered headdress) and her milk stolen by men from Holland, France, and Spain. To one side an Englishman wrings his hands because he is unable to wake the sleeping lion (representing the British establishment and people). To add insult to injury, there is a French pug urinating on the back of the lion, a popular motif in caricature at this time and often applied to pottery. The print alleges that Britain is being "milked" for its assets by other European countries, weakened by the war with America, and humiliated at the hands of France. In the background the brother officers, General Howe and Admiral Howe, sit slumped and inactive over a punch bowl in Philadelphia. This was a popular design in the United States, where it was freely adapted to include other nationalities.[4]

The reverse of the jug has a stock print of a three-masted ship flying the British flag riding on waves above military and naval trophies.[5] The iron-red color of the print was an alternative to black. Although popular in the late eighteenth century, the color is rarely found in nineteenth-century creamware for the American market. This jug may have been made for sale in England as well as America, for there were undoubtedly customers in both countries who would have found the political cartoon an irresistible observation on the status quo.

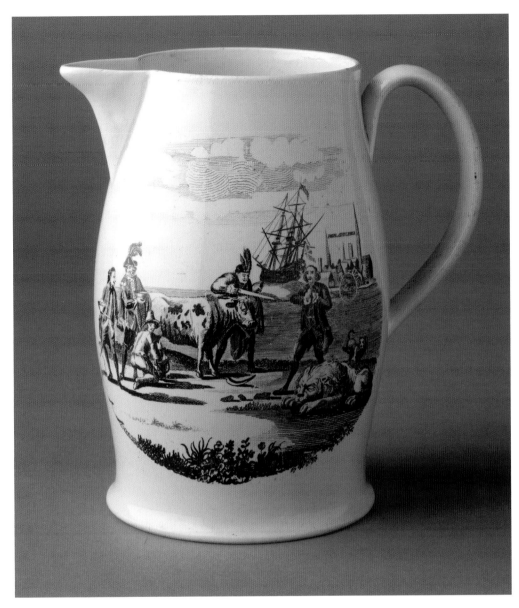

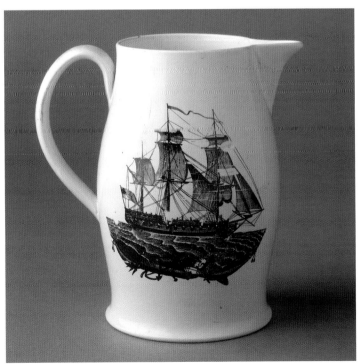

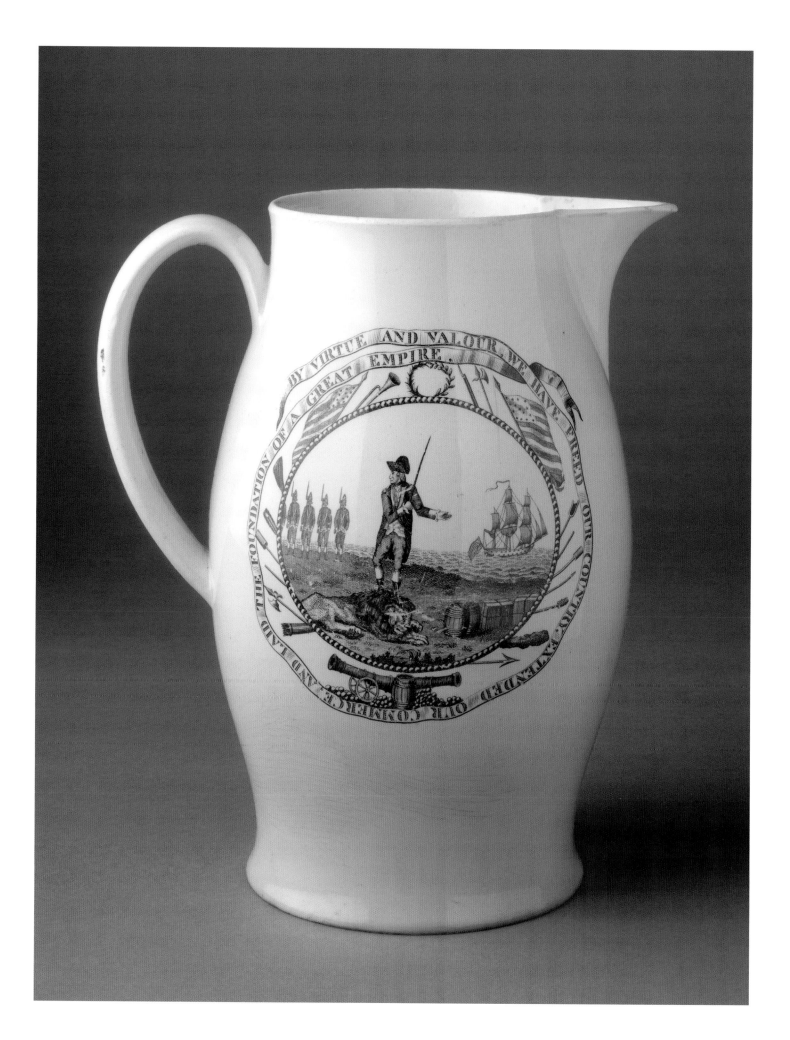

5. Jug

Probably Staffordshire, England; 1785–90
Creamware printed in black and painted in enamels
Diam. 8½ in. (215 mm), H. 10 in. (254 mm)
1958.1198 Bequest of Henry Francis du Pont

A triumphant George Washington with his foot on the neck of the defeated British lion is the centerpiece of the printed decoration on this baluster-shape jug. Encircled by the celebratory banner reading "BY VIRTUE AND VALOUR, WE HAVE FREED OUR COUNTRY, EXTENDED OUR COMMERCE, AND LAID THE FOUNDATION OF A GREAT EMPIRE," the design commemorates Washington's resounding victory as leader of the American colonists in their revolution against British rule. The image matches the description of a seal specially designed and sent as a gift to Washington in early 1783 by William Duke Moore of Dublin, who was probably the jeweler of that name recorded in Dublin in the 1780s.[1] The timing suggests that Moore was motivated by the finalizing of the Treaty of Paris in November 1782, when Britain's negotiators finally acknowledged that they were ratifying a treaty not with "colonies" but with "13 United States."

Moore's seal was delivered to Washington by Mrs. Ann Bingham, the wife of a Captain Charles Bingham of the 105th regiment in the British Army's Volunteers of Ireland. In writing to Washington, Moore describes the scene as "your Excellency in Front, Trampling on the late Enemy of your Country, pointing to a Ship Underway departing from the Coast, with your Face at the same time turned to your Army, expressing the Motto by Virtue and Valour." Washington sent a thank-you note to Moore.

New York, December 3, 1783. Sir: Mrs. Bingham has done me the honor to deliver me your Letter of the 15 March with the Seal you have been so polite as to present to me and for which you will please to accept my thanks. I could only wish the object had been more worthy the great talents shewn in the invention and execution of the Seal. You will however believe that I feel myself extremely flatterd by this mark of attention and that I am, etc.[2]

It is not clear how this design made its way into the pottery engravers' repertoire. Perhaps after receiving Washington's acknowledgment, Moore distributed copies for publication; however, no printed source has been identified. The reverse of the jug has a stock print of a three-masted sailing vessel above a conventional swag of military and naval trophies.[3] The print is enlivened with hand-painted enamel colors. In particular, a red, white, and blue American flag flies from the stern.

6. Plaque

Probably Herculaneum Pottery
Liverpool, England; ca. 1800
Creamware printed in black
H. 8⅛ in. (206 mm), W. 6 in. (152 mm)
2009.21.2 Gift of S. Robert Teitelman

Benjamin Franklin became "the most famous American of his time. He helped found a new nation and defined the American character. Writer, inventor, diplomat, businessman, musician, scientist, humorist, civic leader, international celebrity . . . genius."[1] It is not surprising that such a man was a popular figure in portraiture, and this was especially so during his years of foreign service. Although he had been the subject of numerous engravings on paper, only two such bust portraits were the source for prints on pottery. The first, seen on this plaque, is after a 1778 painting of Franklin by Joseph Duplessis that was exhibited in the Paris Salon of 1779.[2] In discussing the portrait, Metropolitan Museum of Art curators comment that its success was

> due in large part it must be said to the remarkable popularity of the sitter. A connoisseur of the time, M. du Pont de Nemours, the ancestor of the American family of that name, wrote an ecstatic eulogy of the man and the portrait in his *Lettres sur les salons*, addressed to the Margrave of Baden. "It is not enough to say that Franklin is handsome," wrote du Pont, "one must say that he has been one of the most handsome men of the world, none of his time equally so. All his proportions announce the vigor of Hercules and at seventy-five years of age he still has suppleness and lightness; his wide forehead speaks of strong thoughts and his robust neck of the strength of his character. He has in his eyes the equanimity of his soul and on his lips the smile of an inalterable serenity. It does not appear that work has fatigued his nerves. He has gay

> wrinkles; some are tender and proud, none are tired. One sees that he has conceived more than he has studied, that he has played with sciences, with men, with affairs. And it is still almost in play that at the decline of his years he works at the founding of the most important republic. There is placed beneath his portrait the laconic inscription V I R. Neither a line of his face nor his life gainsays it."[3]

Not surprisingly, within the year Franklin was recommending that other artists copy this painting rather than have him sit for new portraits.[4]

This appealing image of Franklin has not been seen on any other plaque or piece of pottery. The only other representation of Franklin on creamware depicts him wearing a fur hat and spectacles, a print that is more commonly found. That likeness is based on an engraving made in 1777 by Auguste de Saint Aubin after a drawing by Charles Nicholas Cochin.[5] Creamware plaques with printed portraits are exceedingly rare; two others are in the Teitelman Collection. One is the most frequently seen small example, with a portrait of George Washington after Gilbert Stuart (see Appendix II.15). The other, possibly unique, is a large oval plaque with Washington on one side and Jefferson on the other (see cat. no. 14). The two are usually attributed to the Herculaneum Pottery, as the Washington portrait appears on a marked Herculaneum jug also in the Teitelman Collection (see Appendix II.12). The usual format of the printed plaque is oval, with the portrait being centered and bordered by a narrow black line set about ¼ inch from the edge of the print. The rarity of these pieces may be the result of the precarious system of hanging them with ribbon laced through two holes at the top of the plaque. On the other hand, perhaps they could not compete with the cost of the same image printed on paper, which could be displayed in the same way with a greater degree of safety.

7. Bowl

Probably made in Staffordshire and printed in
Liverpool, England; 1785–95
Creamware printed in black and painted in enamels
Diam. 9⅞ in. (251 mm), H. 4¼ in. (108 mm)
1959.586 Bequest of Henry Francis du Pont

This bowl is one of the many kinds of objects made to
acknowledge George Washington's victorious leadership
during the Revolutionary War. On the exterior are two
images of Washington, separated by printed floral sprays.
The equestrian scene is likely derived from a popular
mezzotint published by C. Shepherd of London in 1775
and inscribed "Done from an original Drawn from Life
by Alexr. Campbell of Williamsburgh in Virginia." The
author of the standard work on Washington portraits
writes, "No such painter is known to exist; and
Washington himself, with good humor and resignation,
denied having sat for the portrait."[1]

This "Campbell" portrait was widely circulated in
Europe and gave copyists a source for images to supply a
lucrative market that had no means of recognizing
whether portraits truly reflected their subjects. The
accompanying inscription describes Washington as a
Marshall of France; however, he denied holding any such
honor or commission.[2] Prints with this inscription appear
on a number of ceramic pieces, and a discussion of one
in *The History of Frederick County, Maryland* notes that the
image and inscription were probably inspired by the
frontispiece of the June edition of Exshaw's *Gentleman's
and London Magazine*, published in Dublin in 1783.[3] So
far, this rare volume has eluded the authors. Should it be
found with such a print, that image will also likely have
been inspired by an edition of the "Campbell" portrait.

The profile portrait of Washington on the reverse side
of the bowl ultimately derives from a drawing completed
on February 1, 1779, by Pierre Eugène du Simitière. It is
similar to the print found on the coffeepot in cat. no. 10,
where it is discussed more fully. Although these two

printed portraits differ in proportion, they appear to have
been taken from the same copperplate engraving. The
differences arise from the distortion of the glue bat that
transferred the design as it was applied to the curved and
undulating surfaces of the pieces. Given the number of
potteries in Staffordshire at this date, it is statistically
probable that the bowl was made there, but engraved
portraits with curvaceous title banners and rococo
flourishes, as seen in this profile of Washington, are typical
of those printed by Sadler & Green in Liverpool, and
none is known to be of Staffordshire origin.

In the well of the bowl is a stock print of a three-
masted ship sailing on a green painted ocean and flying
an American flag touched with blue and red enamel
color.[4] The interior rim is printed with four conventional
designs of naval and military trophies, making this a
suitable acquisition for a mariner or soldier of the
Revolution. One can imagine a bowl of this kind filled
with punch and American patriots using it in support of
their triumphant toasts.

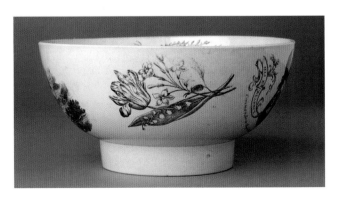

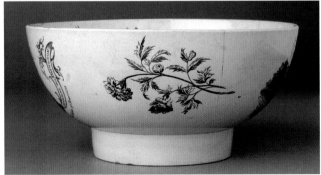

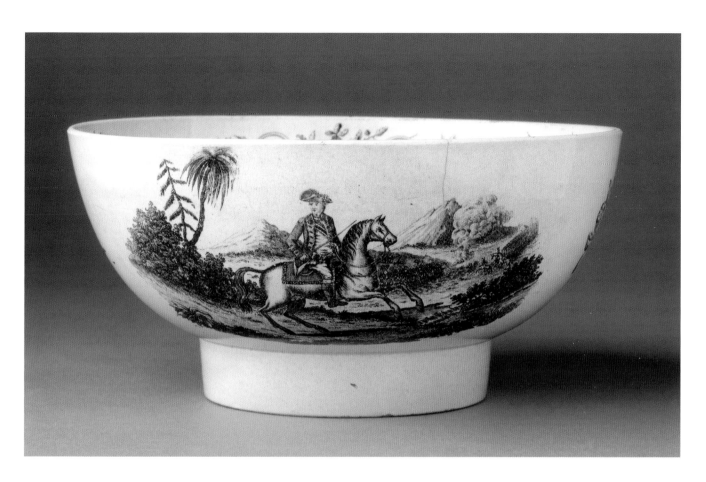

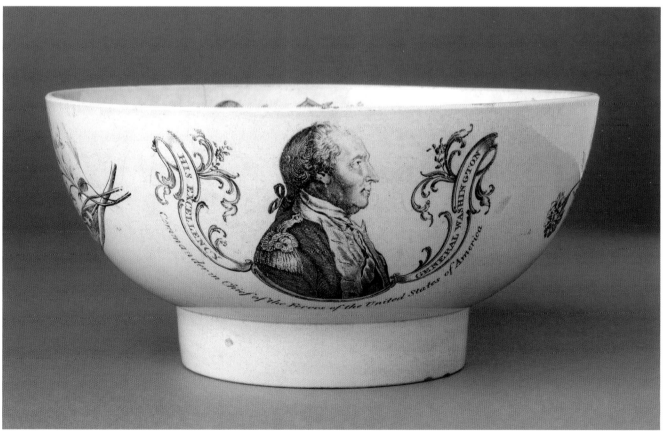

8. Jug

Probably Herculaneum Pottery
Liverpool, England; 1800–1807
Creamware printed in black and painted in enamels
H. 10 ⁷⁄₁₆ in. (265 mm)
2007.31.13 Gift of S. Robert Teitelman

This remarkable jug is dedicated to imagery memorializing George Washington. The inscriptions create a unique juxtaposition of designs commemorating his glory in both life and death. On one side a hand-painted design shows Washington as commander in chief of the Revolutionary forces. His imposing figure in military uniform is placed centrally in the scene; he holds a telescope and appears to be ready to observe a military encampment in the distance. Behind him is one of the two horses he rode during the Revolutionary War. His favorite mount, especially in time of action, was Nelson, a sorrel. This image appears to depict his second horse, Blue Skin, named for the light bluish gray, almost white, coat.[1] The horse is held by an African American, probably William (Billy) Lee, a slave who worked as Washington's valet for many years and was known as a wonderful horseman.[2] Lee served Washington during the Revolutionary War and later lived at Mount Vernon. In his will, Washington made arrangements to free Lee, providing him with food, clothing, and $30 a year for the rest of his life. The image seen here is not known to depict any particular moment in Washington's campaigns but is a generic portrayal of his heroic leadership and is entitled "WASHINGTON IN HIS GLORY." It is the only example known of this design, which is not surprising, as painted designs by their nature are usually singular.

The colorful scene of Washington in his prime contrasts starkly with the black-printed mourning tribute on the reverse entitled "WASHINGTON IN GLORY AMERICA IN TEARS." The general died on December 14, 1799, after a brief illness. In the months that followed, many engraved prints were published in tribute. One of the first was that by James Akin and William Harrison Jr. of Philadelphia, who published *America lamenting her Loss at the Tomb of GENERAL WASHINGTON* on January 20, 1800.[3] That print was the source for a popular design on creamware jugs, and various versions are known (see cat. no. 61). Although it may have been inspired by Akin and Harrison's original print, there are many differences between the source print and this engraving, including the pottery engraver's depiction of a more radiant heavens, the portrait of Washington facing to the right instead of the left, and the simplified memorial tablet. There is no doubt, however, that it is a mourning tribute, as symbols of America in the form of an eagle and a classical female figure both retain their distressed attitudes at the foot of the obelisk.

Beneath the lip of the jug is a printed oval medallion framed in a foliate wreath with the hand-painted monogram "PF," referring to the owner of the jug, who so far has not been identified. Beneath the initials is a second printed inscription commonly seen on English pottery made to meet American demands for tangible expressions of respect and admiration for Washington (see cat. nos. 11, 44, 55). The medallion is inscribed with the moving words spoken by Thomas Paine in his eulogy to Washington: "A MAN without example A PATRIOT without reproach," a phrase rarely remembered except through the ceramic survivors of this poignant event.[4]

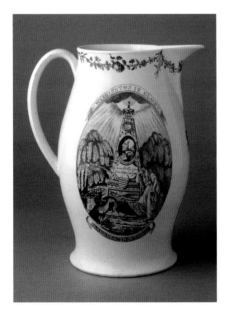
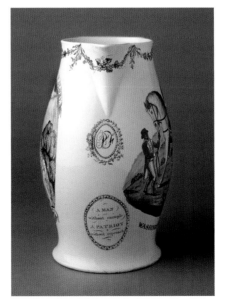
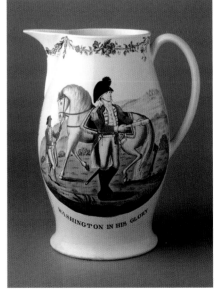

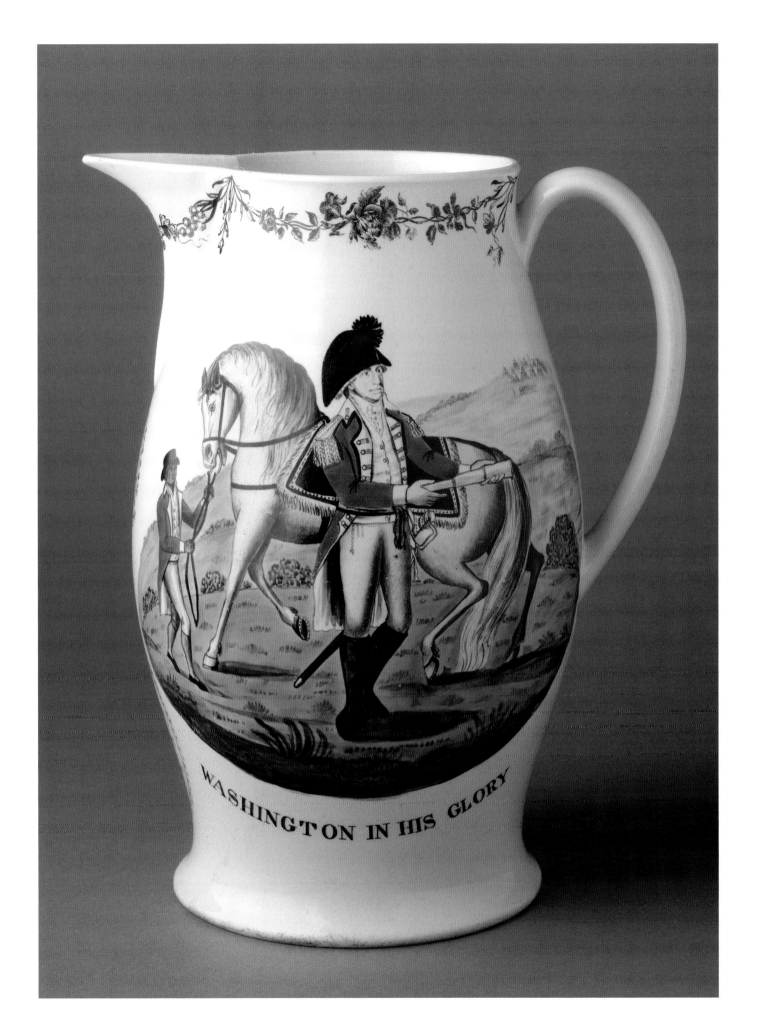

WASHINGTON IN HIS GLORY

9. Mug
Staffordshire or Liverpool, England; 1795–1800
Creamware printed in black
H. 4¾ in. (120 mm)
1966.46 Gift of Mr. B. Thatcher Feustman

In an age when allusion, allegory, and symbolism were widely understood and readily used, the design on this mug, a deliberate attempt at political propaganda, would have been easily recognized. The central portrait of George Washington may ultimately derive from one of the better-known portrait engravings, but it does not exactly conform to any of them. The torso is depicted in three-quarter view, and the head is in profile; his otherwise civilian suit of clothes bears the distinctive military epaulettes seen in Joseph Wright's profile portrait of him in uniform.[1] This Washington commemorative, however, is far from generic. The inscriptions set it in a specific historic context.

There is only one known source for the long inscription beginning "Deafness to the Ear," and it was part of a drinking toast offered at an event recorded in a number of newspapers in November 1795, including Boston's *Columbian Centinel* of November 4, where it is noted, "A TOAST Worthy Americans, given a few days since, at an entertainment, after a military parade, at *Ipswich*. Deafness to the ear, that would patiently hear, dumbness to the tongue that would utter a calumny against the immortal WASHINGTON."

A clue as to the impetus to make such a toast may be found in the article published in the same newspaper, which reads: "FEDERAL FEATURES. The Grand Jury for the district of Newburn, N. C. has presented, 'a certain riotous and tumultuous meeting that took place in that town, in consequence of the treaty.'" Was it this "treaty" that caused such as stir? If so, what was it and why was it so contentious? Elected to serve a second term as president, Washington faced challenges to his stand of neutrality on the matter of war between France and England. Concerned with growing French influence in American politics, apprehensive about the growing tension with Britain, hoping to avoid war, and wishing to re-establish trading links, Washington accepted the 1794 London Treaty formulated by John Jay, America's first chief justice.[2] He submitted it to the Senate, where it was passed by a vote of 20 to 10 on June 24, 1795. Rival political parties, the Democratic-Republicans and the Federalists disagreed on whether it would be more advantageous to ally with France or Britain. Opposing views on the treaty were strongly expressed and reported in newspapers. One toast cited, "May the embassy of John Jay prove as beneficial to his country as his appointment was important; and may his services be rewarded with the gratitude of his fellow citizens."[3] Alternately, if you were of the opposite point view you could raise a glass like "The VOLUNTEER COMPANIES *of Wilmington, Delaware*," who toasted "The Coalition of Hypocritical Federalism and Malignant Toryism, with its offspring, Justice Jay's treaty—may the *tria juncto in uno* be speedily strangled by the genius of liberty . . . may he and his treaty be forever politically d_____d. "[4]

Feelings were running high, and toasts were made in support of one side or the other. Washington supporters felt their hero had been maligned in the press. It is not surprising that the British pottery industry took the side of Washington, Jay, and the London Treaty of 1794, which settled outstanding issues from the Revolutionary War and established new trading possibilities between America and her former colonial masters. The potters adapted the toast that supported Washington together with an engraved design containing a central portrait of him flanked by figures of Justice and Liberty. From the mouth of Justice comes a cartoon bubble containing the inscription "Deafness to the Ear that will patiently hear & Dumbness to the Tongue that will utter a Calumny against the immortal Washington." From the mouth of Liberty comes a cartoon bubble containing a rarely seen inscription, "My Favorite Son." Below the portrait is a ribbon inscribed "Long Live the president of the United States."

The newspaper reports that relate so well to this print suggest that this mug dates to the last years of Washington's presidency. Their accounts of Washington's political activities at this time may have occasionally given rise to criticism, but there is no doubt about the support offered by the owner who raised this mug to salute his president.

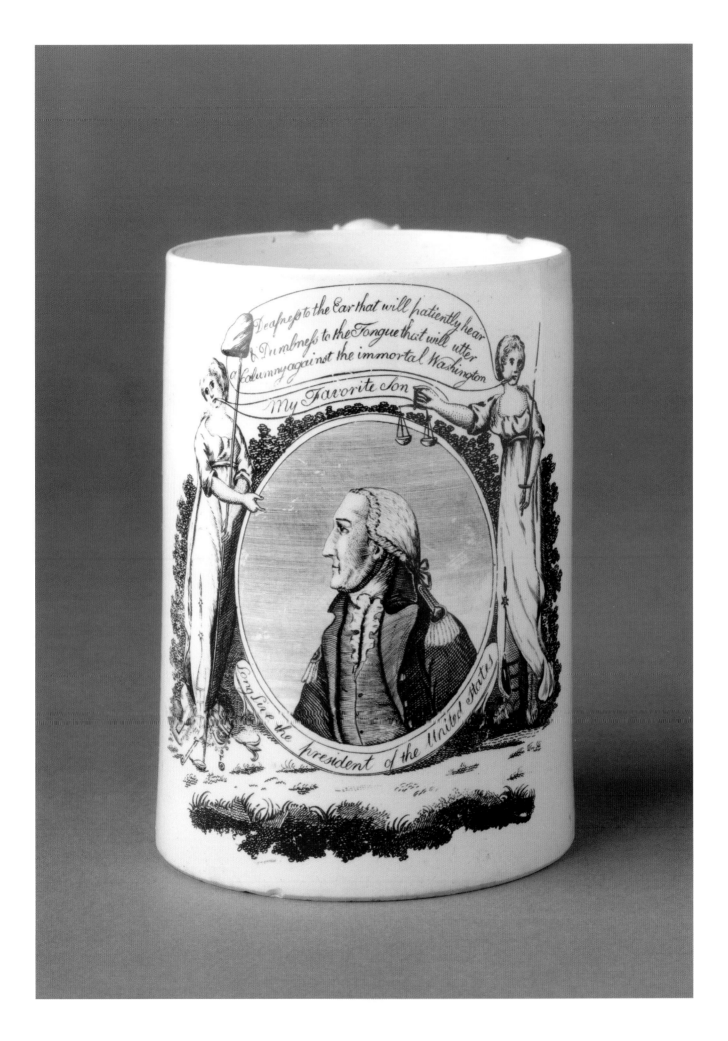

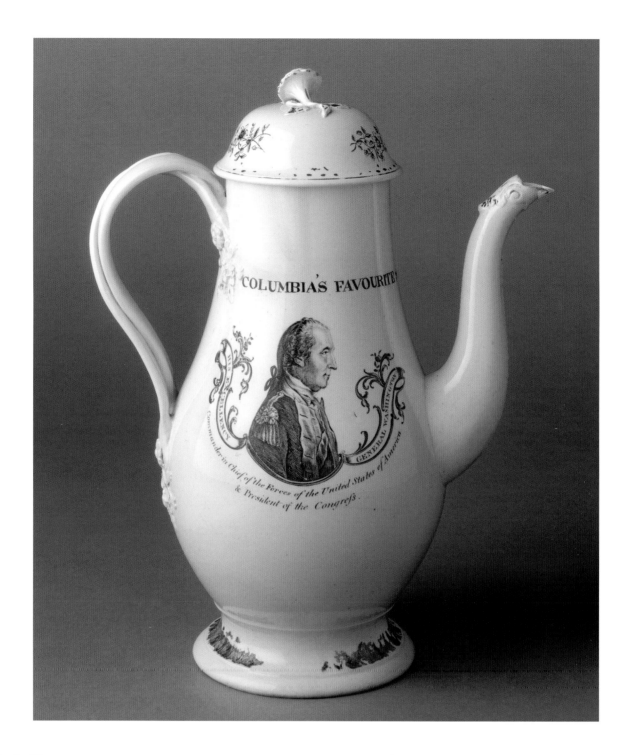

10. Coffeepot
Probably made in Staffordshire and printed and painted in Liverpool, England; 1790–1800
Creamware printed in black and painted in enamels with traces of original gilding
H. 12 in. (304 mm)
1959.592 Bequest of Henry Francis du Pont

George Washington was an American icon. Having led the Continental Army to victory over Great Britain, in 1789 he was unanimously elected America's first president. He proved to be an exemplary politician and a man of virtue devoted to his civic duties. He was the nation's foremost military hero, politician, and statesman, "first in war, first in peace, and first in the hearts of his countrymen."[1] During his lifetime he had many portraits made. Artists and publishers sought to present his image to a world where a person's face was believed to convey his essential character.

Three authentic likenesses of Washington were introduced in the 1780s. One was based on a pencil drawing by Pierre Eugène du Simitière, a Swiss artist working in America who recorded the struggles of an emerging nation.[2] Du Simitière's completion of the Washington drawing was noted in his commonplace book on February 1, 1779. Later that year the drawing was dispatched to France for engraving together with portrait drawings of thirteen other Revolutionary War heroes. A few sets of prints were supplied by 1781, but it

was the Washington portrait that drew most attention. After the war, the prints were widely copied in Europe. The set of thirteen subjects was published by two different London printers in May 1783, and, following those editions, the Washington portrait became a popular source for book and magazine illustrations.[3]

The bust portrait on this coffeepot derives ultimately from the du Simitière drawing but was likely inspired by one of the subsequent London editions. One such engraving is entitled *His Excellency GENERAL WASHINGTON Commander in Chief of the united States of North America &c Pubd May 15th 1783 by R.Wilkinson, No.38 Cornhill, London* and signed "BBE." An example in the National Portrait Gallery has a handwritten insertion "*of the Forces*" after the word Chief.[4] The printed portrait on the coffeepot has a similar inscription within scrolling decorative rococo flourishes and reads "HIS EXCELLENCY GENERAL WASHINGTON." Below the scroll is "Commander in Chief of the Forces of the United States of America & President of the Congress." This last statement is in error, for Washington was never president of Congress.[5] The print, which is typical of the style employed by Sadler & Green in Liverpool, is often seen on English creamware for the American market (see cat. no. 7), but above the image on this example is the painted and rarely seen inscription "COLUMBIA'S FAVOURITE SON."

In 1789, on the occasion of President Washington's visit to Boston after his inauguration, Oliver Holden wrote and set to music his popular ode "Columbia's Favourite Son." The Boston newspaper coverage was extensive and included this report:

On the president's arrival at the State-house, he ascended a temporary balcony adjoining the gallery where were a select choir of Singers, who upon the President's appearance sang the following

TO COLUMBIA'S FAVOURITE SON
GREAT WASHINGTON the Hero's come
Each here exulting hears the sound
Thousand's to their Deliverer throng
And shout his welcome all around
Now in full chorus join the song
And shout aloud Great WASHINGTON

Their view Columbia's favourite Son
Her Father, Saviour, Friend and Guide
There see the Immortal WASHINGTON
His Country's Glory, Boast, and Pride
Now in full Chorus &c.[6]

Six more verses ensue, extolling the virtues of America's first president. As the earliest known use of the phrase "Columbia's Favourite Son," it seems that it is from the title and the first line of verse two that the quotation is taken for use with Washington's image. So although this printed portrait may have been in use on pottery from shortly after 1783 (when it first appeared as a print on paper in London), it is likely that this coffeepot with the additional inscription dates from 1790 or later.

The reverse of the coffeepot has a printed cartouche of rococo c-shape flourishes entwined with scrolling grape and vine and hops with a bacchanalian head at the top of the design. When the coffeepot was made, the cartouche was left blank, to be quickly and easily painted and fired with an inscription to suit the needs of the customer; in this case a large monogram, "BSE," has been inserted. The cover also has printed decoration of three different small floral sprays.

The hand-thrown baluster coffeepot body has a twisted strap handle ending in large floral terminals. The molded spout has a foliate lip, and the knob on the lid is in the form of a flower. All these details have traces of original gilding, which can also be seen at the rim of the cover and in the survival of parts of a gilt leaf border at the foot of the pot that would probably have been matched by one at the rim (restored). In all, this would have been an expensive, showy piece that expressed a remarkable devotion to George Washington. It would have been an expensive commission for the unknown recipient, "BSE."

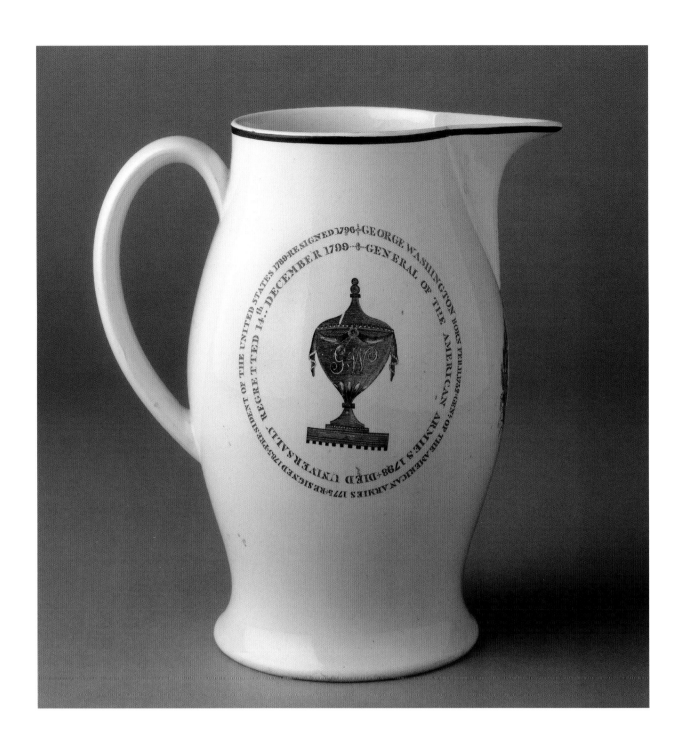

11. Jug
Probably Herculaneum Pottery
Liverpool, England; 1800–1807
Creamware printed in black
H. 9¼ in. (235 mm)
2009.23.3 Gift of S. Robert Teitelman, Roy T. Lefkoe, and
Sydney Ann Lefkoe in memory of S. Robert Teitelman

This simple, elegant jug pays homage to George
Washington through an unusual array of printed designs
commemorating his untimely death. Imagery surrounding
his death and national mourning could be seen in all kinds
of artwork. This jug has a group of the less commonly seen
designs.[1] On one side a funerary urn bearing the initials

"GW" is framed by two circular inscriptions. The outer
inscription reads "GEORGE WASHINGTON BORN
FEB.11, 1732 ★ GEN[L]. OF THE AMERICAN ARMIES
1775 ★ RESIGNED 1783 ★ PRESIDENT OF THE
UNITED STATES 1789★ RESIGNED 1796." The inner
inscription reads "GENERAL OF THE AMERICAN
ARMIES 1798 ★ DIED UNIVERSALLY REGRETTED
14th. DECEMBER 1799."

On the reverse, a black-printed design shows a profile
bust portrait of Washington derived from an original
engraving by Joseph Wright published about 1790 and
destined to become one of the most influential
Washington images. The English pottery engraver may
have used any number of London prints copied from

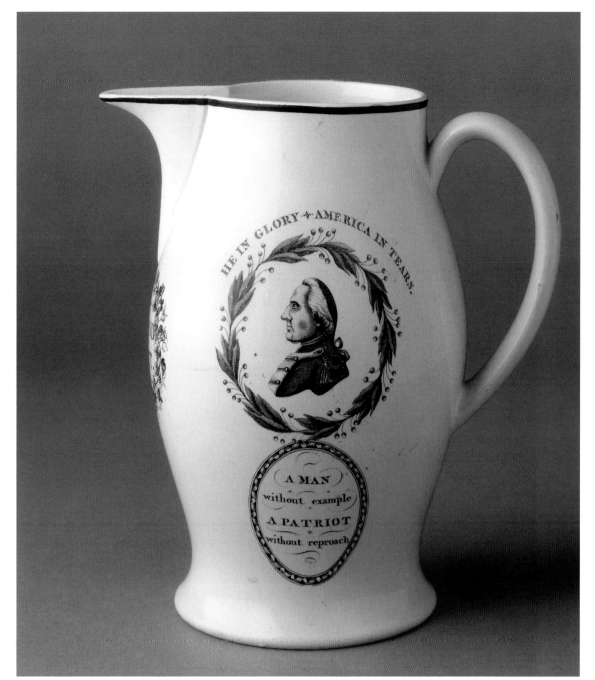

Wright, including that by Thomas Holloway published in the *Literary Magazine and British Review,* July 1792.[2] The portrait is framed in a laurel wreath, signifying victory and glory, and above the portrait is the inscription "HE IN GLORY ★ AMERICA IN TEARS."[3] This phrase is commonly found on Washington memorials, but less commonly found are the moving words spoken by Thomas Paine in his eulogy and seen in oval medallion inscribed "A MAN without example A PATRIOT without reproach."[4]

Below the spout is the name "EDMUND SWETT." painted within a printed wreath of hops and grapevines. Whether Swett commissioned the piece or was the recipient, the decoration suggests he was a patriotic admirer of Washington.[5] The Swett family had a long association in

the town of Newbury, Essex County, Massachusetts, with John Swett admitted as a freeman in 1642. Edmund was born there on June 19, 1743; his son of the same name died in 1794 before this jug was made,[6] but it is remotely possible that it was made as a gift for his grandson, Edmund Swett III, born in 1793. Swett was a merchant in the town of Newburyport, where in 1814 he bought an established business at 14 State Street.[7] During the next few years, newspaper advertisements identify his stock as haberdashery, textiles, clothing accessories, "crockery and glass ware" for sale wholesale and retail.[8] The advertisements for the business continued until the announcement on March 11, 1825, in the *Newburyport Herald* and other newspapers that carried the death notice "In Newbury, Mr. Edmund Swett, aged 81."

12. Jug
Herculaneum Pottery
Liverpool, England; 1806
Creamware printed in black and painted in enamels
Printed mark beneath the spout
H. 10⅜ in. (264 mm)
2009.23.17 Gift of S. Robert Teitelman, Roy T. Lefkoe, and Sydney Ann Lefkoe in memory of S. Robert Teitelman

As news of George Washington's death on December 14, 1799, spread throughout the nation, there were personal and civic expressions of deep sadness. Citizens wore mourning crepe; many cities, including Philadelphia, held symbolic funeral processions; honors were paid at all military stations; a national monument was proposed; and a national day of mourning was declared for February 22, 1800, the anniversary of Washington's birth. The nation gained comfort from the sincere conviction that their beloved Washington had ascended to immortal glory. Testimonials and memorials continued for many years. Some were more colorful than others, and one included a fireworks display on the Green in Charleston, South Carolina, in which "Monsieur Gaston, Artist from Paris" concluded with "WASHINGTON in GLORY, Surrounded by sizteen [sic] STARS."[1] More lasting accolades are found in the many printed images of Washington memorials, some of which were inspired by the staged funeral and mourning tributes.[2]

Perhaps the best known of the printed commemoratives was that engraved by John James Barralet in 1800 and published by Simon Chaudron and Barralet in Philadelphia. That image was the source for the design on the reverse of this jug.[3] In early February 1802, J. J. Barralet advertised his print "*APOTHEOSIS OF WASHINGTON FINISHED FOR DELIVERY… The subject Gen.–Washington raised from the Tomb, by the Poetical and Historical Genius, assisted by Immortality–at his feet America weeping over his Armour, on the opposite side an Indian crouched in surly sorrow, in the third ground the Mental Virtues, Faith Hope and Charity.*" In her study of this image, Phoebe Lloyd Jacobs identifies the "Poetical and Historical Genius" as a traditional depiction of Father Time who helps Washington in his ascent.[4] The weeping America is also emblematic of Liberty, the subjects being interchangeable in American iconography. And finally, the Christian virtues are transformed into "Mental Virtues" in republican America. Jacobs estimates that as many as 600 prints could have been pulled from Barralet's engraving and that there was a wide distribution. The print was reissued in 1816, and further editions were produced as Washington's memory continued to be honored in the century after his death.

No doubt some examples of Barralet's first edition traveled to England, where enterprising manufacturers adapted the image for decoration on goods destined for the American market. Trade with the port of Liverpool was increased as merchant ships plied the waters between Europe, the Caribbean, and the eastern seaboard of America. The ship and its owners referenced on this jug and its companion piece (see cat. no. 50) are known to have been trading between Massachusetts and Liverpool from 1805 to 1812. This example bears the prominent mark of the Herculaneum Pottery, which was established in Liverpool in 1796. The firm offered many American printed designs alongside undecorated pieces that could have hand-painted designs and inscriptions applied to order.[5] Their mark is an American eagle based on the design of the Great Seal of the United States.[6] The Herculaneum eagle is distinctive, with a radiance containing the stars representing the thirteen original states and an additional star on either side of the eagle's head for the states of Vermont and Kentucky, which entered the Union in 1791 and 1792 respectively. The characteristics of the Herculaneum eagle include the motto ribbon, which the eagle grips in the center and carries in front of its body. The shape of the eagle's wing, particularly the conformation of the leading edge, differs from that of other factory images. Although it occurs in many sizes and often without HERCULANEUM beneath, the image is consistently portrayed in the same way.[7]

The reverse of this jug has a stock print entitled "TWO BROTHERS OF KITTERY JN⁰. FOLLETT MASTER." The history of this ship may be found at cat. no. 50, where the companion piece dated 1806 is discussed in detail. The two brothers mentioned are John and Robert Follett. Evidence suggests that this piece was probably kept by John while the other was suitably inscribed as a gift to his brother.

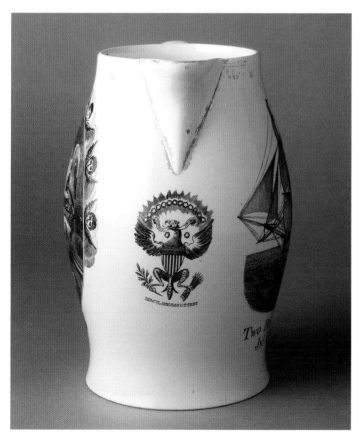

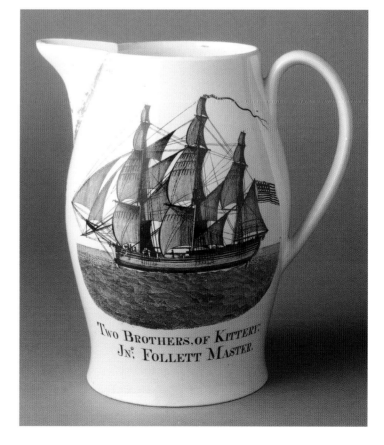

13. Jug

Probably Herculaneum Pottery
Liverpool, England; 1798–1810
Creamware printed in black with gilding
H. 10 in. (255 mm)
2009.21.8 Gift of S. Robert Teitelman

"JOHN ADAMS, President of the United States of America" is the title of the print on one side of this jug. An oval medallion contains a portrait, presumably of Adams, although it would be difficult to identify this gentleman without the title beneath. The portrait is supported by allegorical female figures of Plenty, with an overflowing Horn of Plenty, and Justice with her scales, while a cupid holding a liberty cap on a staff looks down on the scene. This classical design is typical of the conventional tributes paid to leaders of the new republic.[1] Although Adams was the second president and in office from 1797 to 1801, there is reason to suppose that this piece may date to after his presidency.

The poem on the reverse, "As he tills your rich glebe, the old peasant shall tell, While his bosom with Liberty glows, How your Warren expire'd _ how Montgomery fell, And how WASHINGTON humbled your foes," was written by Edward Rushton, a radical Liverpool poet who abhorred the slave trade and lost his sight after contracting an infection while trying to help slaves on board a ship.[2] The verse is part of a longer work entitled *Ode on the Fourth of July*, published in 1806 and printed in at least one newspaper in America the following year where its "poetic excellence and patriotic fervor" were admired.[3] The references in the verse are to heroes who died in the Revolutionary War and are not so well known in the twenty-first century. Joseph Warren was an officer in the colonial militia and was in command of the forces at the Battle of Bunker Hill, June 17, 1775. Shot through the head with a musket ball, he was the first officer to lose his life in that war, a death that was commemorated in a major painting by John Trumbull.[4] Richard Montgomery served first as a delegate in the New York Provincial Congress and then as a brigadier general in the Continental Army. On the night of December 30–31, 1775, he launched a disastrous assault on Quebec, which cost him his life and effectively ended the American bid to seize Canada.[5] The loss of these two military leaders is honored in the poem and in the printed devices that decorate it; above the words is a liberty cap on a staff flanked by an American flag emblazoned with an eagle and to the right a star-spangled banner flutters. Below the medallion is a banner inscribed "INDEPENDENCE" amid symbols of agriculture, arts, and learning.

Whether the poem was known in Liverpool before its inclusion in the volume published in 1806 is not certain. If it was available only after that date, it makes the juxtaposition of the print of John Adams rather incongruous, as his presidency ended with his retirement in 1801. That's not to say that patriotic New Englanders might not have continued to purchase such wares, particularly with the printed inscription seen in an oak-leaf cartouche under the spout, which declares "SUCCESS TO AMERICA."[6] Beneath is a printed version of the Great Seal of the United States.[7] The eagle is a smaller version than that marked Herculaneum on cat. no. 12, but it bears all the characteristics of that factory's print. The commissioner of this item not only wanted to proclaim his patriotism, he wanted to do it in style and went to the additional expense of having the jug embellished with gilding and a now-illegible monogram. The surviving gold-painted design, similar to that found at cat. no. 15, indicates that this was a costly and flamboyant purchase.

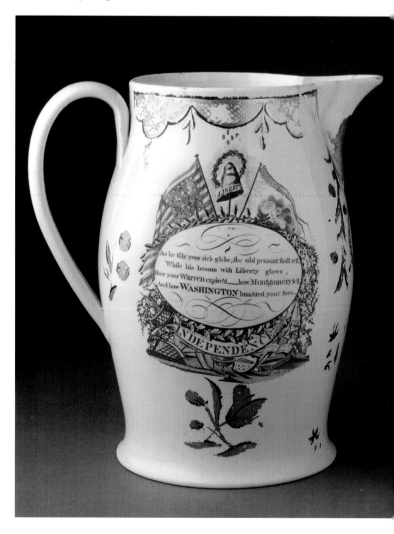

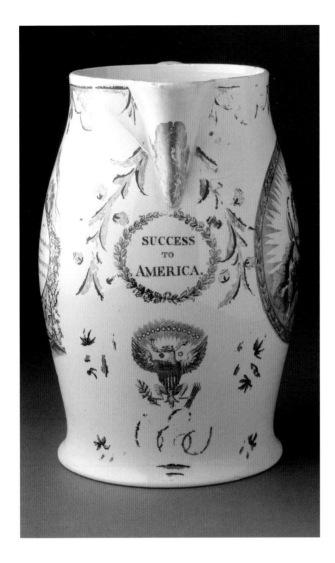

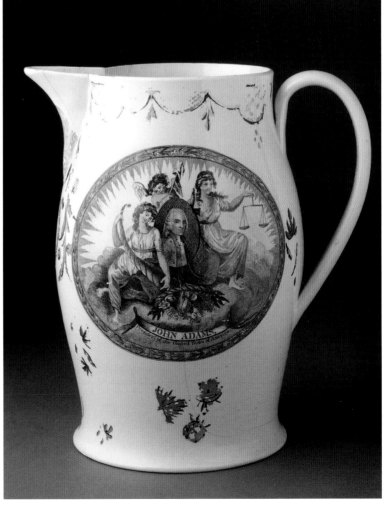

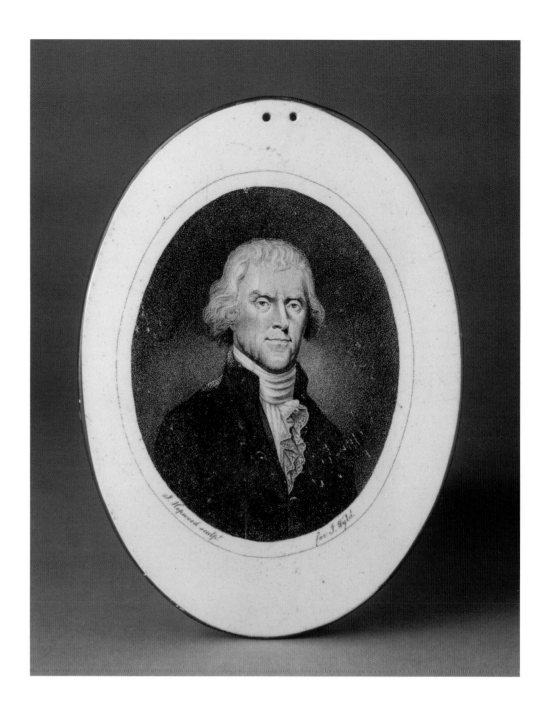

14. Plaque
Herculaneum Pottery
Liverpool, England; 1801–9
Creamware printed in black
H. 7 in. (178 mm), W. 5⅛ in. (130 mm)
2009.23.5 Gift of S. Robert Teitelman, Roy T. Lefkoe,
and Sydney Ann Lefkoe in memory of S. Robert
Teitelman

At age fifty-seven, Vice President Thomas Jefferson sat for a portrait in the Philadelphia studio of the young Rembrandt Peale, between late December 1799 and the middle of May 1800. It is "among the earliest and most penetrating likenesses of Jefferson, . . . unrivalled in having played a more significant iconographic role during Jefferson's lifetime than any other portrait . . . It was the ultimate source of the French and English image of the man."[1] The first engraving of this portrait was made in 1800 by English-born engraver David Edwin. Although it was widely used as source of inspiration for other engravers, it was not well received by Peale. Peale then initiated his own engraved copy, and, although finding it less accurate than he would have liked, wrote to Jefferson that "it is much better."[2] It is this second engraving done by Cornelius Tiebout and published by Matthew Carey in Philadelphia, on February 20, 1801, that appears to have been the inspiration for the print applied to the creamware plaque seen here.

The inscription below the portrait indicates that the image was engraved by J. Hopwood for J. Wyld. James Hopwood the elder (1752–1819) was a self-taught engraver who worked in London from about 1797.[3] He is

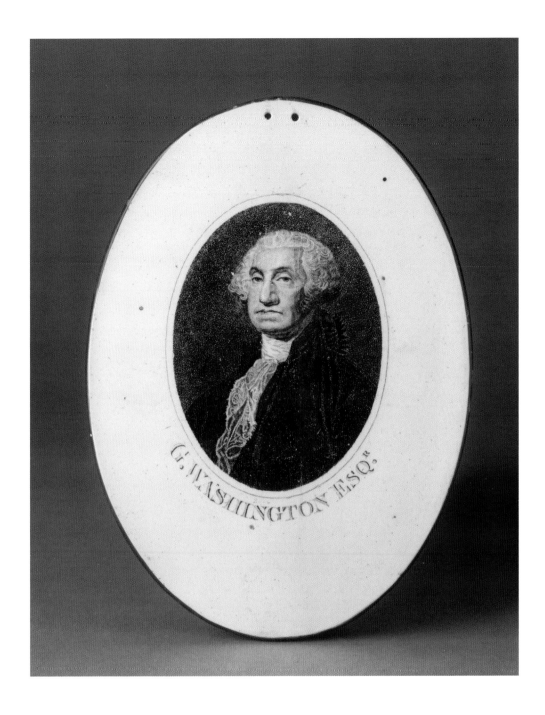

known for his portraits, and the National Gallery, London, has eleven of his works in their collection with dated examples from 1807 to 1818. J. Wyld cannot be identified with any certainty, but he was probably a publisher. The engraver who produced this image for the pottery industry seems to have used the Hopwood/Wyld original as a source, including the publishing details in the design.

It is likely that this plaque was produced during Jefferson's time as third president, 1801 to 1809. It is perhaps the finest depiction of the man found on English pottery; the engraver has used the effect of stippling to achieve a high degree of sensitivity in the rendering of the face, hair, and lace neck cloth.

A rare, if not unique, aspect of this plaque is the fact that it is printed on both sides. The reverse has a portrait of George Washington after Gilbert Stuart's 1796 unfinished portrait of Washington, the so-called "Athenaeum" portrait. Many engraved and printed versions are known to have been published in America and England, including those by William Nutter in London in January and February 1798.[4] The Nutter print may have been the source for this version of the portrait, but similar prints are known and would have provided the engraver with an adequate starting point.[5]

The edge of the plaque is painted with black enamel; the portraits each have a line of dots framing the image. It is possible that all the creamware plaques with American patriotic portraits were made in Liverpool; this example is attributed to the Herculaneum Pottery on the basis of its similarity to a print of George Washington on a marked Herculaneum jug in the Teitelman Collection (see Appendix II.12).

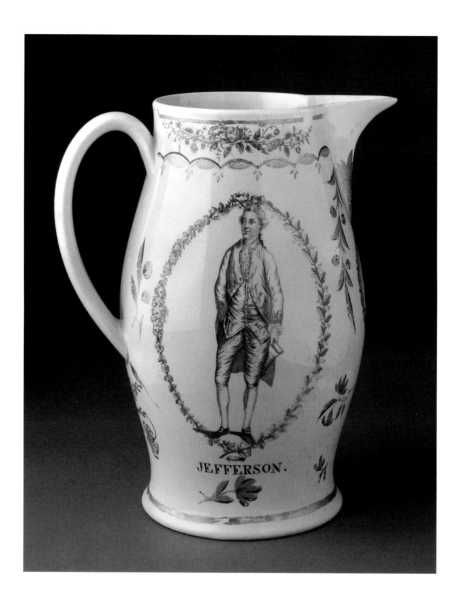

15. Jug

Possibly Herculaneum Pottery
Liverpool, England; 1801–9
Creamware printed in black and painted in enamels
with gilding
H. 9½ in. (242 mm)
2009.21.3 Gift of S. Robert Teitelman

This rare jug celebrates two great Americans and displays the Great Seal of the United States. On one side is a floral garland framing a full-length portrait entitled "JEFFERSON." Intended to convey the stature and gentility of the Founding Father and third president of the United States, this print is not based on any known likeness of Jefferson; however, the generic image captures his elegance, and the document he holds could conceivably represent the Declaration of Independence, of which he is considered to be the principal author. No doubt made during his presidential term (1801–9), this jug would have appealed to members of the Democratic-Republican party who were relieved to see Jefferson elected after a long and bitterly fought election.

The portrait on the reverse needed no title, for the grieving American public would all recognize the image of George Washington and understand the inscription "HE IN GLORY AMERICA IN TEARS." The portrait is based on a small engraving by Charles Balthazar Julien Févret de Saint-Mémin, which in turn was based on a drawing of Washington (now lost) that is believed to be the last portrait of the president done in his lifetime.[1] The engraving, made shortly after his death, was intended as an insert for mourning rings. It is possible that the English engraver had access to a paper print as his source or perhaps saw a mourning ring and used that for inspiration. This image is frequently seen on English pottery, sometimes with the first word of the inscription replaced by Washington's name. The laurel wreath frame that encloses the portrait was not only a popular neoclassical pattern but also a symbol of victory and glory, which Washington enjoyed in life and death.

Beneath the lip of the jug are two more decorative prints. The uppermost design is a printed foliate medallion with the monogram "EHT" hand painted in flourishing script. As yet, it has not been possible to identify to whom this piece was dedicated. The lower image is a version of

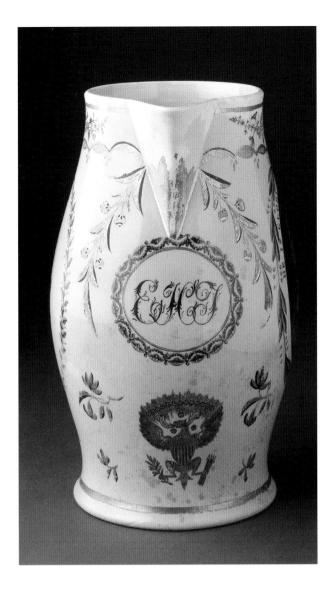

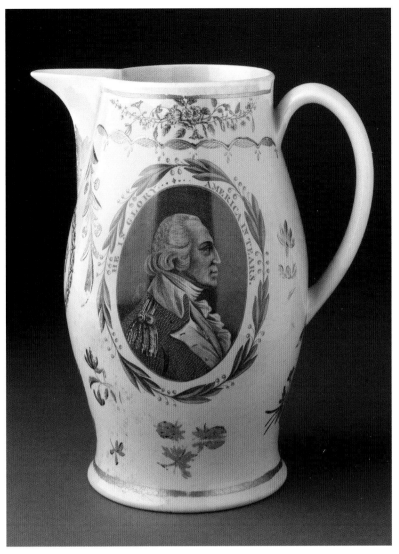

the Great Seal of the United States, one of the most popular designs on wares made for the American market at this time.[2] The print of the eagle is similar to a larger version seen on the marked Herculaneum jug in cat. no. 12 and the eagle print in cat. no. 13; however, there is an additional star above the head of the eagle, and all the stars have additional engraving in the center. Whether this constitutes a different Liverpool engraver/printer or represents yet another version of Herculaneum's Great Seal prints is only a matter of conjecture, with no evidence to support a definitive opinion. This jug also has hand-painted gilding, and although the black-printed floral swags at the neck restrict the space available, the gilt design is similar to that found on cat. no. 13, especially in the decoration beneath the lip. The addition of gilding would have transformed this piece from a standard factory production to an expensive high-end product for a more sophisticated and discerning customer. Unfortunately the fragile nature of early nineteenth-century gilding has resulted in surface losses; the jug no longer reflects completely the investment that the original owner made to announce his status and patriotism.

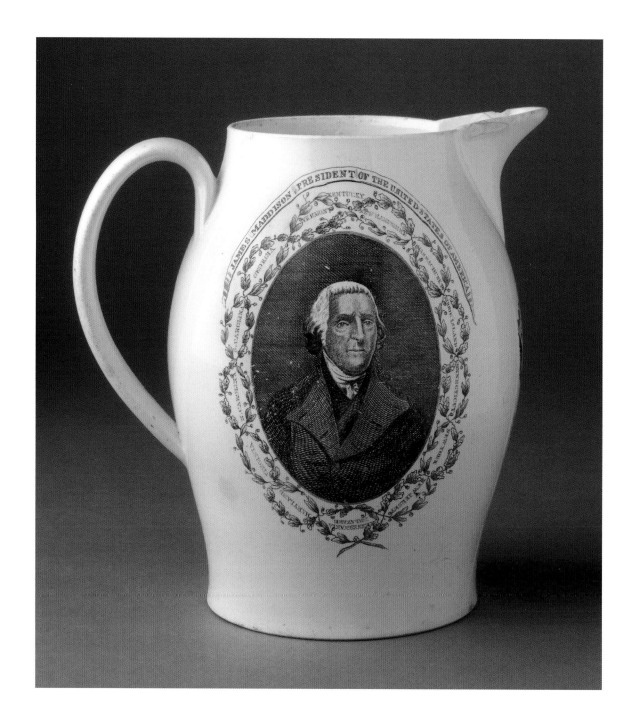

16. Jug
Probably Liverpool, England; 1809–17
Creamware printed in black
H. 8 in. (203 mm)
2009.23.13 Gift of S. Robert Teitelman, Roy T. Lefkoe, and Sydney Ann Lefkoe in memory of S. Robert Teitelman

Although entitled "JAMES MADDISON, PRESIDENT OF THE UNITED STATES OF AMERICA," the commemorative print on this jug is adapted from a previous presidency. Framed in a chain of leaves, with each link containing the name of one of fifteen states (Pennsylvania and Delaware are grouped together), the central image of the design is that of Thomas Jefferson. This pattern with a Jefferson title was produced on creamware in the 1801–9 period of Jefferson's presidency. Perhaps it was a fairly new pattern in 1809, when Madison succeeded Jefferson, and English potters and printers, reluctant to lose the investment they had made in obtaining this engraving, substituted a revised title ribbon and repurposed the design for Madison, the fourth president.

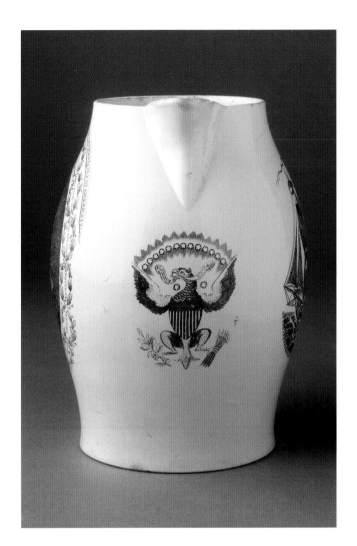

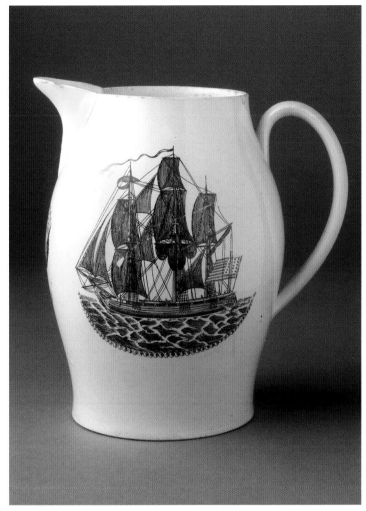

The image is after a print from the first portrait painted of Jefferson by Gilbert Stuart.[1] The earliest known example is a stipple engraving inscribed *Thos. Jefferson President of the United States of America. Painted by Stuart in America. Sold and published August 1, 1801 by Edw. Orme, New Bond Street, London.* The Stuart portrait was widely copied. Another version was issued by Verner and Hood of London on October 1, 1801, and a similar engraving appeared in the *European Magazine* published by T. Cornhill, June 1, 1802.[2] The print made for ceramics could have been adapted from any one of the many English sources. The use of the Jefferson portrait to represent Madison was almost credible, as Stuart painted stylistically similar portraits of both men, with Madison and Jefferson depicted in a similar pose and dress.[3]

The reverse of the jug carries a stock print of a frigate flying the American flag with fifteen stars and stripes, and beneath the lip is an adaptation of the Great Seal of the United States.[4] James Madison made a major contribution to the ratification of the Constitution, and he helped to frame the Bill of Rights. He was Secretary of State to Jefferson, and his collaboration with Jefferson led to the development of the Republican, or Jeffersonian, Party. He was the last of the Founding Fathers to become president, and he served in the office until 1817.[5] Madison is also the last American president to be depicted on black-printed creamware, which was being replaced in the popular marketplace with new kinds of pottery such as blue-printed pearlware and pink luster, which carried different kinds of designs created for the fashionable American consumer.

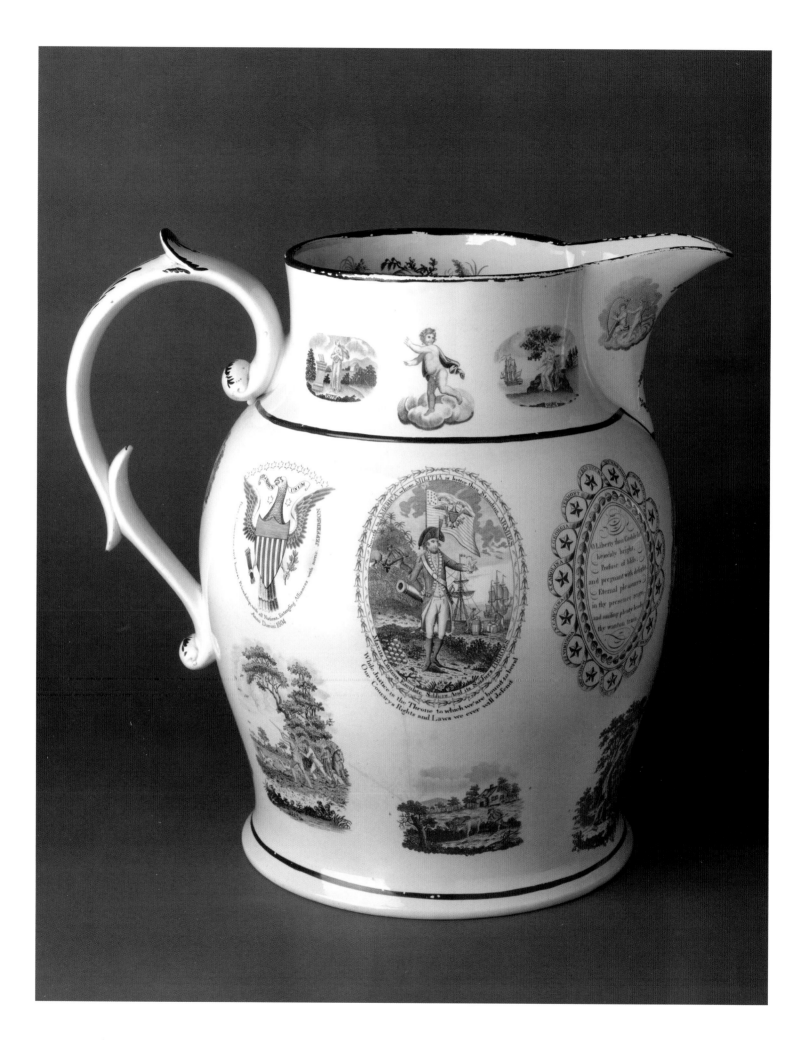

17. Jug
Staffordshire, England; 1804–15
Pearlware printed in purple
Prints signed "F. Morris" "Shelton"
H. 17¾ in. (451 mm)
2007.31.9 Gift of S. Robert Teitelman

Remarkable for its size and range of decorative designs, this is one of few surviving jugs that appears to have been made for display purposes. A similar-size piece in this collection (cat. no. 24) was made for shop display, but this example seems to be a showcase for the work of printer Francis Morris, whose signature can be seen on several of the images. In tiny script he signs "F. Morris" and "Shelton," the name of a town within the Staffordshire potteries where he worked. We have few detailed trade directories for the Staffordshire potteries before 1800, but on this date Morris is listed as a "black printer" in Vale Pleasant, Shelton, Staffordshire, and by 1809 he is entered as "gilder, enameller, & printer of earthenware, Shelton." He does not appear in the 1818 directory and presumably was retired or out of business by that time.[1]

One of the most prominent prints on the jug is that placed below the spout: "The Memory of WASHINGTON and the Proscribed PATRIOTS of AMERICA" and "Liberty, Virtue, Peace, Justice, and Equity to ALL Mankind." The design has portraits of Samuel Adams to the left and John Hancock to the right, surmounted by a memorial obelisk dedicated to the memory of George Washington. The juxtaposition of these Founding Fathers makes this image a strong patriotic subject appealing to those who supported the Revolutionary War, particularly New Englanders. A rhyming couplet below the images proclaims "Columbias Sons inspir'd by Freedom's Flame/Live in the Annals of immortal Fame."

Within the design are allusions to Freemasonry, and while it seems unlikely that Adams was a Freemason, George Washington and John Hancock were both members of the fraternity. In particular, the active beehive between the portraits is an important Masonic symbol representing industry. Masonic literature suggests, "It teaches us, that as we came into the world rational and intelligent beings, so we should ever be industrious ones; never sitting down contented while our fellow-creatures around us are in want, when it is in our power to relieve them, without inconvenience to ourselves."[2] In discussing the design, Ada Walker Camehl suggests that the "Proscribed Patriots" John Hancock and Sam Adams evaded the king's orders for their capture and execution by the British military, inspiring

an English rhyme:

> "As for their King, John Hancock,
> And Adams, if they're taken,
> Their heads for signs shall hang up high
> Upon that Hill called Beacon."[3]

That the British potters were keen to supply this kind of imagery to the American market speaks loudly of their pragmatic approach to business.

To the right of this central image is a design framed with the chain of the states,[4] "Washington crown'd with Laurels by Liberty" and signed "F. Morris" and "Shelton." To the right of this image is a second popular "Morris of Shelton" print that illustrates a map of the eastern seaboard of America. These designs are not uncommon and must have found favor with American customers; they appear on other pieces in the S. Robert Teitelman Collection at Winterthur and are discussed in more detail at cat. no. 20.

To the left of the central design, also framed in a variation of the chain of states, is a poem beginning "O Liberty thou Goddess heavenly bright." It is taken from "A Letter To The Right Honourable Charles Lord Halifax, Apostrophe to Liberty" by Joseph Addison (1672–1719), the English essayist, poet, and man of letters. His work was held in high regard in the eighteenth century and was part of any English or American gentleman's education. Although Addison had been writing about the Britain of his day, colonial Americans applied these apt words to their own struggle for liberty.

To the left of the poem, on the reverse side of the jug, is a third image that appears on other pieces in the Winterthur collection (see cat. no. 34 for a full discussion). The subject is titled "Success to AMERICA whose MILITIA is better than Standing ARMIES" and takes one side in the argument about the danger of strong armies and the preference in America for state militia. Discussions on this topic continued after the Revolutionary War and throughout the early decades of the nineteenth century.

The final two American patriotic images on this piece are placed on either side of the handle and illustrate a characteristic Francis Morris version of the Great Seal of the United States.[5] The engraving includes an inscription quoted from the inaugural address of the newly elected president Thomas Jefferson, March 4, 1801. It reads "Peace, Commerce and honest Friendship with all Nations–Entangling Alliances with none–JEFFERSON."[6] This printed version includes the date of the engraving "Anno Domini 1804." In advocating a cautious foreign policy, Jefferson had echoed the words of George Washington who, in his 1796 presidential farewell address,

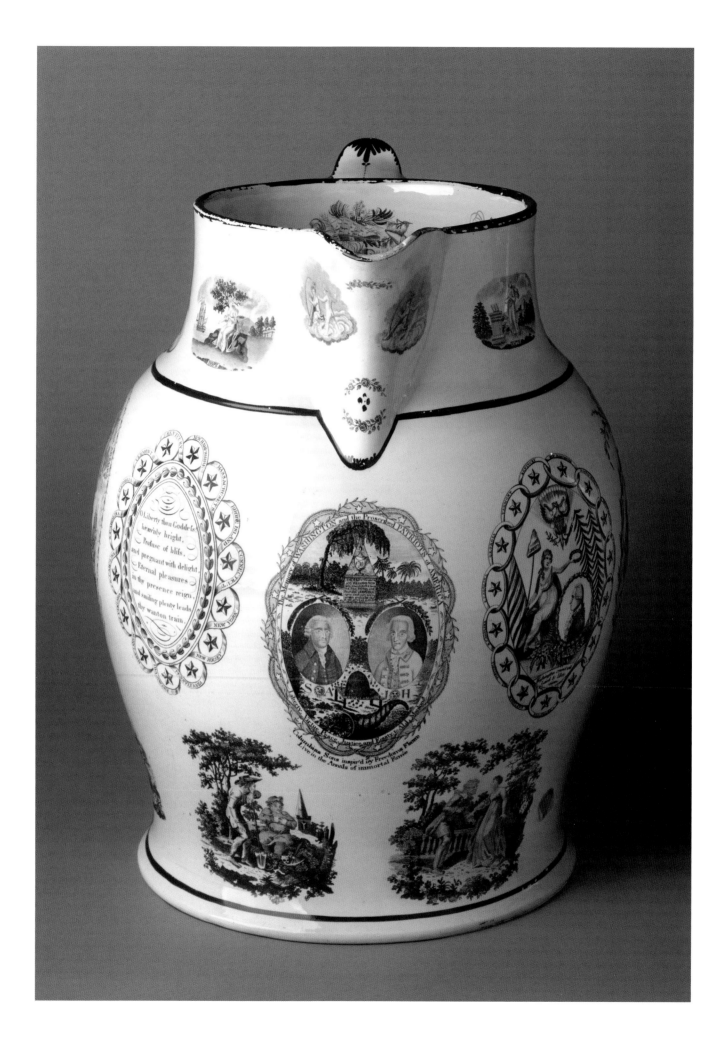

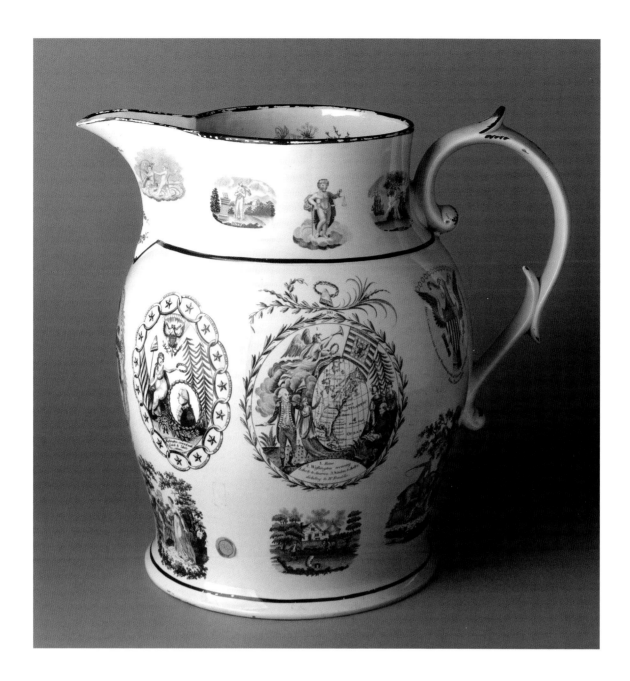

wrote, "It is our true policy to steer clear of entangling alliances with any portion of the foreign world."

There are many other prints on the body, base, and inside of this jug, including small vignettes of cherubs and allegorical female figures representing Faith, Hope, and Charity; pastoral landscape scenes of various subjects, including grave diggers and hunters; and large prints of "The Hearty Good Fellow" who drinks and smokes enjoying a life that "shortly must end." But most prominently placed are those meant for the American market. Whether this piece stood in a workshop in Staffordshire so potters could see how well Morris printed pottery; stood in a shop in Liverpool for patrons to custom order their wares; or even made its way to America to secure customers for Morris, perhaps we'll never know. What is clear is the willingness of the English potter to provide goods to the American market despite frequent hostilities, political embargoes, declarations of

war, and skirmishes on land and sea. The English potters seized every opportunity to celebrate America's triumphs and commemorate America's heroes in an effort to acquire the business of this expanding nation.

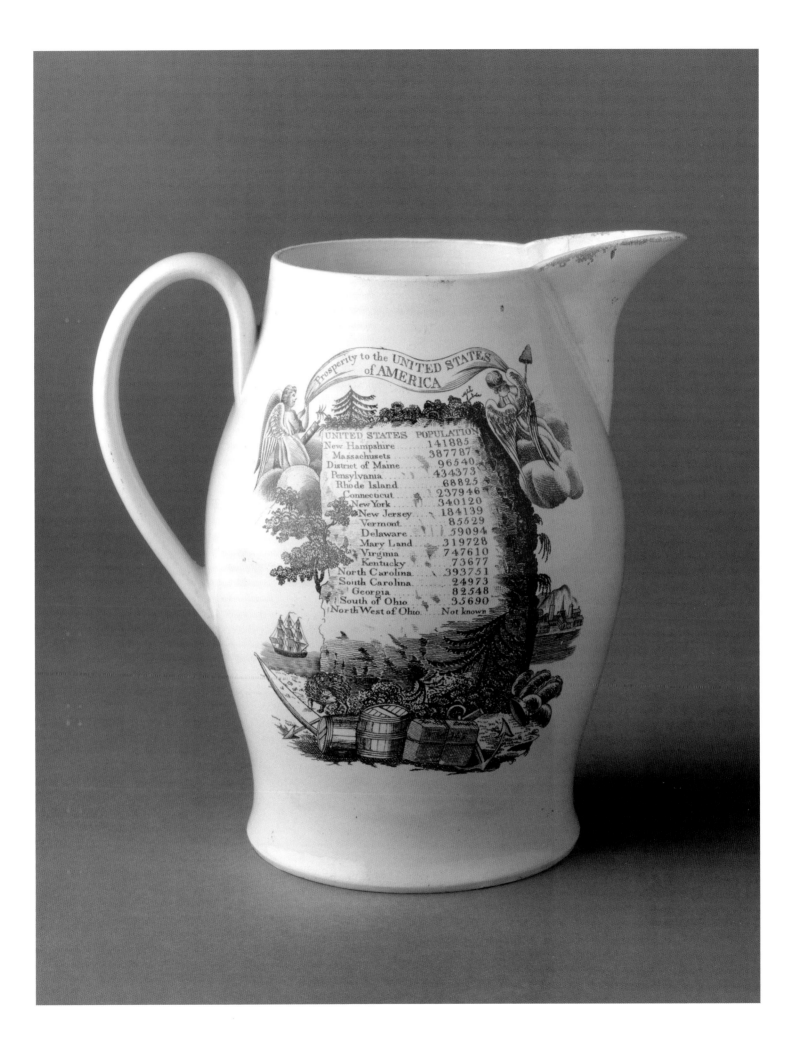

UNITED STATES POPULATION
New Hampshire.......141885
Massachusets........387787
District of Maine.....96540
Pensylvania.........434373
Rhode Island.........68825
Connecticut.........237946
New York...........340120
New Jersey..........184139
Vermont.............85529
Delaware............59094
Mary Land..........319728
Virginia...........747610
Kentucky............73677
North Carolina......393751
South Carolina.......24973
Georgia.............82548
South of Ohio........35690
North West of Ohio...Not known

Prosperity to the UNITED STATES
of AMERICA

98

18. Jug
Probably Staffordshire, England; 1790–95
Creamware printed in black
H. 7½ in. (191mm)
1999.38.2 Bequest of Henry Francis du Pont

In the early years of the new republic of the United States of America, citizens were eager to express their admiration for George Washington and their excitement about the development of their nation. This jug has printed decorations that would meet both criteria. On one side, within a landscape cartouche, are symbols of the new nation. The bow and arrow and feathered headdress represent the traditional depiction of America, and they are joined by barrels, a crate labeled "For . . . London," a ship, and an anchor that signifies the developing international trade. Above, the winged figures of Victory and Liberty hold a banner inscribed "Prosperity to the UNITED STATES of AMERICA." The main focus of the design is a depiction of the first national census taken in 1790, as mandated by Article 1, Section 2 of the U. S. Constitution, adopted in 1787.

The first census began on Monday, August 2, 1790, a year after the inauguration of President Washington and shortly before the second session of the first Congress ended. Marshals of each judicial district were responsible for supervising the census, which required that every household be visited and that completed schedules be posted in "two of the most public places, there to remain for the inspection of all concerned." The six questions called for the name of the head of the family and the number of persons in each household of the following descriptions: free white males of sixteen years and upward (to assess the country's industrial and military potential); free white males under sixteen years; free white females; all other free persons (by sex and color); and slaves. The Founding Fathers concluded that the states' wishes to report few people in order to lower their shares in the war debt would be offset by a desire for the largest possible representation in Congress. Thus, the census would be fairly accurate.[1]

Essentially an accurate representation of the census returns, the print on the jug seen here has transposed two numerals in the return of Massachusetts, which should read 378,787 not 387,787; South of Ohio is identified in the 1793 official report as "South of the River Ohio" where several Captains had not "as yet returned the Schedules of the numbers of their Districts." The published return for that area was 35,691, one more than that cited on the jug. The official census results showed that 3,929,326 people were living in the United States of which 697,681 were slaves. The largest cities were Philadelphia and its suburbs with 42,584 inhabitants; New York City with 33,131; Boston with 18,038; Charleston, South Carolina, with 16,359; and Baltimore with 13,503.[2]

On the other side of the jug is a print of George Washington "father of his country."[3] A victorious Washington stands with his foot on the neck of the British lion, overseeing his troops and presiding at the establishment of a merchant shipping fleet. This design and its origins are discussed more fully at cat. no. 5. This small jug with the print of a national hero, details of the first census, and the announcement predicting future prosperity tells us of the pride in the nation and speaks of the very foundation of the country.

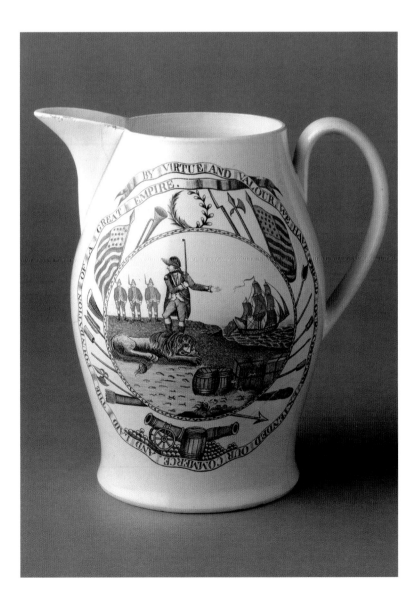

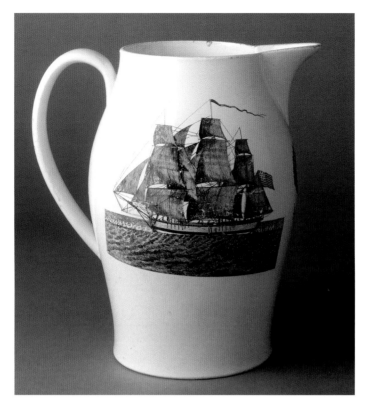

19. Jug

Herculaneum Pottery
Liverpool, England; 1796–1800
Creamware printed in black
H. 10 in. (254 mm)
2009.23.1 Gift of S. Robert Teitelman, Roy T. Lefkoe, and
Sydney Ann Lefkoe in memory of S. Robert Teitelman

The main design on this jug is entitled "PLAN OF THE CITY OF WASHINGTON." According to Article 1 of the Constitution, the capital city of the new United States of America was required to be a federal district separate from the states. Although no location was named, as a condition of assuming the Revolutionary War debt, Congress determined that the site should be in the South. On July 16, 1790, the Residence Act provided for a permanent capital to be located on the Potomac River, the exact area to be selected by President Washington. On September 9, 1791, the "Federal City" was officially named Washington and French architect Pierre Charles L'Enfant, who had worked in New York City, was engaged as the designer. L'Enfant drew a plan that same year, but by February 1792 it was clear that his temperament was unsuited to working for a city commission. He tendered his resignation, which Washington accepted.[1] The plan was then handed to Andrew Ellicott for completion, and with few alterations it was ready within a month. It was engraved by Thackara and Vallance and first published in small format in Philadelphia in March 1792.[2] A similar engraving was published in Boston in May.[3] In November 1792 Thackara and Vallance produced the final folio version, *Plan of the City of Washington in the Territory of Columbia*, and it became the official city plan.[4] Copies were re-engraved and published in America, France, and England and widely distributed for the purpose of securing investment in the project.

The engraver of the design on this jug may have used any one of the many published source prints. He incorporated the L'Enfant/Ellicott plan within a larger image in which Britannia, with her shield on the ground, joins America, with her eagle symbol also on the ground, and together they examine the city map. Surprisingly, while America looks on, it is Britannia who points to the site of the proposed capitol building, where construction began in 1793 and the U.S. Congress met for the first time in November 1800. Also in the design, immediately beneath the map, are several sailing ships, perhaps signifying a desire for increased commerce between the two nations.

As if to emphasize the importance of the maritime trade, the reverse side of the jug carries a stock print of a three-masted ship flying the American flag, which bears sixteen stars and stripes.[5] Beneath the lip of the jug is a printed version of the Great Seal of the United States, whose many characteristics were used by Herculaneum Pottery and incorporated into one of their factory marks (see cat. no. 12).[6]

Creamware printed with the plan of the city of Washington was obviously designed for the American market, but is not commonly seen. It may have been introduced in the mid-1790s, when excitement over the new capital was still fresh.[7] It was possibly eclipsed by the demand for George Washington commemoratives after his death on December 14, 1799, shocked his nation into a prolonged period of mourning.

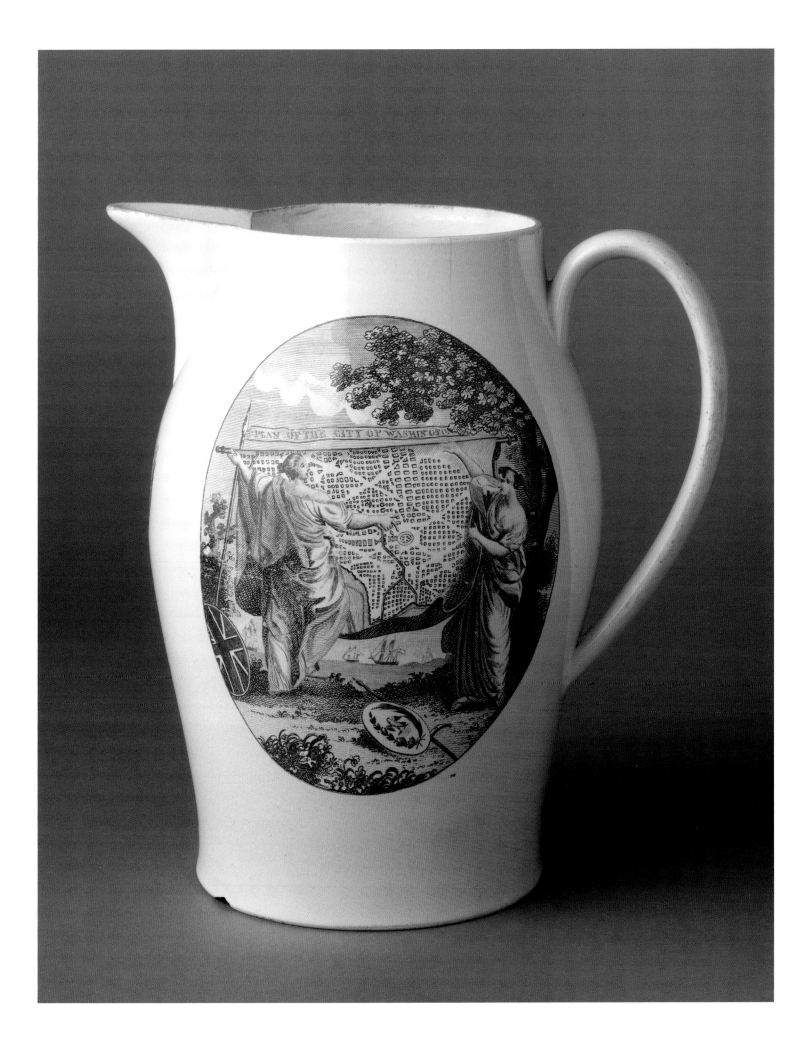

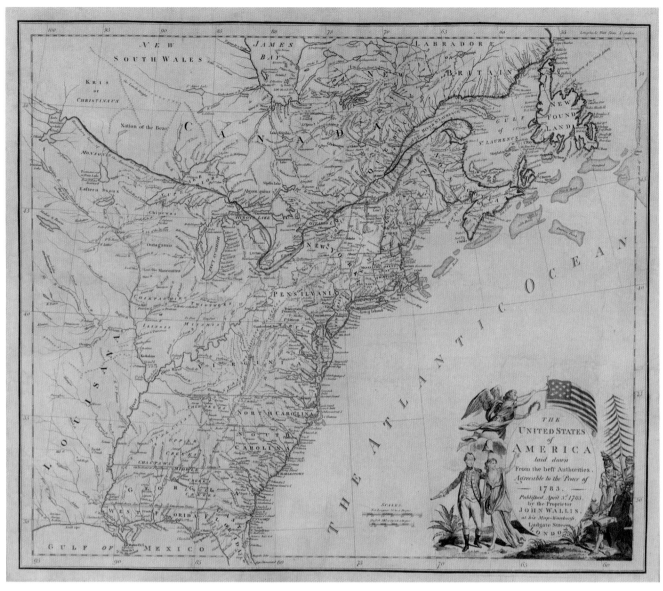

Map entitled *THE UNITED STATES of AMERICA laid down From the Best Authorities, Agreeable to the Peace of 1783*. Published April 3, 1783, by John Wallis, London. The cartouche in the lower right corner has become the frame for the map seen on the jug. 1968.517 Winterthur Museum, bequest of Henry Francis du Pont.

20. Jug

Staffordshire, England; 1800–1810
Creamware printed in black
Prints signed "F. Morris Shelton"
H. 8 in. (203 mm)
2009.23.6 Gift of S. Robert Teitelman, Roy T. Lefkoe, and Sydney Ann Lefkoe in memory of S. Robert Teitelman

Designs on both sides of this jug honor George Washington and were produced to appeal to American customers in the midst of their grief after his untimely death. One of the printed images is based on a large map of the United States published by John Wallis of London, the first edition dated April 3, 1783. Wallis's "Map-Warehouse" was in business from about 1780 to 1815, and other versions of his American map are known.

Printed in London shortly after the signing of the Paris Peace Treaty, this is one of the first published European images to recognize the new nation's independence and the first to incorporate the American flag, which is part of the iconography of the map's title cartouche.[1]

In this adaptation, the cartouche is enlarged and becomes the pictorial frame for a smaller map of the eastern seaboard of North America. To the left we see Washington with an allegorical female figure of Liberty; to the right, Benjamin Franklin, seated beneath a pine tree, writes in a book inscribed "4 July 1776," flanked by allegorical female figures of Justice and Wisdom. Above the whole, the traditional classical figure of Fame blows a trumpet and holds a victor's laurel wreath, trailing a ribbon inscribed "WASHINGTON." Unlike Wallis's original, the flag in this design is emblazoned with an American eagle

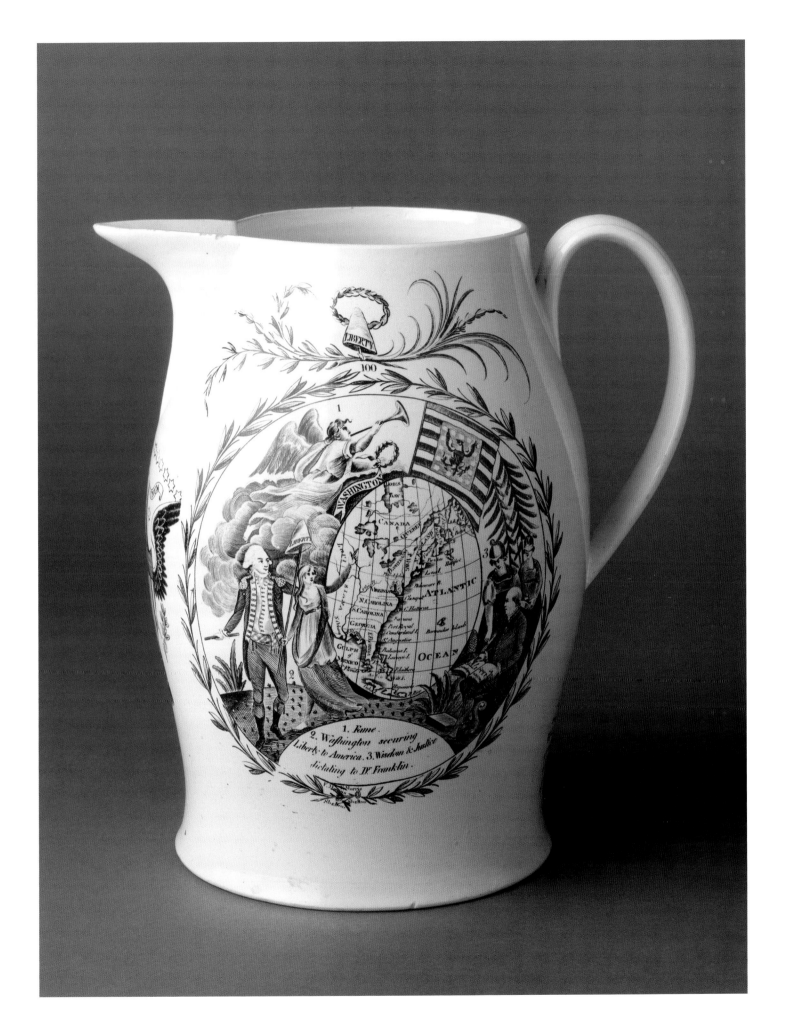

1. Fame.
2. Washington securing Liberty to America. 3. Wisdom & Justice dictating to Dr. Franklin.

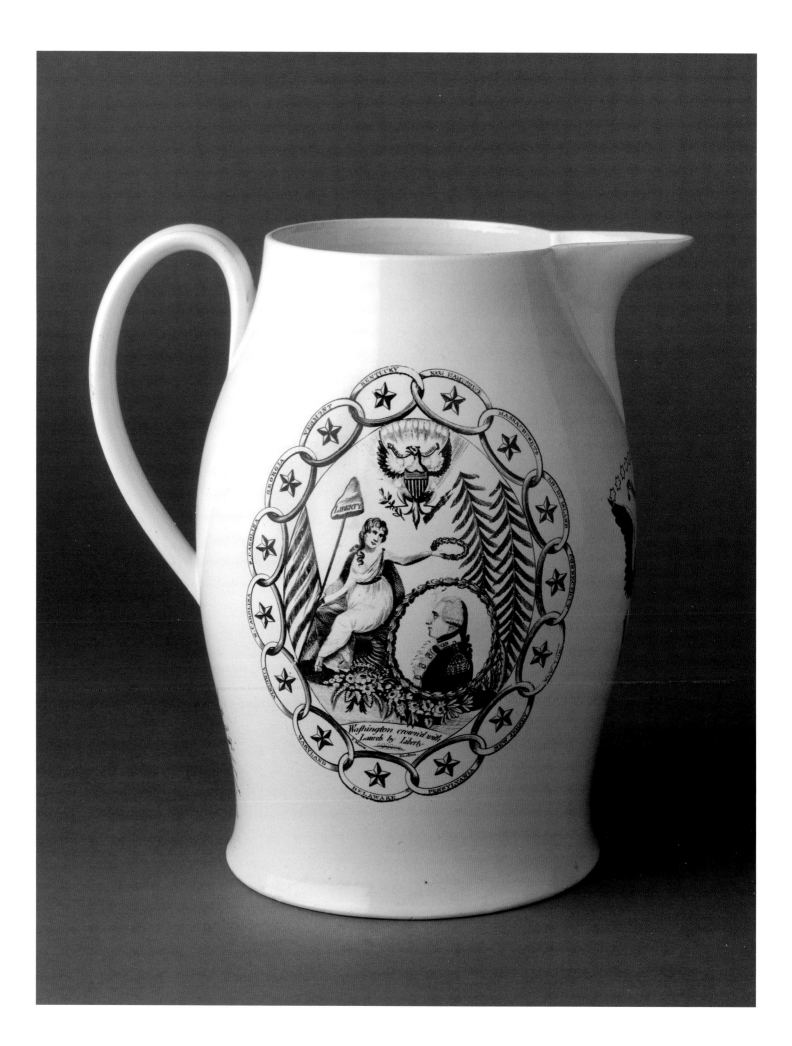

based on the Great Seal of the United States.[2] These scenes are marked 1, 2, and 3, and a key printed at the base of the print reads "1. Fame. 2. Washington securing Liberty to America. 3. Wisdom & Justice dictating to Dr. Franklin." Beneath the inscription within the laurel wreath frame is "F. Morris Shelton," printed twice.

Francis Morris was a pottery printer in Shelton and was responsible for a series of American patriotic prints that occur regularly in this collection.[3] Another of his commonly found prints can be seen on the reverse of this jug. Although neither of the images of Washington specifically mentions his death, there is no evidence that Morris was in business before 1800, which suggests these designs were produced to meet the demands of the mourning nation. The second Morris print on this jug has an oval frame based on the chain-of-states design and includes Kentucky, the fifteenth state to enter the Union, on June 1, 1792.[4] The central design is entitled "Washington crown'd with Laurels by Liberty" and depicts Liberty as a classical female carrying the liberty cap on her staff. She sits above a horn of plenty and to the side of an American flag. Liberty holds a crown of laurels above a laurel-framed profile portrait of Washington honoring him for his valor and lamenting his death. Above the whole scene hovers the eagle of the Great Seal of the United States. The small Washington portrait ultimately derives from an etching by George Wright published about 1780. Considered among the most influential of Washington portraits, it was copied by many American and British engravers.

Beneath the handle is a print of a compass rose with a banner inscribed "COME BOX THE COMPASS." Boxing the compass was a test of seamanship and involved naming all thirty-two principal points of the compass in clockwise order. This was a common and appropriate design to include on pottery intended primarily for maritime trade. Beneath the spout is a version of the Great Seal of the United States. The motto banner flying behind the bird's head, the fifteen open stars across the top, the shape of the wings, the flights on the base of the arrows, and the shading on the tail are characteristic of the work of Francis Morris. Although unsigned, examples of this print occur on pieces with his signed work and can appear with or without the addition of an inscription.[5]

This jug represents a standard Staffordshire product made in the middle of England, where there was little possibility of special commissions and personalized inscriptions. It was probably made for direct export to the United States rather than resale in Liverpool, where local potters and printers had the benefit of direct interaction with American merchants. It is probably typical of the English pottery that would have been widely available in America for the customer wanting a patriotic display for the home.

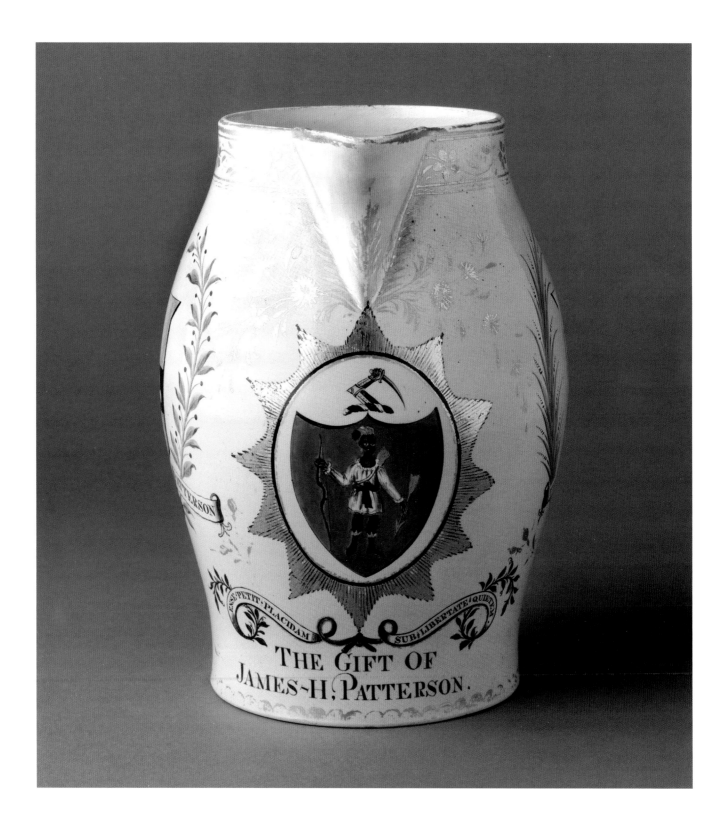

21. Jug

Staffordshire or Liverpool, probably painted in
Liverpool, England; 1790–1805
Creamware painted in enamels with gilding
H. 9¼ in. (234 mm)
2007.31.1 Gift of S. Robert Teitelman

Below the spout of this jug is a hand-painted version of the
Great Seal of the Commonwealth of Massachusetts. It
shows a Native American holding an arrow pointed down

as a sign of peace, with the motto "ENSE PETIT
PLACIDAM SUB LIBERTATE QUITEM," which
loosely translates as "By the sword we seek peace, but peace
only under liberty." The seal was first granted to the
Massachusetts Bay Colony by Charles I of England in 1629
and remained in use for most of the seventeenth century.
It was revived in 1780, when the newly established state
legislature appointed a commission "to consider and
determine upon a Seal for this Commonwealth."[1] The seal
on this jug is similar to a version illustrated in *The*

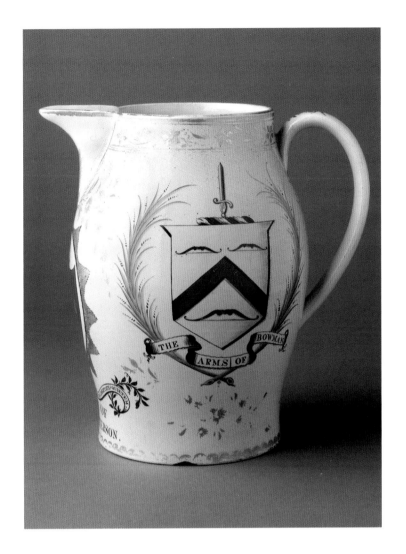

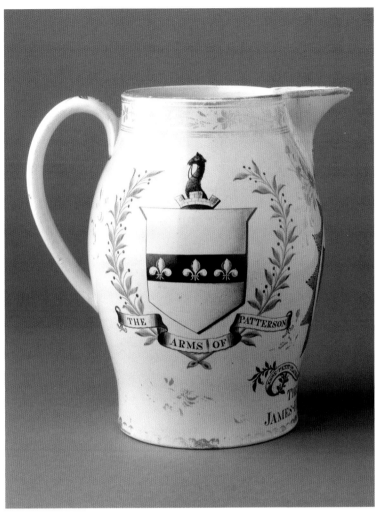

Columbian Magazine for October 1787, suggesting that it may have been the source for the painted arms.

The coats of arms of two prominent Maine families decorate the sides of the jug and are identified by banners "THE ARMS OF BOWMAN" and "THE ARMS OF PATTERSON." Beneath the arms of Massachusetts is the dedicatory inscription "THE GIFT OF JAMES H. PATTERSON." James Patterson was a sea captain, and Jonathan Bowman was a nephew of John Hancock. Through his family connections, Bowman became a justice of the peace and probate judge in Pownalborough, Maine.[2] He built an impressive Georgian house on the Kennebec River in Dresden, Maine, which was a testament to his wealth and status in the community.[3] Both Patterson and Bowman were members of the Dresden Congregational Church.[4] It is not known why Patterson presented the jugs to Bowman, though the inclusion of the coats of arms of both families suggests there was some sort of link, such as marriage. Whatever connection existed is reinforced

by the fact that a Margaret Patterson, widow, conveyed a parcel of land to Jonathan Bowman Jr. in 1802.[5]

There are a number of "Captain" Pattersons recorded as sailing between the United States and Europe, but it has not been possible to document voyages made by James Patterson to Liverpool. He may have commissioned this jug and its mate (see Appendix II.38) while on a voyage to England, or he may have acquired them through his relative Samuel Patterson, who was master of the brig *Jane*, which was taken by a privateer on October 27, 1798, en route from Liverpool to Norfolk, Virginia.[6] The two jugs are recorded in an early twentieth-century newspaper article, "Colonial Home Rich in Antiques," which notes that they "were owned by her great grandfather Jonathan Bowman, and were used at a banquet at the old court house at Pownalborough when Benedict Arnold and Aaron Burr were feasted there."[7] The jug seen here has been praised as "without a doubt the finest Liverpool jug I have ever heard of, and I know of nothing comparable in Chinese export porcelain."[8]

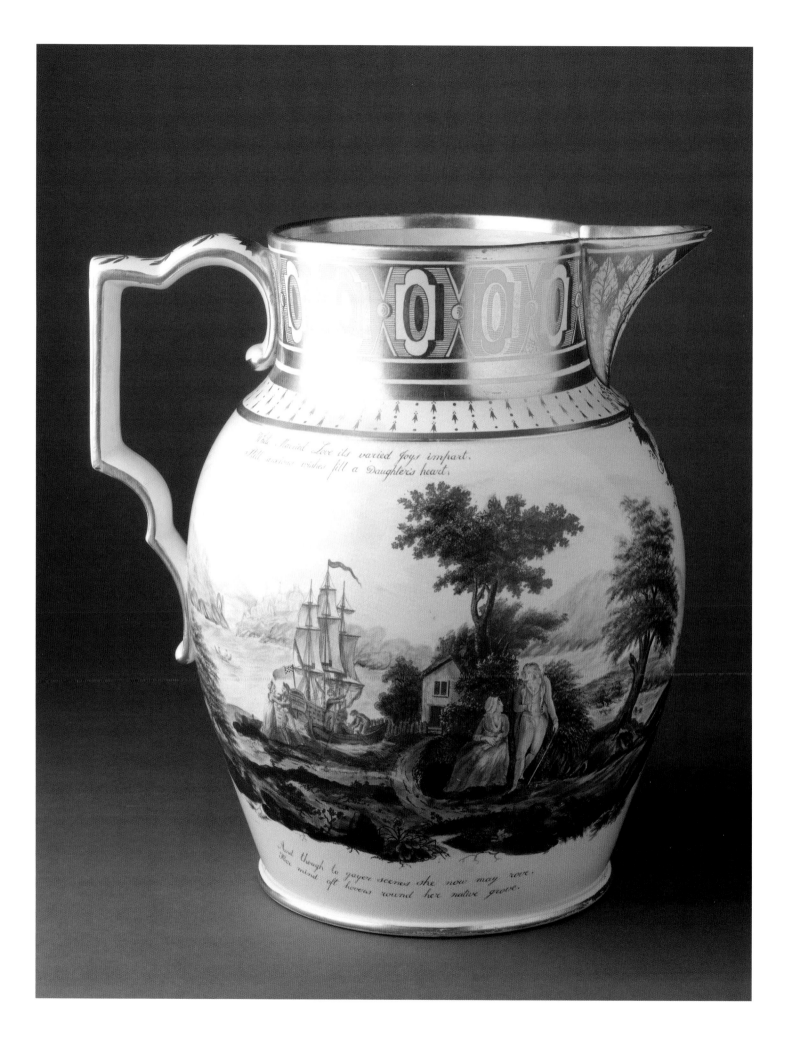

22. Jug

Cambrian Pottery
Swansea, Wales; ca. 1804
Pearlware painted in enamels with gilding
H. 12 in. (305 mm)
2009.21.19 Gift of S. Robert Teitelman

This most unusual jug is one of two known examples related to the Barrell and Wood families of Maine.[1] Both pieces are outstanding examples of the potter's art. Made at Cambrian Pottery, Swansea, Wales, the jugs are completely hand painted in enamel colors with exquisite gilding at the neck and lip. The scenes and inscriptions on either side memorialize the lives and times of the Nathaniel Barrell family of Barrell Grove, York, Maine, in whose possession the jugs descended until the late 1990s. The decoration has been attributed to the hand of William Weston Young, an artist at the Cambrian Pottery between 1803 and 1806.[2] That the jugs were made about 1804 is indicated in correspondence from Sally Barrell Wood to her father, Nathaniel, noting that her stepson's

ship "is now in Charleston and my pitchers upon them."[3]

Sally Sayward Barrell was the eldest child of Nathaniel and Sarah Sayward Barrell. After the untimely death of her first husband, Richard Keating, Sally lived alone with her three children, helped by her family. In an effort to defray some of her expenses, she decided to publish her writings and earn money of her own. Her first novel debuted in 1800. When other novels and poetry followed, she declined to use her name, publishing under a pseudonym. On October 28, 1804, she married Abiel Wood of Wiscasset, Maine, and is therefore usually referred to as Madame Wood when her writings are discussed.

It seems reasonable to conclude that the verses on the jug are her words. On one side, these rhyming couplets appear above and below a painted scene:

While Married Love its varied Joys impart,
Still anxious wishes fill a Daughter's heart
And though to gayer scenes she now may rove,
Her mind oft hovers round her native grove.

The jugs must have been ordered before her marriage, and she was obviously thinking of her family relationships and home, Barrell Grove – *her native grove*. To one side in the foreground we see a couple beneath a tree; the woman is seated with what appears to be a scroll of paper in her hand. She and the man gaze at each other, seemingly content. A path leads back to a house in the trees behind them, and to the left a ship at anchor flies an American flag. A small rowboat brings a sailor ashore to be greeted by a young woman. Across the water are distant headlands and a town. One can imagine many scenarios in a young woman's life that these scenes might represent.[4] On the opposite side of the jug the rhyming couplets read:

> *Here Books and Work employ each moments time,*
> *Unconscious both of Folly or of crime*
> *The Wise directions of Parental Love,*
> *Root out each Vice, and every worth improve.*

The image that is painted between the poetry perhaps shows Sally as a young, single woman at Barrell Grove. With her four younger sisters behind the protective arm of their mother, Sally and the second eldest daughter, Ruth, seem poised to read or pick up books from the ground. Nearby, their father instructs the three Barrell brothers; the agricultural implements in the foreground represent Nathaniel Barrell's change of career from merchant to progressive farmer.

As S. Robert Teitelman wrote in a major article on the Barrell-Wood jugs, "They are more than great examples of Anglo-American historical pottery. They are time capsules that tell us of the lives of women a century before women had the vote, and they speak of uncertainties of our Colonial and early Federal Years. Most of all they illuminate the life of a remarkable human being whose life spanned the whole century during which the United States was trying to invent itself. . . . Along with their other sterling qualities, they are unique historical documents that help us to explain our past. In that, their greatness lies."[5]

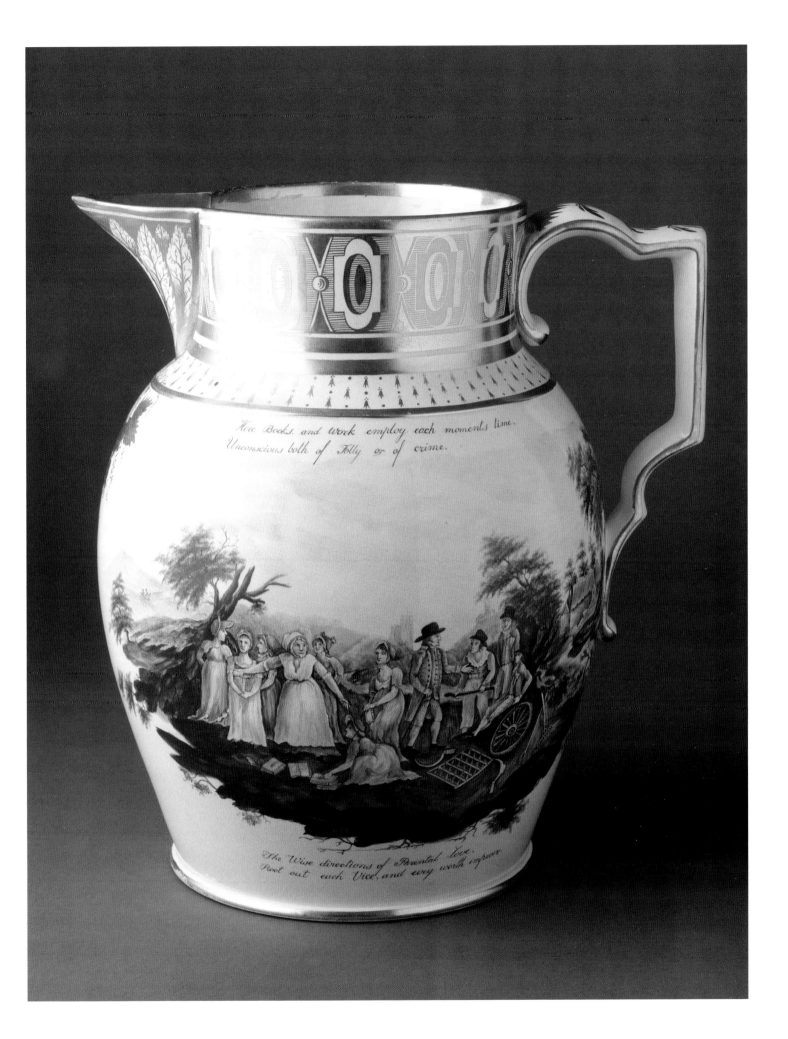

Here Books, and work employ each moments time.
Unconscious both of Folly or of crime.

The Wise directions of Parental love.
Root out each Vice, and every worth improve.

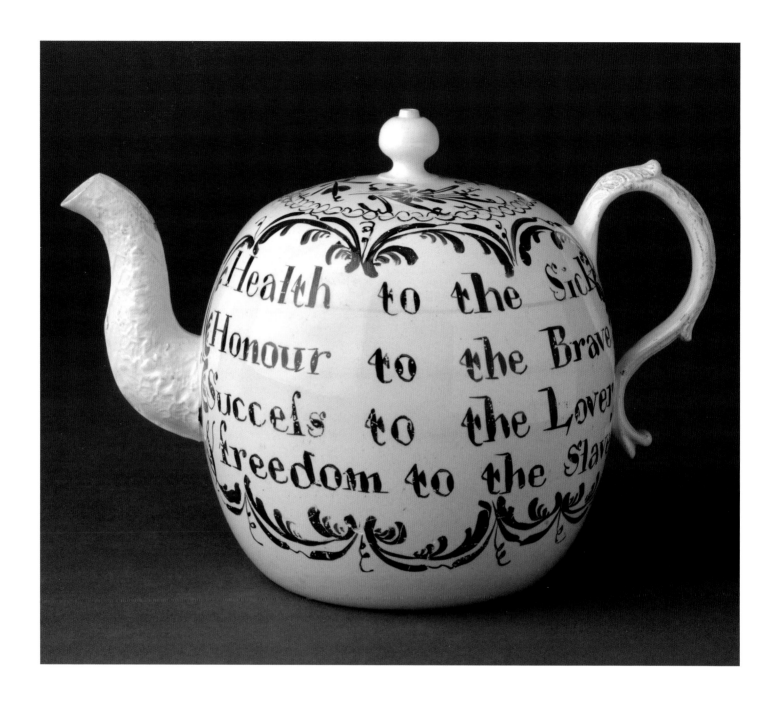

23. Teapot
Probably Staffordshire, England; ca. 1775
Creamware painted in enamels
Diam. 4⅞ in. (124 mm), H. 5⅛ in. (130 mm)
2009.21.15 Gift of S. Robert Teitelman

This teapot, with its short poem, or toast, calling for "Freedom to the Slave," is one of the earliest ceramics known to be decorated with an antislavery message. The lines appeared in *The Review*, by English poet Richard

Duke, which was first published in 1717.[1] Variations were used as a toast by the late eighteenth century, and they continued to be heard throughout the nineteenth, even in the American South, where abolitionists noted with some surprise that the toast was offered by slaveholders on July 4.[2]

Abolitionists skillfully employed objects decorated with images and words to raise awareness of their cause. One early antislavery image, a plan of a slave ship, was often hung in Quaker homes with the purpose of "exciting the attention of those who should come into

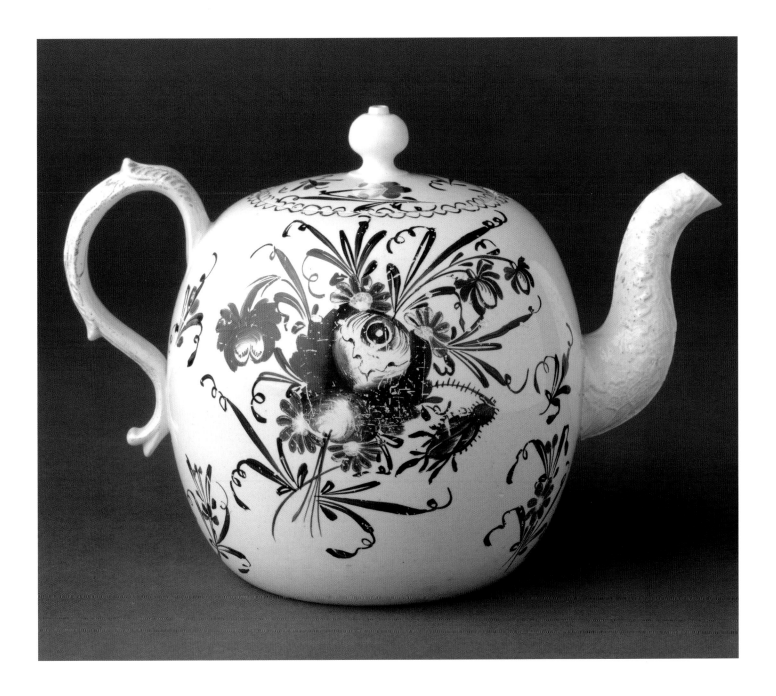

their houses to the case of the injured Africans, and of procuring sympathy in their favour."[3] The tea table, around which people gathered for companionship and conversation, was seen as an appropriate place to voice antislavery sentiments. An early antislavery poem by William Cowper, written in 1788, was even titled "The Negro's Complaint: A Subject for Conversation and Reflection at the Tea Table."[4] The fact that the poem appears on a teapot, which was seen as belonging to the domain of women, also reflects the prominent role that women had in the antislavery movement.

This short poem appears on a number of pieces of English earthenware and porcelain made between about 1775 and 1860, suggesting the growing number of abolitionists who used objects to promote their cause.[5] The words are framed in a red and black enameled cartouche, and the reverse of the pot is decorated with a large enameled floral spray. Though these characteristics are often attributed to Yorkshire, they are in fact common to potteries throughout England in the 1770s and 1780s.

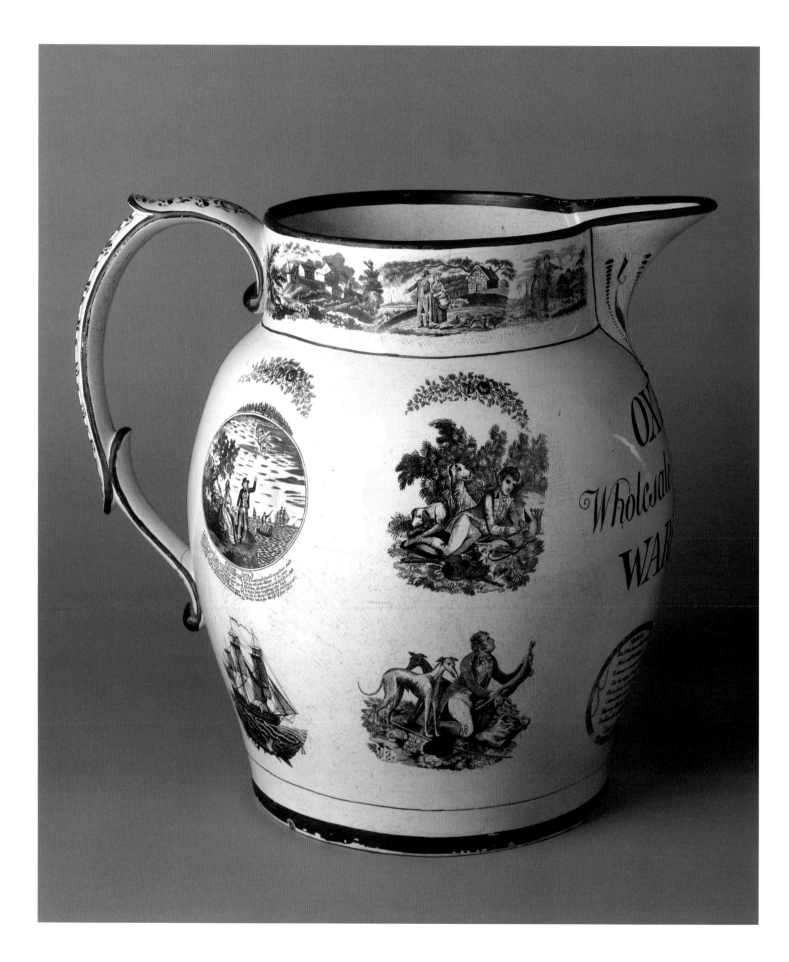

24. Jug
Attributed to Christopher Whitehead
Shelton, Staffordshire, England; 1817–19
Pearlware printed in black
Impressed "W(★★★)" and WS
H. 17½ in. (444 mm)
2007.31.8 Gift of S. Robert Teitelman

This large jug is decorated with a wide variety of transfer-printed images and an advertisement, "OXFORD Wholesale & Retail WAREHOUSE." Among the eleven images on the jug are three dedicated to antislavery sentiments, reflecting the role that objects played in what was one of the most active and controversial social justice movements in the nineteenth century.

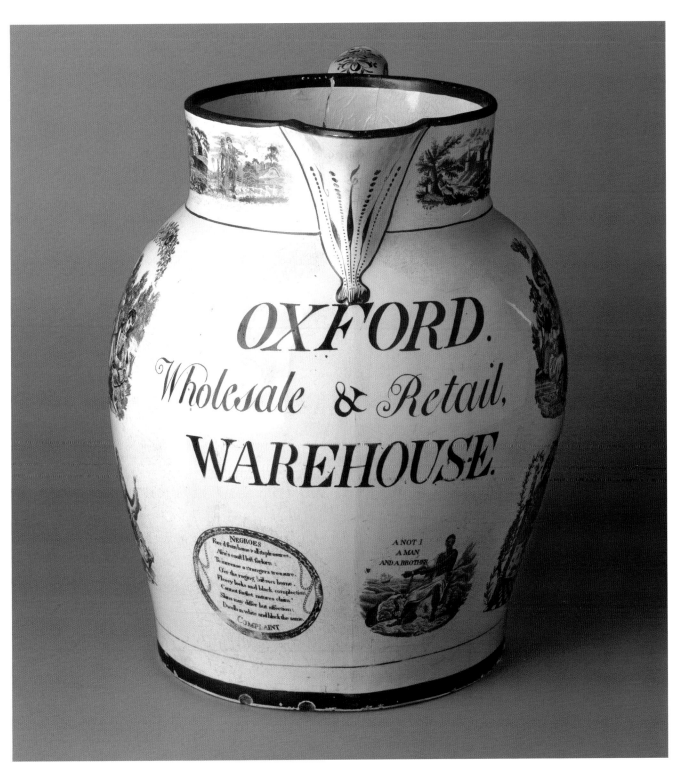

The first print is a variation of the earliest and most famous antislavery image created—an African in chains with the motto "A[M] NOT I A MAN AND A BROTHER." Described as "an African in Chains in a Supplicating Posture with this Motto 'Am I not a Man and a Brother?'" the image was developed in 1787 by the British Committee for the Abolition of the Slave Trade and was used on their promotional literature. It was quickly copied by others, most notably Josiah Wedgwood, who featured the design on jasperware cameos that were made to be distributed by the committee.[1] The image is based on a drawing by Richard Westall that was engraved by John Romney to illustrate part 2 of William Cowper's *Minor Poems*, published in 1817. It included "The Negro's Complaint," written in 1788, which was one of the earliest and most influential antislavery poems.[2]

The second antislavery print on this jug is an oval medallion containing several stanzas from "The Negro's Complaint." The third print, "BRITANNIA PROTECTING THE AFRICANS," shows newly freed enslaved Africans kneeling before Britannia with a slave ship in the background. The image almost certainly celebrates Britain's outlawing of the slave trade, an act passed by Parliament in 1807. Large jugs like this were created primarily for advertising purposes and were probably displayed in shops or shop windows where their size was meant to catch customers' eyes.[3] It is also possible that this particular jug was intended for a specialist ceramic merchant, who might have used its myriad prints as a catalogue of available images for consumers to select to decorate their own ceramic purchases.

At least three other large jugs are known with the enigmatic "W(★★★)" mark that has been attributed to Christopher Whitehead.[4] Unfortunately, it is not known if the Oxford Wholesale and Retail Warehouse was located in England or America. It is also not known if the antislavery images reflected the political beliefs of the maker or the merchant who would have displayed the jug. However, their inclusion does suggest that the antislavery message was becoming more widely supported and less controversial and that there was a growing market for objects with such a sentiment.[5]

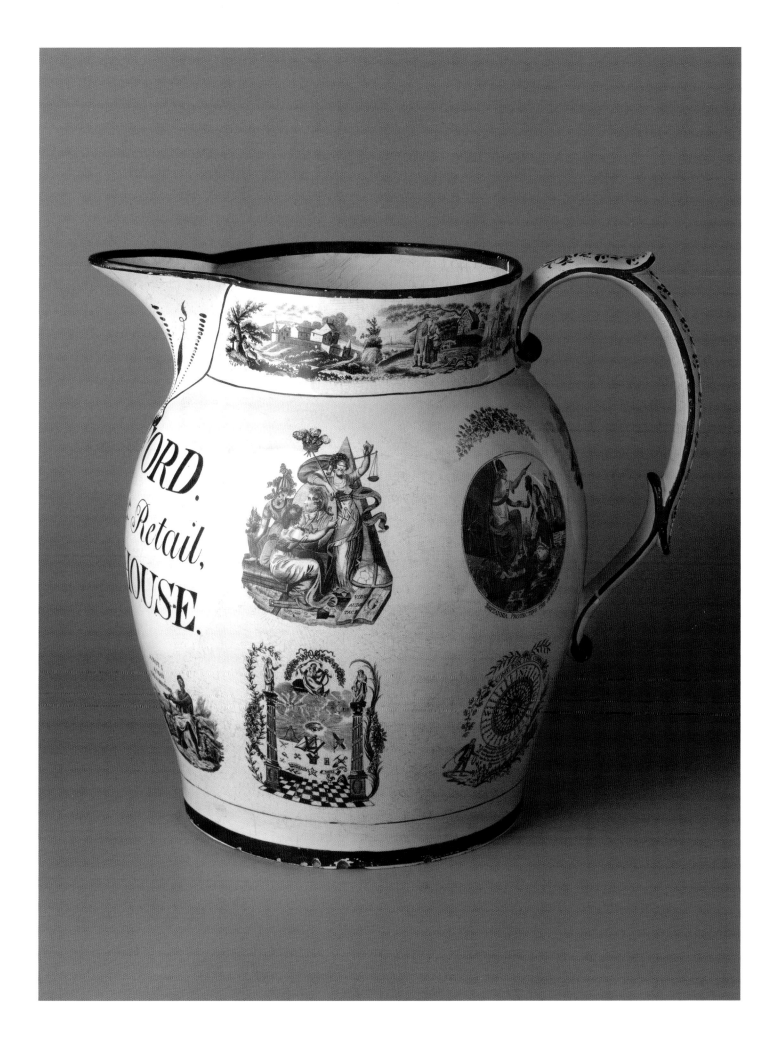

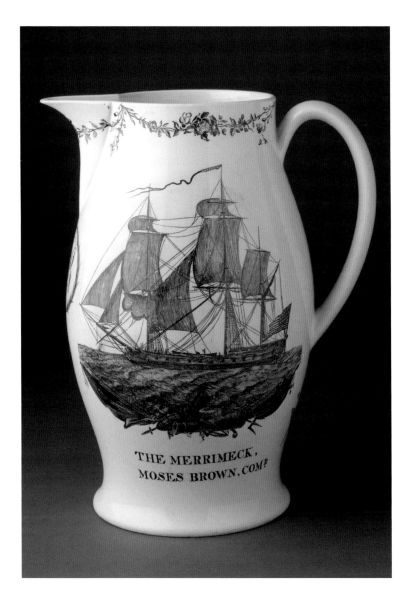

25. Jug
Possibly Herculaneum Pottery
Liverpool, England; 1799–1800
Creamware printed in black and painted in enamels
H. 11⅝ in. (295 mm)
2009.23.14 Gift of S. Robert Teitelman, Roy T. Lefkoe, and
Sydney Ann Lefkoe in memory of S. Robert Teitelman

This jug commemorates the *Merrimack* (misspelled
Merrimeck), one of the subscription ships built to
defend the United States shipping during the Quasi-
War with France. In the spring of 1798 America was on
the verge of war with France, which was seizing neutral
American ships in an attempt to disrupt the trade of
their rival, Great Britain during the Napoleonic Wars.
With a navy of only a few ships, the young United States

was nearly powerless to protect itself. The merchants of
Newburyport, Massachusetts, having already lost dozens
of ships to the French, met on May 29, 1798, and
decided to build a warship and lend it to the U.S. Navy.[1]

Motivated by patriotism and enlightened self-
interest, the citizens of Newburyport quickly raised
$41,158 and pledged to complete the ship in ninety
days. They also challenged their fellow Americans to
follow their example. In a short article in the Boston
Columbian Centinel they announced that "the patriotic
citizens of this town, determined to show their
attachment to their own government, and to vindicate
its commercial rights, have opened a subscription for the
purpose of building a 20 gun ship; and loaning her to
government . . . An example this, worthy of prompt
imitation."[2] The notice was reprinted throughout the

country, and eight other cities rose to the challenge, building ten subscription ships for the navy.[3]

Named after the river on which Newburyport stands, the *Merrimack* was designed by naval architect William Hackett and built by William Cross and Thomas Clark. Her keel was laid on July 9, 1798, and she was launched just ninety-six days later, on October 12. Described as "an elegant specimen of American ingenuity," she was a 90-foot long, 460-ton frigate that carried 20 nine-pound and 8 six-pound cannons.[4]

The *Merrimack* entered service in December 1798 with Moses Brown, a local sea captain and Revolutionary War veteran, as commander. She was sent to the Caribbean with instructions to "intercept the Armed Vessels of the Enemy, & to give most protection to our own commercial vessels."[5] The ship was involved with the capture of several French privateers and successfully escorted convoys of American ships back to New England. After the war ended in 1800, she was sold as part of an effort to reduce the size and cost of the navy. Refitted as a merchant ship and renamed *Monticello*, she was wrecked off Cape Cod soon thereafter.[6]

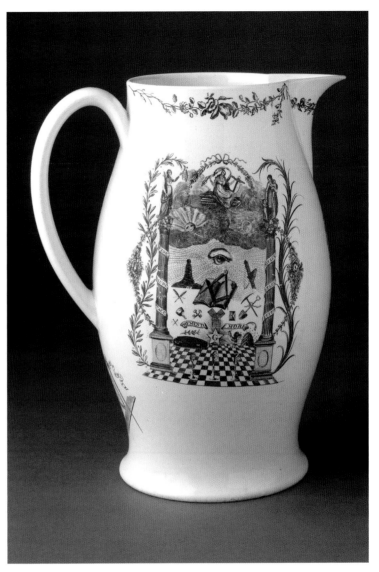

The frigate on the jug is a stock print that has been personalized with the hand-painted inscription "THE MERRIMECK, MOSES BROWN, COM[R]." The initials "PB" painted under the spout are almost certainly those of the original owner of the jug, who was most likely a member of the crew or a resident of Newburyport. The person was presumably connected to the Freemasons, as Masonic emblems appear on the reverse of the jug and under the handle (see cat. no. 65). This jug was possibly made at the Herculaneum Pottery; the print of the Great Seal of the United States that appears below the spout is also found on another jug with the inscription "HERCULANEUM POTTERY" (see cat. no. 12).

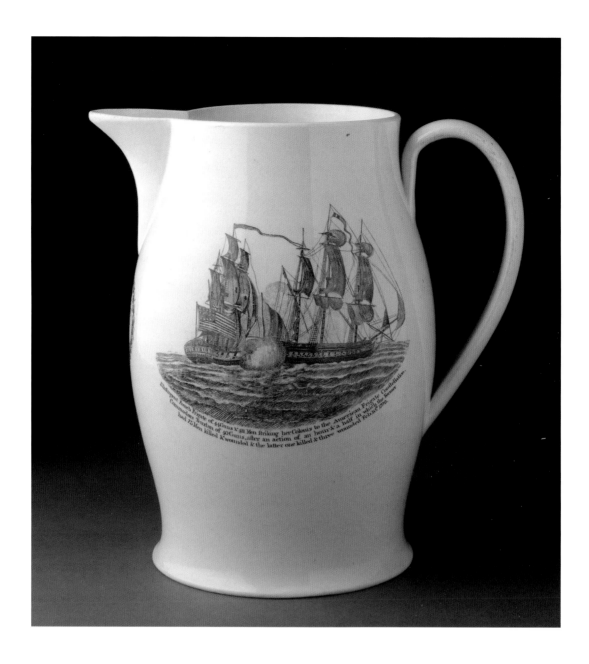

26. Jug
Possibly Herculaneum Pottery
Liverpool, England; 1799–1810
Creamware printed in black
H. 9¹³⁄₁₆ in. (250 mm)
2009.23.12 Gift of S. Robert Teitelman, Roy T. Lefkoe, and
Sydney Ann Lefkoe in memory of S. Robert Teitelman

A print depicting the first major naval victory of the
United States—that of the *Constellation* over the
L'Insurgente—decorates the side of this jug. Launched in
Baltimore in 1797, the *Constellation* was one of the
original six frigates commissioned for the new U.S.
Navy. She was immediately placed in service in the
Quasi-War with France (1798–1800), an undeclared
naval war that resulted from French harassment and
seizure of neutral American ships during the
Napoleonic Wars between England and France.

On February 9, 1799, the *Constellation* under the

command of Commodore Thomas Truxton encountered
the French frigate *L'Insurgente* off the coast of the Caribbean
island of Nevis. Reputed to be the fastest ship in the French
navy, *L'Insurgente*, which had been cruising the Caribbean
harassing American ships, tried to outrun the *Constellation*
but failed. The lengthy inscription beneath the print of the
battle describes the moment of victory: "L'Insurgent French
Frigate of 44 guns and 411 men, striking her colors to the
American Frigate Constellation, Commodore Truxton, of
40 guns, after an action of an hour & a half in which the
former had 75 men killed & wounded & the latter one
killed and three wounded, Feb. 10th, 1799."

When news of the victory reached the United States,
Americans celebrated. Truxton and his crew were feted
with parades, dinners, and balls, and the battle was
commemorated in poems, songs, and prints. At least two
versions of the battle were depicted on transfer-printed
jugs.[1] In Boston the crowd cheered "Capt. Truxton, the
officers and crew of the Constellation, and success to the

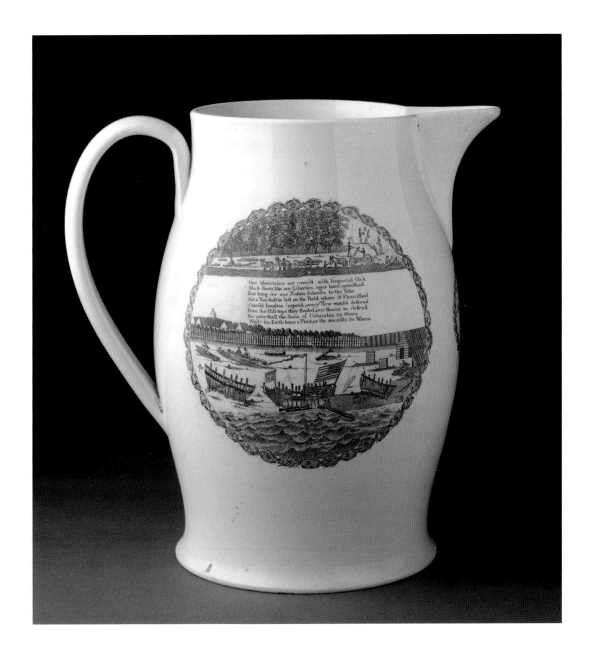

Wooden Walls of America."[2] The "wooden walls" were the vessels of America's new navy. They were also celebrated in the slogan "SUCCESS TO THE INFANT NAVY OF AMERICA," which appears under the spout of this jug with a version of the Great Seal of the United States.[3]

The "wooden walls" are also praised in the printed image of a shipyard and a poem on the reverse of the jug, which claims that "Should Invasion impend, every Tree would descend From the Hill tops they shaded, our shores to defend For ne'er shall the Sons of Columbia be Slaves While the Earth bears a Plant, or the Sea rolls its Waves." It celebrates America's shipbuilding industry, which was seen as a crucial part of the new nation's defense. The words are taken from the song *Adams and Liberty*, which was written by Robert Treat Paine in 1798 for the fourth anniversary of the founding of the Massachusetts Charitable Fire Society. It was sung to the tune of the English drinking song *To Anacreon in Heaven*, which was also the tune chosen for *The Star-Spangled Banner*.[4]

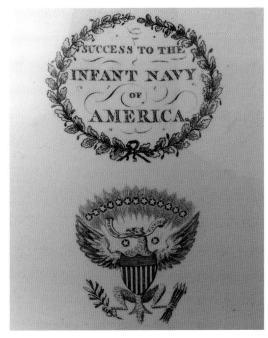

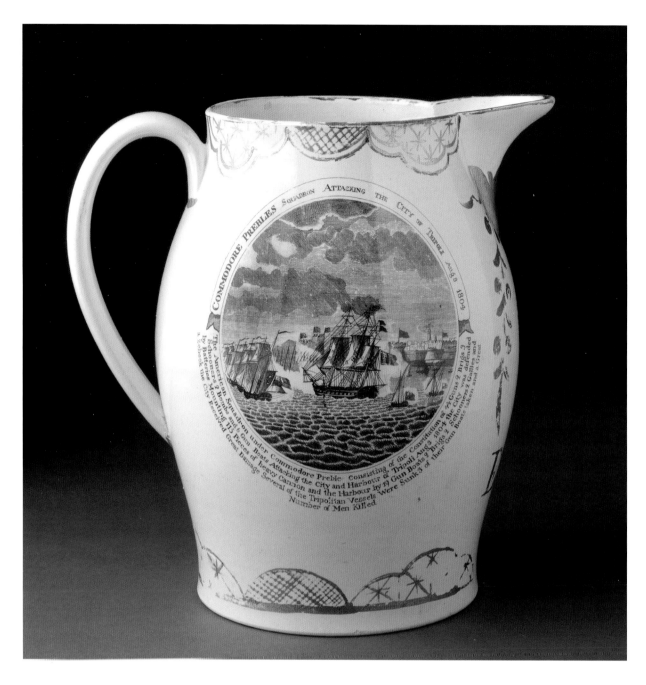

27. Jug

Probably Herculaneum Pottery
Liverpool, England; 1805–7
Creamware printed in black with gilding
H. 9 in. (229 mm)
1958.1191 Bequest of Henry Francis du Pont

This jug celebrates one of the more famous battles of the Tripolitan War (1801–5), when a squadron under the command of Edward Preble shelled the city of Tripoli. In the late eighteenth century, pirates from the Barbary states of Algeria, Tunis, and Tripoli on the northern coast of Africa preyed on American shipping, seizing vessels and enslaving their crews or holding them for ransom.[1] The United States attempted to protect their trade by paying tribute, but as attacks continued and demands increased, Americans turned to a military solution. In the words of

the American consul to Tunis, "If the United States will have a free commerce in this sea, they must defend it."[2]

In 1801, following a declaration of war by the pasha of Tripoli, an American naval squadron blockaded the port. The first years of the blockade were ineffective and even resulted in the capture of the American frigate *Philadelphia* and the imprisonment of her crew. In an attempt to force the Tripolitans to the bargaining table, Captain Preble decided to fire on the city itself. On August 3, 1804, using his own squadron and ships borrowed from the king of Two Sicilies, he attacked both the Tripolitan fleet and her shore defenses, capturing or destroying many vessels and damaging the city and its fortifications.

The view on the jug shows Preble's flagship, the *Constitution*, and other vessels firing on the Tripolitan fleet and city. Above the medallion is a ribbon inscribed "COMMODORE PREBLES SQUADRON

ATTACKING THE CITY OF TRIPOLI Aug 3 1804." Below the medallion is the inscription "The American Squadron under Commodore Preble Consisting of the Constitution of 44 Guns 2 Brigs 3/ Schooners 2 Bombs and 6 Gun Boats Attacking the City and Harbour of Tripoli Aug 3 1804 the City was defended/ by Batteries Mounting 115 Pieces of heavy Cannon and the Harbour by 19 Gun Boats 2 brigs 2 Schooners 2 Gallies and/ a Zebeck the City Received Great Damage Several of the Tripolitan Vessels were Sunk 3 of their Gun Boats taken and a Great/ Number of Men Killed." While the source of the image is unknown, it may be from a contemporary painting of the battle by Michele Felice Cornè.[3] Although this and subsequent attacks did not completely subdue the Tripolitans, it did lay the groundwork for eventual American victory. It also helped restore American confidence after years of losses at the hands of the Barbary pirates.

On the reverse of the jug is a portrait of Commodore Preble (1761–1807). He served in the Revolutionary War and the Quasi-War with France. In 1803 he was placed in command of the U.S. squadron in the Mediterranean. Over the next two years he severely weakened the Barbary pirates' ability to threaten U.S. shipping by forcing Morocco to reaffirm a favorable treaty with the United States; by organizing the destruction of the U.S. frigate *Philadelphia*, which had been captured by the Tripolitans; and by attacking Tripoli itself. Preble returned to America in late 1804 and remained in the navy until his death in 1807. He was noted for his diligence, courage, and temper, and he had a profound influence on the new U.S. Navy, helping train young officers who later served with distinction during the War of 1812.[4] Preble himself owned a jug similar to this one, with the battle scene on one side, the Preble coat of arms on the other, and his name painted under the spout.[5]

The portrait of Preble is signed "D" for Thomas Dixon, an engraver known to have worked for the Herculaneum Pottery (see cat. no. 1). It is probably copied from an engraving by Samuel Harris after a portrait by Rembrandt Peale. The cartouche surrounding the portrait is probably taken from a map cartouche.[6] Beneath the spout is an adaptation of the Great Seal of the United States that has been attributed to the Herculaneum Pottery (see cat. no. 12) and the painted inscription "Elizabeth Davis." Although her identity is unknown, she may have been related to John Davis, a midshipman on the *Constitution* who was part of the group who daringly crept aboard the captured *Philadelphia* and destroyed her.[7]

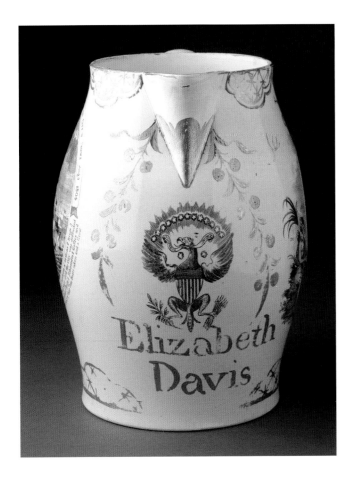

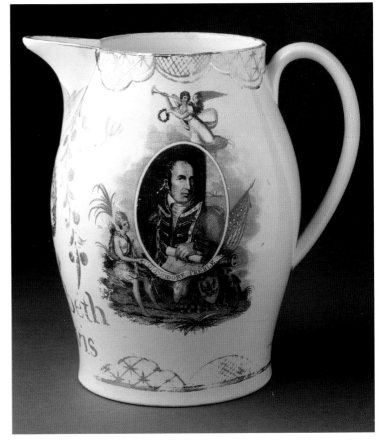

28. Jug

Staffordshire, England; 1816–20
Creamware printed in black and banded in luster
H. 7³⁄₁₆ in. (182 mm)
1968.76 Gift of Mr. B. Thatcher Feustman

A print of the first naval episode of the War of 1812, the escape of the U.S. frigate *Constitution* from a British squadron, decorates the front of this bulbous jug with pink luster bands. On the night of July 16, 1812, off the coast of New York, the *Constitution,* under the command of Captain Isaac Hull, encountered a squadron of British vessels. Hopelessly outnumbered, the *Constitution* had no choice but to run. By the morning of July 17, the wind had failed and all of the vessels were becalmed.

Captain Hull ordered the longboats launched, and rowers began to tow the 175-foot, 1,500-ton vessel through the still waters. The British did the same, thus commencing a slow-motion chase. Hull used a number of creative moves to increase his distance, including dumping fresh water overboard to lighten the ship and dampening the sails to help them catch the breeze. He also followed the suggestion of Lieutenant Morris to kedge the ship, which involved taking the anchor out in a longboat far ahead, dropping it, and winching the ship up to a position over the anchor. This continued into the following day, when a slight breeze finally allowed the *Constitution* to widen its lead. On July 19, after a harrowing sixty-hour chase, the *Constitution* finally sailed out of sight of the British. This print, "Constitution's Escape from the British Squadron after a Chase of Sixty Hours," depicts the moment of escape and includes the five British vessels: the *Africa, Shannon, Eolus, Guerrière,* and *Belvidera,* each of which is identified by the key beneath the image.

The *Constitution* arrived in Boston on July 26, and Hull and his crew were given a hero's welcome. He was even lauded by the British. It was reported that "all of the officers of the British squadrons applauded the conduct of Capt. Hull; and though mortified at losing so fine a ship, gave him much credit for his skill and prudence in managing the frigate."[1] After this somewhat dubious victory, the *Constitution* went on to win several important battles during the War of 1812, including the defeat of the *Guerrière,* which earned her the nickname "Old Ironsides." She became the most famous vessel in the U.S. Navy and was the most widely pictured on English ceramics for the American market. At least nine different transfer-printed designs are known depicting her numerous victories (see cat. no. 29).[2]

On the reverse of the jug is a view of the naval battle between Lieutenant Thomas MacDonough's fleet and a superior British force that occurred on Lake Champlain on September 11, 1814. The American victory forced the British to retreat into Canada and denied them any claims for control of the Great Lakes during the negotiations that ended the War of 1812. Both images are based on illustrations from *The Naval Monument,* published in Boston by Abel Bowen in 1816. They were drawn by M. Cornè and engraved by W. Hoagland.[3] Though published in Boston, the book and its illustrations were probably available in England soon after release, either taken by individual travelers or imported by booksellers such as T. Banning of Liverpool, who earlier advertised that "foreign newspapers and periodicals may be procured from Abroad."[4] Both images on the jug are signed "Bentley Wear & Bourne Engravers & Printers, Shelton, Staffordshire." This partnership of engravers and printers was active from about 1815 until at least 1820 and was located on Vine Street in Shelton, Staffordshire. They supplied copper plates to a number of Staffordshire factories, including C. J. Mason & Co., and were responsible for a series of War of 1812 scenes, all based on illustrations from *The Naval Monument,* of which they clearly had a copy.[5]

Opposite below: *The Constitution's Escape from the British Squadron after a Chase of Sixty Hours.* Drawn by M. Cornè, engraved by W. Hoagland. From *The Naval Monument* (Boston: Abel Bowen, 1816), opp. p. 1. Printed Book and Periodical Collection, Winterthur Library.

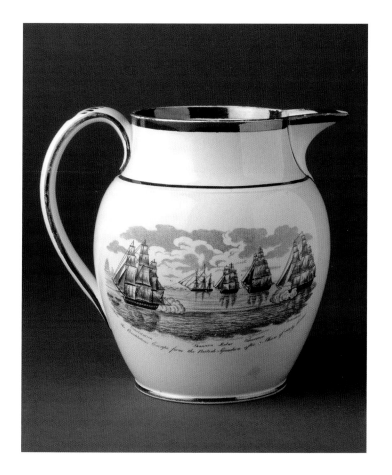

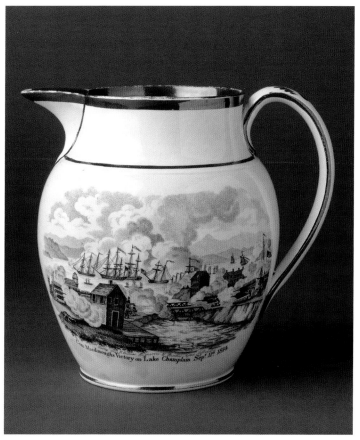

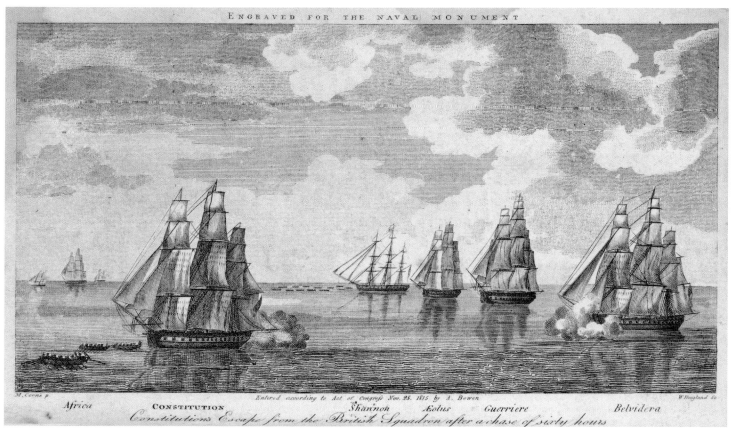

ENGRAVED FOR THE NAVAL MONUMENT

M. Corne p. *W Hoogland Sc*

Africa **CONSTITUTION** Shannon Aolus Guerriere Belvidera

Constitutions Escape from the British Squadron after a chase of sixty hours

29. Jug

Staffordshire, England; 1816–20
Creamware printed in black and banded in luster
H. 7 in. (190 mm)
1968.78 Bequest of Mr. B. Thatcher Feustman

On one side of this jug decorated with pink luster bands is a print depicting the first naval victory of the War of 1812, the battle between the U.S. frigate *Constitution* and the British frigate *Guerrière*, which took place in the North Atlantic on August 19, 1812.[1]

The image, "The CONSTITUTION in close action with the GUERRIERE," shows the moment in battle when the *Guerrière's* mizzenmast went "by the board [collapsed and fell overboard]." According to one of the officers, "When the *Guerrière's* mizzen mast was shot away, Captain H. [Isaac Hull] in the enthusiasm of the moment, swung his hat round his head, and, in true sailor's phrase, exclaimed, 'Huzza! My boys! We have made a brig of her.'"[2] Within minutes the vessel was completely immobilized, and she eventually surrendered. During the attack, when one of the *Guerrière's* cannonballs bounced off the thick oak hull of the *Constitution*, a sailor cried out "Huzza! Her sides are made of iron!" leading to the ship's nickname, "Old Ironsides."[3] The victory was described by one of Hull's

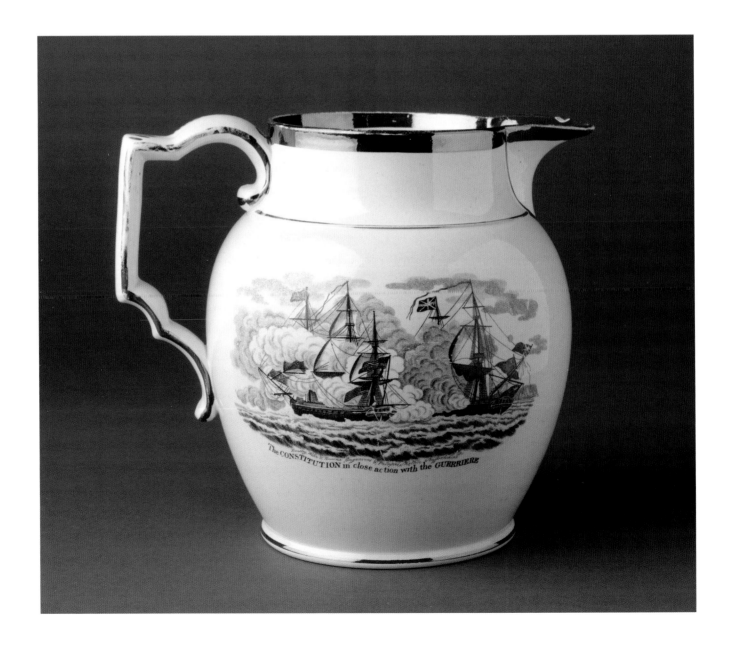

biographers as "one of the most important events that has occurred in the history of this country for many years past."[4] It was an incredible boost to American morale, proving that the new American navy could hold its own against the strongest naval power on earth.

On the reverse of the jug is printed "SECOND VIEW OF COM. PERRY'S VICTORY," which shows the second phase of the Battle of Lake Erie, on September 10, 1813. The print captures the moment when Commander Oliver Hazard Perry ordered his ships to bear down on the attacking British vessels. In Perry's own words, "At 45 minutes past 2, the signal was made for close action. The *Niagara* [lost in smoke in the center of the image] being very little injured, I determined to pass through the enemy's line, bore up and passed ahead of their two ships and a brig, giving a raking fire to them from the starboard guns, and to a large schooner and sloop from the larboard side at half pistol shot distance."[5] This daring action broke the British formation, and her scattered ships soon surrendered.

Both prints on the jug are signed "Bentley Wear & Bourne Engravers & Printers, Shelton, Staffordshire" and are based on illustrations from *The Naval Monument*, published in Boston by Abel Bowen in 1816 (see cat. no. 31).[6]

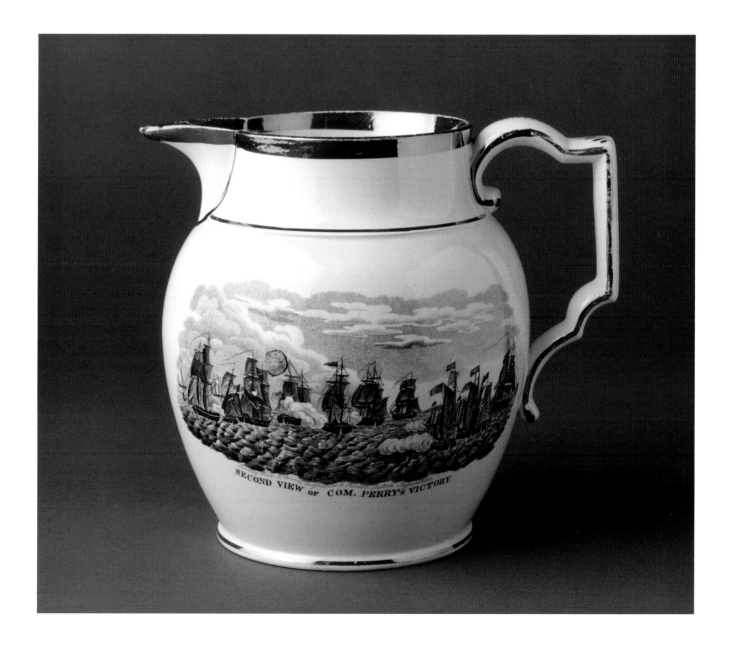

30. Jug

Staffordshire, England; 1816–20
Creamware printed in black and painted in enamels
H. 4¹¹⁄₁₆ in. (119 mm)
1967.14 Gift of Mr. B. Thatcher Feustman

Both sides of this small jug with a rare apple-green ground are decorated with a portrait of one of the most illustrious heroes of the War of 1812, Captain Isaac Hull, the commander of the U.S. frigate *Constitution*. Hull's life at sea began early. As a young man he served on several merchant vessels, rising to the rank of master before enlisting as a lieutenant in the new U.S. Navy in 1798. He served during the Quasi-War with France (1798–1800) and the Tripolitan War (1801–5) and was promoted to captain in 1806.

Described as an "attentive and diligent officer," Hull was given command of the *Constitution* in 1810.[1] He first received public notice in the early months of the War of 1812 when he evaded capture by a British squadron. His fame was assured when he defeated the British frigate *Guerrière* after a battle of only thirty minutes on August 19, 1812, giving young America her first victory over the seemingly invincible British navy. Hull went on to have a long career, serving as the commander of the Pacific Squadron (1823–27), the Mediterranean Squadron (1839–41), and the Portsmouth and Boston navy yards.

The portrait of Hull on this jug is almost certainly based on an engraving by David Edwin after a painting by Gilbert Stuart. The print first appeared in *The Analectic Magazine* in March 1813, where it illustrated a biography of Captain Hull.[2] Under the editorship of Washington Irving (who wrote, among other works, *The Legend of Sleepy Hollow*), the *Analectic Magazine* published a series of popular biographies of War of 1812 heroes that were accompanied by engraved portraits. So popular was the *Analectic* that the monthly editions were reissued as a series of bound volumes around 1816. The portraits that illustrate this later reissue are thought to have been used as the models for the decoration on ceramics.[3]

ISAAC HULL ESQR. of the United States Navy. Engraved by David Edwin, after a painting by Gilbert Stuart. From the *Analectic Magazine* (March 1813). Printed Book and Periodical Collection, Winterthur Library.

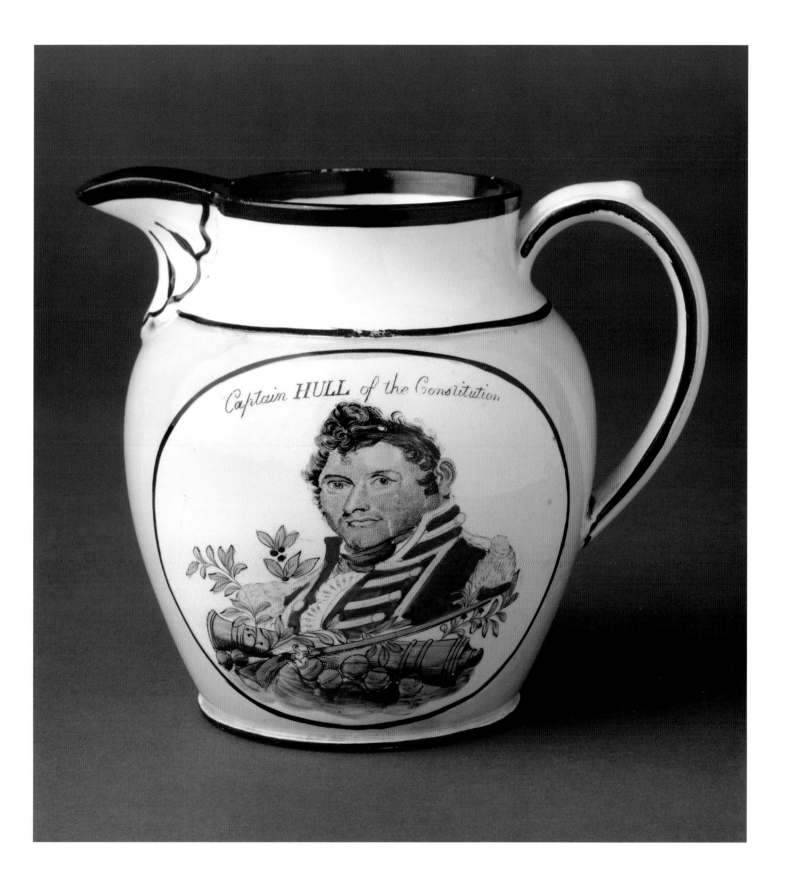

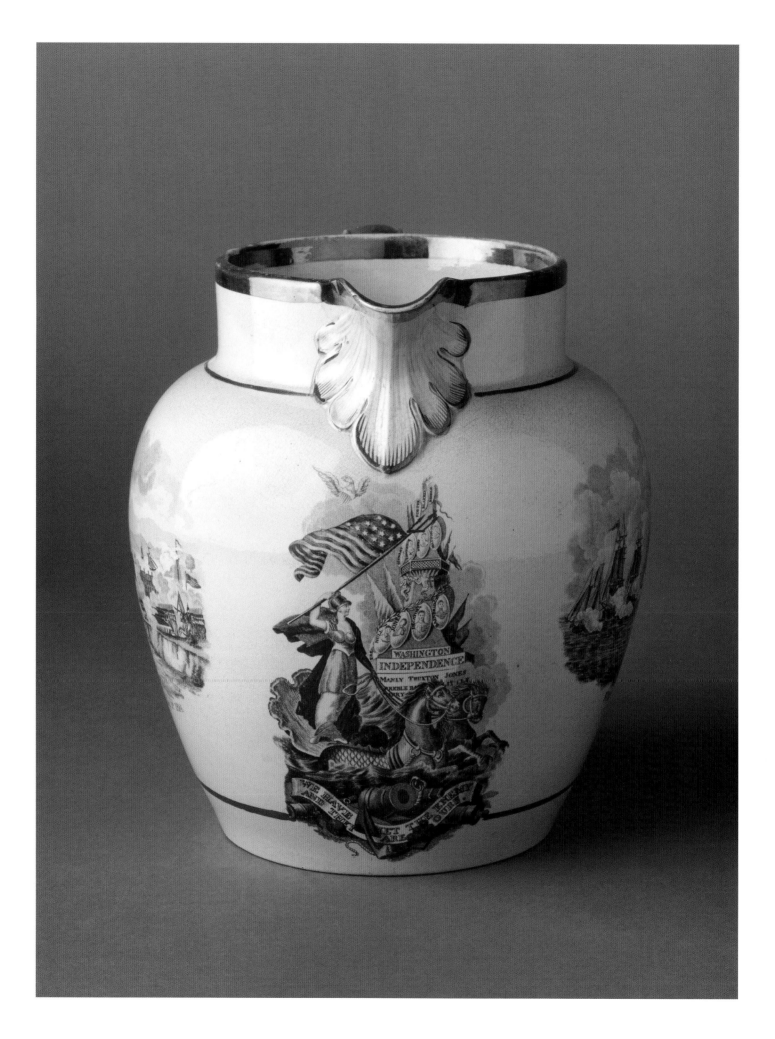

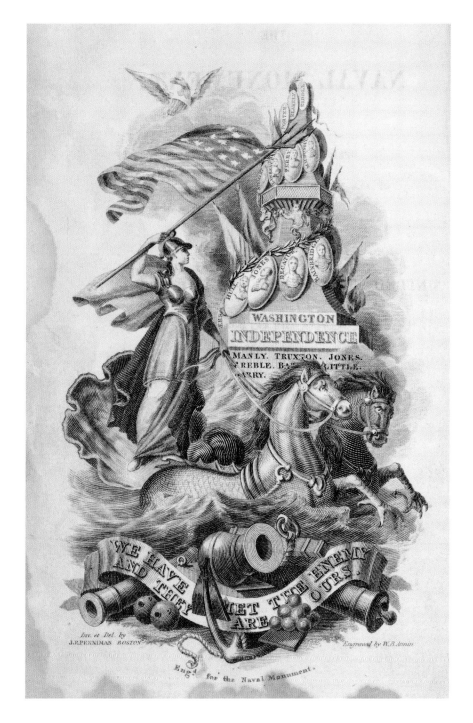

The Naval Monument. Drawn by J. R. Penniman, engraved by W. B. Annin. From *The Naval Monument* (Boston: Abel Bowen, 1816), frontispiece. Printed Book and Periodical Collection, Winterthur Library.

31. Jug

Staffordshire, England; 1816–20
Drabware printed in black and banded in luster
H. 9 in. (229 mm)
2009.23.9 Gift of S. Robert Teitelman, Roy T. Lefkoe, and Sydney Ann Lefkoe in memory of S. Robert Teitelman

American naval victories were crucial to the successful outcome of the War of 1812, and the prints on this jug celebrate several as well as the naval officers in charge. Beneath the spout is a print of a pyramidal monument decorated with the portraits of officers Porter, Blakely, Biddle, Stewart, Lawrence, Perry, MacDonough, Hull, Jones, Decatur, and Bainbridge. Engraved on the base are the names

Manly, Truxton, Jones, Preble, Barron, Little, and Barry. The monument is also decorated with a banner bearing the slogan "We have met the enemy and they are ours," which was uttered by Commodore Perry during his victory over the British fleet in the battle of Lake Erie. This image is based on the frontispiece of *The Naval Monument*, a book about American naval victories that was published in 1816. The book, like the image itself, was dedicated to "the officers of the United States Navy, who by their bravery and skill have exalted the American character, secured the applause of their country, and excited the admiration of the world."[1]

Jugs and other pieces decorated with portraits of American heroes were no doubt designed to inspire their viewers, a sentiment echoed by the late

nineteenth-century ceramic historian Alice Morse Earle, who wrote in *China Collecting in America*, "I know of no other way to impress upon a child, or to recall to a grown person, the lesson of bravery, courage, and love of country, than by showing him the likeness of Perry, Decatur, and Lawrence on a mug or pitcher."[2]

On the sides of this jug are views of two important naval battles that took place on the Great Lakes, then on the western edge of the United States. One is the Battle of Lake Erie, fought on September 10, 1813, between a squadron led by Commodore Oliver Hazard Perry and a British fleet that controlled the lake. The battle was fierce, and Perry's flagship, the *Lawrence* (named after the late Captain James Lawrence), was disabled. This image shows the moment when Perry was being rowed from the crippled *Lawrence* (center) to the *Niagara* (center foreground). In the words of one of his officers, "With his usual gallantry he went off standing up in the stern of the boat."[3] Perry's bravery and leadership led to victory, which gave the Americans control of Lake Erie, protecting the

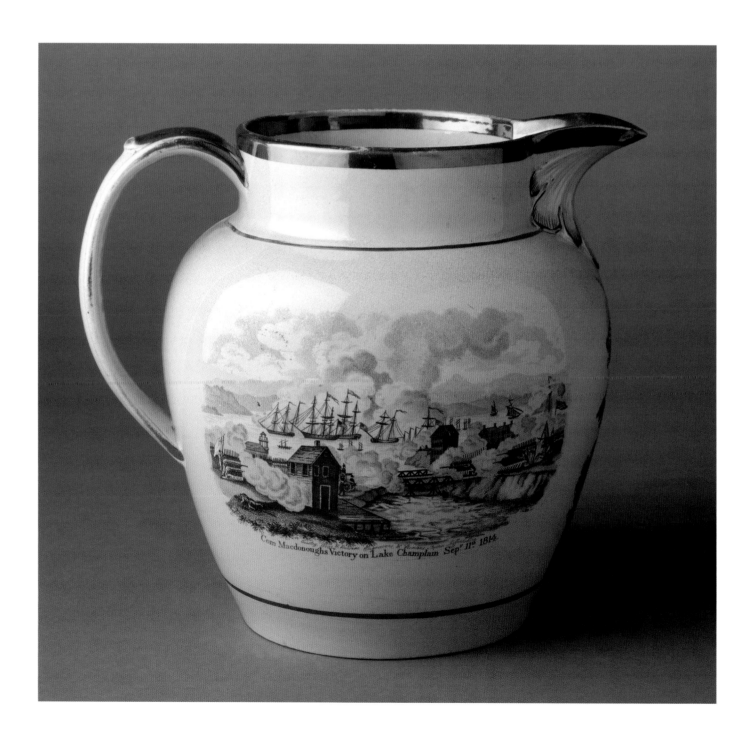

Northwest Territory of the United States and allowing U.S. forces to capture part of Canada, giving greater bargaining power in negotiating peace with Great Britain.[4]

On the other side of the jug is a view of the Battle of Lake Champlain, which took place just one year later, September 11, 1814. Led by Lieutenant Thomas MacDonough, the American fleet defeated the British after a fierce battle. According to one contemporary chronicler, "The battle was exceedingly obstinate; the enemy fought gallantly; but the superiority of our

gunnery was irresistible."[5] The victory helped prevent the larger British forces in Canada from dominating the Northwest Territory of the United States.[6]

All three images are based on illustrations from *The Naval Monument*.[7] The two battle images are marked "Bentley Wear & Bourne Engravers & Printers, Shelton Staffordshire" (see cat. no 28). The shape of this jug is what was known in the period as a "Dutch" jug.[8] The buff, or drab, body achieves its color by staining the earthenware body. That treatment was popular between 1815 and 1830.[9]

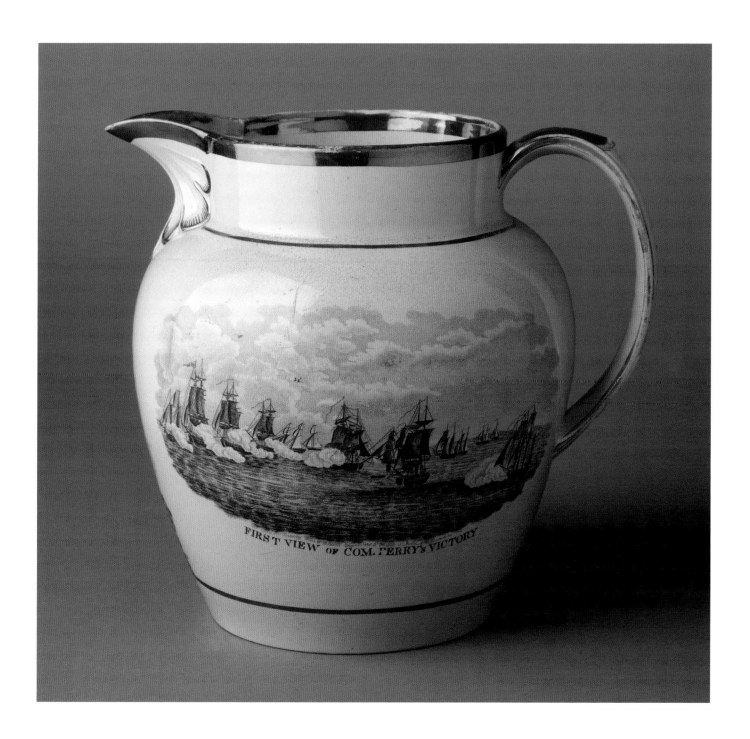

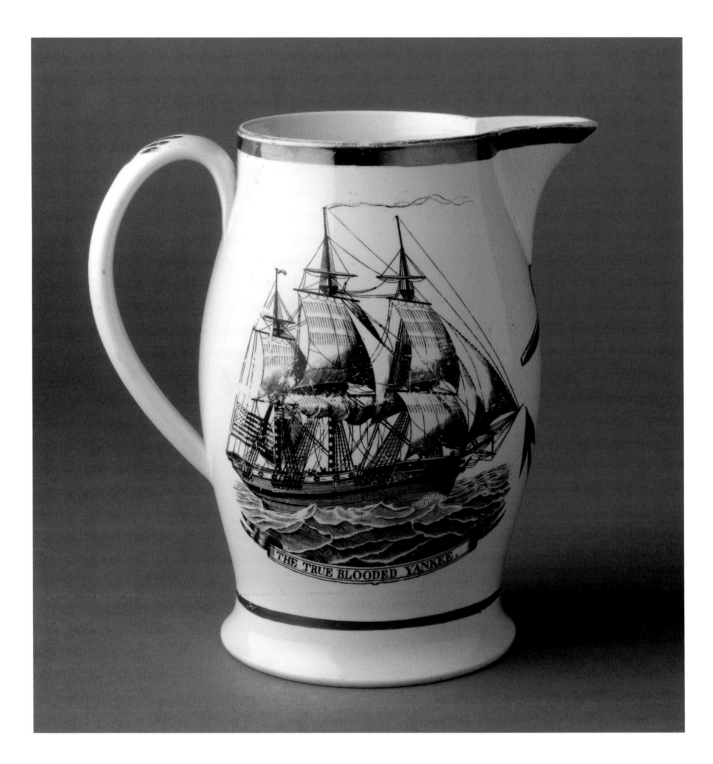

32. Jug
Staffordshire, England; 1815–20
Creamware printed in black and painted with luster
H. 7⁵⁄₁₆ in. (185 mm)
1966.63 Gift of Mr. B. Thatcher Feustman

One of the most successful privateers of the War of 1812, the *True Blooded Yankee*, appears on the side of this jug. Privateers were private ships authorized by a government to attack an enemy's shipping during a time of war. Though the owners, captains, and crew of privateers are not to be confused with pirates, they were often motivated as much by profit as by patriotism, being rewarded with money that came from the sale of the seized vessel and its cargo.

During the War of 1812, the U.S. government authorized some 500 privateers to seize or destroy British merchant vessels in order to disrupt that nation's

economy and force her into peace negotiations. These typically small, fast-sailing vessels and their brave and audacious crews had tremendous success, capturing some 1,400 British ships.[1] According to one contemporary newspaper article, "The importance of privateers, as the engines of annoyance to the enemy, will the more fully appear, when it is recollected that some of our *smallest privateers* have taken more *prizes*, than any of our *largest frigates.*"[2]

The *True Blooded Yankee* was a French-built brig fitted out in Brest, France, by a Rhode Island merchant, Mr. Preble. She sailed on March 1, 1813, under the command of Captain Hailey.[3] A newspaper account after the war proudly reported that "she was extremely successful in her captures and perhaps proved a greater scourge to the enemy than any other American Privateer. She was frequently chased, but always escaped being captured by her superior sailing."[4] The British captain W. F. Wise was more succinct, admitting that she "outsailed everything."[5] During one extraordinary voyage in 1814, which lasted a mere thirty-seven days, the brig captured twenty-seven vessels off the coast of Ireland and Scotland, sailed into a Scottish harbor and burned seven ships, and even occupied an Irish island for seven days.[6] She made at least three cruises but was eventually captured by the British in late 1814. She was either released or escaped and continued her career as a privateer, sailing under the flag of Chile until at least 1817.[7]

On the opposite side of the jug, which is also decorated with pink luster bands at the rim and a pink luster anchor under the spout, is an adaptation of the Great Seal of the United States with a banner inscribed "MAY SUCCESS ATTEND OUR AGRICULTURE TRADE AND MANUFACTURES," which is a reference to the economic underpinnings of the new United States. The print, "The True Blooded Yankee," is not an actual portrait of the vessel, but rather a stock print. An identical print that has the title "A PRIVATEER ON A CRUISE" in the banner beneath the scene is also known, suggesting that one engraver provided two copper plates with the same vessel but different titles. The "PRIVATEER" print appears on several other jugs with pink luster bands and on a monumental jug thought to have been made at the Staffordshire factory of Christopher Whitehead between 1817 and 1819, suggesting a possible maker for all jugs with similar ship prints.[8]

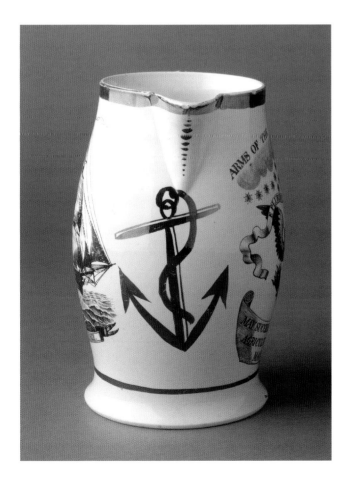

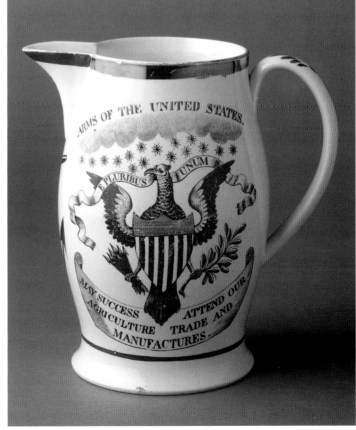

33. Jug

Staffordshire or Liverpool, England; 1790–1800
Creamware printed in black and painted in enamels
with gilding
H. 11½ in. (292 mm)
2009.21.1 Gift of S. Robert Teitelman

A portrait of a member of the Boston Fusiliers, resplendent in his uniform, decorates this jug.[1] The militia, whose full name was the Independent Fusiliers of Boston, was founded by a group of retired Revolutionary War officers in 1787. According to their history, the uniforms were red jackets with tall, black fur hats abandoned by British soldiers during their evacuation of Boston during the Revolution.[2] The Boston Fusiliers served as an honor guard and escort for Massachusetts governors and visiting presidents as well as at parades and celebrations such as the ratification of the federal Constitution in 1788, the laying of the cornerstone of the Massachusetts State House in 1795, and the reception to honor the return of the Marquis de Lafayette in 1825. The group organized a company of volunteers during the Civil War and continued to serve

as an honorary escort for dignitaries and on special occasions into the twentieth century.[3]

The Boston Fusilier on this jug holds a staff bearing what is probably the regimental flag of the organization;[4] their motto, "AUT VINCERE AUT MORI" (either to conquer or to die), is inscribed on the oval frame. The design is replete with Masonic imagery: the black-and-white pavement on which the fusilier stands; an All-Seeing Eye; sun, moon, and stars; square; compass; and the letter "G" above the oval frame.[5] On the reverse is an allegorical image with figures representing Liberty, Justice, and Peace above a scene representing agriculture, trade, and commerce. The image is surrounded by a chain of states, symbolizing strength through unity; it is reinforced by the motto "UNITED WE STAND–DIVIDED WE FALL."[6]

This jug is one of several thought to have been made for Samuel Jenks (1731–1801), a blacksmith and bellows maker who was a member of King Solomon's Masonic Lodge in Charlestown, Massachusetts, and a captain of the Boston Fusiliers. Jenks is said to have ordered 100 jugs in 1790 for presentation to his fellow members. The jugs were made in two sizes: a larger one at 11½ inches tall, and a smaller version at 9½ inches tall.[7]

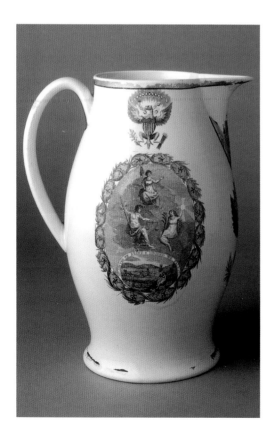

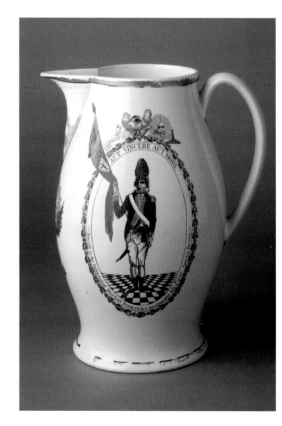

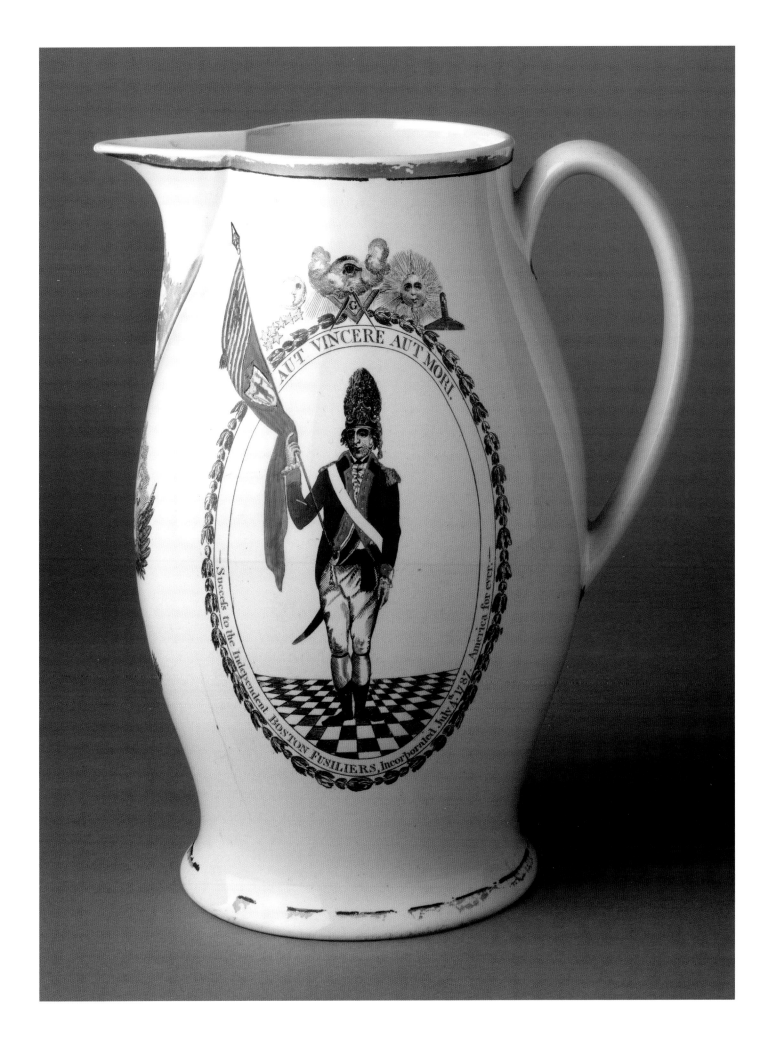

AUT VINCERE AUT MORI.

— Success to the Independent BOSTON FUSILIERS, Incorporated July 4th 1787. America for ever. —

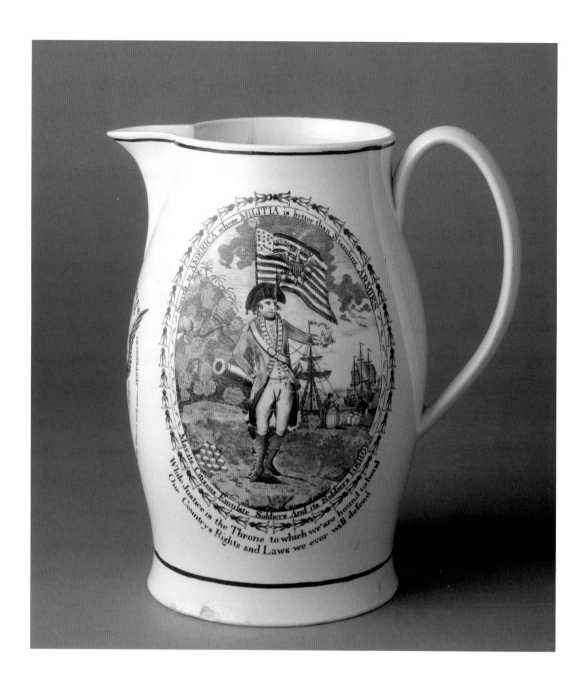

34. Jug

Staffordshire, England; 1804–15
Creamware printed in black and painted in enamels
H. 8⅞ in. (225 mm)
1958.1186 Bequest of Henry Francis du Pont

This jug commemorates the third president of the United States, Thomas Jefferson, and also weighs in on one of the most fiercely debated topics of the early national period—the role of the army and the militia in the defense of the new nation. On the front of the jug is a printed and enameled image of an American soldier surrounded by emblems of the country's new independence and prosperity: a cannon, an American flag, a farmer bent to his plow, and laborers loading a merchant ship. The images were possibly printed by Francis Morris of Staffordshire.[1] The soldier is framed by the slogans "Success to AMERICA

whose MILITIA is better than standing ARMIES" and "May its Citizens emulate Soldiers and its Soldiers HEROES." Below the medallion is a third slogan, "While Justice is the Throne to which we are bound to bend Our Countrys Rights and Laws we ever will defend." Though the origin of these slogans has not yet been identified, their rhetoric is entirely consistent with the American discourse about the role of the military in the new nation.

Numerous American citizens had an ambivalent attitude toward standing armies, which were seen by many as a tool of tyrants and a threat to liberty. Among the crimes of George III enumerated in the Declaration of Independence was the fact that "He has kept among us, in times of peace, Standing Armies without the Consent of our legislatures." The debate was especially fierce during the ratification of the Constitution and continued during the early years of the new republic. Jefferson was an ardent

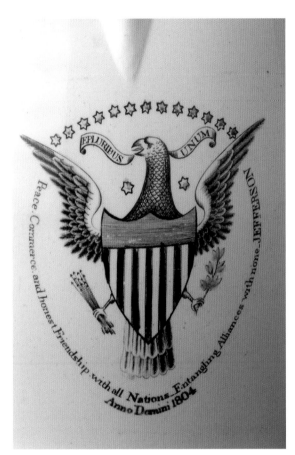

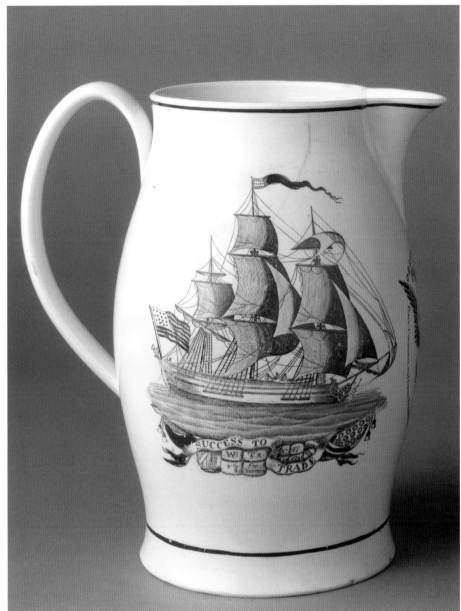

opponent of standing armies and a supporter of state militias as defenders of the nation's liberty.

Beneath the spout of the jug is a version of the Great Seal of the United States, framed with the inscription "Peace, Commerce, and Honest Friendship with all Nations–Entangling Alliances with none–JEFFERSON" and the date "1804." This quote comes from Jefferson's first inaugural address, delivered on March 4, 1801, and the sentiments form part of what Jefferson called "the essential principles of our Government, and consequently those which ought to shape its Administration."[2]

Jefferson found it difficult to avoid entanglement with foreign powers, as the United States was increasingly affected by the conflict between Great Britain and France that was waged between 1793 and 1814. America attempted to trade with both sides, and despite its protestations of neutrality, found its merchant vessels stopped, searched, and seized by both British and French naval vessels. In an attempt to avoid war and force Europeans to accept American neutrality, Jefferson and Congress passed the Embargo Act of 1807, which forbade international trade to and from America. The policy was an absolute failure. It caused only minor inconvenience to Britain and France but devastated the American economy; in 1808 exports plunged to one-fifth their level in 1807. The Embargo Act was repealed in 1809, and British harassment of American shipping continued—a leading cause of the War of 1812.[3]

On the reverse of this jug is a view of an American merchant vessel proudly flying the American flag. Below the waves is a cartouche consisting of an American flag, barrels, bundles, and a banner inscribed "SUCCESS TO TRADE." Any question as to whose trade was to be successful is answered by the inscription "For America," which marks one of the bundles of goods.

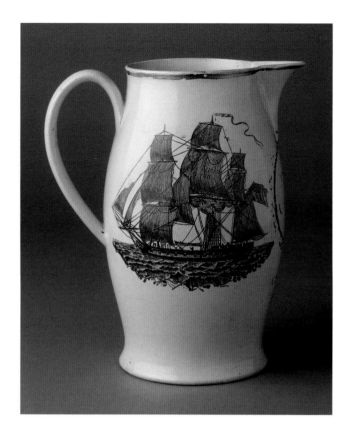 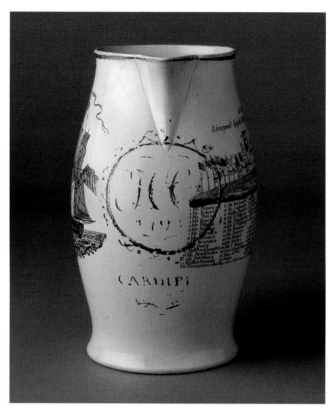

35. Jug
Made in Staffordshire or Liverpool and printed in
Liverpool, England; ca. 1790
Creamware printed in black and painted in enamels
with gilding
H. 8½ in. (216 mm)
2009.23.4 Gift of S. Robert Teitelman, Roy T. Lefkoe, and
Sydney Ann Lefkoe in memory of S. Robert Teitelman

Printed in black and over-painted in enamel colors is a
view of a lighthouse and signal flags entitled "AN EAST
VIEW OF Liverpool Light House & Signals on Bidston
Hill." Below the view is a key to fifty six flags and other
instructions that were part of an early warning system for
the merchants and ship owners of Liverpool. The port of
Liverpool, standing on the eastern side of the estuary of the
river Mersey, was increasingly important in the eighteenth
century, eventually becoming second only to London.[1]

Bidston is one of the highest points of land on the
Wirral peninsula, between the rivers Mersey and Dee.
Ancient carvings in the hillside attest to its long history as
a site of some note. From 1763 Bidston Hill was part of a
chain of signal stations along the northwest coast of Britain
that employed a system of flags to indicate approaching
ships. The first lighthouse was erected on the site in 1771
and is shown in the print in the midst of the signals. The
flag system could be used to warn of enemy warships or of
vessels in distress, but, more important, the flags alerted
Liverpool merchants to the approach of their incoming
ships. The first sight of a ship would be off Holyhead in
Wales, and within eight minutes the information would be
relayed to Liverpool through a network of signal stations
and system of flags. The position of the flags on particular
flagpoles would indicate which merchant's ships were
approaching the entrance to the Mersey. For example, the
flag numbered 19 belonged to Mr. Staniforth; flag 26
signaled "Men of War" sighted; and 48 indicated "London
Cheese Ships" approaching. At the height of its activity,
Bidston Hill had more than 100 flagpoles on the ridge to
serve the growing maritime activities in Liverpool.[2]

The changes in merchants and subscribers meant that
the Bidston Hill signals changed regularly, and these are
reflected in the various versions of this design that are
known on ceramics and other decorative objects. At least
three versions are known with dates and similar, but not
identical, prints; a creamware mug dated 1789 signed
"Printed by Josh. Johnson Liverpool," a glass beaker dated
1788, and an unsigned print on a mug impressed
"Wedgwood & Co."[3] An updated view of Bidston Lights
was published annually in *Holden's Almanac and Tide Table for
Liverpool* from at least 1798, perhaps earlier. Such illustrations
may have been used as a source for prints of this kind.[4]

The inscription "CARDIFF," in gilt beneath the spout,
most likely refers to the capital and largest city of Wales.
Located on the southwest coast of Britain, Cardiff was not
part of the signal relay, but it had a busy port. On the reverse
of the jug is a stock print of a three-masted ship flying the
British flag.[5] The rim of the jug is finished with a gilt band.
This piece may have been made for someone engaged in
the British coastal trade but has been included in this
collection because of the importance of Bidston Hill to
American mariners who made the voyage to Liverpool.

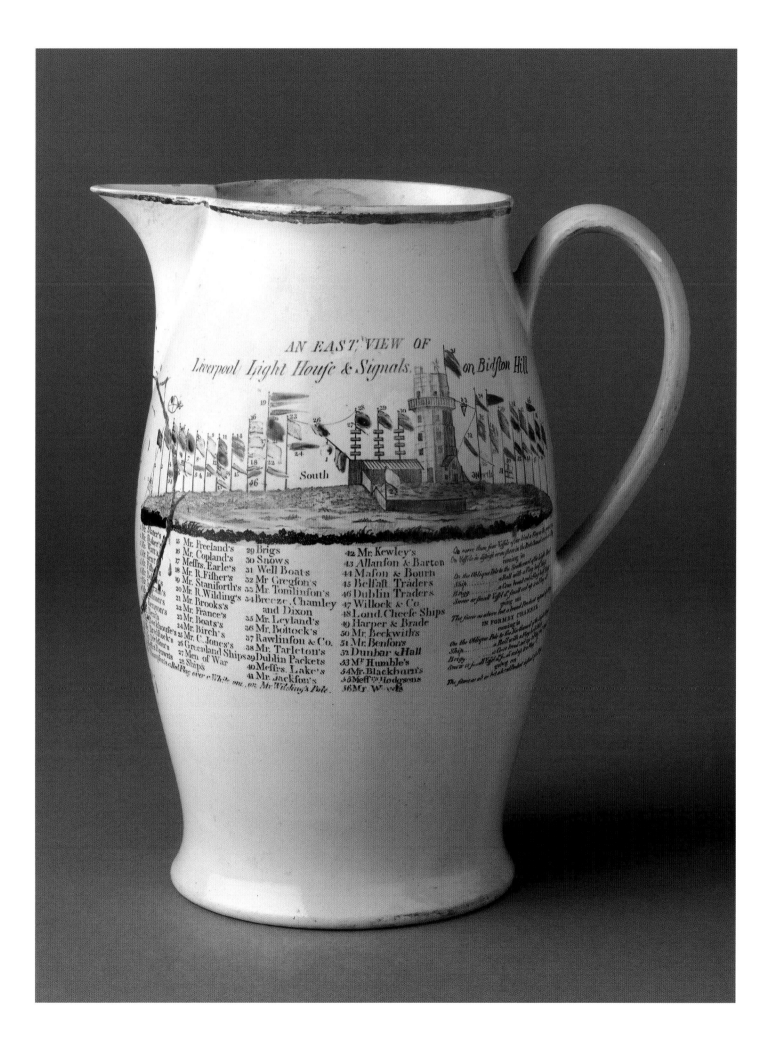

AN EAST VIEW OF
Liverpool Light Houfe & Signals on Bidfton Hill

South

Mr. Slater's	29 Brigs	42 Mr. Kewley's
15 Mr. Freeland's	30 Snows	43 Allanfon & Barton
16 Mr. Copland's	31 Well Boats	44 Mafon & Bourn
17 Meffrs. Earle's	32 Mr Gregfon's	45 Belfaft Traders
18 Mr. R. Fifher's	33 Mr. Tomlinfon's	46 Dublin Traders
19 Mr. Staniforth's	34 Breeze, Chamley	47 Willock & Co
20 Mr. R. Wilding's	and Dixon	48 Lond. Cheefe Ships
21 Mr. Brooks's	35 Mr. Leyland's	49 Harper & Brade
22 Mr. France's	36 Mr. Bollock's	50 Mr. Beckwith's
23 Mr. Boats's	37 Rawlinfon & Co.	51 Mr. Benfon's
24 Mr. Birch's	38 Mr. Tarleton's	52 Dunbar & Hall
25 Mr. C. Jones's	39 Dublin Packets	53 Mr Humble's
26 Greenland Ships	40 Meffrs. Lake's	54 Mr. Blackburn's
27 Men of War	41 Mr. Jackfon's	55 Meffrs Hodgfens
28 Ships		56 Mr. Woods

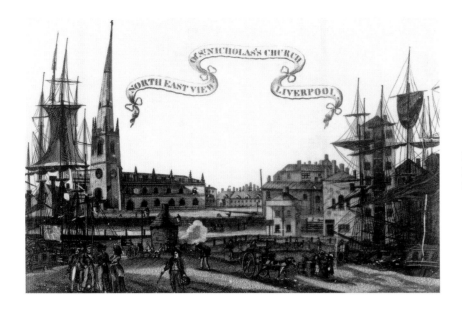

Panorama of scene on the jug. Photo, Hans Lorenz, courtesy of Colonial Williamsburg Foundation.

36. Mug

Made in Staffordshire or Liverpool and probably printed in Liverpool, England; 1775–80
Creamware printed in black
H. 6 in. (152 mm)
2009.21.9 Gift of S. Robert Teitelman

This mug is printed with a waterfront scene and church prominently depicted in the left background. Below is a banner inscribed "NORTH EAST VIEW OF ST. NICHOLAS'S CHURCH LIVERPOOL." Many port churches were dedicated to St. Nicholas, the patron saint of sailors, and played a central role in the maritime community. The St. Nicholas church seen here is the parish church of the city of Liverpool and is often known as the Sailors Church. Standing in the heart of the trading center of the city docks, the church had a long association with the slave trade. In the corner of the churchyard stood a coffee house in which shackles were fixed for the slave-trader auctions during the eighteenth century. The new-found prosperity from this trade funded the expansion of the church and its grounds.[1]

The print on this mug is an unrecorded view of the church, which was established in the fourteenth century. In 1746 a spire was added, and in 1774 the body of the church was rebuilt. This engraving dates after that time, as the spire is clearly visible. On Sunday, February 11, 1810, the spire collapsed, killing twenty-five people, mainly children from a nearby charity school who were crushed under the rubble.

Although most of the English creamware decorated with American patriotic imagery was made in the form of jugs, small mugs have been recorded. This appears to be one of a set, or at least a pair, as a similar example is known in the National Galleries on Merseyside, Liverpool.[2] While it may have been made with the Liverpool home market in mind, the view of St. Nicholas Church would have been a familiar landmark for American sailors approaching the Liverpool docks. With the association of St. Nicholas as a guardian of mariners, any visiting sailor might have considered it an auspicious purchase.

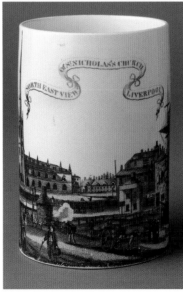
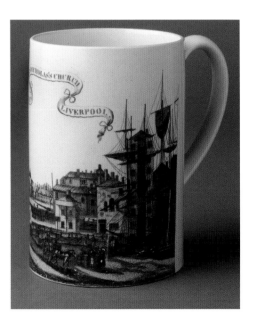

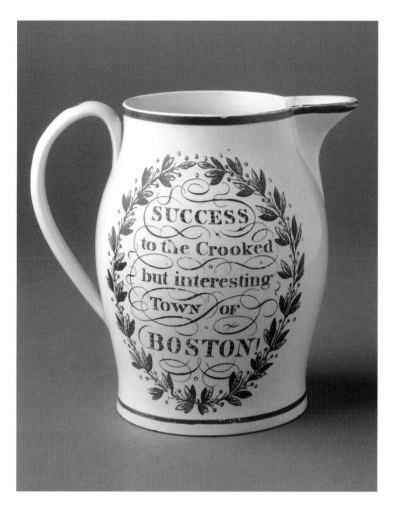

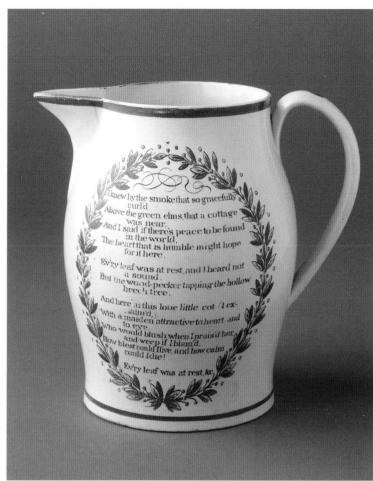

37. Jug

Probably Staffordshire, England; 1808–15
Creamware printed in red
H. 6¼ in. (159 mm)
2007.31.2 Gift of S. Robert Teitelman

This jug, printed in iron red, is unusual in that it has no pictorial images. The intriguing inscription framed in an oval laurel wreath reads, "SUCCESS to the Crooked but interesting TOWN OF BOSTON!" This sentiment appears to be an expression unique to pottery of this kind. The origins of the exact phrase are obscure but no doubt lie in early descriptions of Boston's streets. Annie Haven Thwing notes of Boston that "in 1664 the Royal Commissioners say 'their houses are generally wooden, the streets crooked with little decency and no uniformity.'" She goes on to write, "There has been much speculation and a great deal of fun made in regard to the crooked and narrow streets of Boston, and they have been the subject of good-natured banter from wits of ages."[1] So the streets, and by implication the city, of Boston had long been described as crooked. The addition of "interesting" turns what might have been a pejorative statement into an example of "good-natured banter."

On the reverse, also in an oval laurel wreath, is the poem that begins "I knew by the smoke that so gracefully curl'd Above the green elms, that a cottage was near." The lines are adapted from a "Ballad Stanza" by Irish poet and musician Thomas Moore (1779–1852). Following a year in Bermuda as a government-appointed officer, Moore traveled to America in 1804, visiting New York, Washington, Baltimore, Philadelphia, Boston, and then Canada before returning to England. His "Epistles, Odes, and Other Poems" was published in 1806. It is not known exactly when the poem on the reverse of this jug was first published but it is likely to be 1808 at the earliest. It may have been included in popular music publications throughout Moore's lifetime. He is most remembered for his strong friendship with Lord Byron and received popular acclaim for his verses set to folk tunes, perhaps the best known of which is *The Last Rose of Summer*. Many of these songs appealed particularly to Irish nationalist ex-patriots. Moore continued to publish until his death in 1852 and was held in high esteem by his readership in England, Ireland, and America.[2]

Although amusing, this design may not have been popular with Bostonians or with American consumers looking for patriotic prints. Few original examples with this decoration are known to have survived; however, a reproduction made by the Wedgwood Company in the twentieth century can often be found.

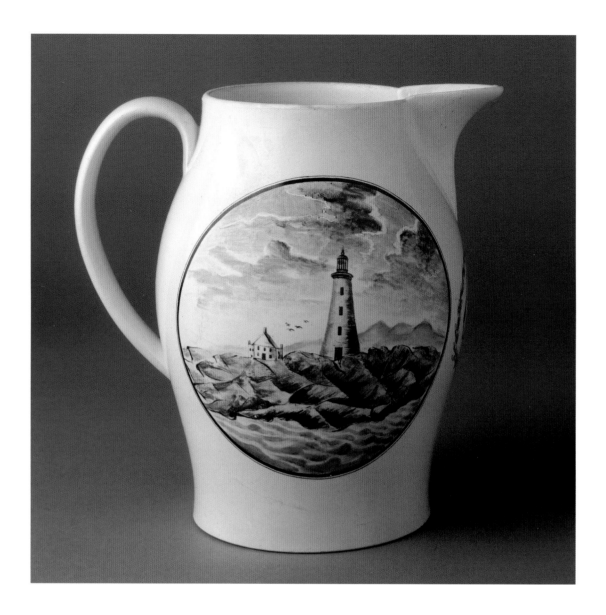

38. Jug

Made in Staffordshire or Liverpool, decorated in Liverpool, England; 1795–1805
Creamware printed in black and painted in enamels
H. 9 in. (229 mm)
2009.21.17 Gift of S. Robert Teitelman

The scenes on this jug, hand painted in overglaze enamel colors, depict specific places and events that suggest that the jug was commissioned for a Boston family. An important port and shipbuilding town, Boston became one of the world's wealthiest trading ports after the Revolutionary War. Not surprisingly, both scenes have maritime connections.

On one side of this jug an oval medallion frames a painting of a lighthouse, recognizable from at least one contemporary print entitled *Engraving, representing a South West View of the Light House, and of the Island on which it is situated*. The print illustrates an article on the Boston lighthouse published in 1789, along with an account of its history and position for shipping.[1] It is likely that the 1789

engraving or a similar print was carried to England and offered as a source for decorating this jug. The Boston lighthouse was the first to be built in America and was constructed on Little Brewster Island in outer Boston Harbor about 1716. During the Revolutionary War, it was occupied by British forces and attacked and burned on two occasions by American troops. In 1776, as they withdrew, the British blew up the tower. In 1783, at the end of the war, when merchant shipping was an essential part of the developing commerce of the United States, the lighthouse was rebuilt. It is this newly built structure that is depicted on the jug.

On the other side of the jug is a three-masted ship flying the American flag. The ship bears a female figurehead and sits just off land in a river or estuary, perhaps adjacent to a shipyard, for she seems to be in the final stages of construction. In the foreground are coils of rope for the rigging and to the right we see a warehouse-like building that might be storage for cargo. Below the image is the inscription, "JANE GOODWIN, BOSTON." The Goodwin name is associated with

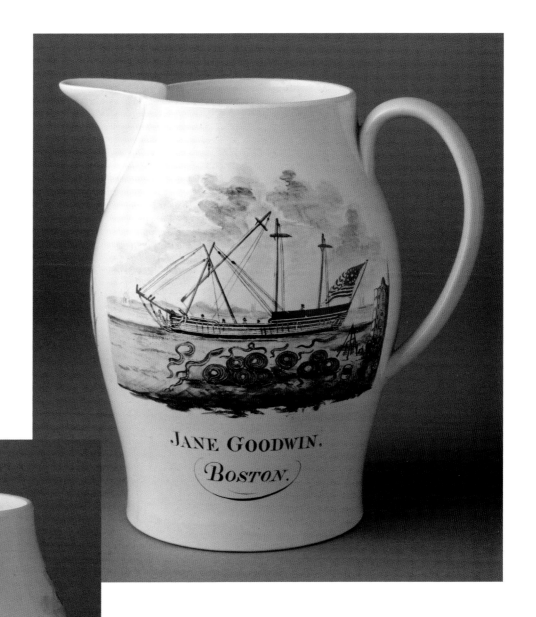

shipbuilding and mercantile activity in late eighteenth- and early nineteenth-century Boston. In 1776 the Continental Congress authorized the purchasing or building of several vessels, including three fitted with seventy-four guns. The only one of these to be built in Boston was begun at the boatyard of Benjamin Goodwin, close to Charlestown. The ship was never completed as Congress deemed that "the extravagant prices now demanded for all kinds of material used in shipbuilding and the enormous wages demanded by tradesmen and laborers' made the commission too costly." By 1784, the crisis having passed, the ship was sold.[2]

Although this piece is associated with the Goodwin family through the inscription, it has proved impossible to locate the Jane Goodwin for whom the jug was inscribed. Neither an appropriate person nor ship of that name has been discovered. The initials painted in feathered script in a printed oval foliate medallion beneath the spout are fanciful but unclear. They might read "CLG" and be another Goodwin reference, or possibly they read "CLS." In either case, they remain a mystery.

39. Jug
Probably Herculaneum Pottery
Liverpool, England; 1805–10
Creamware printed in black with traces of gilding
H. 11⅞ in. (302 mm)
2009.23.8 Gift of S. Robert Teitelman, Roy T. Lefkoe, and
Sydney Ann Lefkoe in memory of S. Robert Teitelman

Every print on this jug speaks to its having been made for a mariner. It is decorated with black-printed nautical designs, and what remains of the gilding suggests this was an expensive item at the time of its manufacture. The most unusual print is a map titled "NEWBURYPORT HARBOUR" and in a banner below, "SUCCESS TO THE COMMERCE of NEWBURYPORT." In 1764 the port of Newbury in Massachusetts broke away from its parent town and became the independent city of Newburyport. Focusing on maritime trade, it was well populated and had a thriving economy from the end of the Revolutionary War into the first decade of the nineteenth century. However, a catastrophic fire in 1811 and the War of 1812 accounted for the beginning of a decline of its seafaring fortunes.

This jug was probably made at the height of Newburyport's prominence. The chart shows a plan of the city and the approach by water from the Atlantic

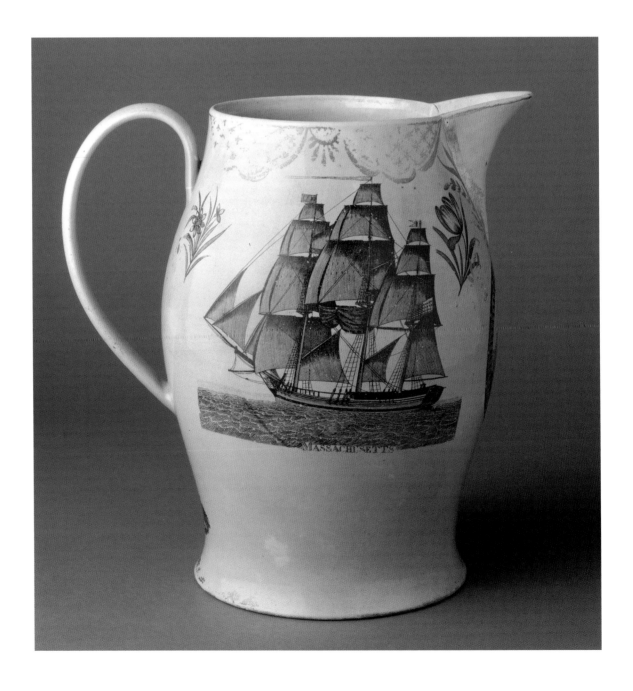

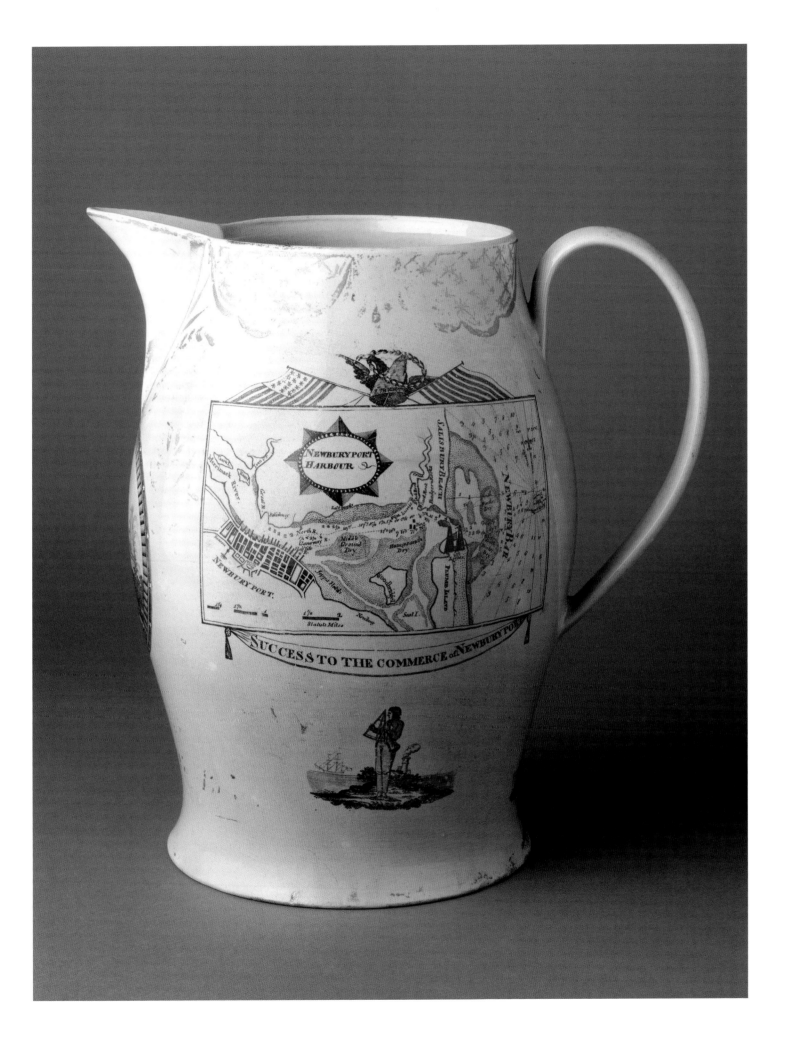

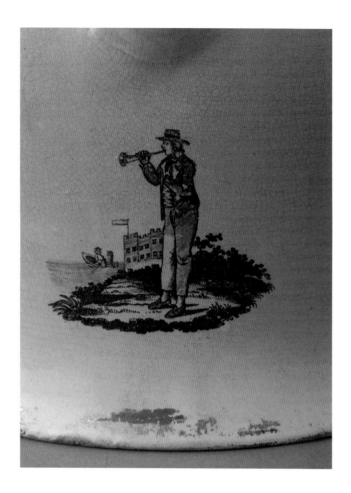

Ocean to its location on the south bank of the Merrimack River. Such charts, usually printed on more convenient material, were essential guides to safe navigation. It is a graphic portrayal of the marine environment, including the nature of the coastline, the depth of the water, the location of hazards, and aids to navigation.[1] This version of the chart was first published in 1804 in the fourth edition of *The American Coast Pilot.* It was enlarged and revised for the fifth edition, published in 1806. It depicts the Newbury sandbar at the entrance to the estuary, the lights, piers, and docks together with water depths of a shallow-sounding three to seventeen feet. On the reverse side of the jug is a stock print of a three-masted ship. Although such prints do not usually represent a particular vessel, in this case it has been personalized with the addition of the inscription "MASSACHUSETTS" below.

The juxtaposition of the name *Massachusetts* and the 1804 chart of Newburyport suggests that this jug relates to the merchant ship of that name built in Newburyport in 1805 that sailed to Liverpool with Thomas Buntin as master. A pair to this jug retains the full gilt inscription "Thomas and Mary Buntin."[2] An advertisement in the *New England Palladium* for August 5, 1806, tells us that

the "Massachusetts, Thos. Buntin, master" has arrived from Liverpool with 1,200 hogsheads of salt and is looking for freight to carry back to Europe. The advert continues, "Said ship is 300 tons burthen, 1 year old and sails remarkably fast." An advertisement in the same newspaper one week later added that the ship has "made but one voyage." Perhaps it was on putting into Liverpool on this maiden voyage that Buntin ordered this jug. It is reasonable to suggest that he would have been carrying the 1804 edition of *The American Coast Pilot,* which included a chart of his home port and could have served as a source for the decorative print seen on this jug.

On his second voyage, Buntin left Newburyport in early September 1806, calling at ports down the coast and clearing Boston for Liverpool on September 23. There is no news of this voyage or the return, and we may conclude it was uneventful, which is more than can be said for his voyage in 1807. In a dispatch we learn that on March 1, 1807, a number of ships detained by the French were at Leghorn, including the *Massachusetts,* Buntin master, of Newburyport.[3] Leghorn was the anglicized name of Livorno, a major Italian port, and the French were acting under Napoleon's Berlin Decree of November 1806, which prohibited British trade with all countries under French influence, including trade in British products carried by neutral ships. The *Massachusetts* was eventually allowed to proceed and was on the way to Manfredonia, another major Italian port under the control of the French, when it was seized again, this time by a British ship. A letter from John Ross & Co. merchants, dated Malta May 28, was sent to Newburyport: "We regret to inform, that ship Massachusetts, Capt. Buntin, has been detained and brought in here by an English privateer, while proceeding on a voyage from Leghorn to Manfredonia, in ballast. The U.S. agent (W. Higgins, Esq.) has come forward to protect the property, and has lodged a claim in the V.A. Court for the vessel, &c. and given bail. In consequence of the decree of Bonaparte declaring G. Britain and her colonies in a state of Blockade, the English Government by way of reprisal, have published an order of Council, prohibiting the trade between any two ports, where the British Flag is not permitted to enter, and it is, we believe, upon this Legislative order, that the Massachusetts has been detained. P.S. June 3—We are sorry to inform, that the Massachusetts has, by sentence pronounced this day, been condemned." The report goes on to say, "A letter from the same, of June 6, says the owners ought to appeal, and for that purpose they have a twelve month before them." And published in the *Newburyport Herald* was the following: "A letter

from Capt. Buntin of June 5 says–'This place is full of prize vessels and coming in daily–There are 18 sail of Americans sent in here, some with valuable cargoes, and it is considered that there is not much short of 600,000 dollars worth of American property detained and condemned, in this port.'"[4] Eventually the *Massachusetts* was released, arriving in Boston in September 1807 from Malta via Trapan (Trapani, Sicily). Undaunted by these experiences, Captain Buntin continued to sail the ship between the East Coast of America and Liverpool, with voyages to Europe recorded in 1809 and 1810.[5]

In addition to these two major prints, there are a number of generic prints on the jug. Below the handle is a sailor blowing a horn, and on one side is a sailor taking a sight with a sextant. Beneath the lip is a large circular medallion surrounded by fifteen stars containing a classical female figure representing Columbia. She holds an olive branch aloft as if saluting the maritime trade, which is referenced by a sailing ship heading away from the shore, a print known on a marked Herculaneum plate.[6] Other jugs are known with the print of Newburyport harbor;[7] however, the reverse sides of those pieces are not described and we have no way of knowing if they also feature the *Massachusetts*. Although Captain Buntin made a number of voyages, there is no evidence to determine on which occasion this jug was purchased.

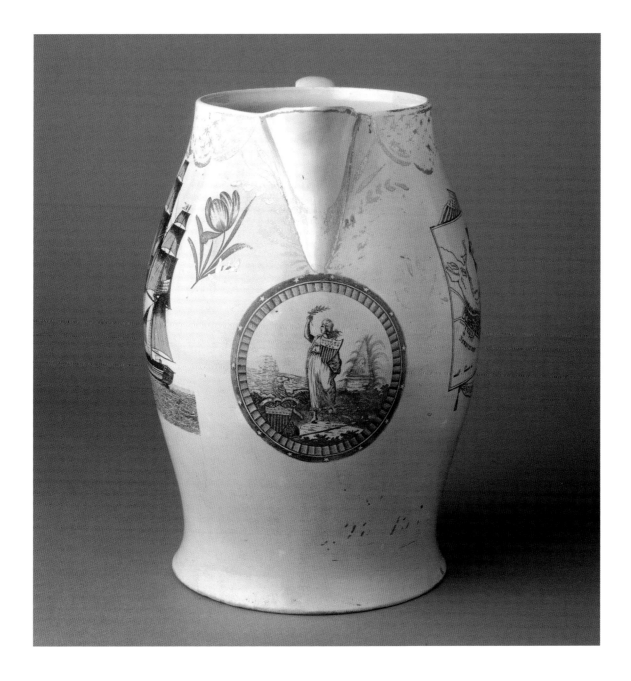

40. Jug

Staffordshire or Liverpool, England; 1807–15
Creamware printed in black and painted in enamels
H. 9¼ in. (235 mm)
1966.313 Gift of Mr. B. Thatcher Feustman

One of the major requirements of a successful maritime trade was navigational expertise and an efficient communications system. This jug has a print entitled "SIGNALS AT PORTLAND OBSERVATORY," celebrating a great landmark for transatlantic shipping approaching Portland, Maine. Established in 1786, Portland was a good deep-water port that grew rapidly as a major shipping center. The topography of the harbor, however, meant that merchants could not see and identify their ships on approach. Advance knowledge of an incoming vessel gave the merchant a financial advantage, as he could prepare for arrival, secure the necessary wharfage and manpower to unload, begin

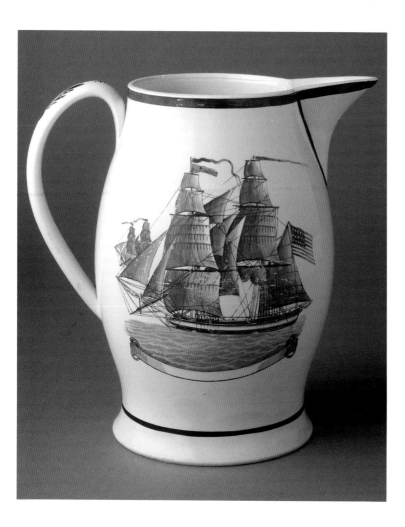

selling incoming cargo, and arrange for return cargo.

Munjoy Hill (later Mount Joy Hill), at the eastern end of the harbor, was the perfect spot for a lookout, and in 1807 a subscription was raised for the purpose of building an observatory in the form of a lighthouse equipped with a "good telescope." Plans were made and construction was completed within the year. Captain Lemuel Moody (1768–1846) was instrumental in getting the lookout and lighthouse built. The light tower was a wooden structure, eighty-six-feet high, and Moody ordered the most up-to-date equipment, purchasing an achromatic refracting telescope made by Dolland's of London. The lookout became "the Observatory," and Moody was in control. He built his home and other buildings near the tower. The complex was replete with banquet and dance halls as well as a bowling alley.[1]

It is thought that the view on this jug may take its inspiration from an anonymous nineteenth-century watercolor now in the collection of Maine Historical Society.[2] The watercolor and print on the jug display a block of twelve signal flags, a "WESTERN STAFF" and an "EASTERN STAFF," with an "EXPLANATION" below, telling what each flag signifies. The flags are a general set of signals relating to the position of ships, type of ship, and emergency situations. Flag 1 signaled "A Ship Westward off the Lighthouse"; flag 7 warned of "An Armed Ship"; flag 12 told of "A Wreck or Vessel that needs assistance"; and flag 18 announced the approach of "Four Brigs." These signal flags would have remained relatively constant while the individual flags of merchant ships that would have flown alongside the appropriate message would have changed annually, subject to payment of a subscription. For a print of a similar English observatory see that of Bidston Hill at cat. no. 35.

It has been suggested that Lemuel Moody himself ordered seventy-five of these commemorative Portland jugs, but only twelve or so are currently known.[3] It is interesting to note that on the reverse side of this piece, and perhaps on others, there is a print of a ship with an empty title banner below. If all the jugs were ordered by one person, it must have been with the expectation of selling them later and having them inscribed with names of particular ships. The ship on this example is highly colored with hand-painted decoration over the print. From the time it opened in 1807, Portland Observatory has been a tourist attraction. Following a laudable restoration in 1998–2000, it remains today a reminder of Portland's maritime past, and this jug a souvenir of its transatlantic trade.

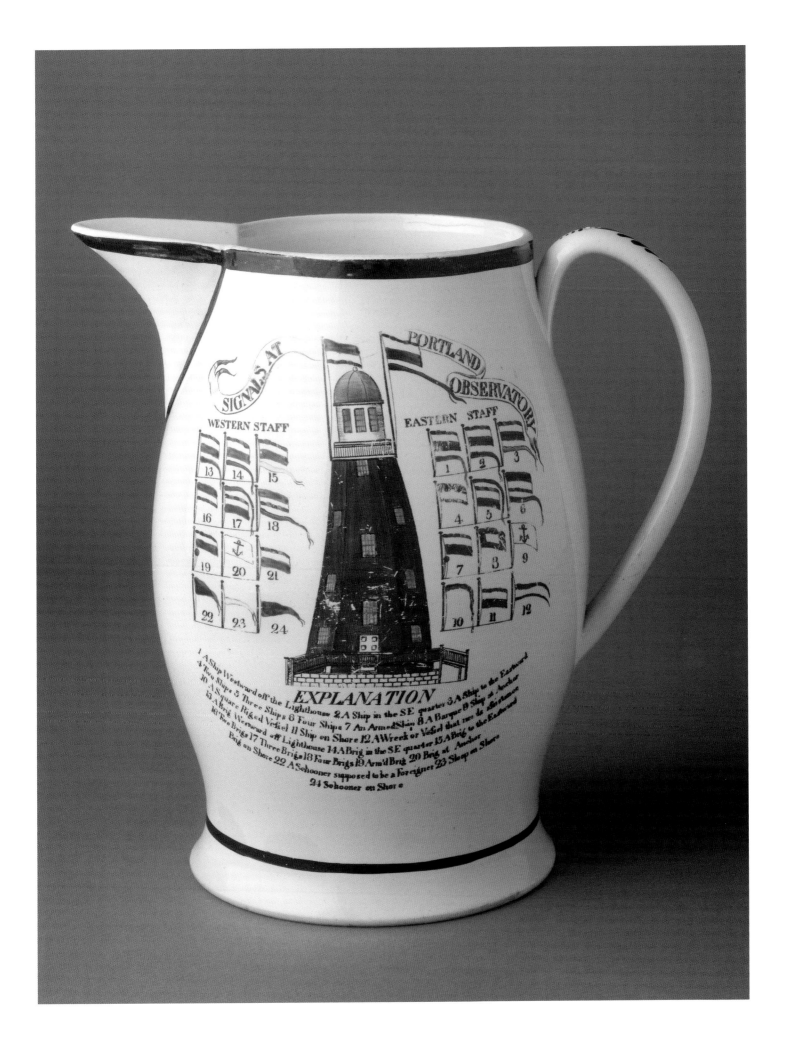

SIGNALS AT PORTLAND OBSERVATORY

WESTERN STAFF

EASTERN STAFF

EXPLANATION

1 A Ship Westward off the Lighthouse 2 A Ship in the SE quarter 3 A Ship to the Eastward
4 Two Ships 5 Three Ships 6 Four Ships 7 An Armed Ship 8 A Barque 9 Ship at Anchor
10 A Square Riged Vessel 11 Ship on Shore 12 A Wreck or Vessel that run to the Eastward
13 A Brig Westward off Lighthouse 14 A Brig in the SE quarter 15 A Brig to the Eastward
16 Two Brigs 17 Three Brigs 18 Four Brigs 19 Arm'd Brig 20 Brig at Anchor
21 Brig on Shore 22 A Schooner supposed to be a Foreigner 23 Sloop on Shore
24 Schooner on Shore

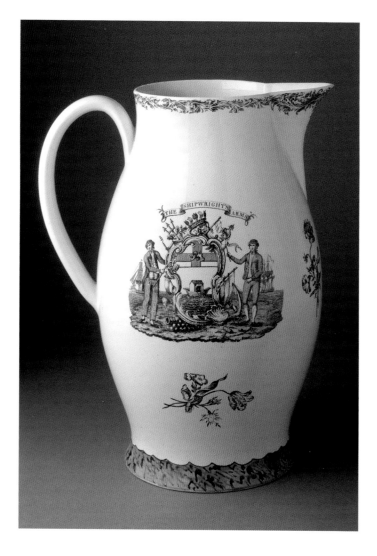

41. Jug
Possibly Herculaneum Pottery
Liverpool, England; 1800–1810
Creamware printed in black and painted in enamels
H. 14¼ in. (362 mm)
2007.31.14 Gift of S. Robert Teitelman

This large jug is decorated with a detailed painting of the launching of a brig that is described with a clear, bold script, "THE LYDIA Jacob Rhoades Builder."

Jacob Rhoades (1742–1820) was a shipwright in Boston, a center of America's shipbuilding industry. According to family history, he was born in Charlestown and learned his craft from his father, also named Jacob

(1715–76). He moved to Boston sometime after 1776, and city directories document him as living on the aptly named Ship Street from at least 1798 until his death in 1820. Though the directories list his occupation as a shipwright, family history also states that at some point he bought and ran the tavern *Two Palaverers*, which was located on Ship Street near Rhoades Wharf.[1]

On the reverse of this jug is a large depiction of the so-called shipwright's arms. This pseudo coat of arms is loosely based on the arms of the Shipwright's Company, one of the London guilds that traces its history to the twelfth century.[2] The image may be taken from documents of a shipwright's friendly society or support group, or it may have been inspired by a tavern sign. There are a number of English taverns known as *The Shipwright's Arms*. Located in coastal towns near shipyards, they would have catered to shipwrights and served as a meeting hall, employment office, and place for recreation and refreshment.[3]

This jug was probably made for Jacob Rhoades. An early twentieth-century tag that was once on the jug notes that it belonged to Mabel Adelaide Rhoades and that it had "belonged to my great great grandfather." Another label refers to "various Arms Jugs" that belonged to Mabel, suggesting that several had descended in the family. At least one other jug is known that was probably made for Jacob. It is decorated with a painted portrait of a ship with the inscription "THE ALERT Jacob Rhoades Builder" on one side and a printed image of the shipwright's arms on the other. The arms, the border at the rim, and the printed floral sprays are identical to those found on the "LYDIA" jug.[4]

Although the unknown artist has done an excellent job of carefully delineating the ship's hull and rigging, he has made one rather dramatic error. Instead of showing the ship sliding down the shipway into the water, he has tilted the entire horizon of the image to convey the idea of the ship's launch. The other mistake is the inclusion of the vessel's masts and rigging, which were usually not put in place until the hull was floating in the water. The unusual green marbled band at the base of the jug is known on one other jug, also in the Teitelman Collection at Winterthur (see cat. no. 49). The printed floral sprays are similar to ones found on pieces made at the Herculaneum Pottery, suggesting a possible origin for this jug.

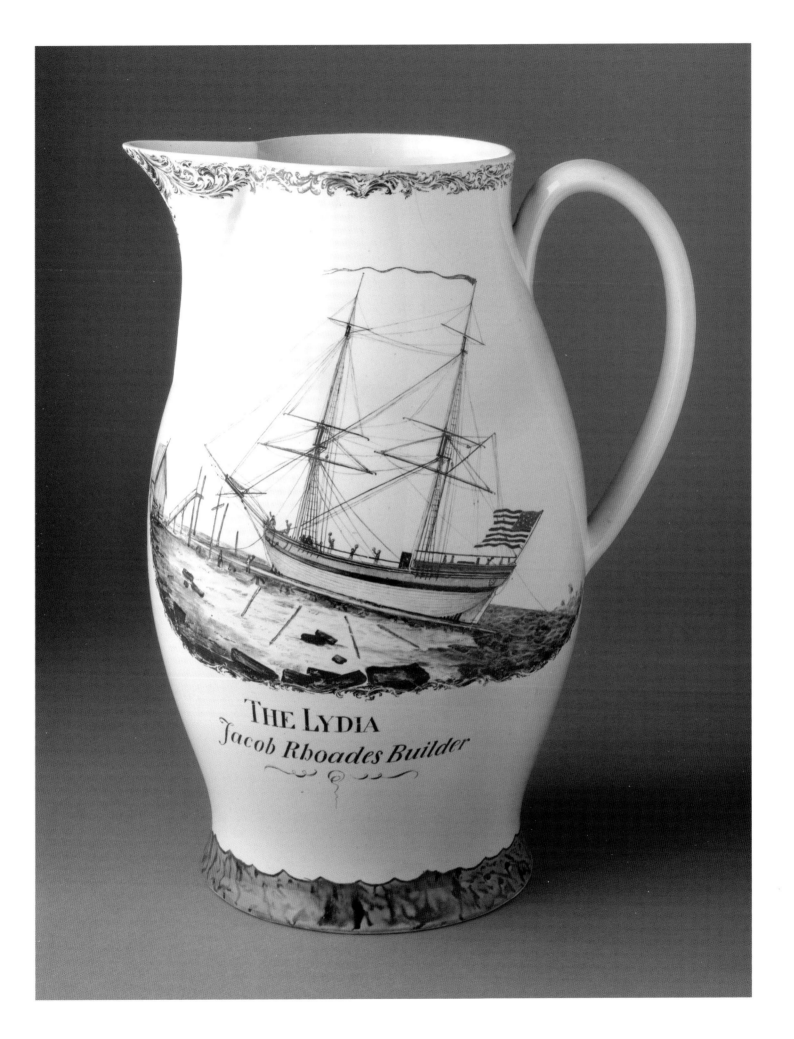

THE LYDIA
Jacob Rhoades Builder

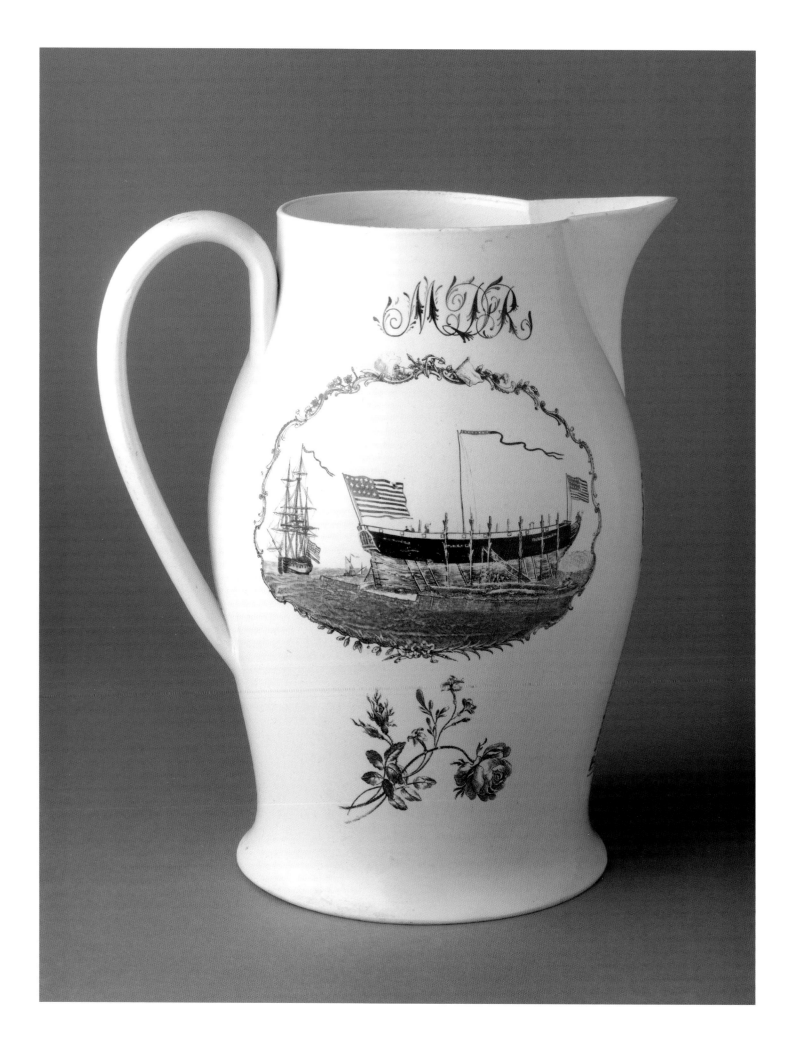

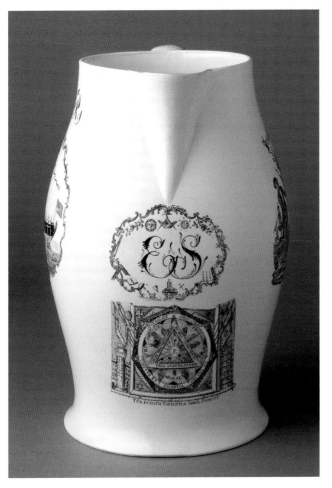
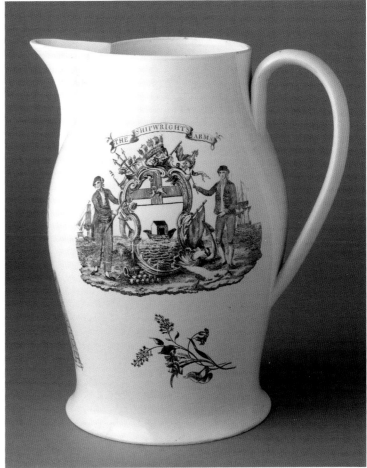

42. Jug

Probably Liverpool, England; 1799–1805
Creamware printed in black and painted in enamels
H. 11 in. (280 mm)
2009.23.2 Gift of S. Robert Teitelman, Roy T. Lefkoe, and
Sydney Ann Lefkoe in memory of S. Robert Teitelman

The enamel-painted print on this jug shows the hull of
a ship being prepared for launching. Constructing a ship
from the keel up took several months and involved a
range of craftspeople: sawyers who cut and shaped the
timbers; carpenters and caulkers who built and sealed
the hull; mastmakers, sailmakers, and cordwainers who
made the masts, sails, and rigging that powered the
vessel; and ironmongers who formed the metal fittings.
A launching was cause for community-wide
celebration, and the flags and crowds depicted on this
jug suggest the noise and festive atmosphere.

According to family tradition, the vessel is the *Patapsco*,
a subscription ship built in Baltimore in 1799 for the
Quasi-War with France.[1] Launched with great fanfare on
June 20, 1799, she was a 418-ton sloop of war that carried
eighteen guns. According to the local newspaper, the
Patapsco was "safely committed to the waves, amidst the
loud acclamations of a large concourse of spectators, the
discharge of cannon from the new brig *John Brickwood*, and

a ship at the fort, seconded by vollies from the volunteers
and marines on board. On no occasion was there ever a
launch conducted in a more masterly manner, or one that
terminated more to the honor, or satisfactory to the
feelings of the builder."[2]

The builder of the *Patapsco* was Lewis de Rochbrune
(1764–1802), who had a successful shipyard in Baltimore at
Fells Point. He seems to have commemorated the
construction of his most famous vessel by ordering two
jugs; this one and its mate, which remains with his
descendants.[3] The mate bears the initials "LDR" under the
spout, presumably for Lewis de Rochbrune. The "MDR"
that appears above the ship-launching scene on both jugs
most likely refers to de Rochbrune's daughter, Mary. This
jug carries the painted initials "ES" under the spout, but
the referent is not known. Also beneath the spout are
Masonic symbols and the inscription "TPK INITIUM
SAPIENTAE AMOR DOMINI." On the reverse of both
jugs is a depiction of the shipwright's arms (see cat. no. 41).

The printed image of the ship being launched is not
a portrait of the *Patapsco*, but rather a generic stock
print. There were at least two versions of the print; this
one is flying the American flag and another flies the
British flag. The copper plates were no doubt made by
the same engraver, who provided different versions for
customers of different nationalities.[4]

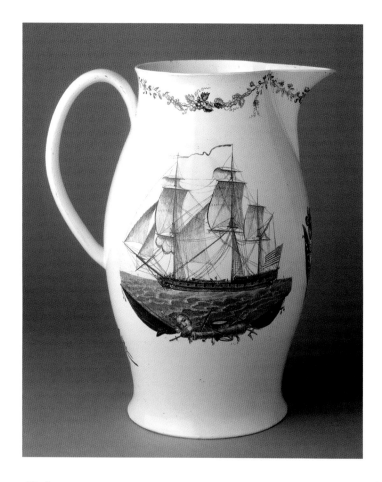

43. Jug

Probably Liverpool, England; 1792–1805
Creamware printed in black and painted in enamels
H. 13⅞ in. (345 mm)
2009.21.11 Gift of S. Robert Teitelman

This extraordinary jug is decorated with a rare view of an early American industrial complex: George and Peter Cade's Ropewalk in Boston, Massachusetts. A ropewalk is a long, narrow building in which rope is made by winding strands of fiber together. Rope was indispensible for sailing ships; a typical frigate like the *Constitution*, built in Boston in 1797, required approximately twenty miles of the product.[1] Ropewalks were common in port cities, and there were no fewer than eleven in Boston during the eighteenth and early nineteenth centuries.[2]

Sons of a ropemaker, the Cade brothers purchased a plot of land 900 feet by 24 feet at the base of Beacon Hill in 1792 and opened the ropewalk soon after.[3] The business nearly did not survive its first year, as the buildings were destroyed during a "storm of wind" in February 1793. A local newspaper recounted the near ruin of the Cades, noting that "by this misfortune, these industrious young Men, are deprived of their only means of procuring a living for themselves and their families. But, we trust, Industry will, as it ever has, on like unfortunate occasions, have the Arm of Generosity extended towards these worthy Fellow Citizens."[4]

The arm of generosity was indeed extended, and within a few weeks "a number of House Carpenters and Masons, have cheerfully offered to assist Messrs Cades, gratis, in rebuilding their Rope Walk."[5] With insurance being rare, it is likely that these sorts of informal community efforts to assist the victims of disasters like storms and fires were common. From these relatively inauspicious beginnings, the ropewalk prospered and by 1798 was valued at $3,300.[6] The Cade brothers continued until at least May 1804, when they advertised the business for sale as "the ropewalk at West Boston, lately occupied by Messrs Cades."[7] In 1805 it and two adjoining ropewalks purchased by developers were demolished, and new housing was created.[8]

Behind the ropewalk rises Beacon Hill, named for the navigational beacon that stood there from as early as 1635 until it was destroyed during the American Revolution. The column atop the hill was constructed in 1790 as a memorial to the Revolutionary War. It was removed in 1811, when the hill was regraded and the land developed.[9]

This jug was probably made to celebrate the establishment of the business in 1792, with the design almost certainly based on a drawing. The Cades no doubt knew many shipowners and captains who could have taken the design to Liverpool and commissioned the jug. With its bold inscription, "AMERICAN MANUFACTURE. Cables & Cordage Manufactured by Geo: & Peter Cade at their ROPE WALK near Beacon Hill, BOSTON. N.B. Shipping supplied with large or small quantities," the jug was probably intended to serve as an advertisement.

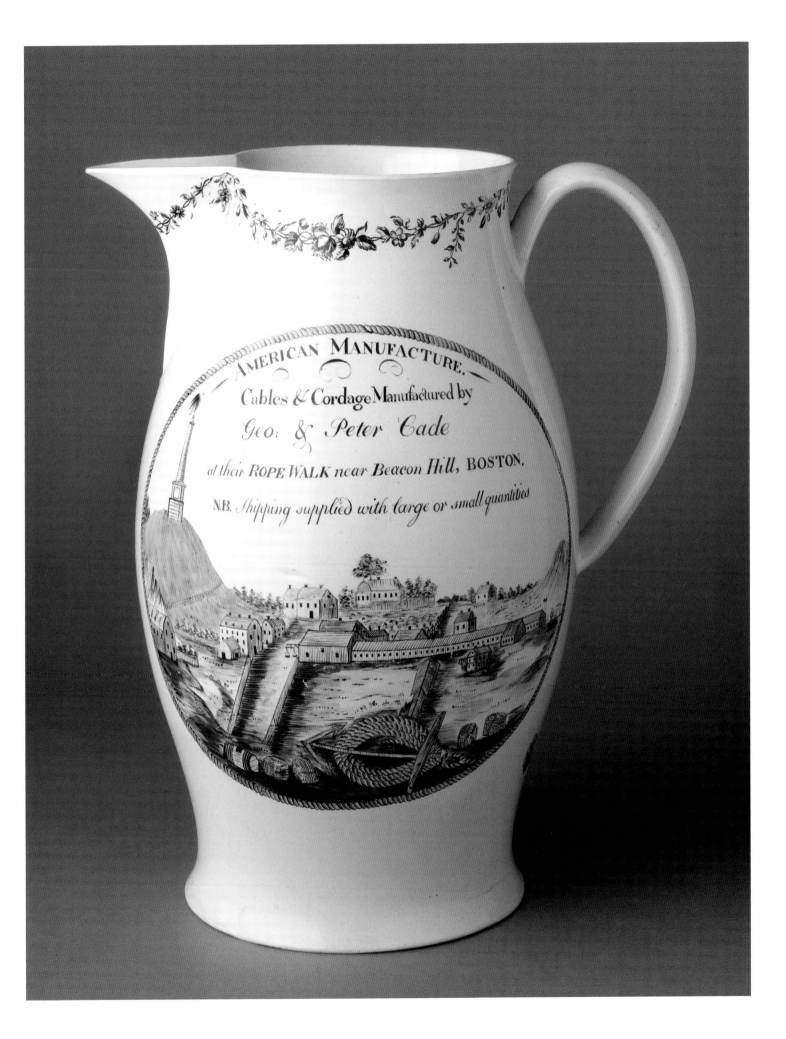

AMERICAN MANUFACTURE.

Cables & Cordage Manufactured by

Geo: & Peter Cade

at their ROPE WALK near Beacon Hill, BOSTON.

N.B. Shipping supplied with large or small quantities

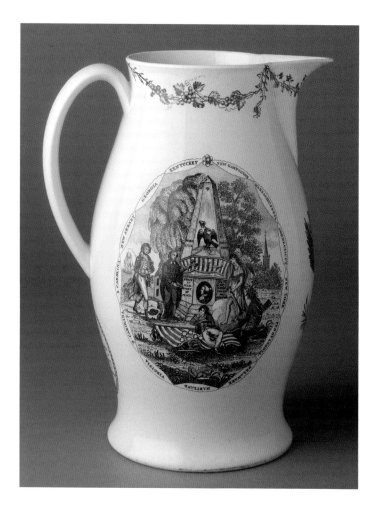

44. Jug
Probably Herculaneum Pottery
Liverpool, England; 1800–1810
Creamware printed in black
H. 11¾ in. (298 mm)
2009.21.18 Gift of S. Robert Teitelman

This jug is decorated with a print showing three sailmakers at work beneath a banner inscribed "SUCCESS TO THE SAIL MAKERS." Well-made sails were crucial to a vessel's safe and swift movement, and sailmaking was an important profession in every port city. Most large vessels in the eighteenth and early nineteenth centuries were square-rigged, meaning they were outfitted with trapezoidal sheets of canvas hung from horizontal spars that were themselves hung perpendicular, or square, to the keel of the vessel. In addition, they also had fore-and-aft sails, which were triangular or trapezoidal canvases sometimes hung on spars and booms, also parallel to a vessel's keel. Large vessels had many sails; the *Constitution*, built in 1797 for the U.S. Navy, had approximately thirty-five sails and would have carried spares in case of damage or loss.[1]

The jug is also decorated with a memorial to George Washington. This scene is commonly found on English creamware attributed to Herculaneum (see cat. nos. 49, 55) and is known on a printed cotton handkerchief made by

Jonathan Maclie & Co. of Glasgow about 1800.[2] The origin of the design is likely to be a print on paper, but so far it has not been identified. The design is encircled by a chain of states, and the central feature is an obelisk.[3] The base carries a profile portrait of George Washington and is inscribed "FIRST IN WAR. FIRST IN PEACE" to the right and "FIRST IN FAME FIRST IN VIRTUE" to the left. On the upper part of the obelisk is an eagle holding a staff with the liberty cap and the inscriptions "BORN 1732 DIED 1799." At the pinnacle of the obelisk is the Masonic symbol of the All-Seeing Eye, indicating watchfulness and the Supreme Being. Around the base of the memorial is a group of mourners. At the extreme right we see a kneeling figure of America in the form of an Indian princess. Fame stands with her trumpet lowered as she regards the monument. On the ground at the center, lying on an American flag and amid weapons of war, is a young man who may be a Revolutionary War soldier; a clergyman represents Washington's religious affiliations; and a sailor, his ship in the background, approaches to offer his condolences. More than any other Washington memorial on a ceramic body, this scene captures the spiritual and temporal aspects of Washington in life and in death.

Beneath the lip of the jug is the print of a large, handsome eagle, a design based on the Great Seal of the United States. This jug is attributed to the Herculaneum Pottery based on the fact that the eagle is a larger version of the one used in the Herculaneum mark (see cat. no. 12).[4] Beneath the handle an oval medallion containing a motto honoring Washington reads "A MAN without example A Patriot without reproach." This sentiment often appears on English creamware and is taken from Thomas Paine's "Eulogy on the Life of General Washington," delivered at Newburyport, January 2, 1800.[5] The image of the sailmakers is not often seen and could conceivably have been engraved for any maritime customer. With the addition of three American subjects, however, it is clear that the Herculaneum Pottery was trying to attract American customers by offering an opportunity to celebrate maritime trade as well as honor the memory of George Washington.

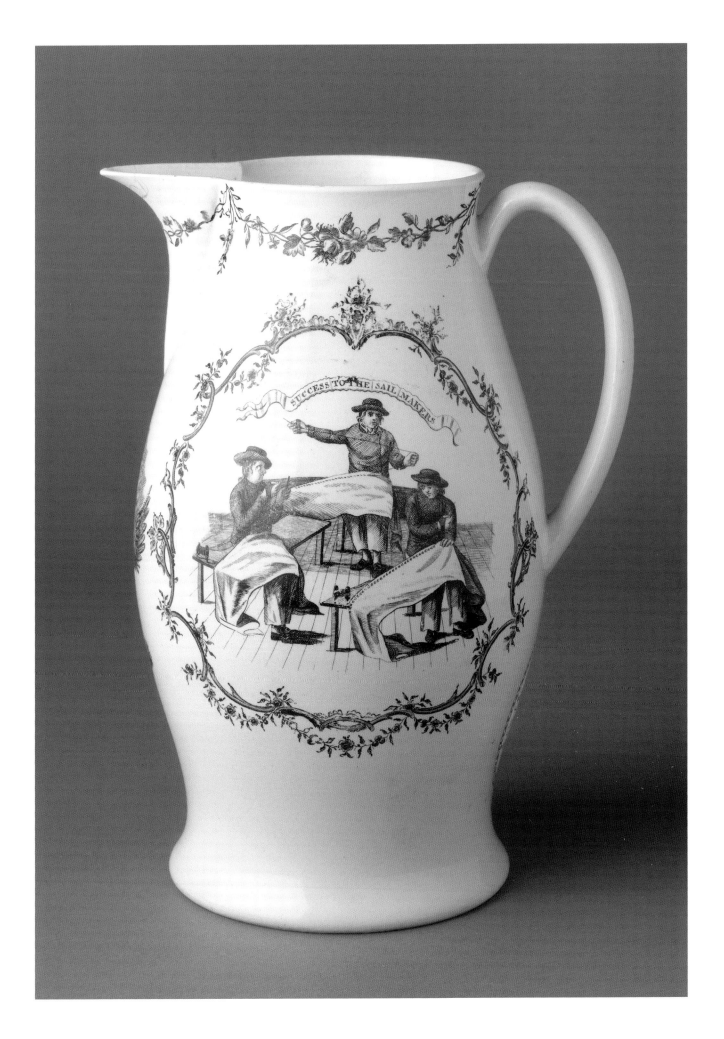

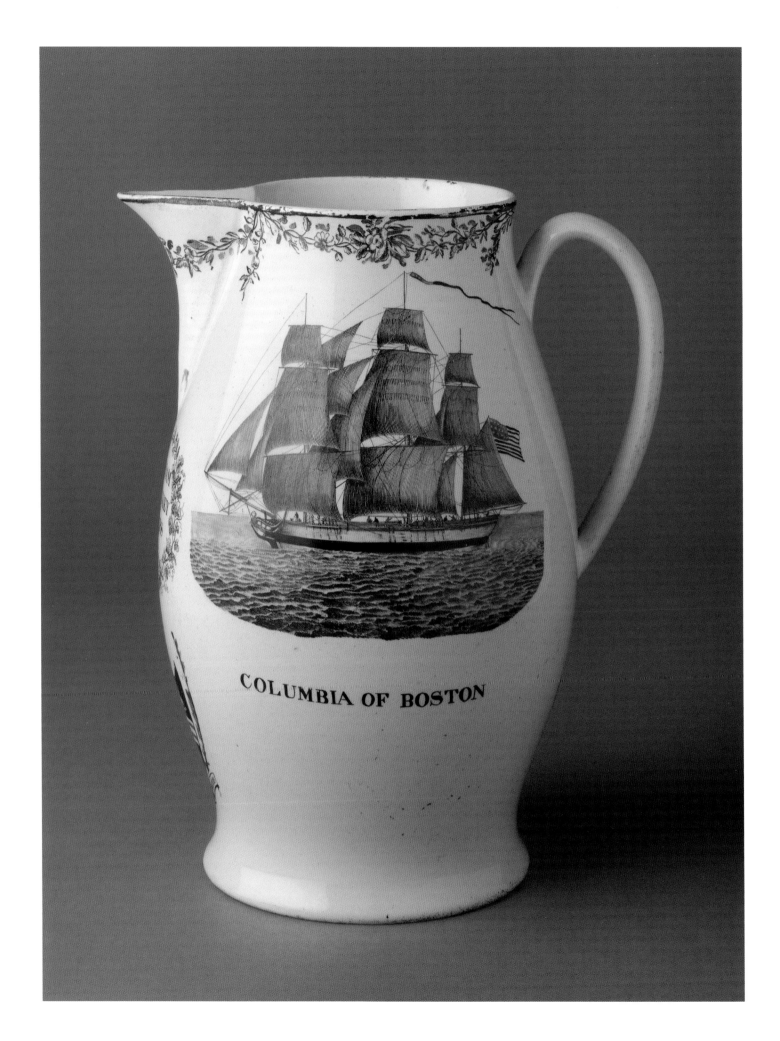

COLUMBIA OF BOSTON

45. Jug
Probably Herculaneum Pottery
Liverpool, England; 1795–1801
Creamware printed in black and painted in enamels
H. 11 in. (279 mm)
2009.23.19 Gift of S. Robert Teitelman, Roy T. Lefkoe, and
Sydney Ann Lefkoe in memory of S. Robert Teitelman

A view of the first American ship to circumnavigate the globe, the *Columbia* of Boston, decorates this jug. Built in Plymouth, Massachusetts, in 1787, she was a large, three-masted ship that measured 83½ feet in length, 24 feet beam, and 212 tons burthen.[1] Owned by a consortium of Boston merchants active in the China Trade, she sailed from Boston on September 30, 1787. Accompanied by the sloop *Lady Washington*, she made her way around Cape Horn and up to the Pacific Northwest (the coast of modern-day Oregon), where the seamen traded with Native Americans for otter pelts, which were much in demand in China. The ship then continued across the Pacific to the Hawaiian Islands and on to Canton (now known as Guangzhou), on the Pearl River in southern China, where the cargo of furs was exchanged for tea. The return trip to America was by way of the Cape of Good Hope and across the Atlantic. She arrived in Boston on August 9, 1790, having traveled 48,889 miles.[2]

The *Columbia* made this long and treacherous voyage twice, departing the second time a scant six weeks after her initial return, on September 28, 1790. During this second voyage the captain, Robert Gray, charted the mouth of the Columbia River, which he named after the ship. The *Columbia* returned to Boston on July 29, 1793, and continued to sail until 1801, when, with her hull badly eaten away by ship worms, she was sold for scrap and "rip't to pieces."[3]

Beneath the spout of this jug is the inscription "Abraham and Sukey Waters" and the Waters coat of arms. Abraham Waters was a seaman on board the *Columbia*. He joined the crew on August 2, 1787 and earned £82.4.0—the fourth highest wage paid, suggesting he was especially skilled.[4] He was the fourth mate by the time of the *Columbia*'s second voyage to the Pacific Northwest in 1790–93 and eventually rose to third mate.[5] Waters remained with the *Columbia* after she was sold and eventually became her master, a position he held until the ship was condemned in 1801.[6] Waters married Sukey Simonds of Boston in 1795.[7] According to family lore, this jug (one of a pair) was a wedding gift from Captain Gray of the *Columbia*, who also thanked Waters for having rescued him from some danger during their second voyage.[8] Waters was lost at sea on August 8, 1819, age fifty-one; his wife lived another twenty years.[9]

The image of the vessel on the jug is a stock print and not a portrait of the actual *Columbia*. On the reverse is a memorial to George Washington (see cat. no. 69).[10]

Beneath the handle is an adaptation of the Great Seal of the United States that has been attributed to the Herculaneum Pottery.

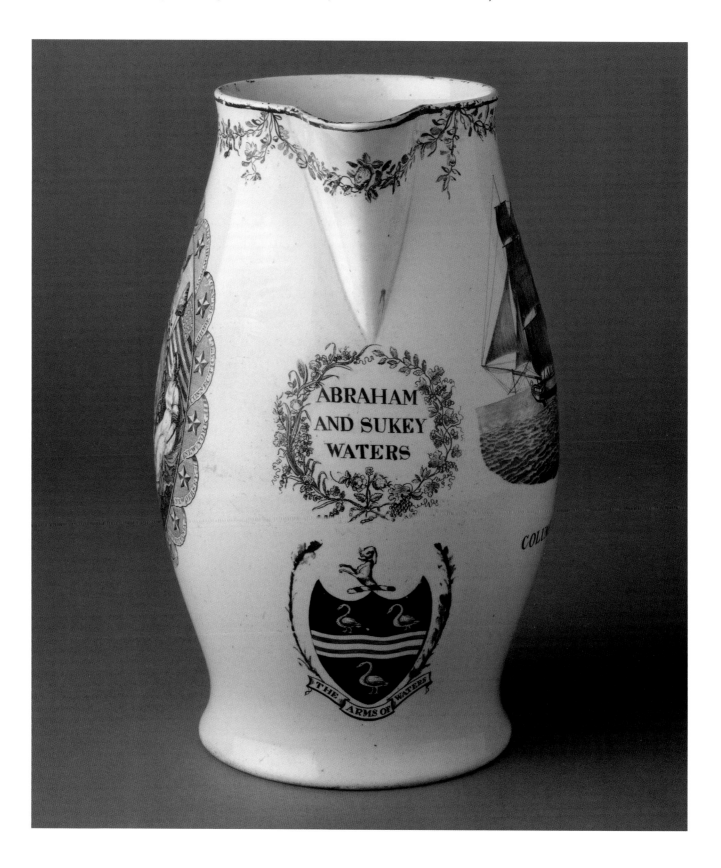

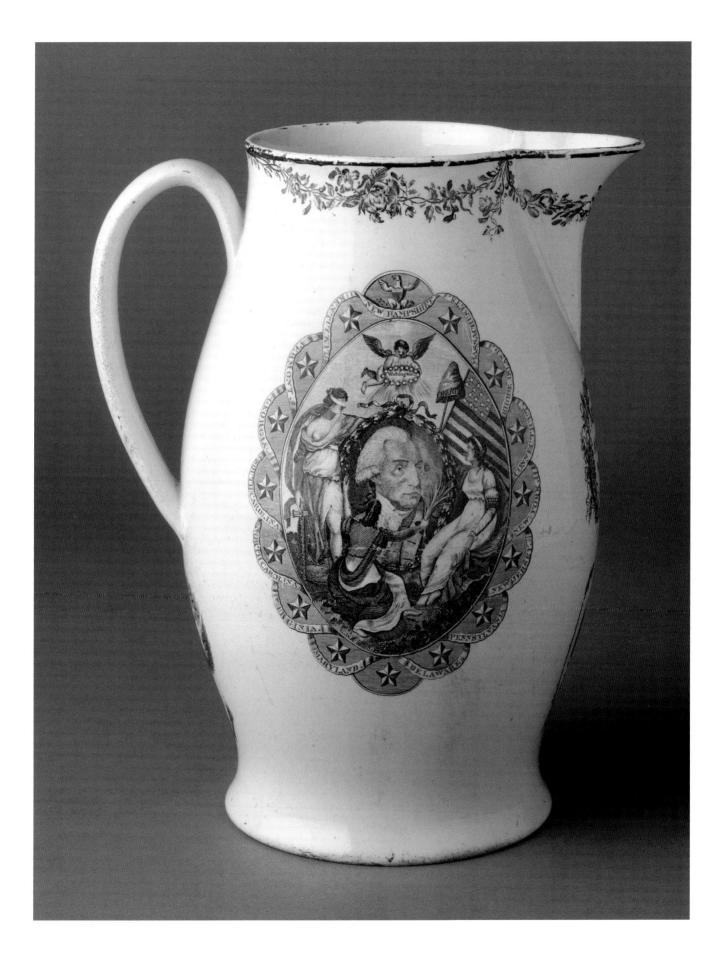

46. Jug
Probably Herculaneum Pottery
Liverpool, England; 1802–8
Creamware printed in black and painted in enamels
H. 11¼ in. (298 mm)
2009.21.14 Gift of S. Robert Teitelman

This jug is decorated with an accurately painted portrait of the *Happy Couple of Savannah*, which was described as a "fast sailing, well accommodated coppered brig" that was "intended as a regular packet" between New York and Savannah, Georgia.[1] She was built in 1798, measured 174 tons, and had a single deck.[2] Joseph Starks, whose name appears beneath the spout on the jug, was master of the brig from at least 1802 until 1808.[3]

The *Happy Couple* carried passengers and cargo consisting primarily of cotton but also rice, ginseng, "pink root," and even orange juice.[4] At the turn of the nineteenth century, New York City was the center of the cotton trade between England and America, with New York bankers and merchants acting as brokers and agents. While some cotton was shipped directly to England from southern ports like Savannah, vast amounts were sent first to New York on smaller boats and then loaded onto larger ships for the transatlantic voyage to Liverpool and the textile mills of England.[5]

In 1803, as she was traveling further afield, the *Happy Couple* became a victim of Britain's attempts to stop American trade with France during the Napoleonic Wars; in the fall of that year it was reported that en route from St. Vincent in the Caribbean to New York the *Happy Couple* "was boarded by four boats, having on board 100 men, armed, from the British frigate *Seraphis*, who behaved in the most wanton manner; knocked down the mate, and threatened to carry the captain on board the frigate and flog him—cut away the studding sail tacks, and robbed the caboose."[6]

During the long war between France and Britain (1799 to 1815 with a hiatus between 1802 and 1803), both sides tried to prevent the United States from supplying the other with foodstuffs and raw materials. This was accomplished by stopping and searching American ships and by impressing, or seizing, sailors into the British navy who were thought to be deserters or British-born. The Napoleonic Wars resumed in May 1803, and harassment of American ships began almost immediately. By August 1805 it was estimated that hundreds of ships had been stopped and some 1,500 American sailors had been impressed—one of the primary causes of the War of 1812.[7]

On the reverse of the jug is a memorial to George

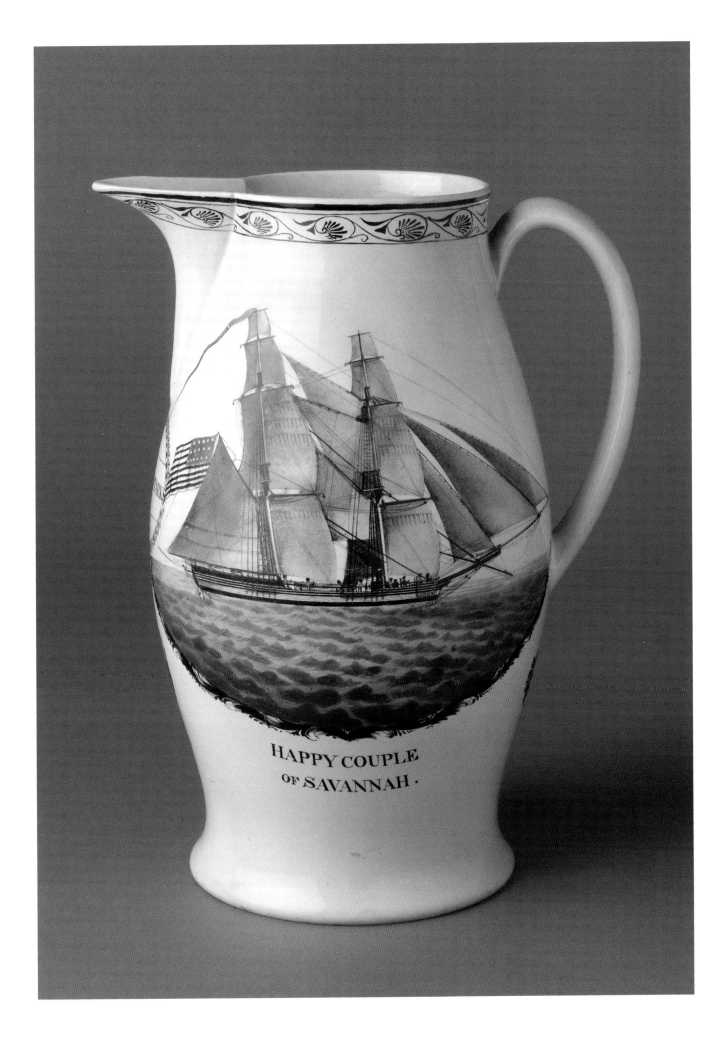

HAPPY COUPLE
OF SAVANNAH.

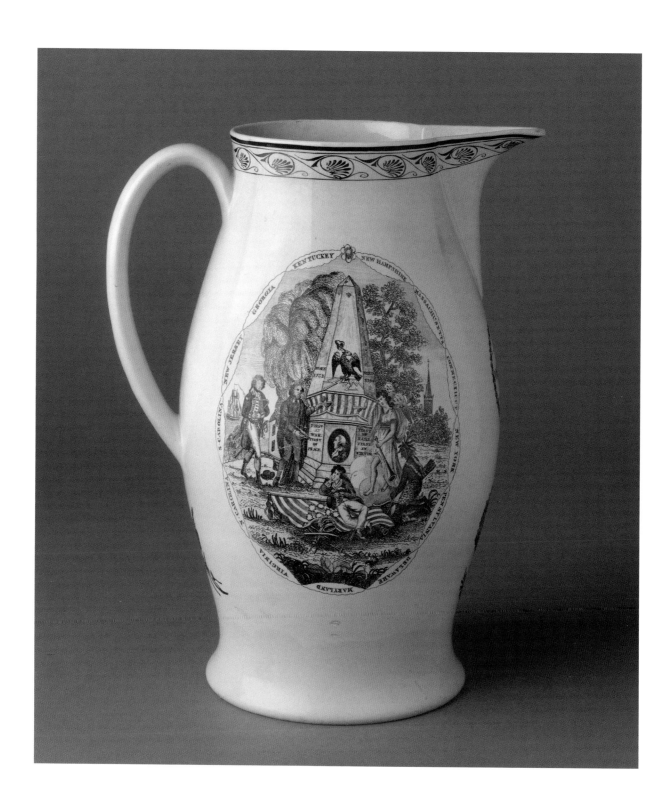

Washington with an obelisk, mourning figures including a Native American, and the inscription "FIRST IN WAR, FIRST IN PEACE, FIRST IN FAME, FIRST IN VIRTUE" (see cat. no. 44). This sentiment was expressed by Henry Lee in his funeral eulogy of Washington when he described him as being "First in War, First in Peace, and First in the Hearts of his Countrymen." The entire scene is framed by a chain of states, with each of the thirteen links containing the name of a state (Rhode Island has been replaced by the fourteenth state, Kentucky).

This jug is part of a small group of creamware jugs with painted portraits of specific vessels that have been attributed to the Herculaneum Pottery based on the fact that two of the jugs in the group bear Herculaneum marks.[8] Many of

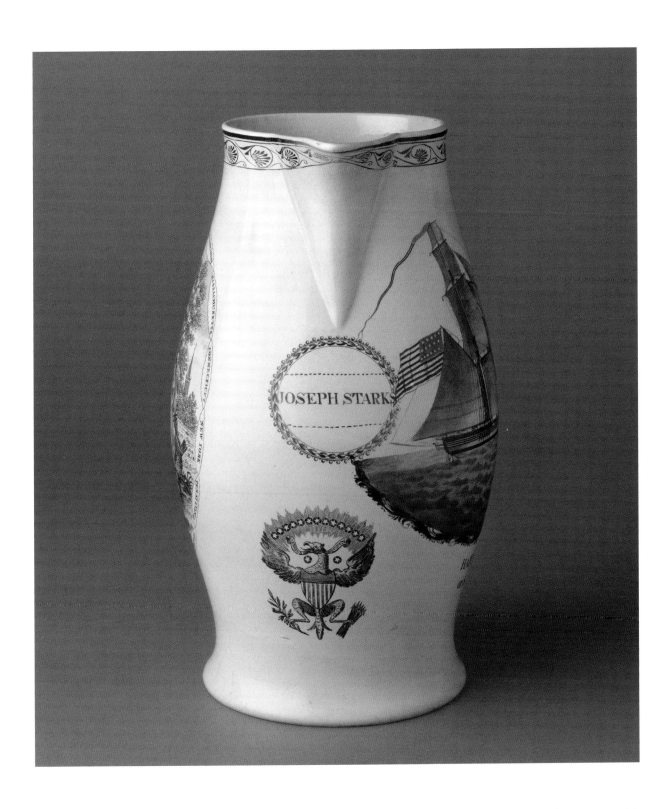

the pieces in this group share an anthemion border at the rim and some have feathering at the spout—characteristics also attributed to Herculaneum. They also bear prints, including a version of the Great Seal of the United States and a memorial to George Washington, that appear on pieces marked or attributed to the Herculaneum factory.

While this attribution is logical, there is also the possibility that the pieces may have been painted by an independent decorator in Liverpool (see Authors' Notes).[9] The fact that other jugs exist with hand-painted ship portraits that do not appear to be part of this group suggests that there were several decorators, or workshops that had a house style, working in Liverpool in the late eighteenth and early nineteenth centuries.[10]

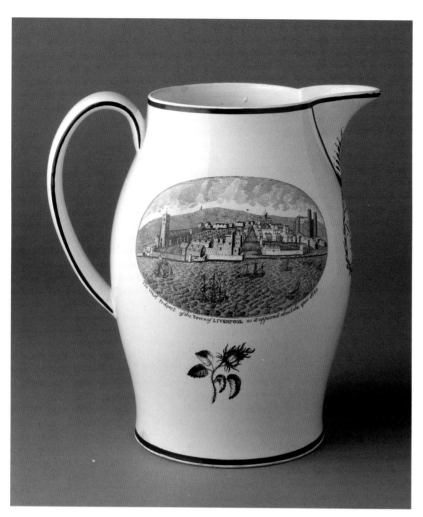

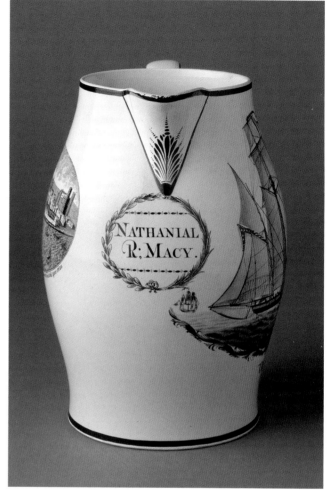

47. Jug

Herculaneum Pottery
Liverpool, England; ca. 1806
Creamware printed in black and painted in enamels
Impressed "HERCULANEUM"
H. 10 in. (255 mm)
2009.21.6 Gift of S. Robert Teitelman

This jug carries a rare, hand-painted portrait of the schooner *Orestes*, which had three masts, one deck, and a square stern. She measured 138 tons, 85 feet in length, 23 feet in width, and drew nearly 8 feet. Built in Baltimore, Maryland, she was registered in New York in 1805.[1]

Orestes was the son of the Trojan War hero Agamemnon. He was tormented by the Furies for killing his mother and her lover in revenge for their murder of his father. There was widespread knowledge of Greek and Roman mythology in the eighteenth and early nineteenth centuries, and ships were often named after ancient gods, goddesses, and heroes. During the same period that the *Orestes* sailed, there were other ships of the same name as well as ships named after Agamemnon and his sister Electra.

Nathaniel Macy is listed as master of the *Orestes* in 1806 on a voyage to Goteborg, Sweden.[2] A native of Nantucket, he was born in 1776, married Elisabeth Clasby in 1799, and in 1802 joined the Marine Society of City of New York, an organization dedicated to providing relief for distressed sea masters, their widows, and children as well as promoting maritime knowledge.[3] On December 1, 1815, at the age of thirty-nine, Nathaniel died at sea.[4]

On the reverse of this jug is the print "The West Prospect of the TOWN of LIVERPOOL as it appeared about the year 1680," before it rose to prominence as one of Great Britain's primary ports. The jug is part of a small group decorated with finely painted portraits of actual vessels.

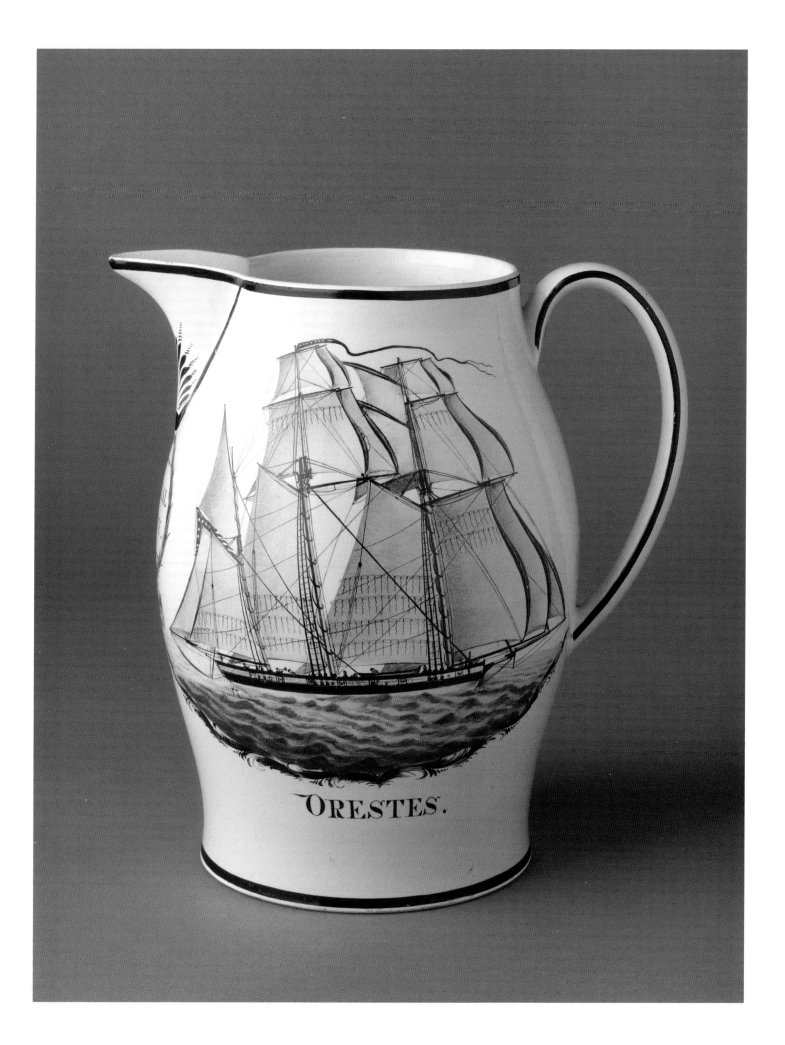

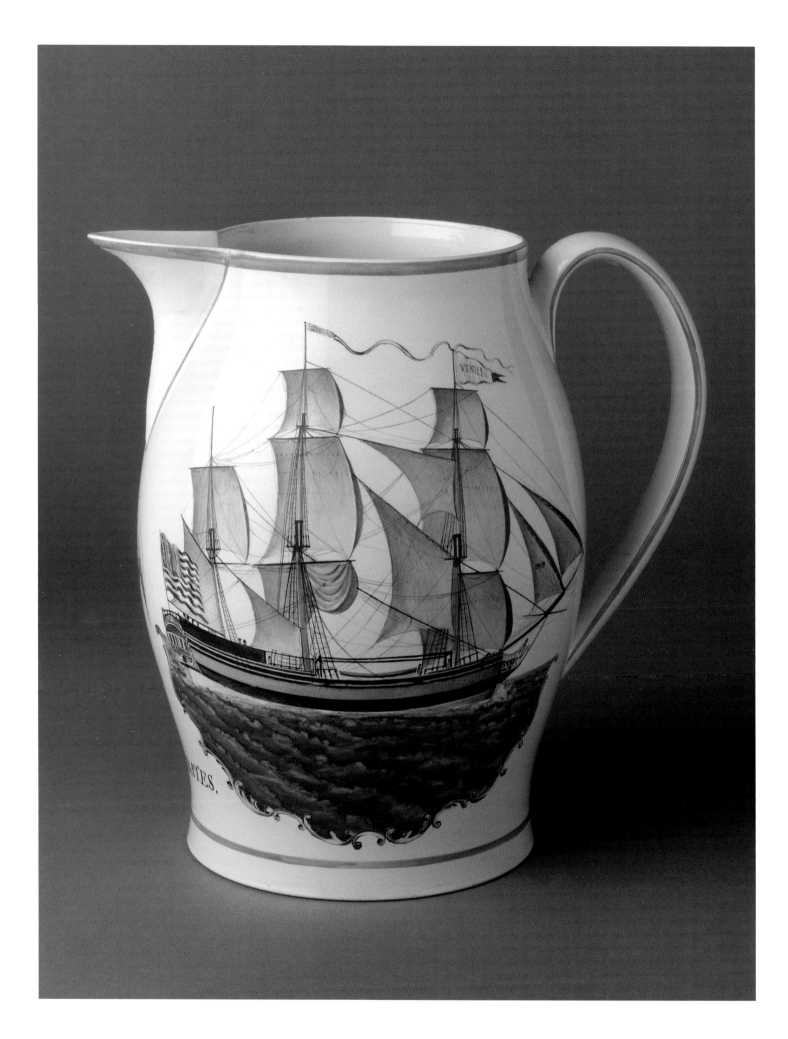

48. Jug

Made in Liverpool or Staffordshire, probably decorated in Liverpool, England; 1798–1801
Creamware printed in purple and painted in enamels
H. 10⅜ in. (264 mm)
2009.21.13 Gift of S. Robert Teitelman

This jug bears a delicately painted view of the ship *Venilia*, which was named after the mythological sea nymph who presided over the winds and coastal waters. The jug was made for the ship's master, Caleb Bates, whose name appears under the spout with an adaptation of the Great Seal of the United States transfer-printed in purple. The *Venilia* was registered in Charlestown, Massachusetts, in February 1798, with Bates as master and David Hinkley of Boston as owner. Advertisements list Bates as the master sailing on at least five voyages between Boston and Liverpool, Dublin, and Cowes.[1] He was captain of the *Venilia* (1798–1801), the *Juno* (1804–9), the *Argonaut* (1809–12), the *Mary* (1816), and the *Minerva* (1818–19). He traveled to Britain, Continental Europe, India, and China.

A native of Scituate, Massachusetts, Bates married Mary Douglas in 1796, and in 1800 they moved to Concord. They had seven children.[2] The income from his voyages gave the family a comfortable lifestyle; they owned a large house in downtown Concord, had a pew on the floor of the Concord Meetinghouse (a placement that had higher status than pews placed elsewhere); and possessed luxury items, including a Chinese export porcelain service and portraits of Bates and Mary.[3]

It is usually thought that hand-painted views on jugs are likely to be fairly accurate portraits of the vessels they portray. However, that may not always be the case. The vessel painted on this jug is a large, three-masted ship, while the registration papers document that the *Venilia* that Bates sailed was a smaller, two-masted 167-ton brigantine built in Haverill, Massachusetts, in 1796.[4] It is unlikely that the ship would have received an additional mast, and it also seems unlikely that a mistake would have been made with the ship's registration. One possibility is that the jug had already been painted, much like jugs decorated with stock prints, and simply had the name added.

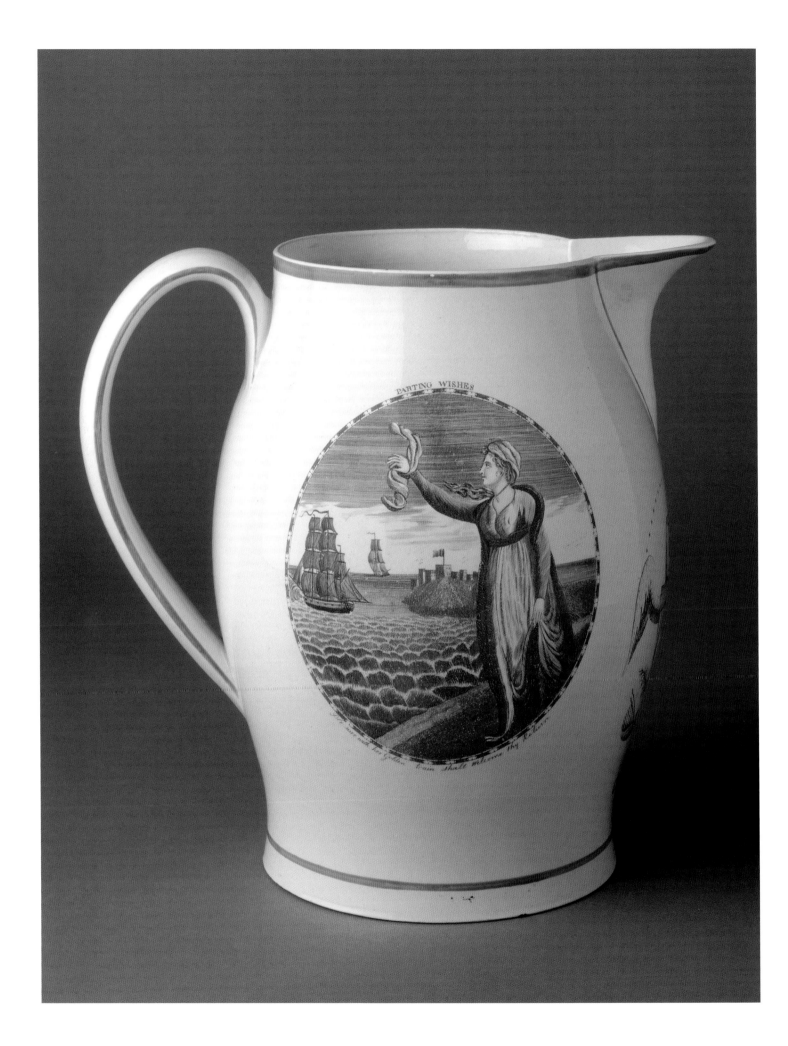

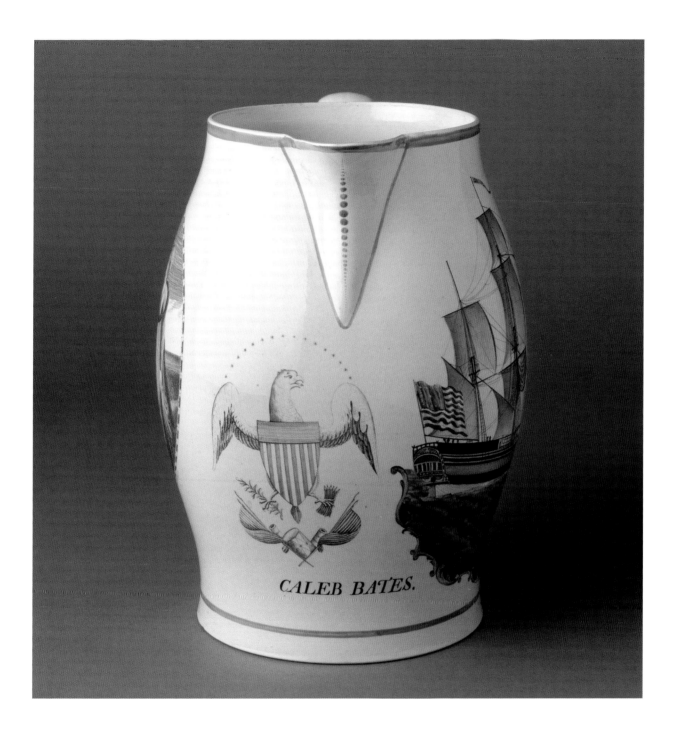

On the reverse of the jug is an image of a woman standing at the water's edge and waving a scarf at a departing ship. Printed in purple, it is accompanied by the inscription "PARTING WISHES," and "Pleasure with her Golden train shall Welcome thy Return." Though likely lines from a poem or ballad, their exact origin has not been discovered. The image expresses a sentiment common among those family members left behind when husbands, fathers, brothers, and sons departed on long and dangerous voyages. Beneath the spout is an eagle, also printed in purple. Bright green enamel lines decorate the rim, base, and edges of the handle and spout. A nearly identical jug with a view of the *Venilia* and the name Lemuel Webb and Leah Webb also exists, suggesting that several crewmembers of the ship commissioned jugs while in England.[5]

Jugs with actual painted portraits of vessels are rare, but there are several groups thought to have been painted by different artists or in different house styles. This jug represents one group; another group is associated with the Herculaneum Pottery (see cat. nos. 46, 47); and a further includes the jug decorated with the *Lydia* (see cat. no. 41).

49. Jug
Probably Herculaneum Pottery
Liverpool, England; 1803–9
Creamware printed in black and painted in enamels
H. 13¹¹⁄₁₆ in. (348 mm)
2007.31.7 Gift of S. Robert Teitelman

This monumental jug is an advertisement for a packet service between the ports of New York and Liverpool. It bears a printed view of a three-masted ship and the inscription "FOR NEW YORK THE SHIP WARREN, B. HAMMOND, MASTER. WILL SAIL WITH ALL POSSIBLE DESPATCH _ FOR FREIGHT OR PASSAGE APPLY TO SAID MASTER, ON BOARD, OR TO CROPPER, BENSON & Cᵒ"

Built in Warren, Rhode Island, in 1795, the *Warren* was a three-masted ship with two decks and a square stern, measuring 96 feet in length, 26 feet beam, and 326 tons.[1] She was originally listed as having no figurehead (which was not uncommon), but by 1801 renovations allowed her to boast of "a man figure head."[2] Advertisements described her as a "fine new ship" with excellent accommodations."[3] The *Warren* was owned in succession by a number of New York merchants.[4] Benjamin Hammond was the master from 1803 until 1809, when she sailed primarily between New York and Liverpool.[5]

The firm of Cropper, Benson & Co. was founded in 1799 and remained in business until 1838. One of Liverpool's leading merchant houses, they traded primarily with the United States, buying cotton and wheat and selling domestic goods such as textiles and ceramics.[6] The company also helped establish the Black Ball Line in 1817, which was the first transatlantic packet service to sail on a fixed schedule between Liverpool and New York.[7]

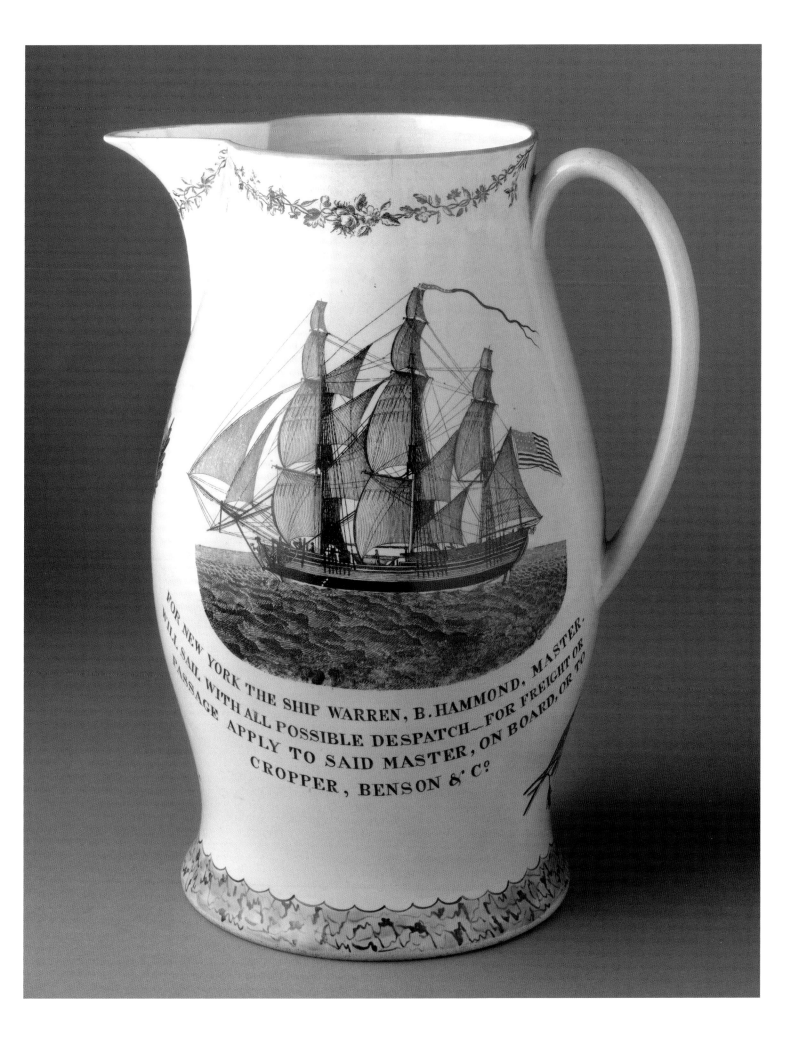

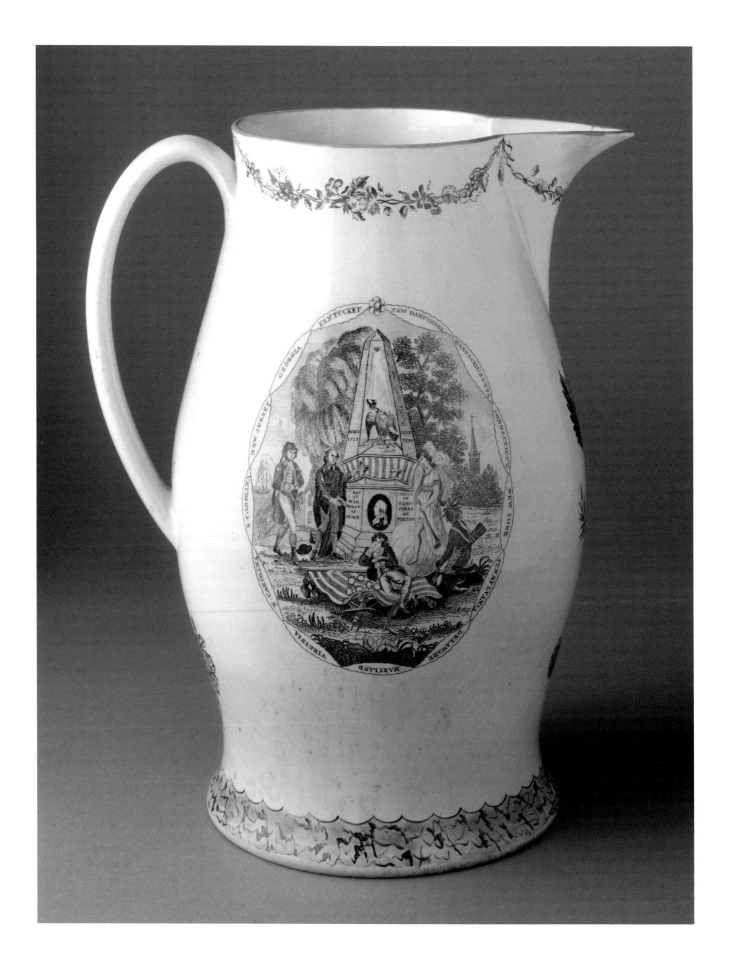

On the reverse of this jug is a memorial to George Washington—an obelisk and the motto "FIRST IN WAR FIRST IN PEACE" on the left and "FIRST IN FAME FIRST IN VIRTUE" framed with a chain of states (see cat. nos. 44, 46). Beneath the spout is a version of the Great Seal of the United States. Both prints as well as the floral sprays are attributed to the Herculaneum Pottery. The unusual green marbled band at the base is known on one other jug, also in the Teitelman Collection (see cat. no. 41). Large jugs bearing the names of manufacturers, retailers, and shipping lines were used for promotional purposes, and this one was an advertisement for the *Warren*, possibly in one of the windows of Cropper, Benson & Co.'s counting house in Liverpool.[8] The jug has been recognized since the turn of the twentieth century as one of the finest Liverpool-type jugs made for the American market.[9]

50. Jug
Herculaneum Pottery
Liverpool, England; 1806
Creamware printed in black and painted in enamels
H. 10⅜ in. (264 mm)
2009.23.16 Gift of S. Robert Teitelman, Roy T. Lefkoe, and Sydney Ann Lefkoe in memory of S. Robert Teitelman

This jug and its companion (see cat. no. 12) are both decorated with a stock print of a ship, the *Two Brothers*. As is befitting the name, the jugs were made for brothers John and Robert Follett, who were the builders and joint owners of the ship. John (1768–1820) and Robert (1770–1815) were also captains in Kittery Point, Maine, across the Piscataqua River from Portsmouth, New Hampshire.[1] The *Two Brothers* was built prior to 1806, when she appears in the Lloyd's Marine Insurance records as a 260-ton ship (meaning it has three masts) with a single deck. John was her master. She is also mentioned in 1807 and 1812 editions, always sailing between Massachusetts and Liverpool. According to a family history, she was sold in Boston in 1811.[2]

The jug seen here is inscribed beneath the spout "R; FOLLETT" and "Presented by JOHN FOLLETT 1806." The "R; Follett" almost certainly refers to Robert, and the inscription "Presented by John Follett" makes clear that the jug was a gift from John to his brother. The other jug, which has no name or dedication, was probably kept by John, who also gifted Robert with a fine English tall-case clock. According to the handwritten label pasted onto the clock, it "was brought from England on the ship 'Two Brothers' in 1805 (Capt John Follett Master) for the Robert Follett Family of Kittery Maine." John acquired a similar clock for himself on the same voyage.[3]

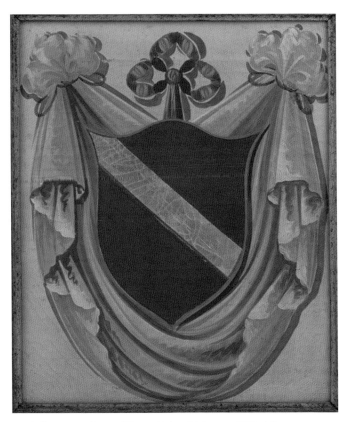

Follett coat of arms, Kittery Point, Maine, ca.1790. Oil on canvas. 1985.14 Collection of Strawbery Banke Museum, gift of Mr. and Mrs. Dean A. Fales Jr. The ink inscription on the stretcher reads: "Captain Follett"

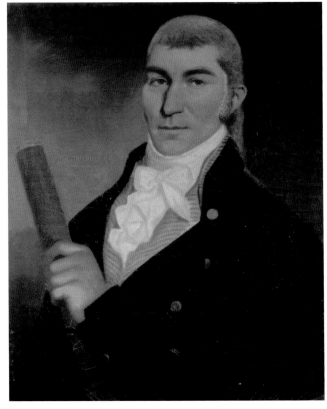

Portrait of John Follett by William Stewart, London, 1801. Oil on canvas. 1980.133 Collection of Strawbery Banke Museum, Museum Purchase. The ink inscription on the top stretcher reads: "By Wm Stewart/In London/John Follett/at the Age of 32 years/ Portrait taken in 1801"

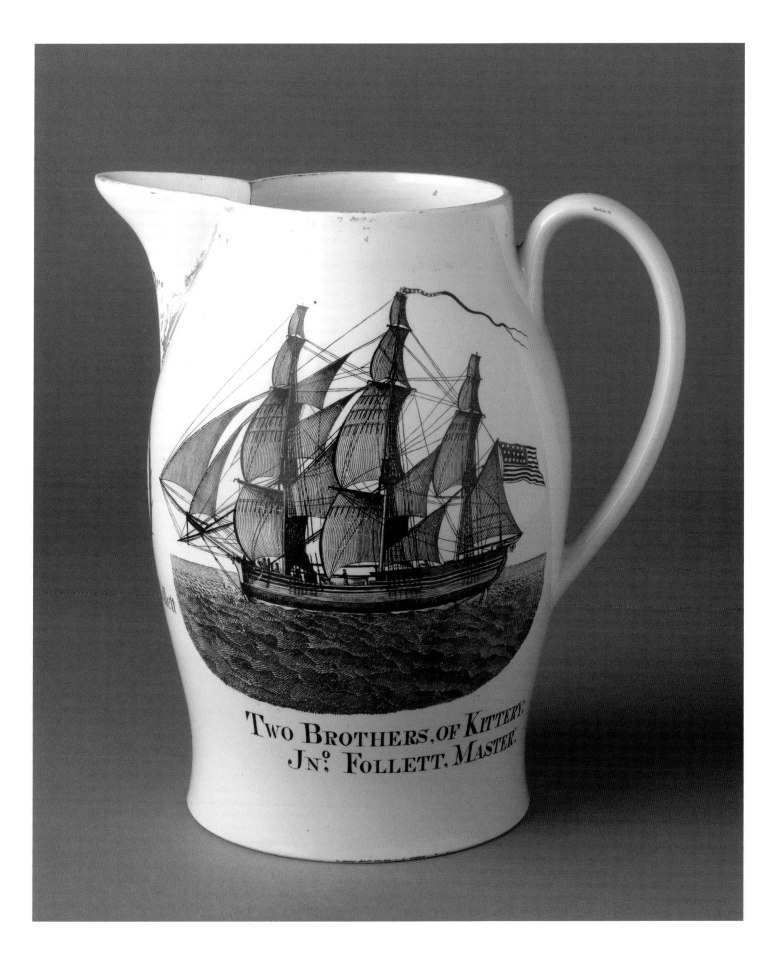

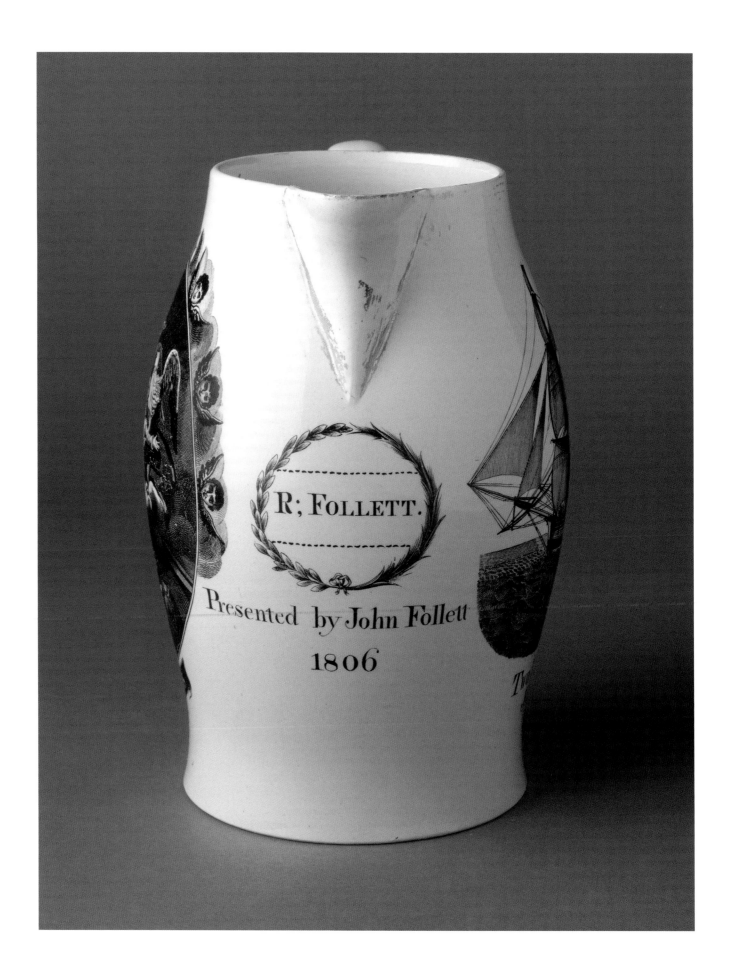

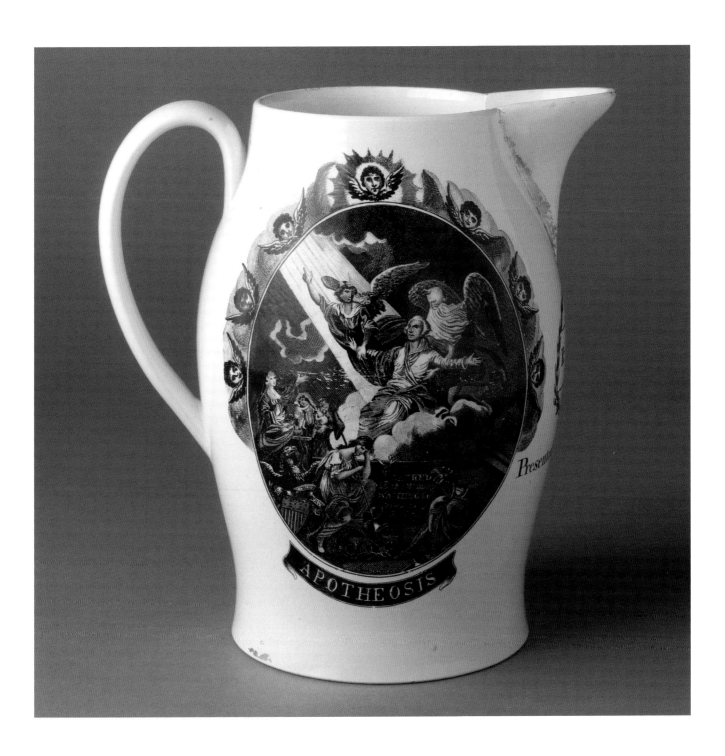

The Folletts are thought to have owned several ships together. Although their joint business dealings, the name of the ship, and the gift of the jugs and clock suggest that the brothers were close, this may not have been the case. Robert left his considerable estate to his two sisters and nephew, giving his brother only "one dollar to be paid within one year after my decease by my Executor."[4] The pitchers remained treasured family heirlooms; one was recorded as "One Family Pitcher ("The Two Brothers") [valued at] $1.00" in the inventory of John and Robert's sister Mercy, who died in 1852.[5] The two jugs were reunited by 1934, when they were owned by Caroline Lewis Gerrish, the last surviving child of Robert Follett Gerrish, the nephew of John and Robert Follett.[6] On the reverse of the jug is "The Apotheosis of Washington," one of the most famous memorial images made after Washington's death in 1799. Although this jug is not marked Herculaneum, its mate is, evidence that both jugs were made there.

51. Soup plate

Probably Wilson Church Works
Staffordshire, England; 1791–1800
Creamware printed in black and painted in enamels
Diam. 9¹¹⁄₁₆ in. (245 mm)
2009.23.20 Gift of S. Robert Teitelman, Roy T. Lefkoe, and
Sydney Ann Lefkoe in memory of S. Robert Teitelman

This soup plate is decorated with a stock print representing the sloop *Aurora*, which was built in Newport, Rhode Island, in 1789, and designed for the active coastal trade that existed between that town and other East Coast ports. Named after the Roman goddess of the dawn, she had a single mast and measured 61 feet in length and 79 tons. She was recorded as having a "woman figure-head," which was almost certainly the goddess Aurora.[1] Mythological names were popular during this period, and there were several ships named *Aurora*.

John Cahoone Jr. was the original owner and master, but during the 1790s ownership was shared with his brothers Stephen and Henry as well as with other Newport mariners and merchants. This practice was not uncommon and was designed to spread the expense and risk of outfitting and owning a vessel among several individuals. John served as master from at least 1789 to 1794 and again in 1798. He continued to be a part owner of the *Aurora* until 1800, when the ship was recorded as being sold in Charleston, South Carolina. In 1803, however, the *Newport Mercury* reported that on July 25, 1803, "arrived here from New-York, the sloop Aurora, Capt. Cahoone, in which came passenger the Hon. Aaron Burr, Vice-President of the United States," suggesting that Cahoone or one of his brothers remained involved in the ship or acquired a second ship of the same name.[2]

The *Aurora* was active in the coastal trade, traveling primarily between Newport, Providence, and New York.[3] She carried passengers and a variety of goods, especially furniture, which was an important export commodity for Newport. Much of the furniture no doubt came from the shop of John Cahoone Sr., who was a successful cabinetmaker before his death in 1792.[4] Cahoone Sr., like many Newport cabinetmakers, depended on the export market for a considerable portion of his income. He was also a partner in several maritime ventures, suggesting that he may have provided at least some of the impetus to John Jr. to purchase the *Aurora*.[5]

Several other plates and a tureen with this pattern are known, suggesting that there was originally a full dinner service.[6] One of the plates is marked "WILSON," referring to Robert Wilson, who operated the Church Works in Hanley, Staffordshire, from 1791 until at least 1801, when he died and his brother David took over the business.[7] Dinnerwares decorated with ships were much less common than jugs, but at least two other services with American ships are known.[8]

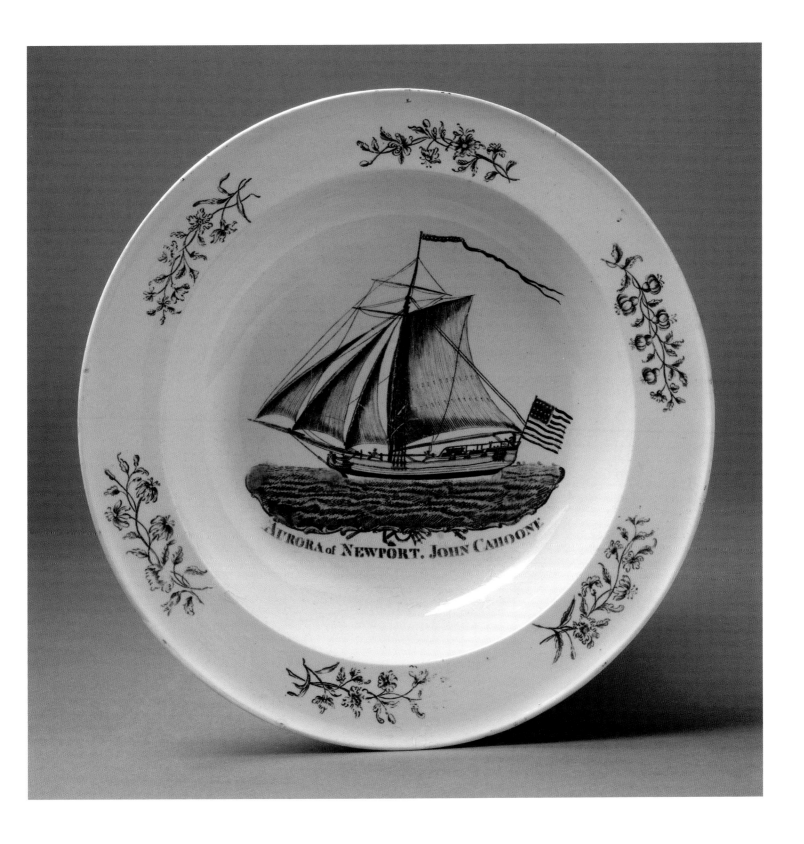

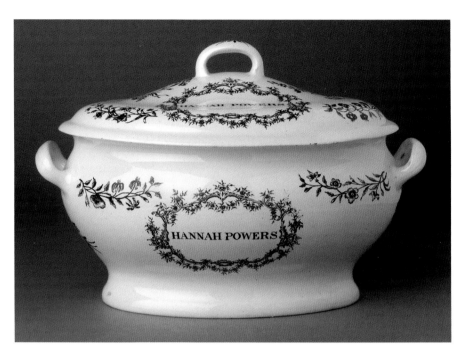

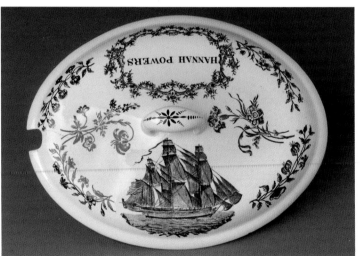

52. Tureen

Probably Liverpool, England; ca. 1800
Creamware printed in black and painted in enamels
H. 8½ in. (216 mm), W. 13¼ in. (333 mm)
1959.593 Bequest of Henry Francis du Pont

This tureen is decorated with a stock print representing the merchant ship *Hope* and is inscribed

with the names of the vessel's captain, Hazard Powers, and his wife, Hannah.[1] Powers was owner and captain of the *Hope* of New London, Connecticut, which, according to family lore and a surviving log book, sailed to England, Continental Europe, South America, and China.[2] In addition to his maritime career, Powers was also a farmer. In 1799 he advertised for sale "a farm containing 45 acres of good land . . . situated about two

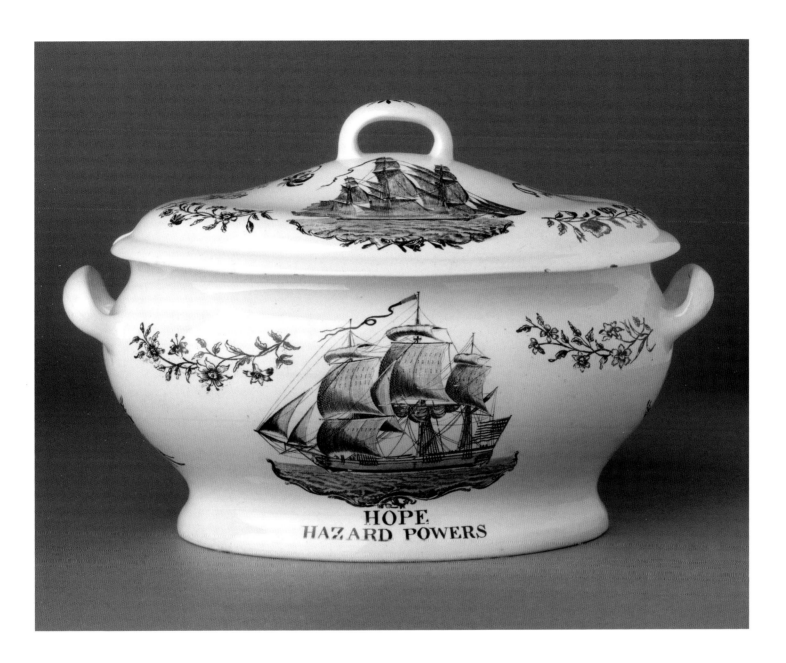

HOPE.
HAZARD POWERS

miles from the city of New-London" and then in 1810 advertised another farm for sale outside Windham, Connecticut, suggesting that he relocated around 1800.[3] At some point, he gave up his maritime career and eventually moved his family from Connecticut to northwestern Pennsylvania, where they were early settlers in Susquehanna County. The move was motivated in part by his desire not to have his sons follow him in a life at sea.[4]

Dinner services decorated with images of vessels are far rarer than jugs, although several are known.[5] In addition to this tureen, a platter from the same service, with a view of the ship and Masonic symbols, is known to survive.[6]

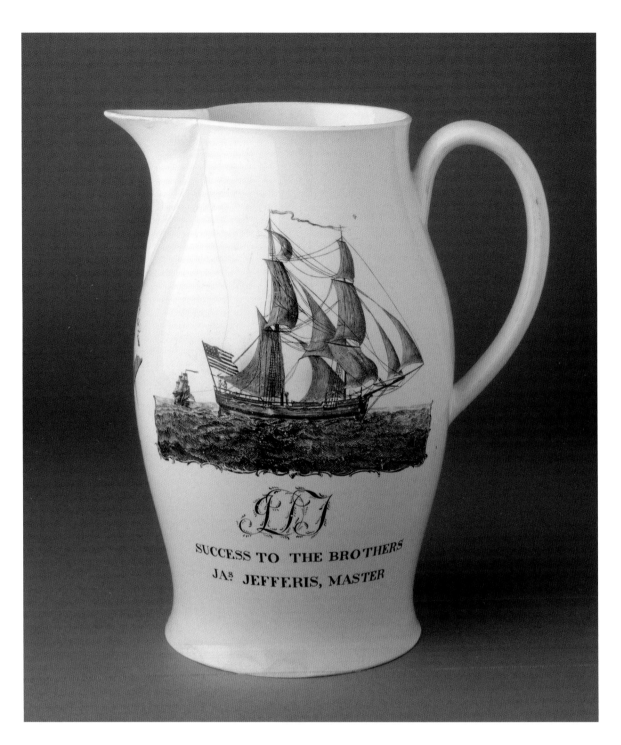

53. Jug
Staffordshire or Liverpool, probably decorated in
Liverpool, England; 1786–90
Creamware printed in black and painted in enamels
H. 10¾ in. (274 mm)
1971.726 Winterthur Museum, acquired through the
merger with The David Wilson Mansion, Inc., 1969,
ex-collection of Mrs. E. Tatnall Warner

This jug is decorated with a stock print commemorating
the brig *Brothers*, of Wilmington, Delaware, and her
master, James Jefferies (misspelled "Jefferis" on the jug).
Beneath the spout are the initials "JDT," which no doubt
are those of the original owner, who may have been part

of the ship's crew. The *Brothers* was sailing at least by
1785, when after a passage of seventeen days, she arrived
in Wilmington from St. Eustatius, an important trading
center in the Caribbean, "laden with rum." Her captain
then was a Mr. Gilpin.[1] She made at least one other
voyage to St. Eustatius under the direction of Captain
Gilpin; an undated newspaper story reports that four
days out of Cape Henlopen she struck a storm that
washed a cargo of Windsor chairs overboard.[2]

Jefferies is first recorded as master of the *Brothers* in
1786, when she arrived once again in Wilmington from
St. Eustatius.[3] She made at least one other voyage to the
Caribbean under Jefferies's command in 1789, to Cape-
Francois in Haiti.[4] The ship also made at least two

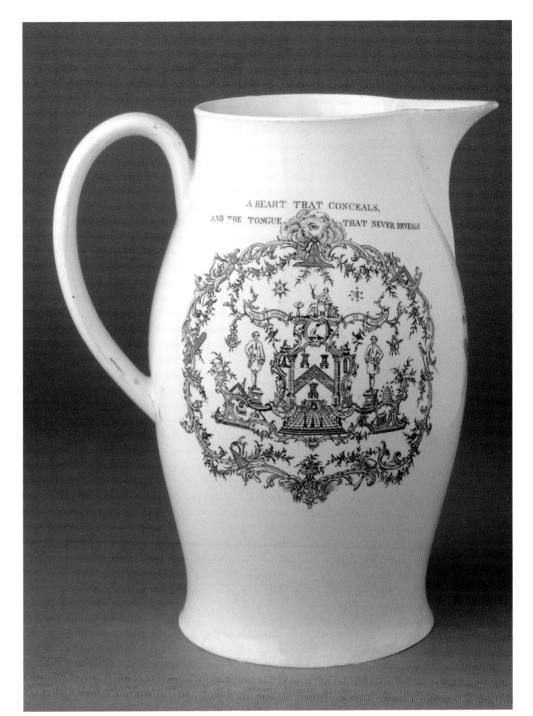

voyages to Belfast, where she loaded Irish immigrants bound for America; 170 came on the 1789 voyage, and 200 arrived with the 1790 voyage.[5] The *Brothers* was one of several vessels traveling regularly between the Delaware River Valley and Ireland, moving flour and other American commodities to Ireland and returning with linen, glassware, and immigrants. One early historian wrote, "One object of this trade was the transportation of emigrants, of which great numbers in early days were brought into this port [Wilmington]."[6] This specialized and profitable commercial operation reached a peak in the 1780s and 1790s, with an estimated half of the Irish immigrants to America during that period settling in Delaware and Pennsylvania.

Delaware Valley merchants took advantage of preexisting commercial ties with Ireland to establish regular immigrant transports.[7] Jefferies's maritime career lasted from at least 1786 until at least 1810.[8] He was master of the *Brothers* until 1790, when he took command of the *Wilmington* (see. cat. no. 54). After retiring from the sea he became active in local commercial activities in Wilmington, including serving as a manager of the Wilmington and Kennett Turnpike and a director of the newly established Bank of Wilmington & Brandywine.[9]

On the reverse of the jug is a large Masonic image with various emblems and mottoes. Beneath the spout is another Masonic image and the inscription "OL No. 257," which is probably a reference to a Masonic lodge.[10]

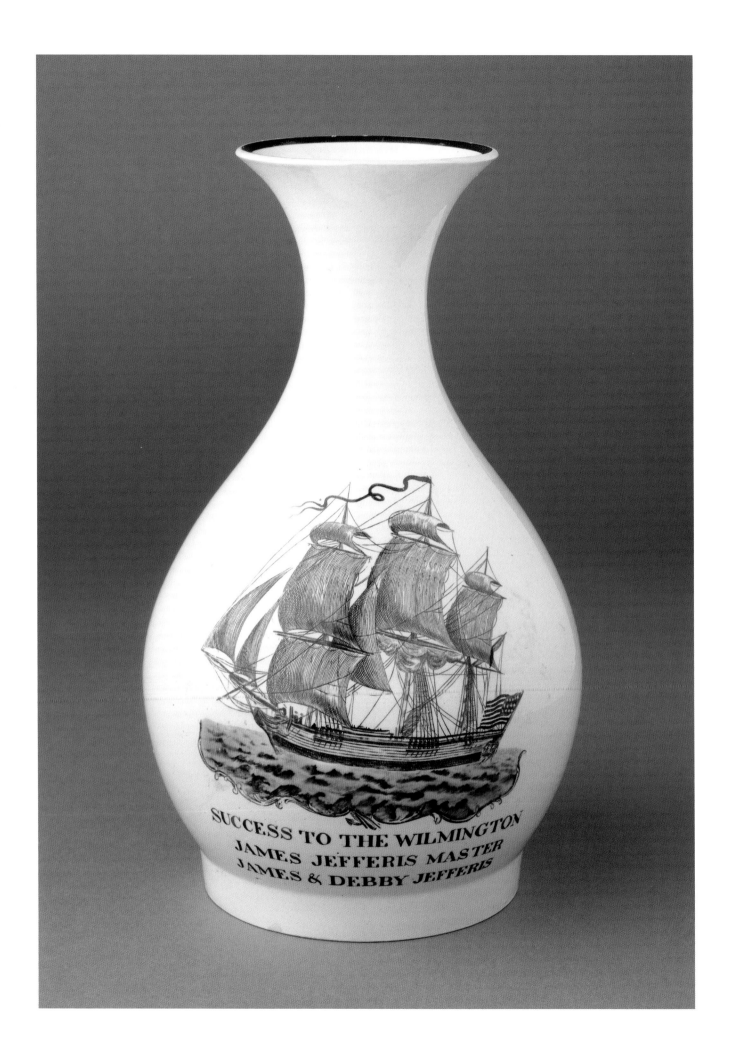

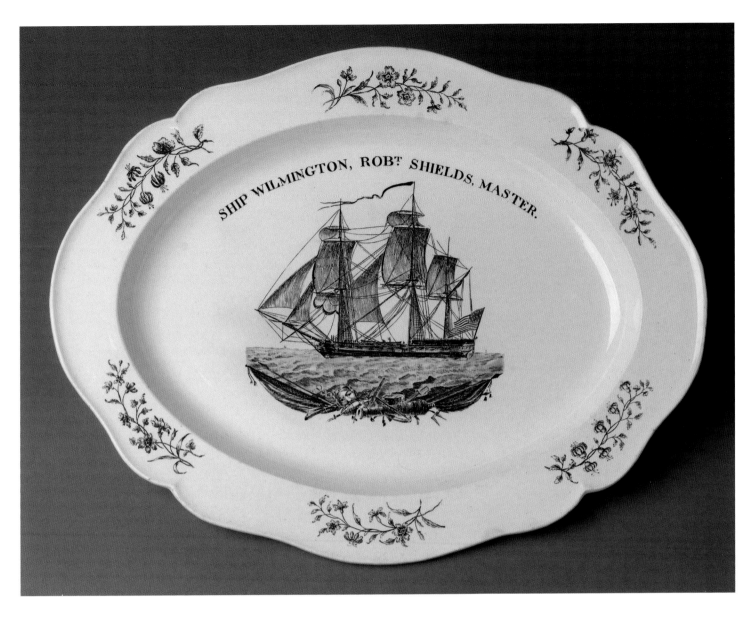

54. Bottle

Staffordshire or Liverpool, probably decorated in
Liverpool, England; 1790–95
Creamware printed in black and painted in enamels
H. 9¼ in. (234 mm)
1971.727 Winterthur Museum, acquired through the
merger with The David Wilson Mansion, Inc., 1969,
ex-collection of Mrs. E. Tatnall Warner

Platter

Staffordshire or Liverpool, probably decorated in
Liverpool, England; ca. 1796
Creamware printed in black and painted in enamels
L. 20⅝ in. (524 mm)
1964.1176 Bequest of Henry Francis du Pont

Relatively few pieces of English creamware made for the
American market record both the ship's name and her
captain. Even rarer, and possibly unique, is the survival of
this platter and bottle made for James Jefferies and Robert
Shields, both masters of the *Wilmington* in the 1790s.

Built in Philadelphia in 1790, the *Wilmington* was a
three-masted ship with two decks, a square stern, and a
female figurehead. Built of live oak and cedar, she
measured 89½ feet in length, 26 feet beam, and 264⅓
tons.[1] Jacob Broom, a prosperous Wilmington, Delaware,
merchant was a co-owner of the ship and may have been
responsible for her name.[2]

Her first master was James Jefferies (misspelled
"Jefferis" on the bottle),[3] whose maritime career spanned
from 1786, when he is reported as captain of the *Brothers*
(see cat. no. 53), until at least 1810.[4] He was master of
the *Wilmington* from 1790 until approximately 1793, and
under his command the ship made several voyages to
Ireland. The first almost ended in disaster. A newspaper
reported in April 1791 that "the Wilmington, Captain
Jefferies, from Philadelphia to Belfast, is lost
at Poolbeg, in Ireland."[5] The initial account was
exaggerated, because a July 28, 1791, report by a
returning captain noted that in late May he was in Sligo,
Ireland, where he "saw Capt. Jefferies, who told him that
he had not quite got his vessel repaired, but that in a few

189

days he expected to proceed with his ship round to Belfast and from thence to Philadelphia."[6] She was back safely in her namesake port by September, when advertisements for "Very Fine Irish Linens JUST IMPORTED, in the ship *Wilmington*, Capt. Jefferies, from Belfast," appeared in the Philadelphia papers.[7] This story hints at the difficulties of communication in the eighteenth century and of the disparate sources of information: newspapers with lists of arrivals and clearances at local and foreign ports, articles gleaned from imported foreign newspapers, extracts from personal letters, and accounts of personal encounters by sea captains in foreign ports and on the high seas.

In September 1791 the *Wilmington* was advertised as available for charter, with the suggestion that she could carry "about twenty four hundred barrels of flour."[8] Flour that was milled along the Brandywine River in Wilmington from wheat grown in southern Delaware and southeastern Pennsylvania was one of Delaware's main exports and was probably the cargo of the *Wilmington* when she cleared Philadelphia bound for Belfast in early December 1791.[9] She arrived back in Delaware in June 1792.[10] Jefferies and the *Wilmington* seem to have made annual trips to Ireland. In April 1793 she arrived in New Castle, Delaware, from Belfast "after a passage of six weeks. She has brought upwards of 450 passengers, who are all in good health."[11] The passengers were clearly immigrants. The *Wilmington* was one of several vessels active in the trade between the Delaware Valley and Ireland, moving flour and other American commodities to Ireland and returning with immigrants. One early historian wrote, "One object of this trade was the transportation of emigrants, of which great numbers in early days were brought into this port [Wilmington]."[12]

Jefferies was last reported as master of the *Wilmington* in 1793. Robert Shields was her master in 1796, when she sailed from her home port of Philadelphia to Liverpool.[13] She arrived back in Philadelphia on October 13, 1796, after a voyage of seventy-two days.[14] By 1797 Shields had been replaced by George Hilliman, but Shields may have returned to the *Wilmington* around 1800, when he is listed as master by the Lloyd's insurance agents of London.[15] Although captains often remained with ships for several years, they also moved from ship to ship, probably being contracted for specific voyages.

The two creamware pieces seen here were probably acquired by Jefferies and Shields during their voyages. In both cases the view of the three-masted ship is a stock print that has been customized by the addition of the name of the vessel and her master. The bottle, inscribed "SUCCESS TO THE WILMINGTON JAMES JEFFERIS MASTER JAMES & DEBBY JEFFERIS," was probably originally paired with a basin and used for washing. On the reverse of the bottle is a print of a woman standing in a rowboat waving goodbye to a departing ship along with the inscription "SWEET POLL OF PLYMOUTH" and a stanza from a popular sea song of the eighteenth century, *Sweet Poll of Plymouth* by Charles Dibdin.[16]

The platter, which is inscribed "SHIP WILMINGTON, ROB[T]. SHIELDS, MASTER," was part of a larger dinner service of which at least one other piece, a soup bowl, survives.[17] Surprisingly, this was not the only dinnerware Shields owned with a view of his ship; a plate decorated with his name and with an image of the *John* is known.[18] While several dinner services with ship views are known, they are far rarer than jugs.

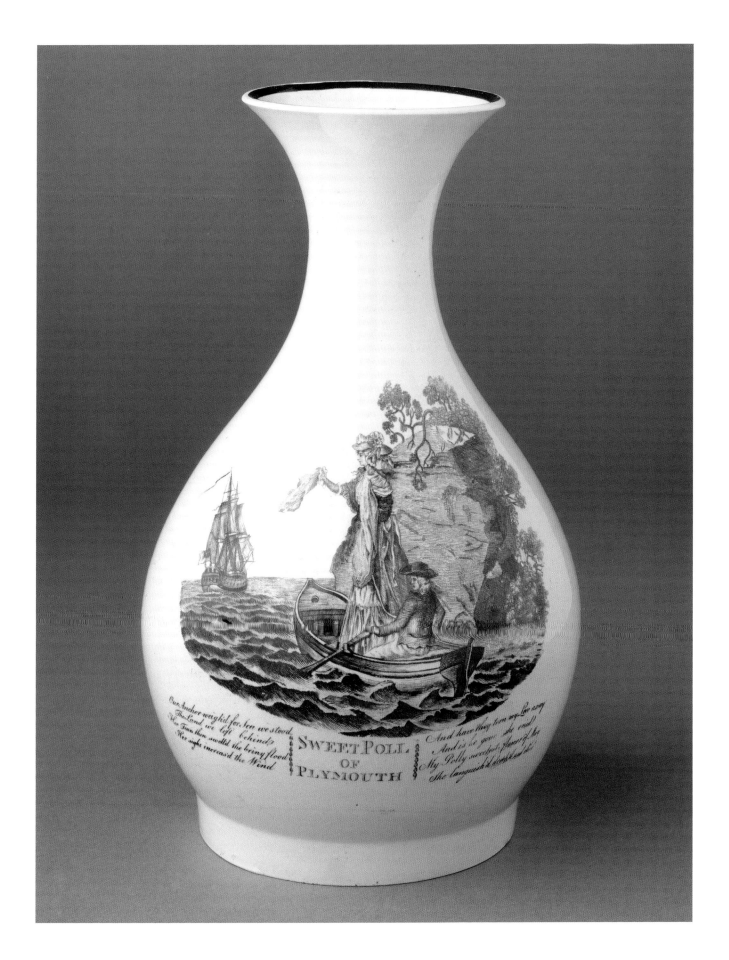

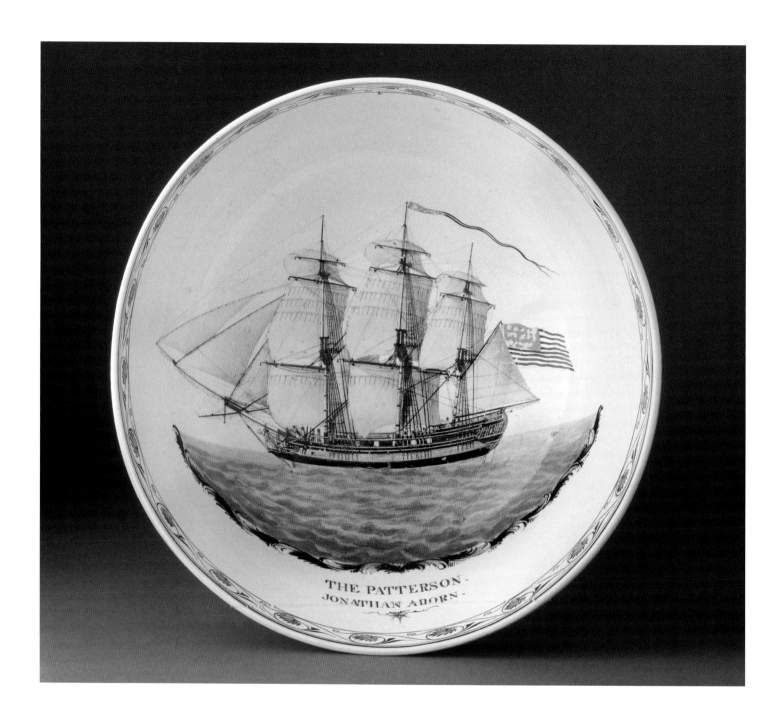

55. Bowl and jug

Probably Herculaneum Pottery
Liverpool, England; 1800–1804
Creamware printed in black and painted in enamels
Bowl: Diam. 12 in. (305 mm), H. 5⅛ in. (130 mm)
Jug: H. 10⅝ in. (270 mm)
2007.31.10, .11 Gift of S. Robert Teitelman

This punch bowl and jug are decorated with transfer-printed patriotic images and hand-painted portraits of

the ship *Patterson*. The two pieces of creamware survive as does a portrait of the ship's master, Captain Jonathan Aborn (misspelled "Abron" on the jug). The *Patterson*, built in Providence, Rhode Island, in 1800, was described as "an elegant, coppered ship." With three masts, two decks, and a "man figure head," she measured 447 tons, 107 feet in length, 31 feet beam, and drew 15½ feet.[1] Owned by a consortium of Providence and Boston merchants, the *Patterson* sailed for a quarter of a century and was eventually broken up in Boston in 1826.[2]

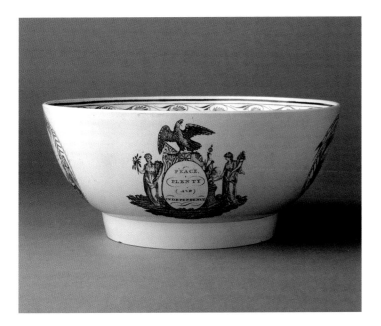

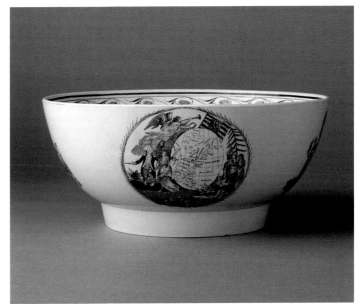

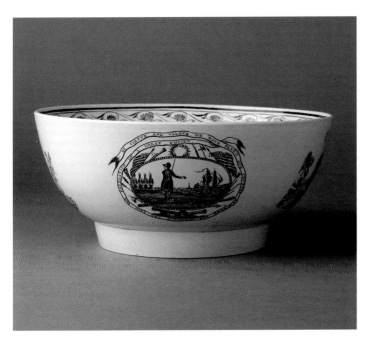

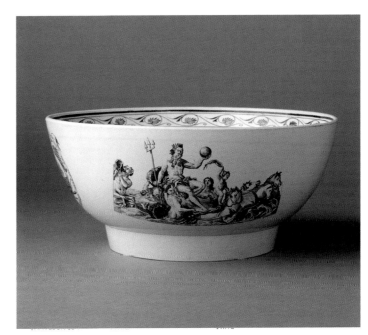

Aborn was listed as the master of the *Patterson* from 1800 until 1804.[3] During that time, the ship made several voyages to Bordeaux, Liverpool, and Canton. She carried a mixed cargo, including "two hundred crates Liverpool assorted Ware, 1st quality" that came to New York in 1802 (see Appendix I). It is likely that this jug and bowl were acquired during that trip. Described as "one of the ablest nautical commanders belonging to our port," Aborn was born in 1773. He lived in Pawtuxet, Rhode Island and married Dorcas Tourtellot in 1797. They had eight

children, and he died at age forty-eight in Calcutta, India, on March 10, 1821.[4]

Patriotic and nautical images decorate the exterior of the punch bowl and the back side of the jug. Around the bowl are vignettes celebrating America, with an eagle and the inscription "PEACE, PLENTY AND INDEPENDENCE"; George Washington, Benjamin Franklin, and Liberty inspecting a map of the East Coast of North America; Neptune riding in a shell drawn through the waves by four horses; and a view of George

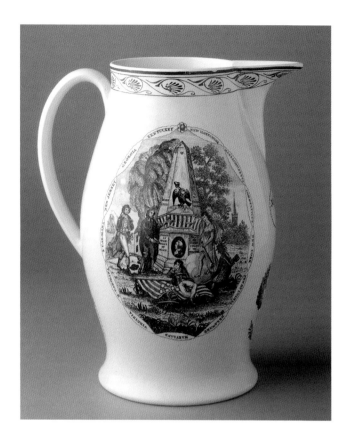

reverse of the jug is a memorial to Washington. Beneath the spout is an adaptation of the Great Seal of the United States, and beneath the handle is a reference to Washington's character: "A MAN without example A PATRIOT without reproach." Most of these prints are attributed to the Herculaneum Pottery. The style of painting also suggests that this bowl and jug are part of a small group of hand-painted wares made at Herculaneum (see cat. no. 46).

Washington with his foot on the head of the British lion with the slogan "BY VIRTUE AND VALOR, WE HAVE FREED OUR COUNTRY, EXTENDED OUR COMERCE, AND LAID THE FOUNDATIONS OF A GREAT EMPIRE." On the

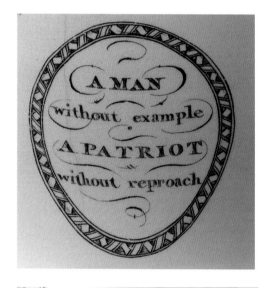

Portrait of Jonathan Aborn, England or America, early 19th century. Oil on canvas. 2007.31.12 Winterthur Museum, gift of S. Robert Teitelman.

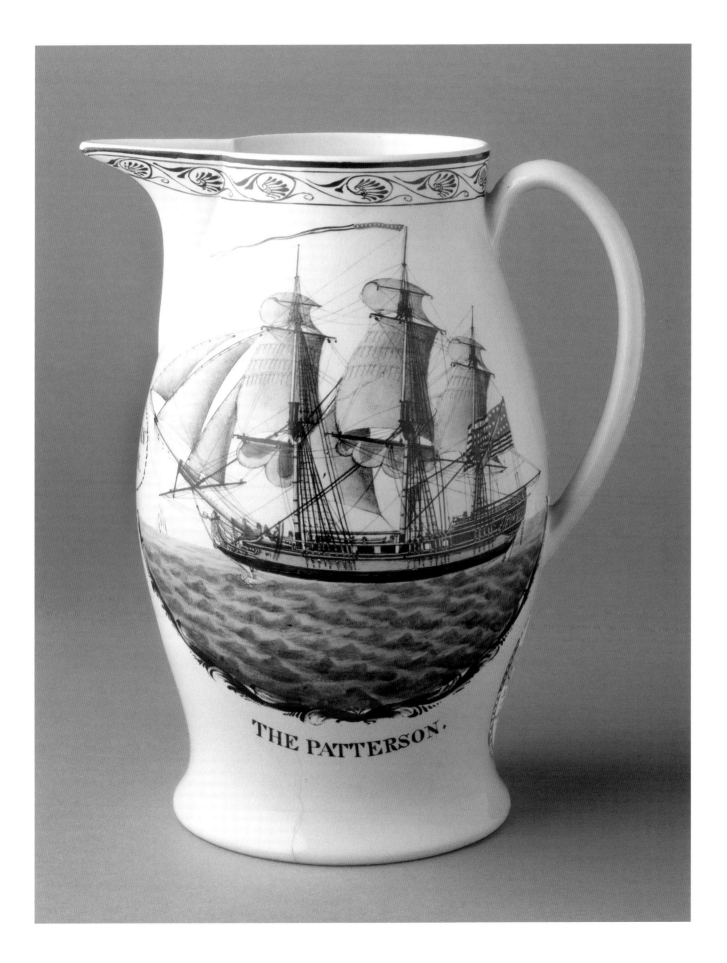

THE PATTERSON.

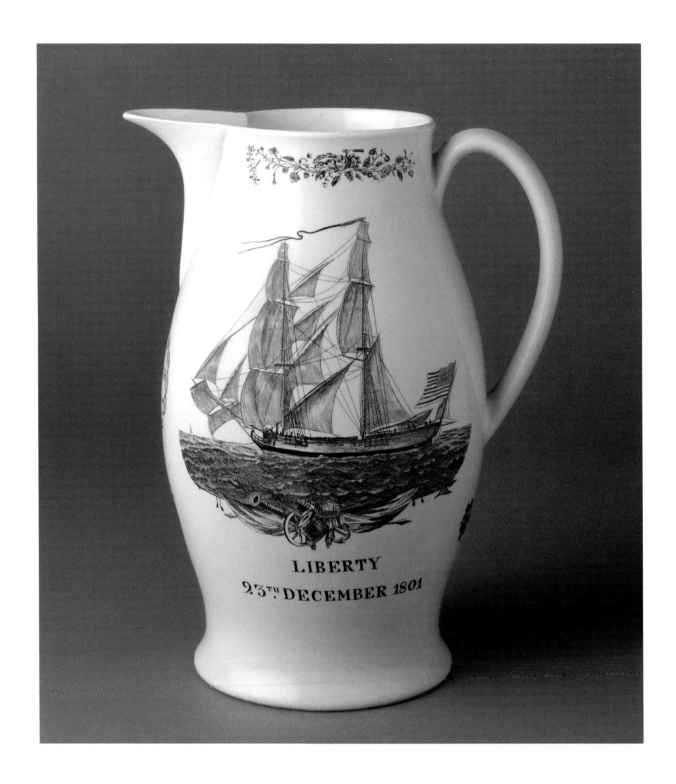

56. Jug
Probably Herculaneum Pottery
Liverpool, England; ca. 1802
Creamware printed in black and painted in enamels
H. 11½ in. (292 mm)
2009.32.11 Gift of S. Robert Teitelman, Roy T. Lefkoe,
and Sydney Ann Lefkoe in memory of S. Robert
Teitelman

The decoration on this jug depicts the dramatic effects of
a Christmas Eve storm on the brig *Liberty*. The view on
the front shows the ship sailing serenely on December

23, 1801. The view on the back illustrates the brig on
December 24, after she was crippled by the storm. Both
her mainmast and foremast have gone "by the board"—
meaning they have been snapped off at deck level and
have fallen overboard. Masts, spars, sails, and rigging were
among the most vulnerable parts of a vessel. Well-
equipped ships carried extras to repair or replace
damaged or lost equipment. No doubt the storm-
wearied crew of the *Liberty*, which probably included a
Mr. N. Cummings, whose name is painted under the
spout, spent most of their Christmas jerry-rigging
temporary masts, spars, sails, and shrouds to enable the

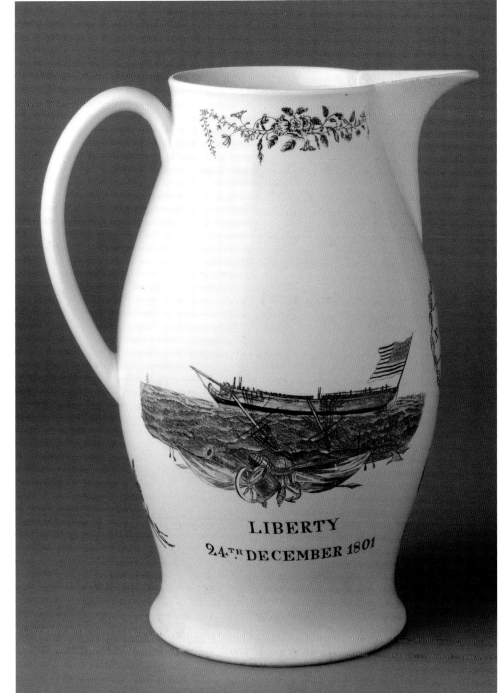

vessel to limp back to land.

One other jug depicting the *Liberty* before and after the storm is known, with the name "S. Dennett" painted under the spout.[1] Although there were several vessels named *Liberty* sailing in 1801, a brig by that name that sailed from Philadelphia on November 18, 1801, bound for St. Petersburg had a Thomas Cummings and a George Bennett, or Dennett, in the crew.[2] These names do not match the N. Cummings or S. Dennett on the two known jugs, but the similarity suggests a possible link.

The two views of the *Liberty* on the jug are stock prints. The one showing the brig after the storm is from the same copper plate as the complete vessel on the other side, but the upper portion with the masts and sails has been cut off. The masts and sails that are dragging in the water were painted over the printed hull. Views of storm-tossed ships have been painted since at least the seventeenth century, but images of specific disasters became increasingly popular in the early nineteenth century. It was not uncommon for paintings or jugs to depict multiple views of the same vessel, such as those seen on this jug.[3] Beneath the spout is a version of the Great Seal of the United States that has been attributed to the Herculaneum Pottery (see cat. no. 12).

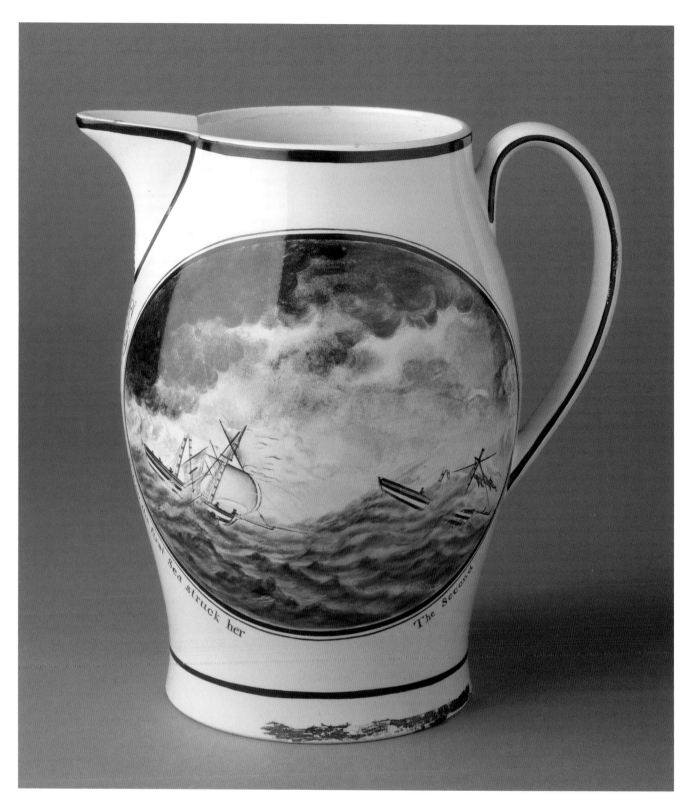

57. Jug
Probably Liverpool, England; 1810–25
Creamware painted in enamels
H. 10⅛ in. (559 mm)
2009.21.20 Gift of S. Robert Teitelman

This jug is one of a pair, and the two together show a brig before, during, and after a storm. On the first jug of the pair, one side has a stock print of a brig sailing serenely on a calm sea. On the reverse is a hand-painted image showing the brig in the storm. The jug seen here is the second in the pair and on one side repeats the view of the brig in the storm, beset by heavy winds, lightning, and high seas. In a convention popular in ship portraits, she is shown in two views: on the left, "When the first Sea Struck her," which has carried away most of her mainmast and the upper part of her foremast and shredded all but her mainsail. On the right she is shown after "The Second," a giant wave that has swept away all but the stump of the foremast. On the other side of the

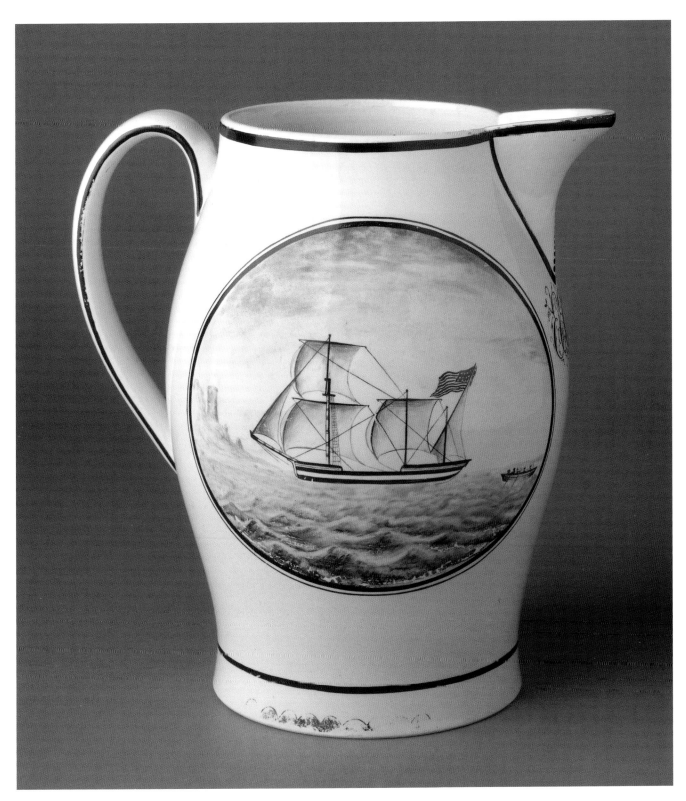

jug the vessel is seen after the storm, limping along with jerry-rigged masts hastily raised by the crew.

Such dramatic images were often commissioned by the survivors or rescuers, which is most likely the case here. In addition to this jug and its mate, a third and a fourth jug from two other pairs also survive, suggesting that there were at least three pairs made.[1] All bear the monogram "EEC" under the spout, which is probably that of a member of the ship's crew who wanted to commemorate his skill and luck in surviving the storm.

58. Jug

Liverpool or Staffordshire, England; ca. 1800
Creamware printed and painted in enamels
H. 8 in. (203 mm)
2009.21.7 Gift of S. Robert Teitelman

This jug is remarkable for the unusual style of the hand-painted decoration. On one side is a waterside landscape with a large central tree inscribed above "GREEN TREE GERMAN TOWN." The small sailboat in the left background and man fishing in the right foreground give a sense of place but are not central to the theme of the design, which likely refers to the Green Tree Inn of Germantown, Pennsylvania. On the other side is a small hand-painted portrait of a woman, an extremely rare subject for this class of pottery. The inscription and the painted initials "RM" on the front of this piece identify Rachel Macknet, wife of the eventual owner of the inn.[1]

The Green Tree is said to have been built in 1748 by Daniel Pastorius as a family mansion.[2] The Pastorius and Macknet families seem to have been related, as members of each family carry the others' surname as a given name. It is not known when Daniel Macknet acquired the property and converted it to an inn, but his widow, Sarah, advertised the business for sale in *Dunlap's Pennsylvania Packet* of April 10, 1775. She describes the property as the tavern in "Germantown, known by the name of Widow Mackenett's, or the Sadler's Arms." It was to be sold by Sarah Heath, formerly widow Mackenett, who married Andrew Heath following the death of her husband.[3] Daniel had obviously died suddenly, as no will had been prepared and his estate was passed to Sarah and the children, Charles and his twin sister, Mary Magdalena.[4] Charles, who may have been leasing the inn from as early as 1775, enlisted during the Revolutionary War. He served first as an ensign and then as a lieutenant with Captain John Markland and fought at the

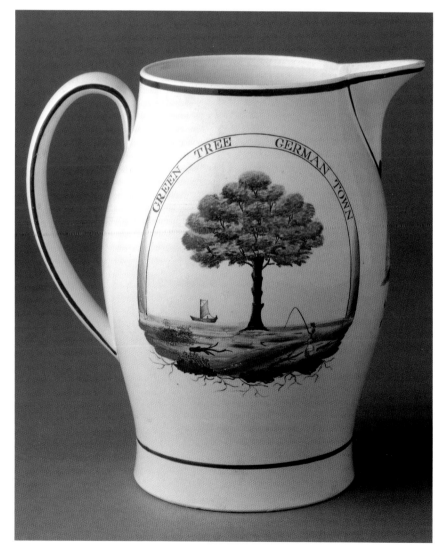

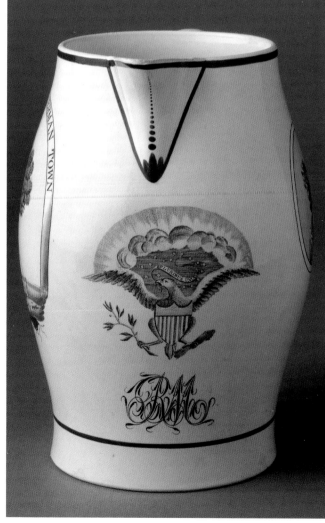

battles of Short Hills, Brandywine, and Germantown.[5] On his return to Germantown he finally acquired title to the Green Tree Inn, in 1797.[6]

It was probably of the Green Tree that Thomas Jefferson, then first Secretary of State, wrote from Germantown in 1793: "According to present appearances, this place cannot lodge a single person more. As a great favor I got a bed in the corner of the public room of a tavern." He later wrote to James Madison that he had found lodging for the both of them in a private home. "They will breakfast you," he wrote, "but you must mess in a tavern; there is a good one across the street."[7] The inn was the scene of many meetings, seemed to play an active role in the social and political life of Germantown, and offered a welcome respite from the busy city of Philadelphia. By 1809 an advertisement in *Poulson's American Daily Advertiser,* July 8 read, " ANY PERSON Desirous of removing to the country for the summer season, may be accommodated with four or five rooms and the use of a kitchen, in a new and elegantly finished House in Germantown. For Further information apply to Charles Macknet At the sign of the Green Tree."

On the front of the jug, beneath the lip, is a red printed version of the Great Seal of the United States, a popular patriotic symbol.[8] Unlike any of the other Great Seal prints in this collection, the eagle in this example grasps the motto ribbon at the end as it floats away behind him, and the heavens with sixteen scattered stars are much more heavily engraved. Beneath the eagle is the "RM" monogram referred to above. Rachel L. Irwin married Charles Macknet on November 17, 1779, in St. Michael's Lutheran Church in Sellersville, Pennsylvania. Other than her wedding date, almost nothing is known of Rachel, but she must have been held in high esteem to have such a remarkable tribute paid to her.

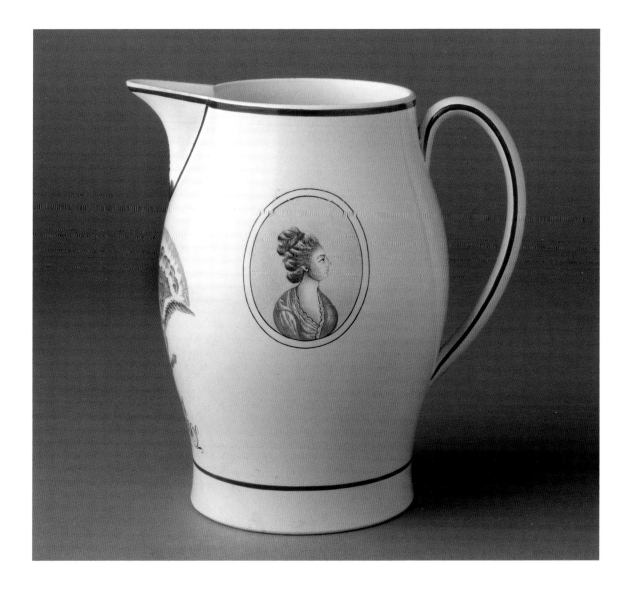

59. Jug
Probably Herculaneum Pottery
Liverpool, England; ca. 1800
Creamware printed in black and painted in enamels
H. 11½ in. (292 mm)
2009.21.5 Gift of S. Robert Teitelman

This jug celebrates the art of the cooper. The baluster-shape body, decorated with a band of scrolling anthemion painted in black at the rim, has "THE COOPERS ARMS" printed in black on one side. Coopers were responsible for crafting the barrels and casks that were a staple eighteenth-century product for storing and shipping everything from gunpowder and tobacco to milk and wine. The Worshipful Company of Coopers in London received its charter in 1501.[1] The coat of arms was granted in 1509 and forms the basis of the arms printed on this jug.[2]

It is likely that the engraver of the print was familiar with the coopers and their guild, especially if the artisan was based in Liverpool, where the making of barrels for the storage and export of goods would have been an important occupation. The arms seen on the jug do differ from the original, which had supporters in the form of bridled camels (symbolic of trade) decorated with small circles representing unity. In this print, the supporters appear more like horses. The original motto beneath the

shield was "Love as Brethren" rather than the more assertive and possibly revolutionary motto that has been substituted. It has been noted that as companies of coopers were established outside London, the mottos changed.[3] This example, with "PROSPERITY ATTEND THE INTEGRITY OF OUR CAUSE," is one that has not been found in the literature except in reference to ceramics decorated with this particular design. The phrase is reminiscent of celebratory toasts that were reported in newspapers, which usually took the form of "May prosperity attend . . ." followed by appropriate sentiments.

The small engraving on the reverse of the jug shows a cooper at work. He is at the point where the cask has been raised up with sufficient staves and hoops to begin the bending process, and he is in the act of "trussing the cask."[4] Thick casks are made using heat to soften the wood before "firing." The firing takes place using a cresset, or metal basket, filled with wood shavings that are lit and kept burning as the barrel is placed over the cresset. The heat is maintained as the hoops are driven down tightly to keep the staves in place while they are bent. The cask is then turned upside down, and the work is repeated from the other end. Our cooper looks calm and controlled in his work, but "Blinding smoke and stubborn truss hoops are all part of the process of firing a stout cask."[5]

On the front of the jug, a hand-painted design

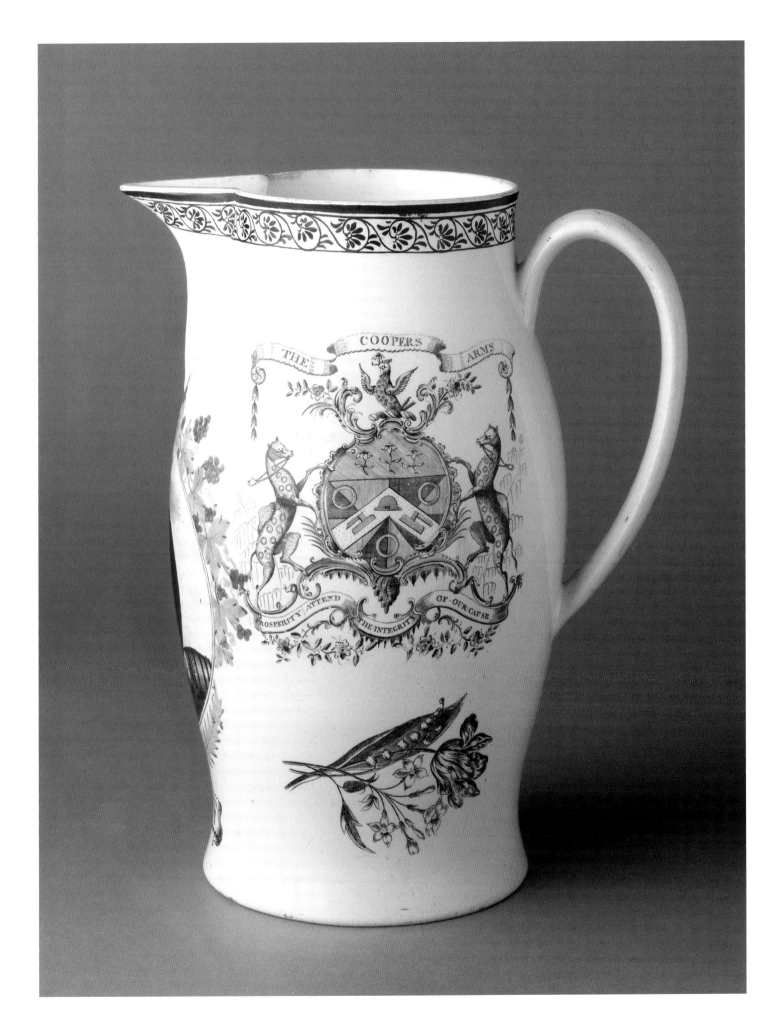

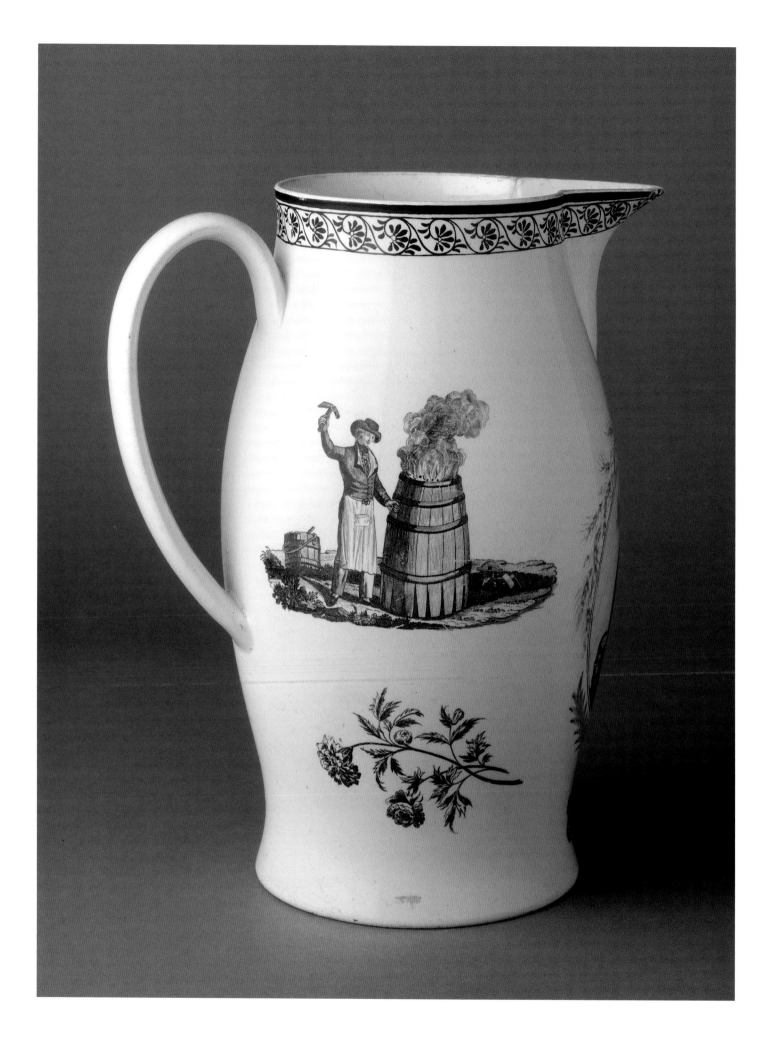

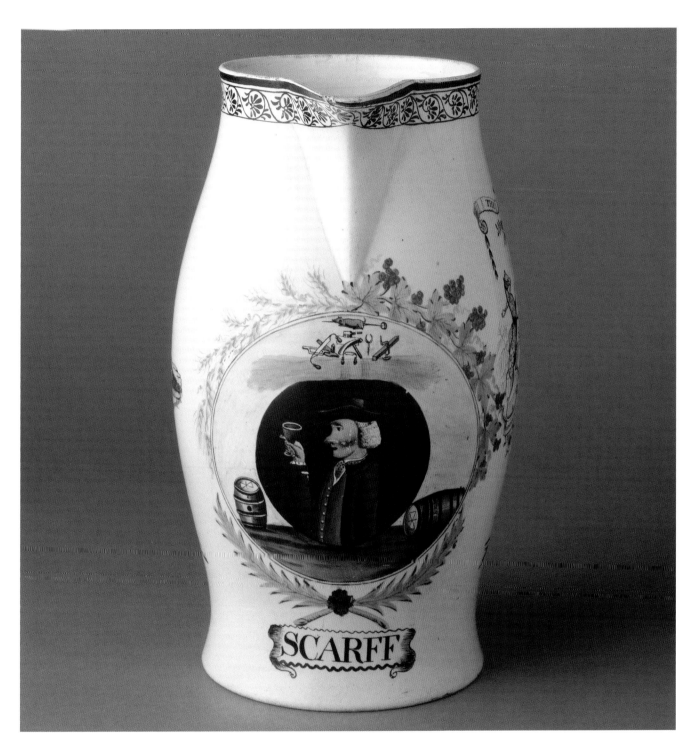

personalizes the piece with a portrait of a man raising a glass amid barrels and beneath the tools of the cooper's trade. The barrel on the right has the name "CALVERT" between two hoops, and framing the whole are garlands of hops and grapevine, leaving us in no doubt that this cooper made barrels for the beer and wine trade. The name "SCARFF" is painted below. The word "CALVERT" gives us a clue as to where Mr. Scarff might be plying his trade, for it probably refers to the Calvert family who secured a royal charter for the founding of the "Maryland Colony" and for whom Calvert County, Maryland, is named. Scarff is a name found in the registers of Calvert County and more widely in Maryland, but nothing is known of a cooper by that name.

There are other examples of jugs with the cooper's arms and a cooper at work, but none has the ambitious painted portrait that dominates the front of this jug.[6] The extraordinary profile and colorful imagery make this the outstanding piece in its class.

60. Jug

Probably Herculaneum Pottery
Liverpool, England; 1800–1810
Creamware printed and painted in black
H. 11⅟₁₆ in. (282 mm)
2009.21.10 Gift of S. Robert Teitelman

Commemorating the service of Joseph Lovering of Boston, this jug is hand painted in black enamel. Before a blazing three-story building, firefighters are in action as helpful neighbors rescue furnishings from the burning house. The scene must have been a familiar one in Boston, where fire among the wooden buildings in the narrow streets was a constant dread and regular occurrence. As you see in this image, organized firefighting was a community action.

> When fire broke out, a watchman or another local resident would run to the nearest church to ring the bell, which would summon his neighbors to the scene. Citizens wielding their buckets formed a line to pass the buckets between a water source . . . to a fire engine. Firefighters, usually called "enginemen" or "firemen," brought the necessary training and expertise to work a fire engine, which threw water higher than a person tossing a bucketful could. Other men carried bags or baskets full of goods, helping to remove people and property from burning buildings. If the owner of the burning house were a member of a private fire club, his fellow club members did their utmost to safeguard his property from thieves and flames. The men carrying ladders and iron hooks could help destroy a house, which would isolate and contain the fire. A man in the center of the action with a speaking trumpet called out directions to the townspeople. In Boston, this man would most likely be one of twelve to sixteen "firewards," respectable leaders appointed by the town who had the authority to order the destruction of houses for firebreaks.[1]

The fireward in this case was Joseph Lovering (1758–1848), whose name appears on the front of the jug.

Lovering was born September 19, 1758, the eldest child of Joseph Mayo Lovering and his wife, Sarah Ellis of Roxbury, Suffolk, Massachusetts. Joseph senior set up business in Boston as a tallow chandler supplying candles and soap to the city.[2] During the 1770s, Boston was a hotbed of unrest. Following widespread protests, in 1773 the British government partially repealed the Townshend Acts through which they had proposed to levy taxes on their American colony; tea was left as the single taxable item. On December 16, 1773, young Joseph, at the age of fifteen, is recorded as having "held the lantern in Mr. John Crane's carpenter shop . . . as fifteen Sons of Liberty disguised themselves before going to Griffin's Wharf . . . Boyish curiosity caused Joseph to accompany the group." So he witnessed what was then called the "Destruction of Tea in Boston Harbor" and which we now call the Boston Tea Party. Apparently Joseph was "closely questioned and severely reprimanded by his parents for being out after 9 o'clock at night, as they were strict in their requirement that he should be in bed at that hour."[3] The Boston Tea Party was a rallying point and, along with other incidents in the thirteen colonies, precipitated the Revolutionary War.

Following the war, the family business continued in Boston, manufacturing candles and soap. Joseph Jr. began to take part in civic duties. He entered the Ancient and Honorable Artillery Company of Massachusetts, and a history of the company published in 1842 records "Ensign Joseph Lovering, Jr, tallow-chandler. Ensign of the Ar. Co. 1797. Representative many years; Selectman and wealthy . . . the oldest member on the roll."[4] In 1799 Joseph Lovering Sr. gave up the business in favor of his sons, who traded in partnership as "Joseph Lovering jun'r and Co."[5] On June 10, 1803, the *Newburyport Herald* reported a story from the *Boston Gazette*, "Fire—Yesterday morning, about two o'clock, a fire broke out in the Soap and Candle Manufactory of Mr. Joseph Lovering, in Bennett-street. The building was severely consumed; and from the rapid progress of the flames, we fear but little of the stock of utensils were preserved." Boston with its crooked, narrow streets and wooden houses was regularly subject to fires large and small; by 1760 the town had nine fire companies each with a captain and eleven to eighteen men.[6] It is not difficult to understand that with such a flammable business, Lovering became more involved with fire services. In addition to being a selectman for Boston, he also held the positions of alderman in the first City Council of 1822, representative to the General Court, treasurer of the Massachusetts Charitable Mechanics Association, and, from 1782, foreman of Fire Engine Number 8, known as the "Cumberland."

The large image on the side of the jug shows a volunteer fire brigade working a pumper engine. The bucket brigade is filling the pumper's tub with water, and men are working the long bars on either side, pumping them up and down to force the piston to suck in water from the tub and expel it out of the hose. The hose in this illustration is a gooseneck nozzle, without the flexibility of the longer leather hoses that were introduced later. Even with these restrictions, pumper engines were able to deliver a greater volume of water onto the fire and reach higher than men tossing a bucket full of

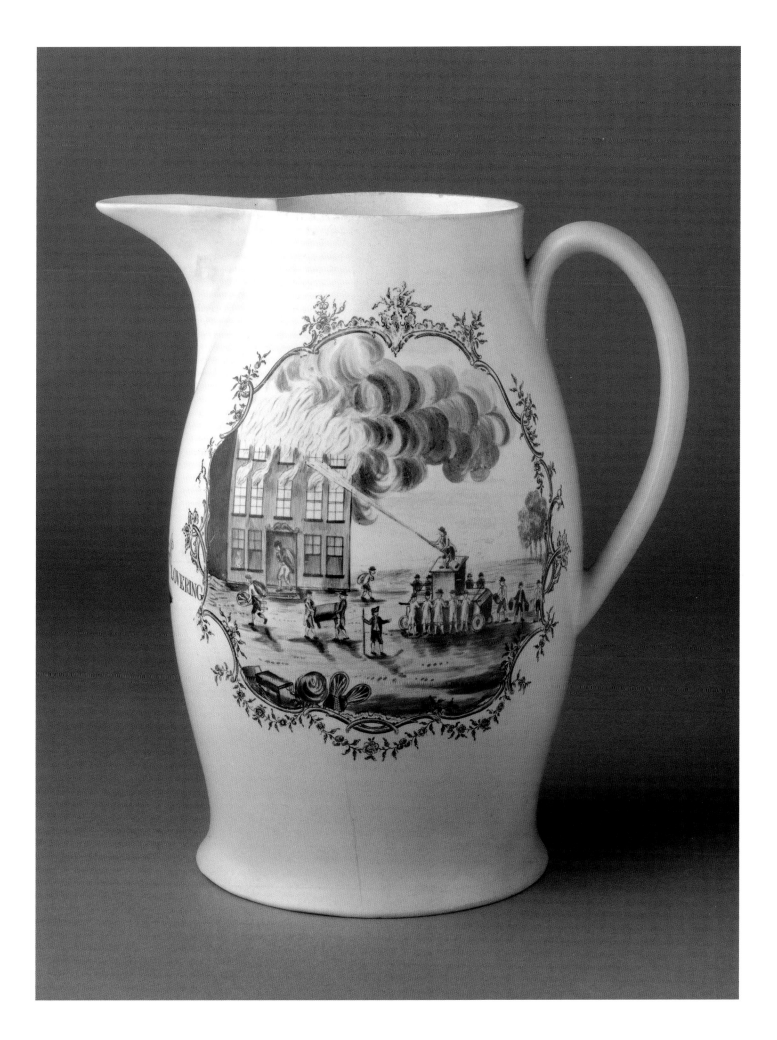

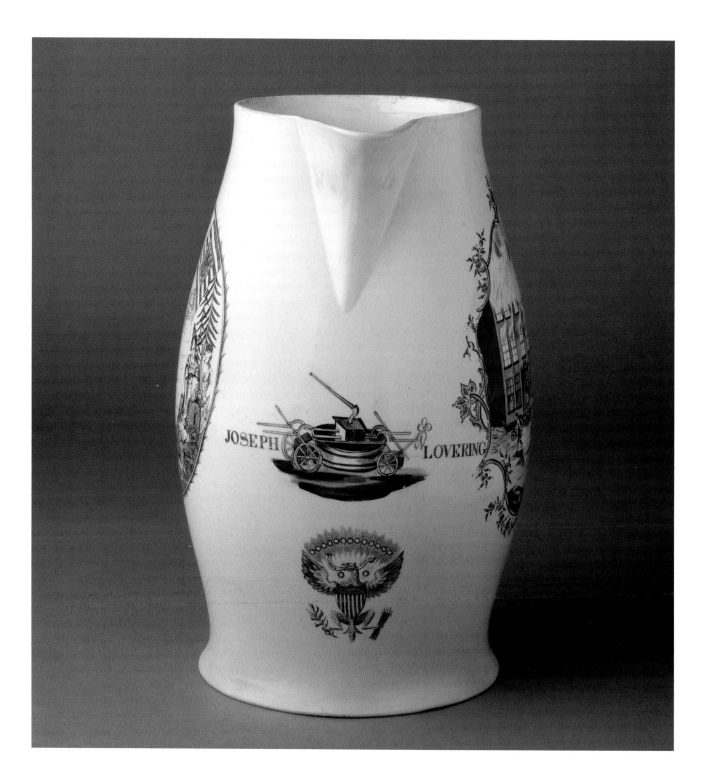

water into the blaze.[7] In 1789 Richard Mason advertised his Philadelphia-made fire engines in the *Massachusetts Centinel*. He warranted them for seven years and offered five levels of power: the third held 120 gallons, threw the water 120 feet, required 10 men to work it, and cost £90.[8] Perhaps it was such an engine that Lovering commanded.

On the front of the jug, beneath the spout is painted "JOSEPH LOVERING" with a fire engine in the center

of the name. It shows a different view of a pumper engine, perhaps even a different model. It is unlikely that the English painter ever saw the firefighters of Boston and would therefore have used any available printed sources for his designs—one for the scene of conflagration and one for the closer view of the engine. It seems that these scenes were popular, and similar hand-painted and printed versions of this subject are known.[9]

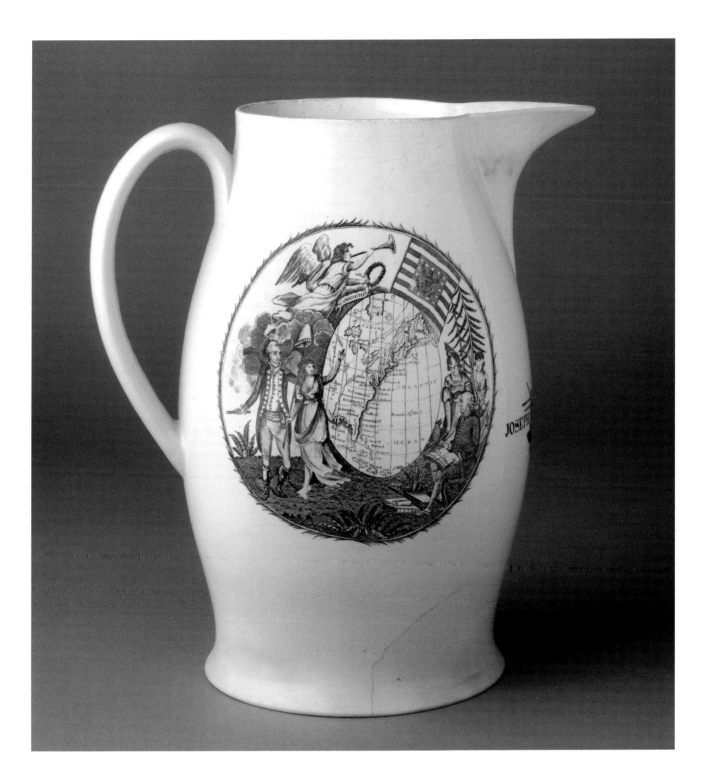

Beneath the painted fire engine is an adaptation of the Great Seal of the United States.[10] This version seems characteristic of the image used by the Herculaneum Pottery in Liverpool, although smaller in size than the factory eagle mark seen in cat. no. 12.

The reverse of the jug has a patriotic print depicting the eastern seaboard of the United States, flanked by George Washington and Benjamin Franklin. This may be a Herculaneum Pottery version of the print by Francis Morris of Staffordshire found at cat. no. 20, where the image is discussed in detail. This adaptation has a much simpler frame and no key to the design.

The story of Lovering is the story of many Americans of the time—a remarkable connection with the Boston Tea Party, Revolutionary War, and the founding of the new nation.

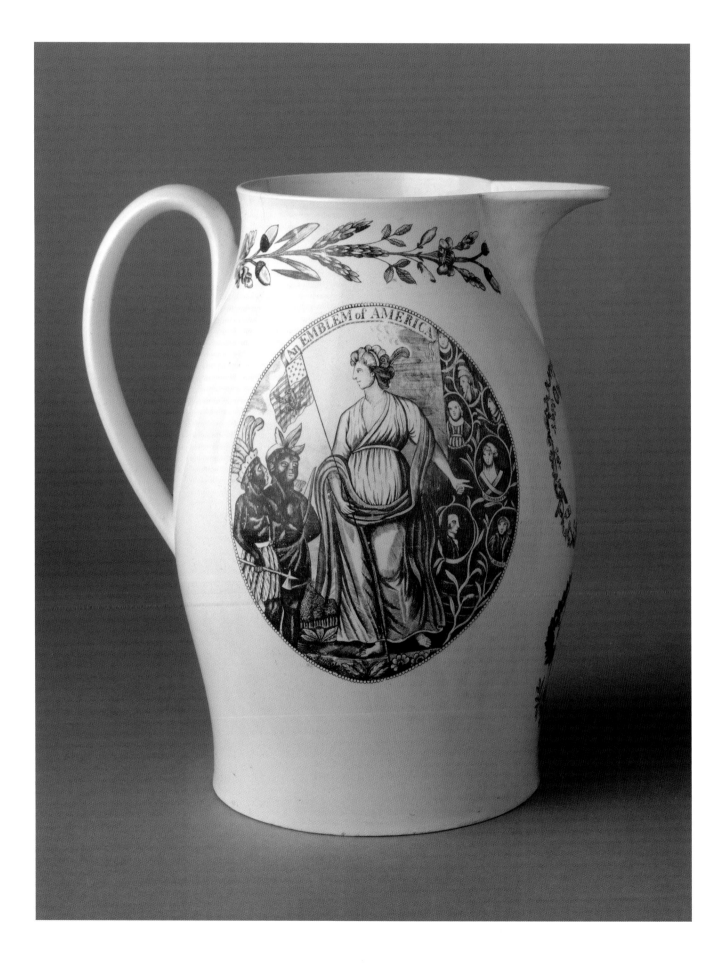

61. Jug

Probably Herculaneum Pottery
Liverpool, England; 1800–1810
Creamware printed in black
H. 8⅟₁₆ in. (218 mm)
2009.23.15 Gift of S. Robert Teitelman, Roy T. Lefkoe,
and Sydney Ann Lefkoe in memory of S. Robert Teitelman

With independence in 1783, the new republic of the United States sought to convey its strength, character, and spirit through specially designed imagery. The Indian princesses and queens that identified early and colonial America were replaced by more contemporary symbolic figures. Influenced by the revival of classical taste that first swept through Europe and then America, the image of a classical Greco-Roman goddess met the aesthetic standards of the day and offered the kind of stature that conveyed power and graciousness.[1] Female classical figures also became commonplace allegories of Liberty, Justice, and Victory, and elements from all of these may be seen in the figure of Columbia, which was featured in late eighteenth- and nineteenth-century patriotic imagery. In the print on this jug, "An EMBLEM of AMERICA," we see a contemporary image of a classical female allegory of America holding an American flag with sixteen stars and seventeen stripes and emblazoned with an eagle. Two Native Americans stand to the left, and on the right the design incorporates important figures in the history of the United States, from Columbus, Americus, and Sir Walter Raleigh to Franklin, Washington, and Adams. The source of this print is a series of engravings depicting the continents published by John Fairburn of London on September 4, 1798.[2] Whether these original images were ever seen in America is difficult to judge, but obviously some enterprising potter or engraver saw the emblem of America as a very commercial image. It is found on a range of jugs including a later, squatter form with the date 1820 as well as an example impressed "HERCULANEUM."[3]

The tall, elegant shape of this jug suggests that it was made about 1800 shortly after the death of George Washington, which is commemorated on the reverse. The image is after that published by James Akin and William Harrison Jr. in Philadelphia, on January 20, 1800, and titled *America lamenting her Loss at the Tomb of GENERAL WASHINGTON Intended as a tribute of respect paid to departed Merit & Virtue, in the remembrance that illustrious Hero & most Amiable man who died Decr. 14 1799.*[4] The central design is an obelisk dedicated to Washington, with an allegorical figure of America weeping at the foot of the monument and the American eagle bowing its head in distress. At the top of the print we read "WASHINGTON IN GLORY" and beneath "AMERICA IN TEARS." The bust of Washington seen on the obelisk was based on an original etching by Joseph Wright published in 1790. This modest profile became the most common source for artists and copyists in America and in Europe and, along with Gilbert Stuart's oil portrait and Houdon's marble bust, may be counted as one of the most influential portraits of Washington.[5] The Akin-Harrison print was a source for a number of engravers for the pottery industry, and an alternate version of this design can be seen at cat. no. 8.

A third print beneath the lip of the jug is also designed for the patriotic American, with an eagle based on the Great Seal of the United States.[6] Above that is a printed cartouche incorporating a number of Masonic symbols.[7] The jug was completely decorated with printed designs and was ready for the American market. The empty cartouche was presumably printed so that an inscription commissioned by the eventual owner might be quickly and inexpensively hand painted later.[8] It offers us a rare insight to the practice of buying and commissioning pottery. It is extremely

unusual to find an example where such a dedication was never added.

Jugs of this kind were just one way in which Americans could express their patriotism and their grief at the loss of Washington. Ceramics, glass, prints on paper, and needlework were all part of the decorative arts commemorating the country and its first president. In the expanding market, buoyed by economic growth and increasing consumer spending, English potters found a lucrative niche in providing these tokens to their former countrymen.

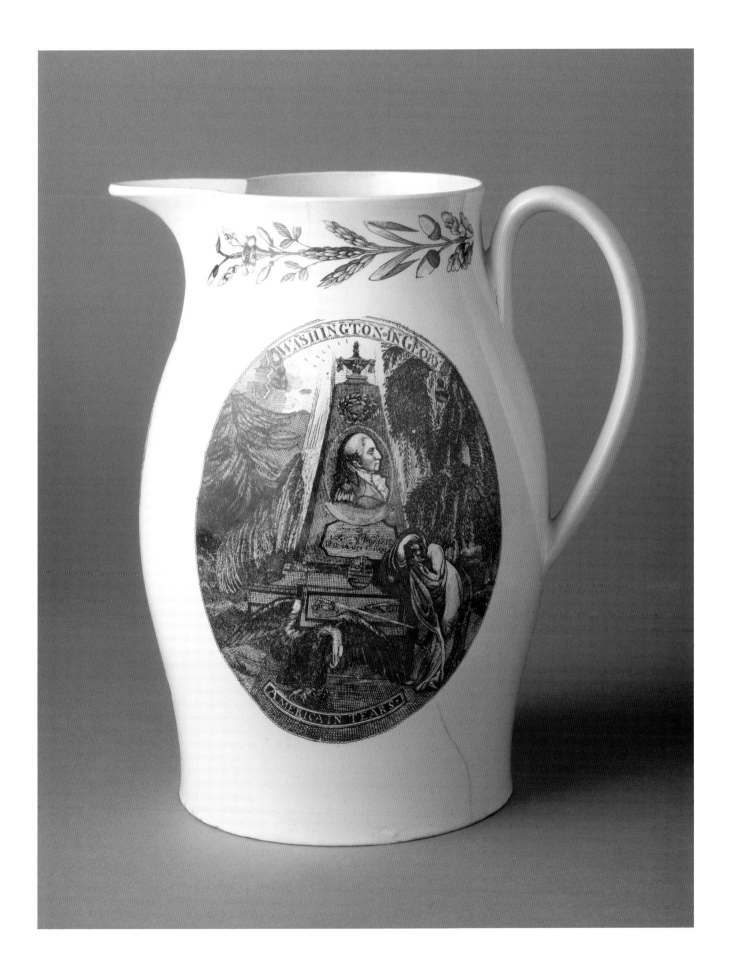

62. Plate

Herculaneum Pottery
Liverpool, England; ca. 1800
Creamware printed in black
Diam. 10⅛ in. (257 mm)
1959.588 Bequest of Henry Francis du Pont

Most of the wares dedicated to specific American customers are presentation pieces, mainly jugs along with a few mugs, bowls, and plates. This plate once formed part of a dinner service and, as such, is a rare survivor of a grand gesture of American patriotism. At least one other similar service appears to have been made, and similar plates are recorded with the monogram "MRR" painted on the rim, for Matthew and Ruth Rogers, of Long Island, who were married in 1797.[1] Those plates were impressed "HERCULANEUM 7" on the underside, and it is reasonable to assume that this plate was also made by Herculaneum Pottery.

The rim of the plate is decorated with an unusual print design. Six lozenges each contain sixteen horizontal stripes and are bordered with sixteen stars, perhaps a reference to the introduction of the sixteenth state, Tennessee, to the Union on June 1, 1796. The craftsman who engraved the central design would probably have used a print on paper as a basis for his work. Although an original source has not been identified, images of this kind could be found in the cartouches in printed maps and documents, in magazines and books, and as popular prints. In the center of the design, Columbia, holding an American shield, stands on a headland overlooking the ocean. At her feet lies a fallen spear next to an American eagle who, in a version of the Great Seal of the United States, bears an American shield and a ribbon with the motto "E PLURIBUS UNUM." Columbia holds an olive branch as if she is in the act of waving Godspeed to a departing ship below and bestowing her blessing on the maritime trade. In the background is a pyramid inscribed "SACRED TO THE memory of WASHINGTON."

This dinner service would have set a splendid table for any maritime merchant wishing to boast of his international trade while demonstrating his patriotism and devotion to the late president.

214

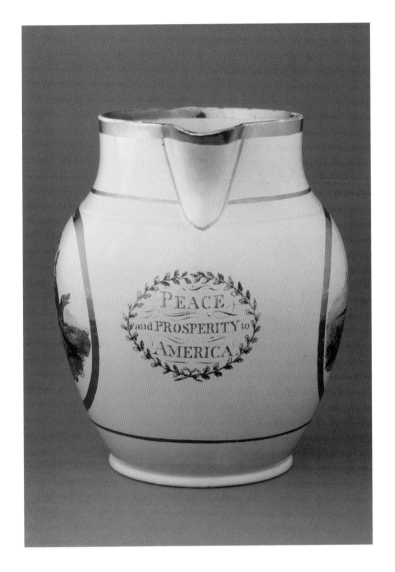

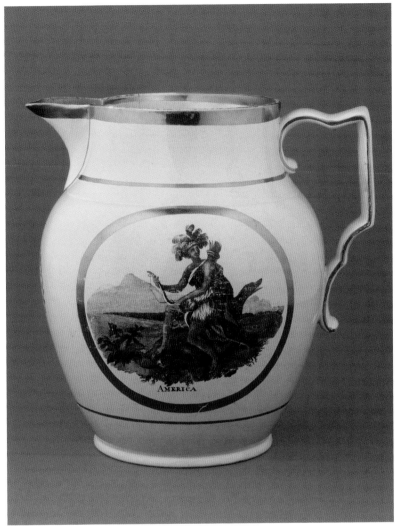

63. Jug

Staffordshire, England; 1810–20
Yellow-glazed earthenware printed in black
H. 8⅜ in. (212 mm)
2009.23.10 Gift of S. Robert Teitelman, Roy T. Lefkoe, and
Sydney Ann Lefkoe in memory of S. Robert Teitelman

Since the sixteenth century, artists have depicted the four continents using symbols to represent their abstract concepts of distant lands. The early European idea of New World America was represented by an Indian princess of Caribbean origins.[1] By the middle of the eighteenth century, this image was modified by the rising importance of the British colony of America, and a more distinctive symbol was devised: the American Indian Queen. Although this new image was superseded by a figure in the classical style (see cat. no. 61), the Indian Queen continued to be recognized as a representation of America. On both sides of this jug she is wearing a feathered headdress and skirt and carries a bow and arrows. Her foot is on the neck of her adversary, which is the traditional pose of Liberty trampling Evil, seen here as an ape-like monster.[2] In the background is an alligator, another early symbol of America. This subject would no doubt have had great appeal to the newly independent United States. To offer even greater appeal to the loyal citizen, there is a slogan printed in black beneath the spout and within a wreath of leaves; it wishes "PEACE and PROSPERITY to AMERICA."[3]

The shape of this jug, its canary yellow ground, and the silver luster detailing are all features of a nineteenth-century date. Silver luster was introduced into pottery decoration about 1805 and was first used on more expensive porcelain and bone china before trickling down to less-expensive earthenware products.[4] This showy piece would have sparkled in candlelight and would surely have been a popular way to express patriotic support for the developing United States of America.

215

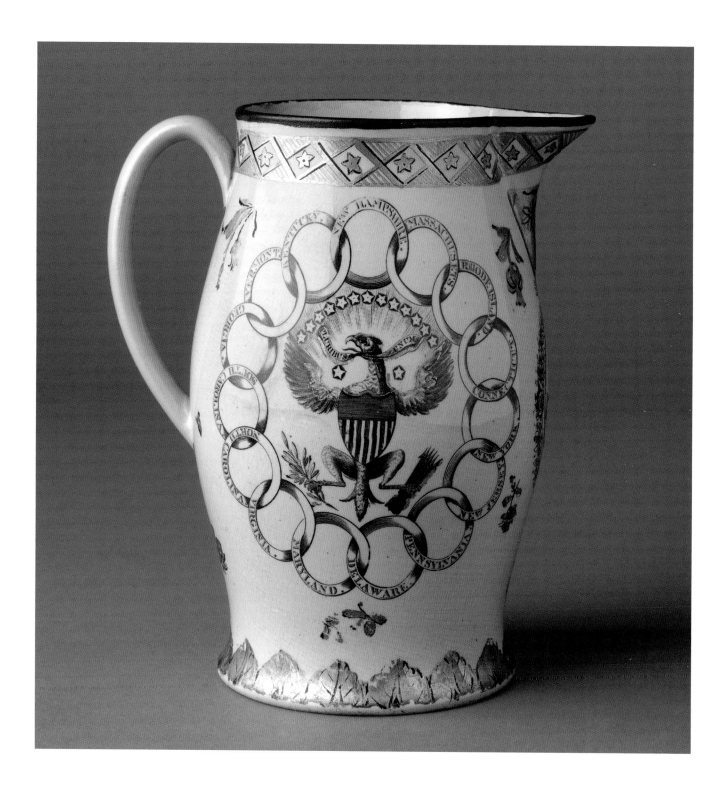

64. Jug
Staffordshire or Liverpool, England; 1795–1800
Creamware printed in black and painted in enamels
with extensive gilding
H. 7⅜ in. (187 mm)
2009.21.4 Gift of S. Robert Teitelman

With its extensive gilding, this jug illustrates how
flamboyant many of these early creamwares might have
been in their original state. The standard black-printed
designs are enhanced by gilt borders at the foot and rim,
and flower sprays and other touches of gold create an

unusual richness.

On one side is printed a version of the Great Seal of the
United States that closely resembles the first die cut in
1782. As with the original, the ribbon with the motto "E
Pluribus Unum" flies in front of the eagle and is grasped in
the center by the eagle's beak. The shield, however, carries
fifteen vertical stripes, more than were ever approved for
the seal. It is difficult to tell how many olive leaves and
arrows are depicted, the symbolism of the number
"thirteen" escaping the engraver who sought to create an
artistic version of the seal rather than an accurate one.[1]

The reverse has a stock print of a ship flying the

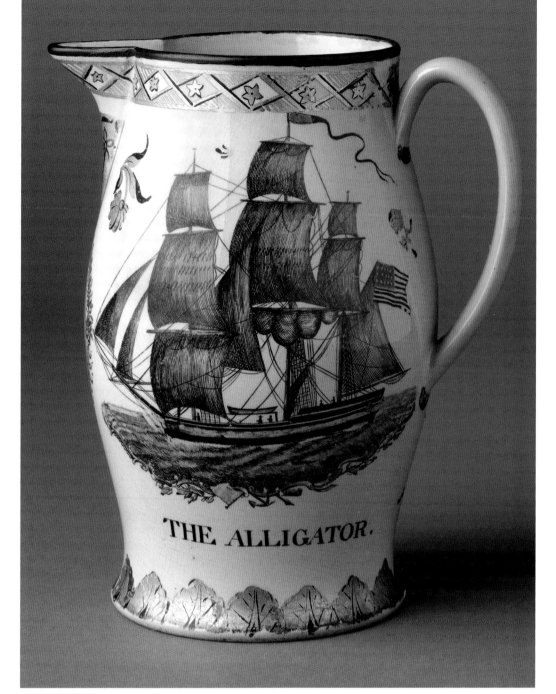

THE ALLIGATOR.

American flag.[2] The scene is enlivened with enamel painting, and the ship has the hand-painted title "The Alligator." Beneath the lip within a black-printed foliate medallion is the hand-painted and gilded letter "P." The alligator has been a symbol of the Americas since the late sixteenth century. Found only in the southeastern United States, the reptile elicited both fear and fascination in early European explorers, who often used the image together with a Native American princess to represent the new continent.[3] Because of its connections, *Alligator* was a popular name for American ships, and several of that name were sailing in the 1790s and early years of the 1800s. If the stock print depicting a three-masted ship on this jug is an accurate representation, then this may be the 239-ton, 88-foot long *Alligator* that was built in Salisbury, Massachusetts, in 1796. If this is the case, then the "P" under the spout may refer to William Parker, the ship's master, or Edward Pierce, one of the owners.[4]

This jug is an extraordinary survival. Gilding on earthenwares of this period is extremely fragile and rarely survives. A number of pieces in this catalogue have the remains of gilding, but only one or two examples survive nearly intact. With this piece we see how showy these jugs would have looked when new; it is reasonable to conclude that they were rarely if ever used.

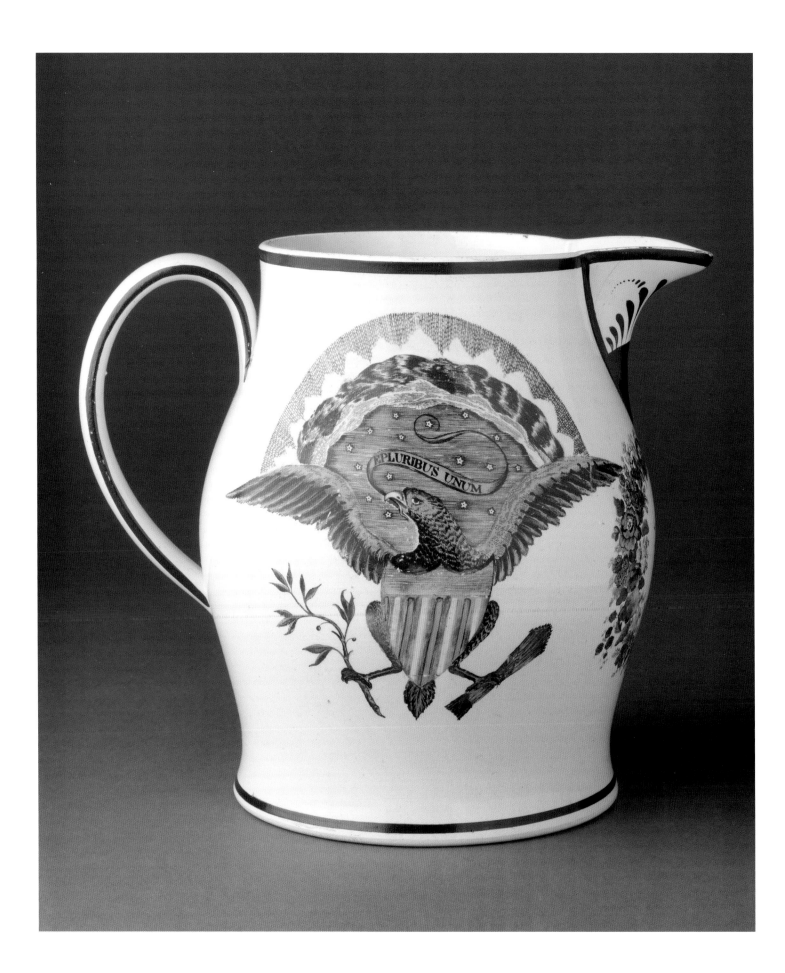

65. Jug

Staffordshire, England; 1815–20
Creamware printed in black and painted in enamels
Signed by the engraver "Kennedy Burslem"
H. 9⅞ in. (251 mm)
1958.1200 Bequest of Henry Francis du Pont

This colorful creamware jug has black-printed designs that are extensively over painted with enamel colors. Beneath the lip is a circlet of flowers carefully filled in with a full palette of appropriate shades; the center has had an inscription added in gold and reads "WR WOODS." At the lower right-hand side the print includes the signature "Kennedy Burslem," for James Kennedy, an engraver who worked in Burslem in the Staffordshire Potteries from about 1815 to 1840.[1]

Although one can be certain that Kennedy engraved the floral cartouche, the other prints are unsigned. One side bears a Masonic image often found on English pottery. It is full of symbolism with depictions from the All-Seeing Eye of the Supreme Being to the three Christian Graces of Faith, Hope, and Charity.[2] The Freemasons are a fraternal organization with early obscure roots that still seem to be the subject of debate and discussion. What is not in doubt is that the organization was established in America by the early 1700s and that George Washington was a prominent member. By 1820 there are estimated to have been 32,000 members in America, and the colorful design on this jug was intended to catch their eye.[3] The reverse has a version of the Great Seal of the United States. The choice of orange and yellow as the principal colors is an unusual one and does not reflect in any way the red, white, and blue of the original design.[4] Together these prints created a decorative jug that offered a rich expression of patriotic and fraternal loyalty to America.

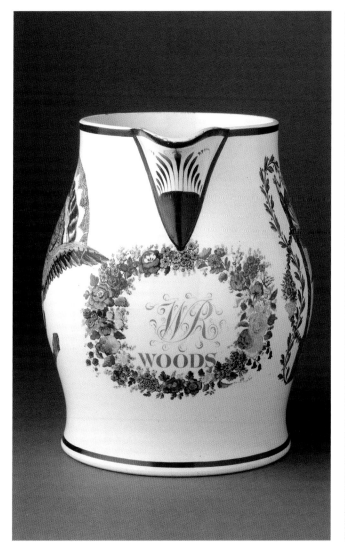

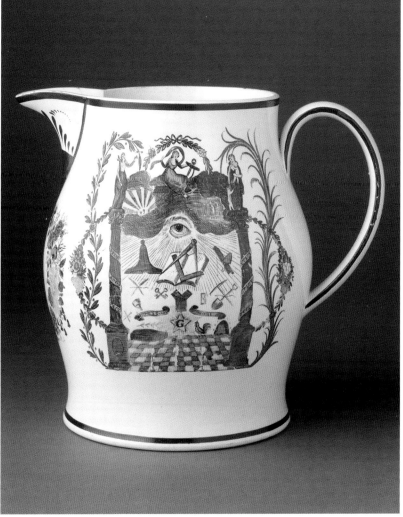

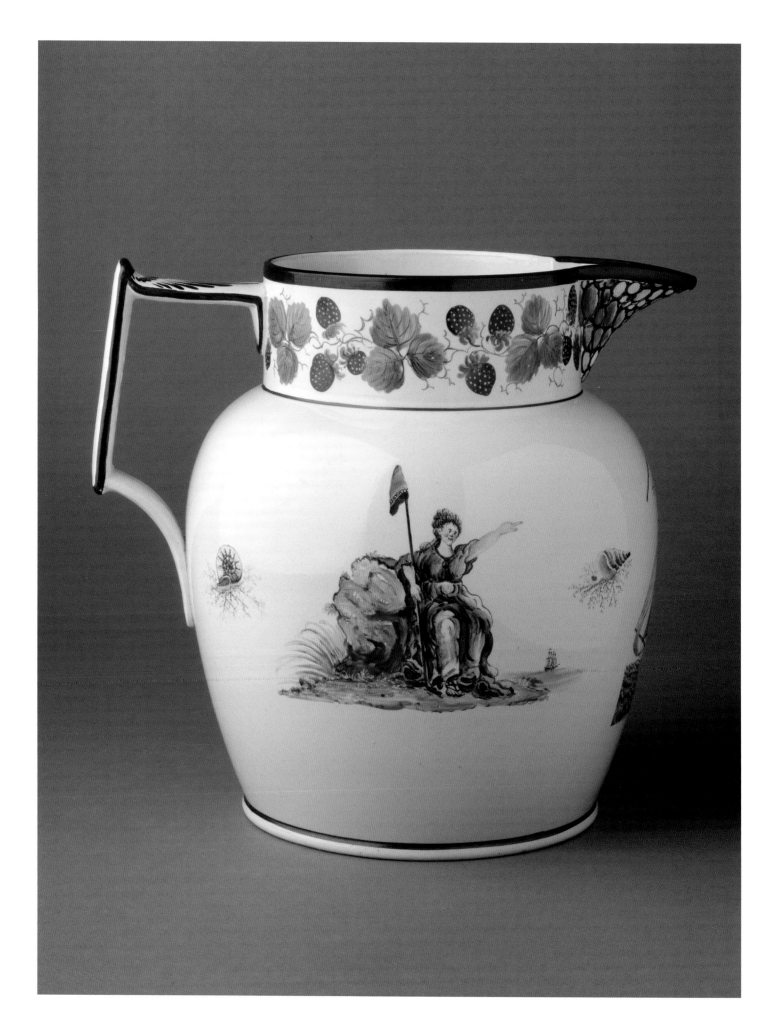

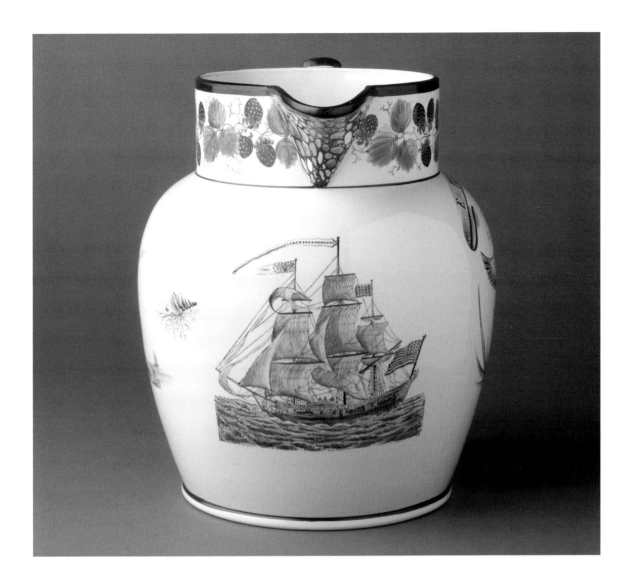

66. Jug

Bristol Pottery
Bristol, England; 1819
Pearlware printed in brown and painted in enamels
Inscribed on the base in brown "Bristol Pottery 1819"
H. 10½ in. (266 mm)
1967.23 Gift of Mr. B. Thatcher Feustman

This jug is an exuberant example of the art of the pottery painter providing goods for the American market. Many of these transatlantic pieces are referred to generically and often erroneously as "Liverpool." This example is marked and comes from another major port city, that of Bristol in southwest England.

A large and well-established pottery industry existed in Bristol by the early years of the eighteenth century. The Temple Pottery, founded to make delftware in 1683, had moved to stoneware production by 1784 and soon after changed over to making creamware. This production was quickly followed by the introduction of China glaze (called pearlware by modern collectors), in which a small amount of cobalt blue was added to the glaze mix, creating a bluish white, porcelainous finish. By the end of

the 1700s the factory had adopted the title of the Bristol Pottery and by 1800 employed more than 100 workers. In 1813 John Decimus Pountney joined the company. He was followed in 1816 by Edwin Allies, and from that time they traded as "Pountney & Allies." The company went from strength to strength, and by 1819 their workforce had increased to 200.[1] It was during this prosperous period in the factory's history that this jug was made.

The neck of the jug has been freely painted with strawberry leaves and fruit, and an extremely decorative lip has a multicolor pebble pattern. This style of painting has often been attributed to William Fifield. A signed plaque by Fifield has figures painted in the same style as "Liberty" seen on the reverse of this jug.[2] Fifield's sketchbook in the Victoria & Albert Museum confirms his quirky style of figure painting. This, together with a similar jug with strawberry border and pebble lip attributed to Fifield in Bristol Museum & Art Gallery, give credence to a Fifield attribution.[3]

Beneath the lip is an image of a three-masted ship printed in outline in brown and extensively enhanced with painting in enamel colors. A number of flags and pennants fly in the breeze, including a passable "stars and stripes" waving at the stern and an interesting

combination of stars emblazoned with an eagle flying from the foremast. Perhaps the most engaging decorations on this piece are the hand-painted images on either side.

One side features a classical figure representing Liberty. She holds her Phrygian cap aloft and, seated on a rock, points over the ocean as if to signal to the distant sailing ship that it should be headed off sailing the seas in search of maritime trade for the free colonies of America. A similar jug formerly in the S. Robert Teitelman Collection had the same design but with the addition of an American flag flying from an elongated liberty staff.[4] The other side of this jug is painted with a version of the Great Seal of the United States. More amusing than accurate, the design observes only some of the conventions seen in the first version of the seal approved by the Continental Congress in 1782.[5] The eagle holds a single arrow (not a bundle of 13) in its proper right talon and an olive branch with 12 leaves (instead of 13) in its left talon. Not only are the numbers wrong, but they should be in opposite talons. There are 13 red and white stripes on the shield, but they should begin and end with white, not red. "E PLURIBUS UNUM" (13 letters) should be on a ribbon held in the beak of the eagle. The number of stars began with 13 on the original seal and gradually increased as new states entered the Union. Illinois joined as the twenty-first state on December 3, 1818, and may account for 21 stars in the constellation above the eagle device.

It is not possible to know whether the general populace of America understood the details of the Great Seal or indeed whether the citizens of any country would recognize the minutiae of their own emblems. Certainly Americans might have had a general understanding of the image, and this colorful rendering would have had a charm and presence admired by any patriot.

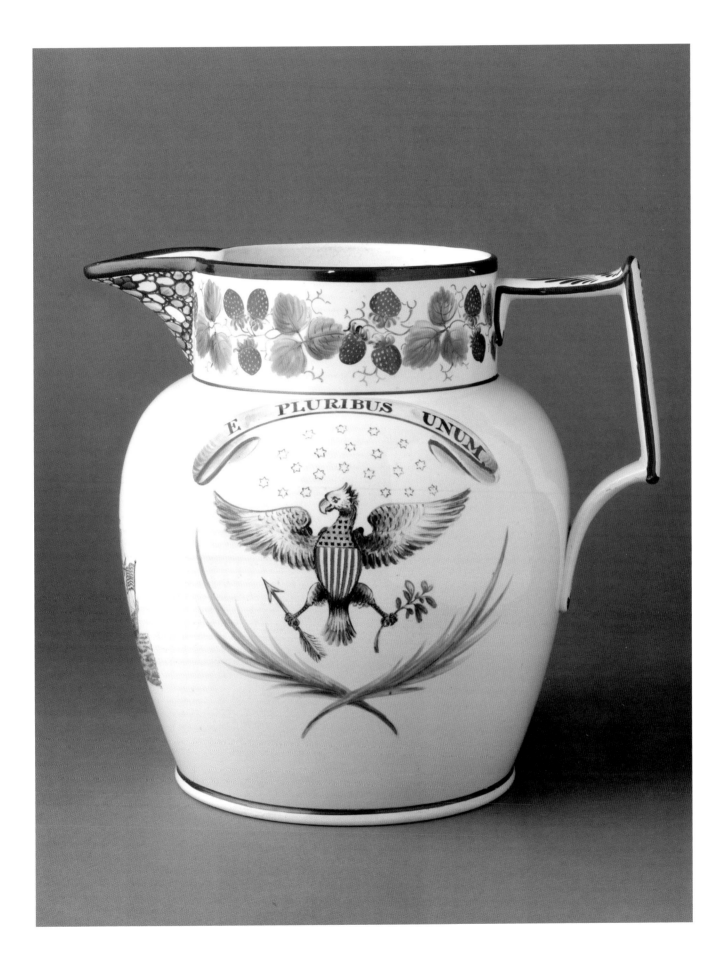

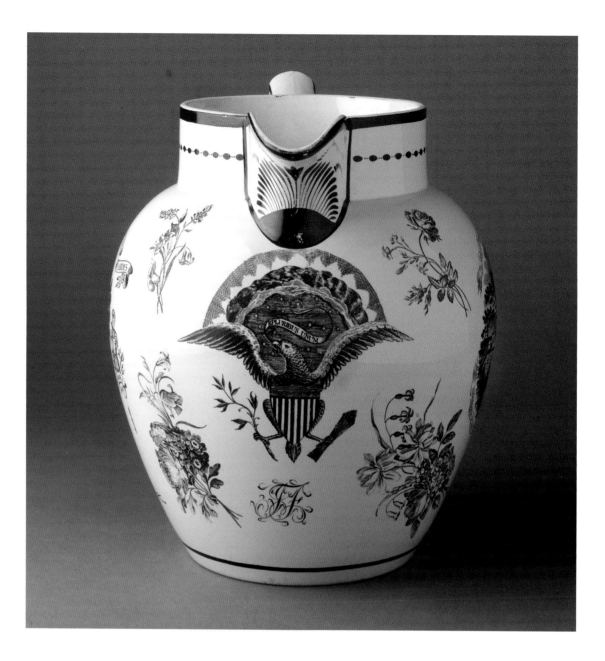

67. Jug

Probably Herculaneum Pottery
Liverpool, England; 1815–20
Creamware printed in black and painted in enamels
H. 12¾ in. (325mm)
1964.1715 Bequest of Henry Francis du Pont

Trade between England and America was inevitably disrupted during the War of 1812, but once peace had been ratified in December 1814 the potteries of England were eager to resume their business with America. The large black print beneath the lip of this jug is an affirmation of their wish to appeal to this lucrative market. This version of the Great Seal of the United States was placed in a prominent place to appeal to the patriotic purchaser.[1] Beneath the print is the monogram "JF" painted with scrolling flourishes. Unfortunately we may never know who JF was and whether he commissioned this piece or was just the lucky recipient. The prints on either side may give us a clue, but perhaps they were the choice of the pottery printer rather than the customer.

Unusual for a jug of this date, we see on one side a print of a guild armorial entitled "THE BLACKSMITHS ARMS." It is a version of the arms of The Worshipful Company of Blacksmiths, who received their first charter in 1571, with arms granted June 24, 1610. By the 1700s the Blacksmiths Livery Company no longer had any control over the trade, and in 1785 they went into hibernation, operating solely to disperse pensions and charitable funds from their investments.[2] In this version of the arms, the supporting lion and swan have been replaced with suits of armor and weapons of war, although the shield remains essentially the same with the motto beneath reading "BY HAMMER AND HAND ALL ARTS DO STAND."

On the opposite side of the jug is a scene from the War of 1812, with a ribbon above "The Gallant Defence of STONINGTON. August 9th 1814." Below this is written "Stonington is free whilst her Heroes have one gun left."

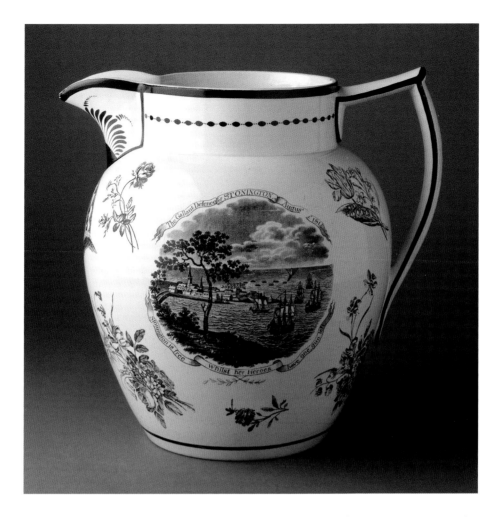

The print depicts the Battle of Stonington, when a sizeable British naval squadron attacked the small coastal village of that name in Connecticut. The British had more than 160 cannons and fired more than 50 tons of shells, rockets, missiles, and cannonballs. Stonington had only 3 cannons in the makeshift garrison, Fort Joseph; nevertheless, they fought bravely and on August 12, 1814, the British withdrew. The story of the battle was trumpeted throughout the nation, one of the few instances of heroism in a war largely lacking either victories or heroes.[3]

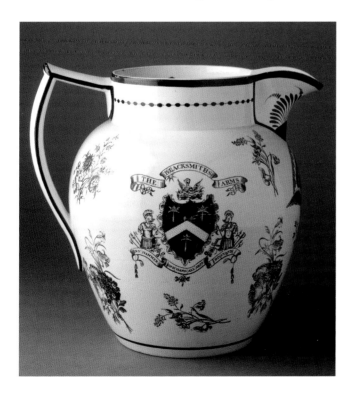

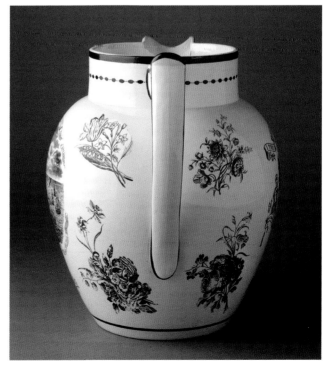

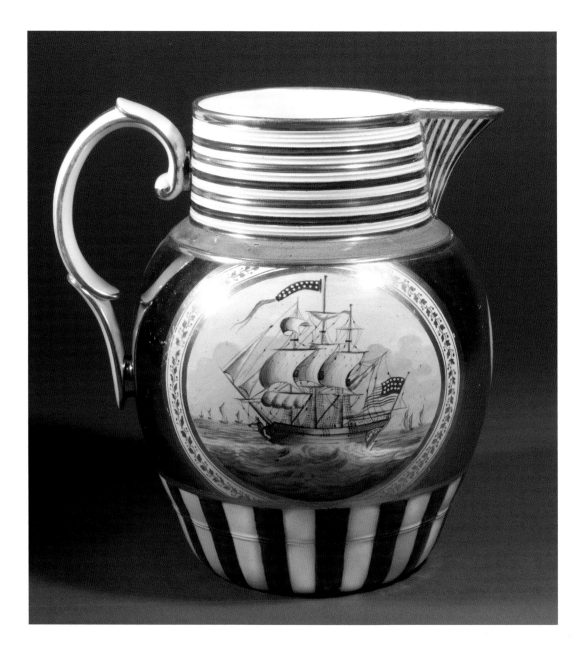

68. Jug

Liverpool or Staffordshire, England; 1810–20
Pearlware painted in silver luster and enamels
H. 9 in. (228 mm)
1964.1282 Bequest of Henry Francis du Pont

This distinctive jug, with its boldly painted pink stripes and silver luster ground, is lavishly decorated with hand-painted images that celebrate its owner's pride in the United States as well as his family. On one side, an oval medallion contains a painted portrait of a three-masted ship proudly flying a large American flag and pennant. The basic design of the flag was created on June 14, 1777, by the Continental Congress, which "resolved, That the flag of the United States be thirteen stripes, alternate red and white: that the union be thirteen stars, white in a blue field, representing a new constellation."[1] Though few other details regarding the flag's development are known, it is thought that it may have been proposed by the Marine

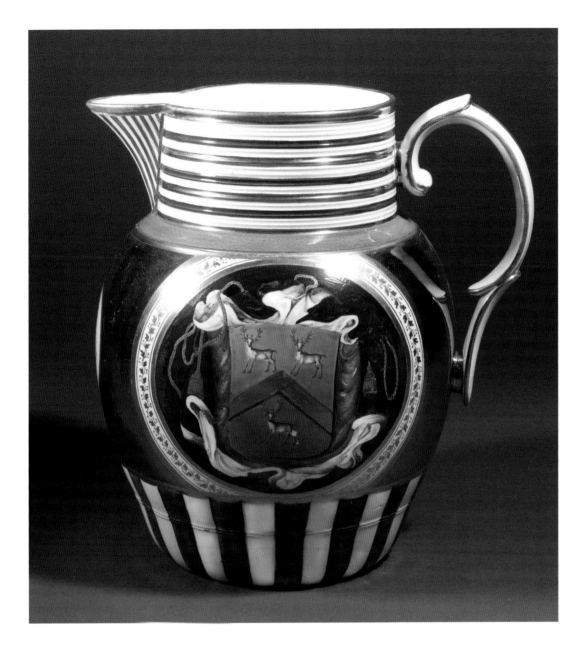

Committee of Congress, who needed a recognizable flag that could be used by ships and naval fortifications.[2]

Both the flag and the pennant painted on this jug have sixteen stars and sixteen stripes, which suggests that it dates to between 1796, when Tennessee was admitted as the sixteenth state, and 1803, when Ohio was admitted as the seventeenth. The official U.S. flag as defined in 1795, when the second flag act went into effect, had fifteen stripes and fifteen stars. Despite the addition of several new states, that version remained in use until the third flag act was authorized on April 4, 1818, stipulating that the flag carry thirteen stripes to honor the original thirteen states and an additional star for each new state admitted to the Union.[3] Unfortunately there was little regulation of flag design, so it is possible that some were made with additional stars and stripes as new states were admitted. It is even more likely that ceramic painters in England did not know or care exactly how many stars and stripes were on the flag and simply painted whatever they thought appropriate.

When the concept of an American flag was developed in the 1770s, it was not seen so much as a national symbol as a practical marker of identification that would be used almost exclusively by the military and navy. Over the next few decades, however, it became a symbol recognized and prized by the general population, especially after American victories in the Quasi-War with France, the wars with Barbary pirates in the Mediterranean, and especially the War of 1812. It was during this period that the American flag began to appear with increasing frequency on objects, especially textiles and ceramics.[4]

On the reverse of the jug is a boldly painted coat of arms and on the front under the spout is the initial "R," expressing an individual's pride in his family and lineage. The arms are those of the Robinsons of England and probably were used by a now-unknown American branch of the family.[5] It was not uncommon for Americans who wanted the social cachet that accompanied armorial bearings to use the coats of arms of their more aristocratic English relatives.

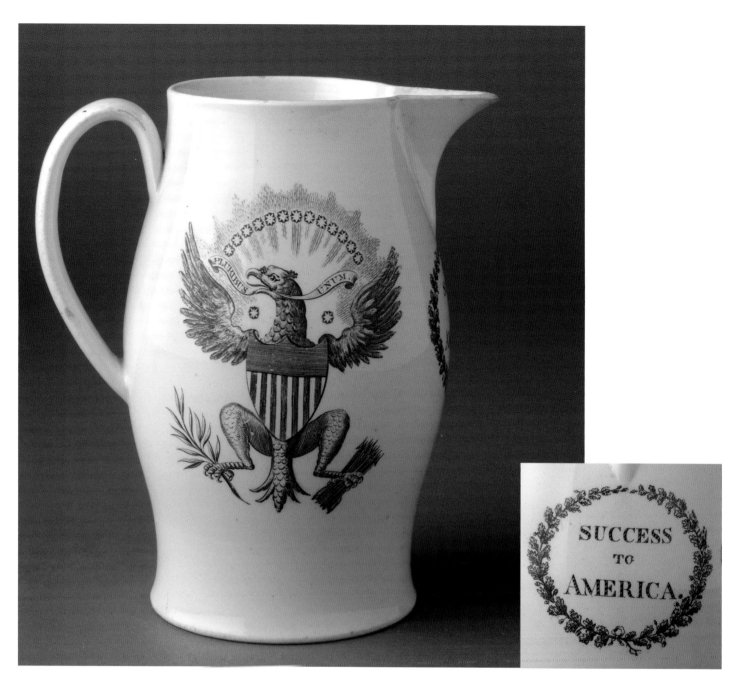

69. Jug

Staffordshire or Liverpool England; 1792–1805
Creamware printed in black
H. 7⅛ in. (181mm)
2009.23.7 Gift of S. Robert Teitelman, Roy T. Lefkoe, and
Sydney Ann Lefkoe in memory of S. Robert Teitelman

The stark black prints on this creamware jug offer an
unequivocal demonstration of patriotism. Beneath the lip is
the printed slogan "SUCCESS TO AMERICA" within an
oval leafy frame. This revolutionary exclamation can be found
on objects crafted as early as September 1776, soon after the
adoption of the Declaration of Independence.[1] From that
time on, it was used as a rallying cry, patriotic toast, and
expression of hope for the future prosperity of the nation.

One side of the jug carries a scene commemorating
George Washington and celebrating his victorious

leadership.[2] The printed design is framed by a scrolling
ribbon creating fifteen loops, each inscribed with the name
of one of the first fifteen states of the Union and featuring a
star representing the state. At the top of the design is a
rudimentary engraving of an American eagle. A central
medallion is engraved with a portrait of George Washington
that derives from the Edward Savage portrait made in 1789
for Harvard University, an image copied and published
widely in America and England. The portrait has a symbolic
laurel-leaf frame held aloft by Victory. She is supported on
the right by Liberty, as proclaimed by the title on her liberty
cap, and on the left by blind Justice.[3] Although Washington
was perhaps the best recognized of all the Revolutionary War
heroes, in case there should be any doubt, a winged angel
holds his name aloft within an oval of fifteen radiant stars.

Kentucky was the fifteenth state admitted to the
Union, on Friday, June 1, 1792, and its inclusion

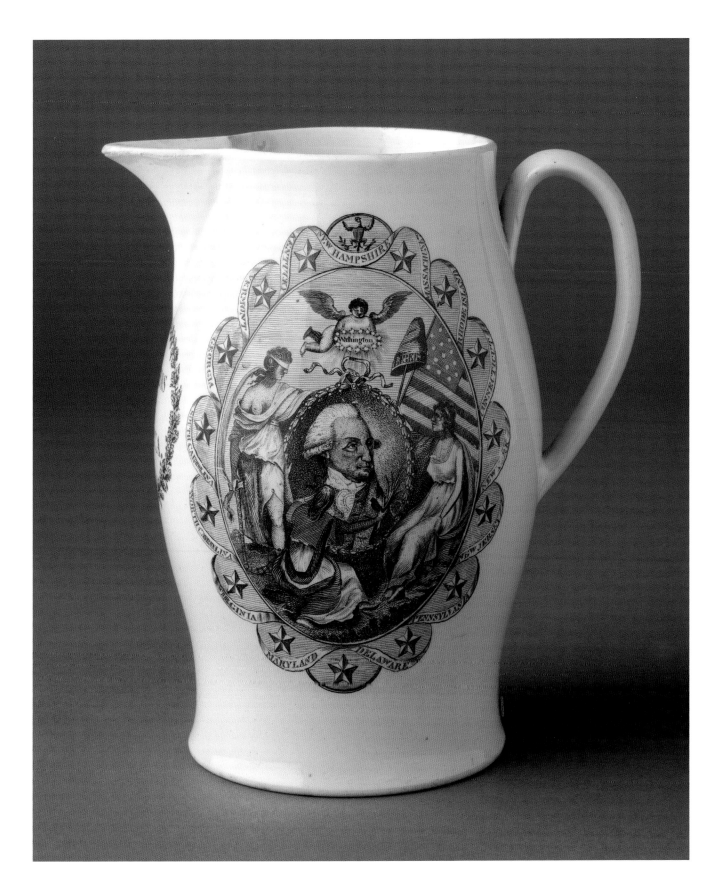

indicates that this print was engraved after that time. The original source for the print has not been identified, but as no memorial inscription is included, perhaps it is based on one of the many celebratory prints produced before Washington's death on December 14, 1799. The reverse side of the jug carries a printed version of the Great Seal of the United States that closely resembles the first die cut in 1782. It is similar to prints occurring on other pieces in this collection and was one of the most easily identifiable American patriotic symbols that English potters used to great effect.

70. Jug

Probably Staffordshire, England; 1815–30
Pearlware printed in black and painted in enamels
H. 4⅞ in. (124 mm)
1966.50 Gift of Mr. B. Thatcher Feustman

This jug is decorated with one of the main rallying cries of the War of 1812: "FREE TRADE AND SAILORS RIGHTS." While there were many sources of friction between Great Britain and the United States that ultimately led to war, few were as galling as Britain's attempt to prevent American trade with France and the impressment of American sailors into the British navy. Both were the result of Britain's twenty-two-year war with Napoleonic France. During that time, Britain had blockaded France and much of Continental Europe, and the British navy stopped, searched, and sometimes seized neutral American vessels, especially those carrying goods from French colonies in the Caribbean that were attempting to circumvent the blockade. The British navy, chronically undermanned, also impressed American sailors

who were judged to be British citizens. Although some were British sailors who had deserted and were working under easily granted American citizenship papers, others were American-born.

These issues were seen by many as a gross violation of American sovereignty, and "Free Trade and Sailors Rights" became a popular rallying cry in the lead-up to the declaration of war in 1812. The motto appeared in speeches, newspaper headlines, and on banners flown by American naval vessels, most notably the *Chesapeake* when she fought and was captured by the *Shannon* in 1813, and the *Essex*, which harassed British ships off the coast of South America before being captured in 1814.[1] The motto continued to resonate after the war and was used into the 1830s by opponents of tariffs on imported goods.

On either side of this bulbous jug are transfer-printed and overglaze enameled vignettes of an American eagle with military trophies and the slogan "ARMS OF THE UNITED STATES." Though not the actual coat of arms of the United States, these patriotic images were often used to symbolize the country.

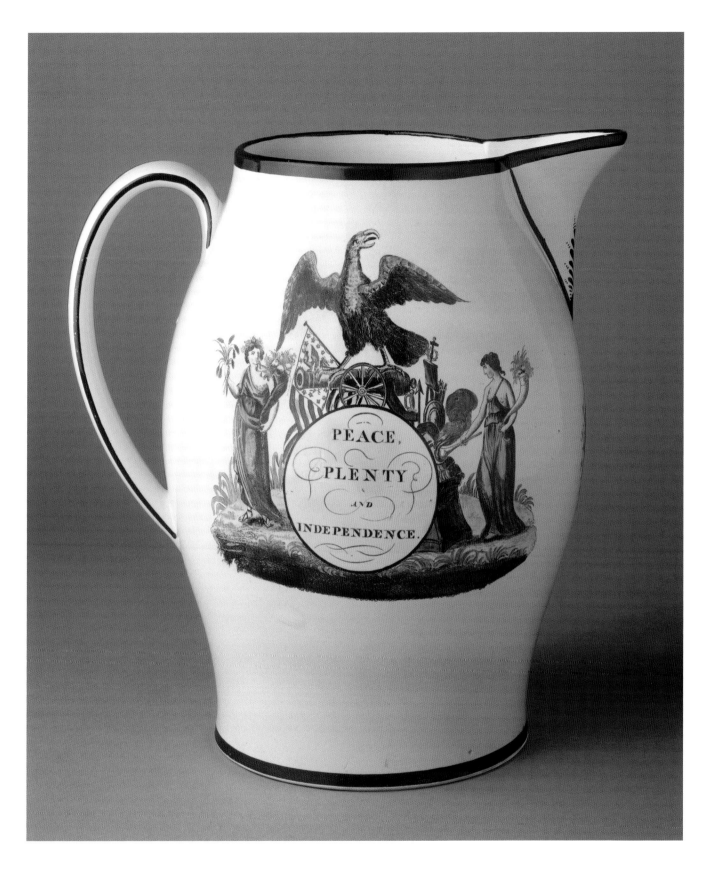

71. Jug
Probably Liverpool, England; 1793–95
Creamware printed in black and painted in enamels
H. 11 in. (280 mm)
2009.21.16 Gift of S. Robert Teitelman

The inscription on this jug, "PEACE, PLENTY AND

INDEPENDENCE," symbolizes the hopes and dreams of many of the citizens of the new United States. Its simple but eloquent message is reinforced by figures of Peace, destroying the tools of war, and Plenty, holding a cornucopia. They flank the central medallion, which is surmounted by a cannon, representing the military might that helped win independence, and an eagle symbolizing America.

Eagles, flags, and patriotic slogans were among the most popular emblems to appear on ceramics made specifically for the American market. This particular design is not uncommon, but this jug is rare because of its brilliant enamel coloring. There were two eighteenth-century ships named *Grand Turk*, both of which belonged to Salem merchant prince Elias Hasket Derby. This is probably the second, which was launched in 1791 in Salem. At 124 feet in length and 550 tons burthen, it was the largest ship built in America to that date. Newspaper reports recall

great numbers of people assembled to see the launching of the large and beautiful ship from Mr. DERBY'S wharf. They were however disappointed in the pleasure they expected, by her stopping when she had run about half her length: And all the efforts which could be made were ineffectual in getting her off at that time: the next day, however, with the aid of proper apparatus she was again put in motion and gained the water.—The name of *The Grand Turk* is revived in this ship, heretofore borne by a ship belonging to Mr. DERBY, remarkably successful as a privateer in the late war, and which was some time since sold in India. The ingenious Mr. ENOS BRIGGS, from the North River, was the masterbuilder of the new ship Grand Turk.[1]

It is possible that the maiden voyage took place the following year, with the report "SALEM, March 6 The beautiful new ship Grand Turk, 550 tons burthen, built in this town, and furnished with sails and rigging from the Salem factories, is ready to sail with the first fair wind for Calcutta, in the East-Indies: She is commanded by Capt. Benjamin Hodges

Safe may she reach her distant, destin'd port,
Nor rocks, nor treach'rous sands, oppose her fame,
May gentle winds her swelling topsails court,
And thousands shout her welcome home again."[2]

The printed oval medallion beneath the spout is elegantly painted in enamel colors and bears the painted monogram "JPM" for Joseph Moseley, captain of the *Grand Turk* from 1793 until 1795.[3] He sailed her to St. Petersburg in late 1794, arriving home in February 1795.[4] Within the month advertisements appeared citing "NEW YORK FOR Sale or Charter, The very fine ship GRAND TURK, Captain Mosely, Just arrived from

Russia, a stout staunch vessel, burthern about 700 tons, little more than 3 years old built under the particular inspection of the owner, is well sound and fitted, and sails fast. For further particulars enquire of the Captain on Board at Murray's wharf."[5]

By 1796 the captaincy of the *Grand Turk* had passed to another master. Captain Moseley continued to sail and may be the subject of a notice in the *Salem Gazette* of July 16, 1799, which reported, "It is with the most painful regret we mention the death of Captain JOSEPH MOSELEY, of this town. Capt. MOSELEY sailed from Philadelphia on the ship Enterprize of this port, bound for Copenhagen, and on his passage fell in with a privateer of 16 guns, which without shewing any colours, fired upon his vessel and killed him. . . . Capt. MOSELEY has always supported an excellent character, and his loss is universally regretted."

This piece serves as not only a testament to a great ship and a brave captain but also a reminder of the dangers faced in the late eighteenth and nineteenth centuries by the intrepid mariners who developed international trade for America.

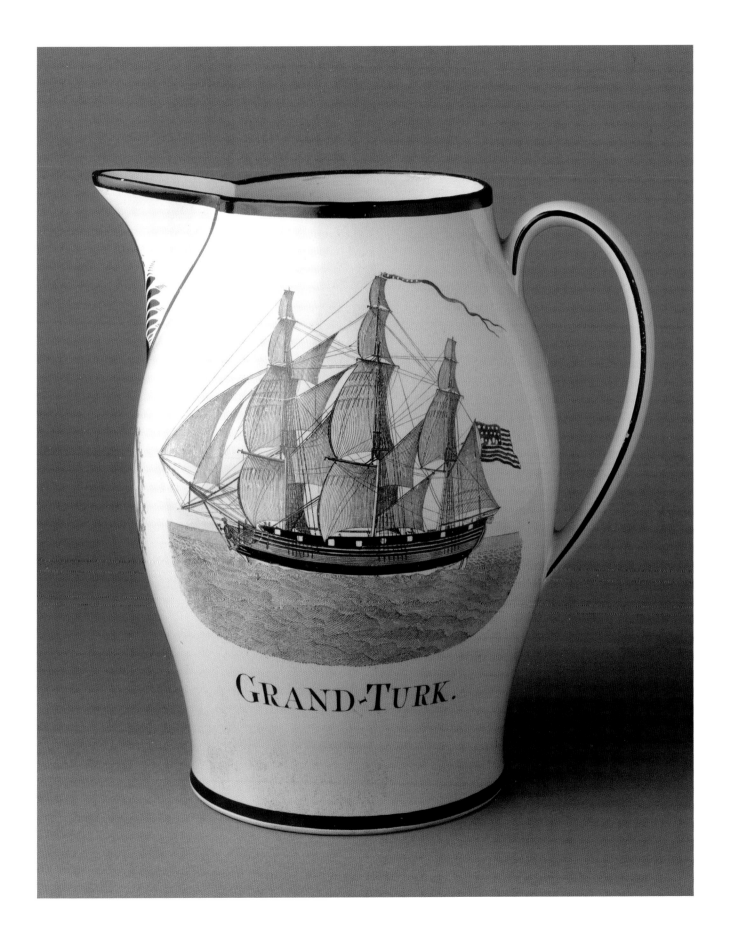

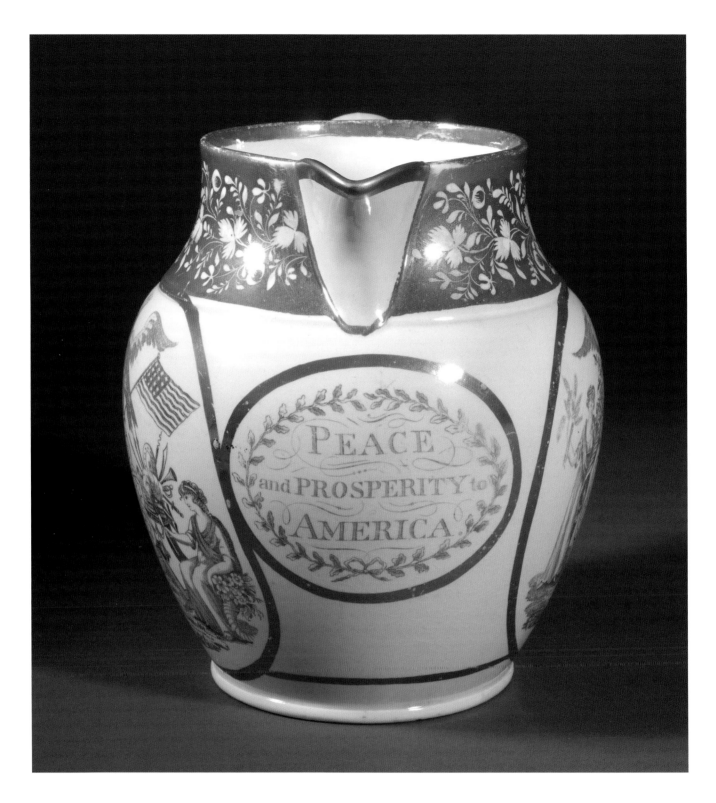

72. Jug

Probably Staffordshire, England; 1805–12
Pearlware printed in lilac and decorated with luster
H. 7 in. (178mm)
1966.59 Gift of Mr. B. Thatcher Feustman

This small jug may have been the perfect vessel to hold liquor for a toast. By the 1800s toasting was not just a common practice but an important ritual at dinner parties and other formal gatherings. Every glass of wine had to be dedicated to someone or something. The toasts heralded local celebrities, leaders, and good causes.[1] As early as 1766, on the occasion of hearing the first news of the repeal of the Stamp Act, the bearer of the tidings was presented with "A large Bowl of Punch . . . in which he drank Prosperity to America."[2] This jug proclaims a version of that traditional phrase; printed in lilac within a foliate wreath are the words "PEACE and PROSPERITY to AMERICA."[3]

On each side of the jug are lilac prints entitled "PEACE PLENTY and INDEPENDENCE," another popular toast from the time of the Revolution through the War of 1812. The design is filled with symbolism: an allegory of Peace (to

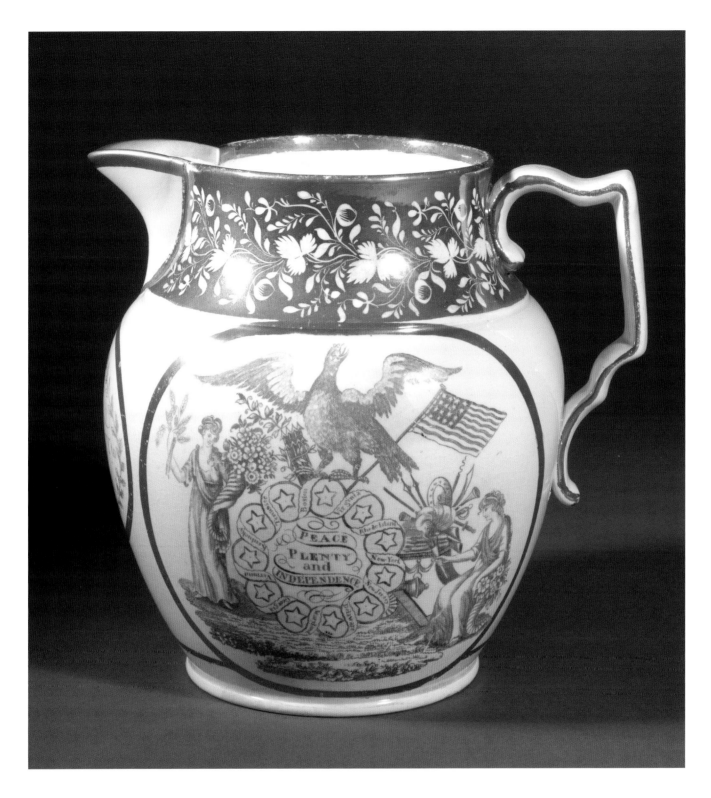

the right), burns weapons of war on an altar, while the figure of Plenty (on the left) carries a sheaf of corn and a brimming cornucopia. An American eagle takes an aggressive stance, his arrows of war prominently displayed atop a ribbon of stars and states design. Perhaps the engraver of this print was less well informed than others, for he included an arbitrary selection of states and the city of Boston.

The jug is also decorated with silver luster. A pattern of flowers and foliage has been achieved around the neck by painting a resist material (probably sugar and water) in the areas to remain white. The luster was then applied all around the rim; when the resist material was later lifted or washed away, the white body was revealed beneath in the desired design. This kind of luster is formed with the use of platinum to create the silver color; silver itself tarnishes and corrodes and therefore is not suitable for ceramic use. First introduced in 1805 as an alternate to gilding on bone china, silver luster soon became a firm favorite with customers and graced a whole range of earthenwares made for a middle-class market.[4] This jug would have been a moderately priced, but not inexpensive, purchase for its American buyer.

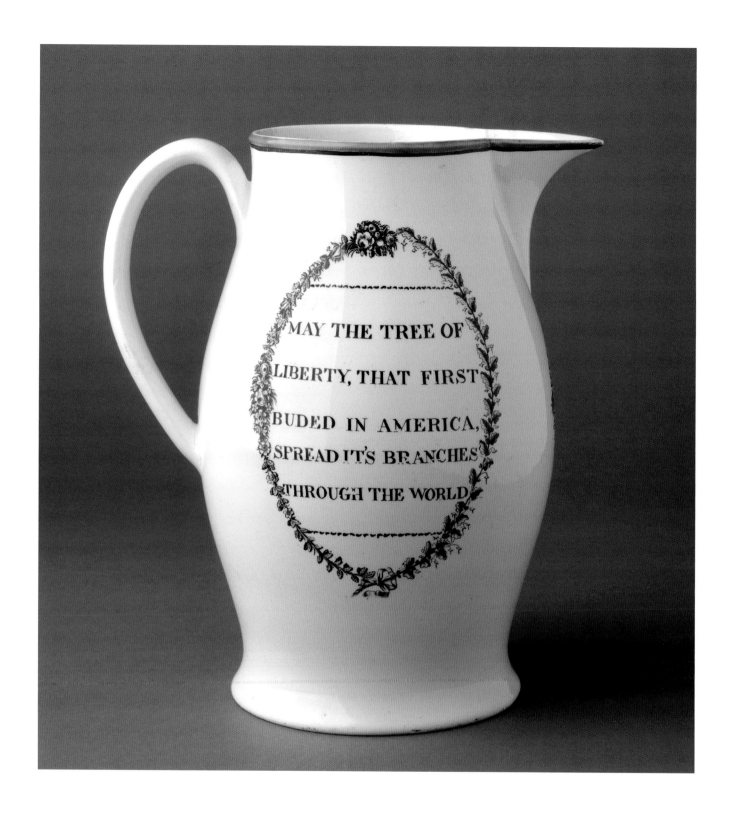

73. Jug and plate

Probably Herculaneum Pottery
Liverpool, England; 1796–98
Creamware printed in black and painted in enamels
H. 9¾ in. (238 mm)
2007.31.3, .6 Gift of S. Robert Teitelman

"MAY THE TREE OF LIBERTY, THAT FIRST BUDED IN AMERICA, SPREAD IT'S BRANCHES THROUGH THE WORLD." is a graphic, powerful, and timeless expression. Painted large on the reverse of this jug, the words appear to be an original patriotic sentiment. The source has not been identified in literature nor has any other example of its usage been found on patriotic pottery. The phrase is believed to have originated with David Alden, the owner of the jug, a fifth-generation descendant of *Mayflower* Puritan John Alden and his wife, Priscilla Mullins Alden, whose romance was immortalized by Henry Wadsworth Longfellow.[1] The reference to the "Tree of Liberty" can be traced to 1765, when Britain imposed the Stamp Act on the colonists.[2] Bostonians protesting the act hung an

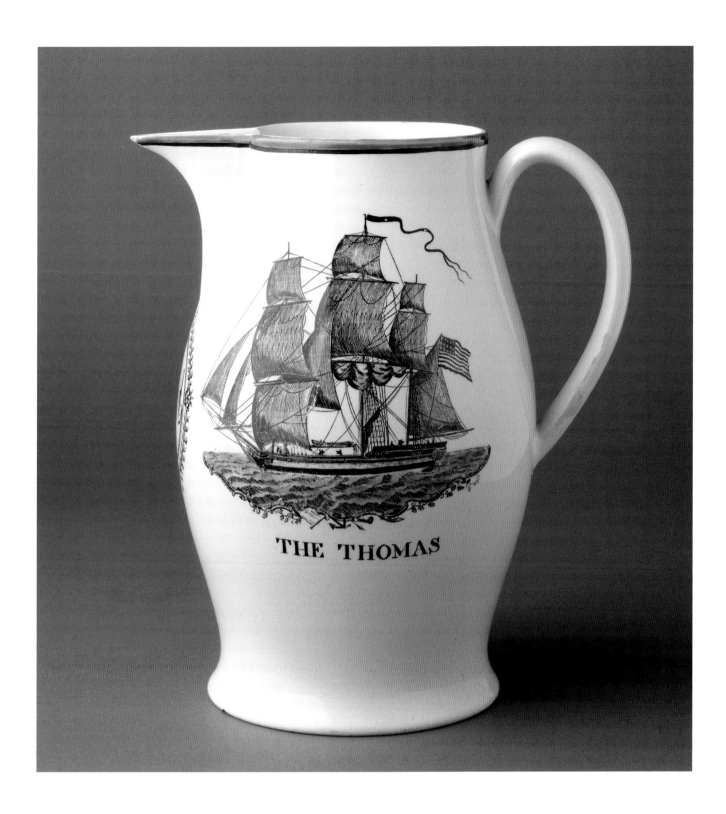

THE THOMAS

effigy of Andrew Oliver, the appointed stamp officer, on the largest of a group of elm trees that stood at the corner of what is today Washington and Essex streets. Thereafter that elm was widely known as the "Liberty Tree."

David Alden was born in Cape Elizabeth, Maine. He became master of the 290-ton ship *The Thomas*, which, according to Lloyd's Register, traded in 1796 between Baltimore and Liverpool and in 1797 and 1798 between New York and Liverpool. It must have been during these years that he ordered and received his jug and plate. Both are decorated with stock prints of sailing vessels flying American flags. The print on the jug is inscribed "THE THOMAS" and shows a ship with the figurehead of a woman; whether this accurately reflects his ship is not known. There are no entries showing Alden as master of the ship in registers beyond 1798, and in 1799 he moved from Portland, Maine, to Northport, settling on a cove known as Little Harbor.[3]

After retiring as a sea captain, Alden became a merchant in Northport and in 1809 assumed the position of magistrate for the town, acting as such on a variety of matters. One of the earliest entries in his journal (1809–19),

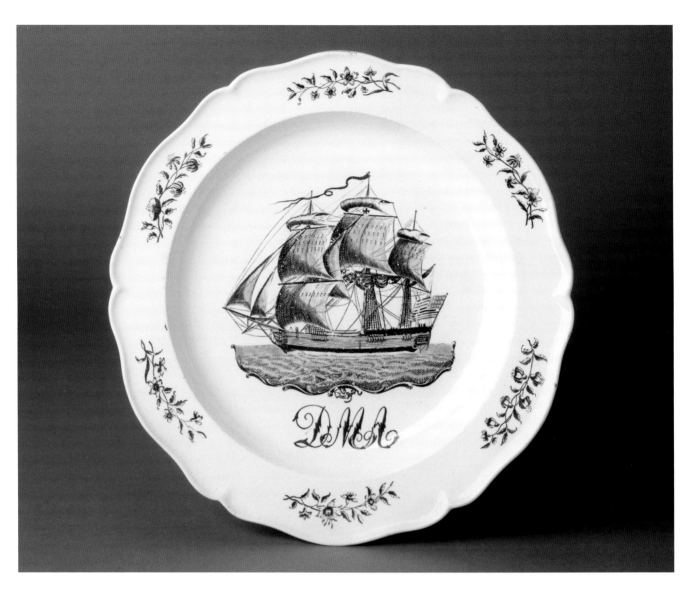

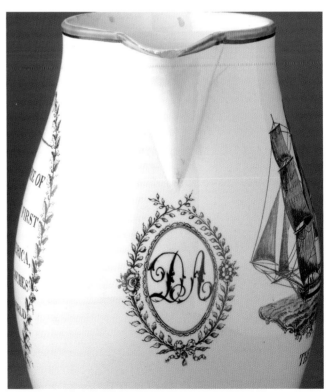

Miniature portrait titled David Alden, 19th–20th century. Watercolor on paper. 2007.31.4 a,b Winterthur Museum, gift of S. Robert Teitelman.

David Alden's magistrate's journal, 1809–19. 2007.31.5a,b Winterthur Museum, gift of S. Robert Teitelman.

under May 2, 1809, is the following: "Charlotte Pendelton Came before me and Confessed that She had Committed fornication on the twentieth day of September and paid a fine of One Dollar being the first offense."

This jug has a printed cartouche beneath the lip with the hand-painted initials "DA." The plate is painted with the initials "DMA" for David and his wife, Mary Small Alden.[4] Whether these were part of a large table service is not known, but an identical plate was also in the Teitelman Collection, (see App. II.86).

HISTORICAL BACKGROUND NOTES

The Chain of States

First seen on Continental currency, the chain of states design was created by Benjamin Franklin and published in February 1776. The chain of thirteen links symbolized the movement from a loose confederation to a strong Union of the United States of America. The design was engraved by Amos Doolittle in 1788–89 with General Washington in the center. It had fourteen interlocking circles; thirteen were inscribed with the names and emblems of each of the first thirteen states. The fourteenth carried the Great Seal of the United States.

The chain design was freely adapted by English engravers and printers. Some interpretations use interwoven ribbons and trailing leafy branches to create the same effect. Links or loops were eventually added to accommodate the increasing number of states to the Union. It should not be assumed that the English potters were always accurate with their designs, so they are not necessarily an aid to dating a particular object.

The Flag of the United States

During the Revolutionary War, flags with several designs were made for the new nation. On June 14, 1777, to establish an official design, the Second Continental Congress passed the first Flag Act: "Resolved, That the flag of the United States be made of thirteen stripes, alternate red and white; that the union be thirteen stars, white in a blue field, representing a new Constellation." The stars reflected the number of states in the Union. On the admission of Vermont and Kentucky, an act of 1794 mandated that after May 1795 there were to be fifteen stars and fifteen stripes. This design endured until April 1818, when a new act provided for thirteen stripes and one star for each state, with new stars to be added on the Fourth of July following the admission of each new state.

Today the flag consists of thirteen horizontal stripes—seven red alternating with six white—representing the thirteen original colonies; the stars indicate the fifty states of the Union. The colors were specified upon the adoption of the Great Seal of the United States: red for hardiness and valor; white for purity and innocence; and blue for vigilance, perseverance, and justice.

Freemasonry

It is generally accepted that Freemasonry arose from the stonemasons' guilds during the Middle Ages. In 1717 the first Grand Lodge of England was founded in London, and within thirty years the organization had spread through Europe and the American colonies. George Washington was a Mason, and Benjamin Franklin served as the head of the fraternity in Pennsylvania. Many colonials were attracted by the ideals of liberty, freedom of worship, and the dignity of man as espoused by the group.

Developed at a time when few were literate, Masonic symbols were a visual shorthand to convey abstract concepts and specific stories. Some of these may be found in designs engraved for printed decoration on pottery. **Two pillars or columns** represent the porch of King Solomon's temple and signify strength and stability. **The checkered or mosaic floor** represents the ground floor of Solomon's temple and is emblematic of human life checkered with good and evil. **The All-Seeing Eye** is an important symbol of the "Supreme Being" and his divine watchfulness and care of the universe. **The square with compasses** represent judgment and discernment. They are often combined, with the letter G in the design signifying geometry and/or God. **The beehive** represents industry and the Masonic virtue of working to support oneself, one's family, and those in distress.

The Great Seal of the United States

On July 4, 1776, the Continental Congress of the United States resolved that "Dr. Franklin, Mr. J. Adams and Mr. Jefferson, be a committee to bring in a device for a seal for the United States of America." The revolutionaries needed an emblem to proclaim their newly won sovereignty and embody their aspirations for the future. It took the efforts of fourteen men before the Great Seal was finally adopted on June 20, 1782.

The most prominent feature on the obverse is an American bald eagle facing proper right, with wings outstretched, bearing a shield. There are no other supporters of the shield, denoting that the United States ought to rely on its own virtue. The escutcheon (shield) has two parts: the lower contains thirteen vertical stripes

alternating red and white; the upper (chief) is blue. It represents the thirteen original states supporting the chief. The colors are those of the flag of the United States; red signifying hardiness and valor; white representing purity and innocence; and blue indicating vigilance, perseverance, and justice. The motto *E Pluribus Unum* (out of many, one) on a scroll in the eagle's beak reinforces the theme of unity. The eagle holds an olive branch in its proper right talon and a bundle of thirteen arrows in its left. These symbolize the power of peace and war. Above its head is a radiant constellation of thirteen stars with rays of light breaking through a cloud, signifying the nation taking its place among other sovereign states.

The design was perfect for use on printed pottery made for the American market. Engravers and artists were not always accurate, however, sometimes depicting the arrows and olive branch in the opposing talons; rarely showing thirteen arrows; not always incorporating thirteen vertical stripes; sometimes omitting the motto; and almost never interpreting the "radiant constellation" correctly. Nevertheless, the image has always been recognizable as the symbol of the United States of America.

Herculaneum Pottery

In 1796 investors and entrepreneurs Worthington, Humble, and Holland established a pottery at Toxteth, Liverpool, on the banks of the river Mersey. They called it the Herculaneum China & Earthenware Manufactory and recruited local skilled workers in addition to men, women, and children from the Staffordshire potteries. For forty-four years the factory made a wide range of earthenwares, stonewares, and porcelains for the home and export markets. Situated close to the docks, and with owners who were founding members of the American Chamber of Commerce in Liverpool, Herculaneum Pottery had a thriving overseas trade.

The pottery used a number of factory marks. Plates were usually impressed on the base with "HERCULANEUM"; jugs with this mark are less commonly found. Intended to attract the patriotic American customer, the factory also used a variety of large printed marks inspired by the Great Seal of the United States. Placed under the spout of jugs made for export, the marks leave one in no doubt as to their origin. Marked pieces allow for a repertoire of Herculaneum printed patterns to be identified.

Herculaneum made a significant contribution to patriotic pottery for the American market, but changes in taste, a need for more efficient production methods, competition from Staffordshire, and a threat of demolition to make way for new docks created an untenable financial situation. In 1840 the factory ceased production.

Stock Prints of Ships

Most of the jugs that commemorate specific sailing vessels are decorated with stock prints—generic views of schooners, brigs, and ships that are customized by the addition of the name of the vessel, her master, or her home port. These images are therefore not accurate representations of the vessels whose names appear on the jug.

Retailers in Liverpool would have owned several copper plates depicting the most common types of vessels, with the appropriate plate being chosen to fill a particular order. In some cases, they had several plates with the same scene but different flags, so they could cater to the impulses of their customers. Retailers also kept a supply of pre-printed jugs, and pieces could be personalized quickly. Some were even printed with an empty banner, where a name could be inscribed (see cat. no. 40). A variety of stock prints are known; in rare cases they can be attributed to specific potteries, but in most instances their origins are unknown.

ENDNOTES

Chapter 1

1. Edmund Burke, *Reflections on the Revolution in France: A Critical Edition*, ed. J. C. D. Clark (Palo Alto, Calif.: Stanford University Press, 2001), pp. 181–83.
2. Benjamin Franklin to Lord Kames, January 3, 1760, cited in *The Papers of Benjamin Franklin*, ed. Leonard W. Labaree et al., vol. 9 (New Haven: Yale University Press, 1966), pp. 6–7.
3. John Trumbull, *The Use and Advantages of the Fine Arts* (New Haven, 1770), pp. 11–12.
4. William Tufant Foster, *Washington's Farewell Address to the People of the United States and Webster's First Bunker Hill Oration* (Boston, 1909), pp. 100–101.
5. Daniel Webster, "The Completion of the Bunker Hill Monument (June 17, 1843)," cited in *The Great Speeches and Orations of Daniel Webster* (Boston, 1887), pp. 145–46, 496–97; *Proceedings of the Bunker Hill Monument Association at the Annual Meeting, June 23, 1875* (Boston, 1875), pp. 143–51.
6. John C. Gray, *An Oration Pronounced on the Fourth of July 1822 at . . . Boston* (Boston, 1822), p. 5.
7. James Russell Lowell, "Address as President of the Wordsworth Society, May 10, 1884," cited in *Democracy and Other Addresses* (London, 1887), p. 152.
8. Michel Chevalier, *Society, Manners, and Politics in the United States* (1839; reprint, New York: Burt Franklin, 1969), p. 424.
9. J. Hector St. John de Crèvecoeur, *Letters from an American Farmer and Sketches of Eighteenth-Century America*, ed. Albert E. Stone (1782; reprint, New York: Signet, 1963), p. 69.
10. Chevalier, *Society, Manners, and Politics*, p. 427.
11. Ibid., p. 428.
12. Letter, Emerson to John B. Hill, Boston, cited in James Elliot Cabot, *A Memoir of Ralph Waldo Emerson*, vol. 1 (Boston, 1887–88), p. 91.
13. Thomas Paine, "American Crisis, XIII," cited in *Rights of Man, Common Sense, and Other Political Writings*, ed. Mark Philip (Oxford: Oxford University Press, 1995), p. 77.
14. Noah Webster, "An Essay on the Necessity, Advantages, and Practicality of Reforming the Mode of Spelling and of Rendering the Orthography of Words Correspondent to Pronunciation" (1789), quoted in Russel Blaine Nye, *This Almost Chosen Land: Essays in the History of Ideas* (East Lansing: Michigan State University Press, 1966), p. 64.
15. Crèvecoeur, *Letters from an American Farmer*, p. 70.
16. Noah Webster, *A Collection of Essays and Fugitive Writing on Moral, Historical, and Literary Subjects* (Boston, 1790), quoted in Russel Blaine Nye, *The Cultural Life of the New Nation, 1776–1830* (New York: Harper Torchbooks, 1960), p. 43.
17. Thomas Jefferson, "First Inaugural Address, March 4, 1801," cited in *Thomas Jefferson, Writings*, ed. Merrill D. Peterson (New York: Penguin Putnam, 1984), p. 494.
18. Johann Joachim Winckelmann, *Thoughts on the Imitation of Greek Works* (1755), quoted in Alex Potts, *Flesh and the Ideal: Winckelmann and the Origins of Art History* (New Haven: Yale University Press, 1994), pp. 1, 326.
19. Ralph Waldo Emerson, "The Young American," Speech at the Mercantile Library Association, February 7, 1844, in *Nature: Addresses and Lectures* (Boston, 1849), p. 334.
20. Coy F. Cross II, *Go West Young Man! Horace Greeley's Vision for America* (Albuquerque: University of New Mexico Press, 1995), pp. 9–12.
21. James Russell Lowell, "The Place of the Independent in Politics," in *Political Essays* (Boston, 1888), p. 310.
22. As quoted in the *Edinburgh Review* 31 (December 1818): 144.
23. Cited in *Arkansas Gazette* (Little Rock), January 1, 1820, and quoted in Clinton Rossiter, *The American Quest, 1790–1860: An Emerging Nation in Search of Identity, Unity, and Modernism* (New York: Harcourt, 1971), p. 131.
24. Alexis de Tocqueville, *Democracy in America*, ed. Phillips Bradley, vol. 1 (New York, 1945), pp. 14, 326.

Chapter 2

1. Susan Gray Detweiler, *George Washington's Chinaware* (New York: Harry N. Abrams, 1982).
2. *Boston Evening Post*, March 11, 1751.
3. Both processes, used throughout the nineteenth and twentieth centuries, are discussed in David Drakard and Paul Holdway, *Spode Transfer-Printed Ware, 1784–1833* (Woodbridge, Eng.: Antique Collectors' Club, 2002).
4. As cited by David Drakard, "Printing in Liverpool," in *Made in Liverpool: Liverpool Pottery & Porcelain, 1700–1850*, ed. E. Myra Brown and Terence A. Lockett (Liverpool: National Museums & Galleries on Merseyside, 1993), p. 3; for more on the glue-bat technique, see Paul Holdway, "Techniques of Transfer Printing on Cream-Coloured Earthenware," in *Creamware and Pearlware* (Stoke-on-Trent: City Museum & Art Gallery, 1986).
5. Gaye Blake Roberts, "Printing in Liverpool: The Association between Wedgwood and Sadler and Green," *Northern Ceramic Society Journal* 14 (1997): 49–50.
6. Ibid., p. 62.
7. Exceptions to this rule might occur when Wedgwood bought blank wares from his contemporaries in Staffordshire, a common practice judging by surviving account books; see John & Thomas Wedgwood account books, City Museum & Art Gallery, Stoke-on-Trent.
8. Wolf Mankowitz and Reginald C. Haggar, *The Concise Encyclopedia of English Pottery and Porcelain* (London: André Deutsch, 1968), pp. 276–88.
9. *The Staffordshire Pottery Directory: to which is prefixed, an historical sketch of the country. And an account of the manufacture of earthenware. With a map* (Staffordshire: J. Allbut and Son, 1800).
10. *Holden's Triennial Directory of Staffordshire, 1809–11; A Directory of Staffordshire Potteries, 1818* (Staffordshire: Staffordshire Educational Council, 1982).
11. Rodney Hampson, "Pottery References in the *Staffordshire Advertiser*, 1795–1865," *Northern Ceramic Society Journal* 4 (2000): 12.

Chapter 3

1. Cited in Alan Smith, *The Illustrated Guide to Liverpool Herculaneum Pottery, 1796–1840* (London: Barrie & Jenkins, 1970), p. 2.
2. F. H. Garner and Michael Archer, *English Delftware* (London: Faber, 1972).
3. Anthony Ray, *Liverpool Printed Tiles* (London: Jonathan Horne, 1994).
4. D. W. Bridges, "Sadler Tiles in Colonial America," *English Ceramic Circle Transactions* 10, pt. 3 (1978): 174–83; Ronald W. Fuchs, "Eighteenth-Century Tiled Fireplaces in the Delaware Valley," *Ars Ceramica*, no. 16 (2000): 50–61.
5. Diana Edwards and Rodney Hampson, *White Salt-glazed Stoneware of the British Isles* (Woodbridge, Eng.: Antique Collectors' Club, 2005), p. 66.
6. Nancy Valpy, "Extracts from 18th-Century London Newspapers," *English Ceramic Circle Transactions* 12, pt. 2 (1985): 162; Smith, *Guide to Liverpool Herculaneum*, p. 5.
7. Rose Meldrum, "Liverpool Creamware: The Okill Pottery," *Northern Ceramic Society Newsletter* (hereafter *NCSN*), no. 82 (1991): 4–6.
8. Knowles Boney, "Documentary Liverpool Saltglaze," *Apollo* (December 1960): 183–86.
9. Roberts, "Printing in Liverpool", pp. 45–70.
10. Meldrum, "Liverpool Creamware."
11. Norman Stretton, "Thomas Rothwell: Engraver and Copper-Plate Printer, 1740–1807," *English Ceramic Circle Transactions* 6, pt. 3 (1967): 249–53.
12. Smith, *Guide to Liverpool Herculaneum*, p. 18.
13. Terence A. Lockett and Geoffrey A. Godden, *Davenport: China, Earthenware, Glass* (London: Barrie & Jenkins, 1989), p. 10.
14. Ibid., p. 11.
15. Geoffrey H. Priestman, *An Illustrated Guide to Minton Printed Pottery, 1796–1836* (Sheffield, Eng.: Endcliffe Press, 2001), pp. 5, 12.
16. Derek Chitty and Joyce Chitty, "Thomas Fletcher: Engraver and Black-Printer," *NCSN*, no. 80 (December 1990): 21–24; Trevor Markin, "An Update on Thomas Fletcher: Engraver and Black-Printer," *NCSN*,

no. 127 (September 2002): 41–43; Derek Chitty and Joyce Chitty, "Thomas Fletcher 3," *NCSN*, no. 128 (December 2002): 42–43.

17. Smith, *Guide to Liverpool Herculaneum*, pp. 34–38.

18. Ibid., pl. 26; Robin Emmerson, *British Teapots and Tea Drinking, 1700–1850* (London: Her Majesty's Stationery Office, 1992), p. 102.

19. "Made in Liverpool: Liverpool Pottery and Porcelain, 1700–1850," *Northern Ceramic Society Exhibition* (Liverpool: Walker Art Gallery, 1993), p. 120, cat. no. 181.

20. Peter Hyland, *The Herculaneum Pottery: Liverpool's Forgotten Glory* (Liverpool: Liverpool University Press/National Museums Liverpool, 2005).

21. Lucy Wood, "George Bullock in Birmingham and Liverpool," in *George Bullock Cabinet-Maker*, ed. Clive Wainwright (London: John Murray/H. Blairman & Sons, 1988), p. 44.

22. For example, see Smith, *Guide to Liverpool Herculaneum*, pls. 23, 30, 45.

23. George L. Miller, Ann Smart Martin, and Nancy S. Dickinson, "Changing Consumption Patterns: English Ceramics and the American Market, 1770–1840," in *Everyday Life in the Early Republic*, ed. Catherine E. Hutchins (Winterthur, Del.: Henry Francis du Pont Winterthur Museum, 1994), pp. 219–48; George L. Miller, "A Revised Set of CC Index Values for Classification and Economic Scaling of English Ceramics, 1770–1880," *Historical Archaeology* 25, no. 1 (1991): 1–25.

24. George L. Miller and Amy C. Earls, "War and Pots: The Impact of Economics and Politics on Ceramic Consumption Patterns," in *Ceramics in America*, ed. Robert Hunter (Milwaukee, Wis.: Chipstone Foundation, 2008), pp. 67–108.

25. The invoice is part of the Joseph Downs Collection of Manuscripts and Printed Ephemera, Winterthur Library.

26. Neil Ewins, "Supplying the Present Wants of Our Yankee Cousins: Staffordshire Ceramics and the American Market, 1775–1880," *Journal of Ceramic History* 15 (1997): 76.

27. The sherds will be published by National Museums Liverpool in a volume on the archaeology of the Liverpool waterfront.

28. Information from Louise Richardson, research assistant, Strawbery Banke Museum, Portsmouth, N.H.

29. Lockett and Godden, *Davenport*, p. 37.

30. Ibid., p. 38.

Catalogue

Cat. no. 1

1. The shield is quartered. Two quarters have the three lions passant guardant of England; one quarter bears the rampant lion of Scotland, and the third quarter depicts a harp for Ireland. In recognition of George III's position as Elector of Hanover, there is an inescutcheon. The garter around the shield bears the motto "*Honi soit qui mal y pense*" (Evil to him who evil thinks), and across the bottom of the shield is the motto "*Dieu et mon droit*" (God and my right). The arms were changed again in 1816, when Hanover became an independent kingdom.

2. Hyland, *Herculaneum Pottery*, p. 63.

3. For the later portrait, see http://digitalgallery.nypl.org/nypldigital/id?1242660.

4. http://www.thepeerage.com/ui02.htm.

Cat. no. 2

1. Scotland was the most northerly kingdom of Great Britain.

2. The silver punch bowl, made in 1768 by Paul Revere, is in the collection of the Museum of Fine Arts, Boston, acc. no. 49.45. The image is available online through http://www.mfa.org/collections/index.asp.

3. The Townshend Acts were passed by Parliament after the repeal of the Stamp Act. They imposed duties on imports of glass, lead, paints, paper, and tea. Boston merchants therefore boycotted English goods. Trade decreased, and the acts were repealed in 1770, except for the tax on tea, which led to the Boston Tea Party.

4. The National Portrait Gallery in London, England, has many portraits illustrated on its Web site at http://www.npg.org.uk/live/search/person.asp?LinkID=mp04827.

5. Yvonne Korshak, "The Liberty Cap as a Revolutionary Symbol in America and France," *Smithsonian Studies in American Art* 1, no. 2

(Autumn 1987): 53–69.

6. For a discussion of Pitt, see cat. no. 3.

Cat. no. 3

1. James Srodes, *Franklin: The Essential Founding Father* (Washington, D.C.: Regnery, 2002), p. 209.

Cat. no. 4

1. E. McSherry Fowble, *Two Centuries of Prints in America, 1680–1880* (Charlottesville: University Press of Virginia, 1987), pp. 167–68.

2. *Encyclopædia Britannica* (2008), s.v. "Howe, William, 5th Viscount."

3. http://www.revolutionarywararchives.org/howewilliam.html.

4. For the design, see Willet Collection, Brighton & Hove Museums, http://www.virtualmuseum.info/collections.

5. For a discussion of stock prints of ships, see p. 241.

Cat. no. 5

1. Moore is referenced in the following: "Lease for three lives renewable for ever of a lot of ground in Gardiner Street by Luke Gardiner to William Duke Moore, jeweller. 16 Jan 1788," MS 36,532/1, Gardiner Papers, National Library of Ireland.

2. For the thank-you note, see http://etext.virginia.edu/toc/modeng/public/WasFi27.html.

3. For a discussion of stock prints of ships, see p. 241.

Cat. no. 6

1. For more on Franklin, see http://www.pbs.org/benfranklin.

2. The Duplessis painting is in the collection of The Metropolitan Museum of Art, New York, acc. no. 32.100.132.

3. Bryson Burroughs and Harry B. Wehle, "Paintings of the XVIII and XIX Centuries," *The Metropolitan Museum of Art Bulletin* 27, no. 11, pt. 2 (November 1932): 50–52, cat. no. 87. VIR translates as "a true man."

4. Charles Sellers, *Benjamin Franklin in Portraiture* (New Haven: Yale University Press, 1962), pp. 247–49.

5. The Cochin drawing is in the collection of the National Portrait Gallery, Washington D.C. and may be seen online at http://www.npg.org.uk/live/search/portrait.asp?LinkID=mp60004&rNo=1&role=art.

Cat. no. 7

1. Wendy C. Wick, *George Washington, An American Icon: The Eighteenth-Century Graphic Portraits* (Washington, D.C.: SITES/National Portrait Gallery, 1982), p. 20.

2. Communication from Christina Keyser, assistant curator, Mount Vernon, September 11, 2007.

3. T. J. C. Williams, *The History of Frederick County, Maryland* (Baltimore: Genealogical Publishing, 1979), p. 248; *Gentleman's and London Magazine; or, Monthly Chronologer* (Dublin: J. Exshaw, 1783).

4. For a discussion of stock prints of ships, see p. 241.

Cat. no. 8

1. For Washington's horses, see http://gwpapers.virginia.edu/project/faq/govern.html.

2. For Billy Lee, see http://www.mountvernon.org/learn/meet_george/index.cfm/ss/101.

3. Wick, *George Washington*, pp. 138–41.

4. Thomas Paine, "Eulogy on the Life of General Washington, Delivered at Newburyport, 2d. January, 1800," in *Memory of Washington* (Newburyport, R.I.: Oliver Farnsworth, 1800), p. 118.

Cat. no. 9

1. Wick, *George Washington*, pp. 36–38.

2. The official title was "Treaty of Amity Commerce and Navigation between His Britannic Majesty and the United States of America."

3. For the toast, see *Worcester Intelligencer*, March 3, 1795, p. 3.

4. For an opposing toast, see *Washington Spy*, July 14, 1795, p. 3.

Endnotes

Cat. no. 10

1. For the quotation from Henry Lee's resolution passed by Congress upon the death of George Washington in 1799, see *Encyclopædia Britannica* http://proxy.nss.udel.edu:2083/eb/article-9047590.

2. Wick, *George Washington,* pp. 22–24.

3. Ibid., p. 26.

4. Ibid., fig. 13.

5. http://bioguide.congress.gov/scripts/biodisplay.pl?index=W000178 ; http://www.bbc.co.uk/dna/h2g2/A4350610.

6. *Boston Gazette,* October 26, 1789.

Cat. no. 11

1. For a similar jug with ownership in Alexandria, Va., 1800–1804, see http://oha.alexandriava.gov/archaeology/ar-collections-highlights.html#heading2; for evidence of an excavated example in Alexandria, see Barbara H. Magid, "Commemorative Wares in George Washington's Hometown," in *Ceramics in America,* ed. Robert Hunter (Milwaukee, Wis.: Chipstone Foundation, 2006), pp. 2–39.

2. Wick, *George Washington,* p. 38.

3. http://www.liza-kliko.com/laurel-wreath/home.htm.

4. Paine, "Eulogy," p. 118.

5. The mate to this jug is in the Mattatuck Museum, Waterbury, Conn.

6. Communication with Swett family member Ben H. Swett, May 23, 2008.

7. For the business, see *Newburyport Herald,* April 1, 1814, p. 4.

8. Ibid.; September 19, 1817, p. 4; May 29, 1818, p. 1; October 13, 1818, p. 1; September 8, 1820, p. 1.

Cat. no. 12

1. *The Times* (Charleston, S.C.), May 28, 1804, p. 3.

2. Davida Tenenbaum Deutsch, "Washington Memorial Prints," *The Magazine Antiques* 111, no. 2 (February 1977): 324.

3. Wick, *George Washington,* pp. 166–67.

4. Phoebe Lloyd Jacobs, "John James Barralet and the Apotheosis of George Washington," in *Winterthur Portfolio 12,* ed. Ian M. G. Quimby (Winterthur, Del.: Henry Francis du Pont Winterthur Museum, 1977), pp. 115–37.

5. See Chapter 3 in this volume.

6. For a discussion of the Great Seal, see pp. 240–41.

7. For contrasting eagles, see cat. nos. 65–68.

Cat. no. 13

1. Wick, *George Washington,* fig. 25.

2. For Rushton, see http://www.btinternet.com/~m.royden/mrlhp/local/rushton/rushtondnb.htm.

3. *Suffolk Gazette,* September 7, 1807, p. 4.

4. For Bunker Hill, see http://www.britishbattles.com/bunker-hill.htm.

5. For Montgomery, see http://inside.fdu.edu/fdupress/05113006.html.

6. See cat. no. 69 for a similar inscription.

7. For the Great Seal, see cat. nos. 66, 67, and 69.

Cat. no. 14

1. Alfred L. Bush, *The Life Portraits of Thomas Jefferson* (Charlottesville, Va.: Thomas Jefferson Memorial Foundation, 1962), pp. 52–55.

2. Noble E. Cunningham, Jr., *The Image of Thomas Jefferson in the Public Eye: Portraits for the People, 1800–1809* (Charlottesville: University Press of Virginia, 1981), p. 45.

3. Michael Bryan, *Dictionary of Painters and Engravers: Biographical and Critical* (London: George Bell and Sons, 1886), p. 679.

4. Wick, *George Washington,* pp. 59–62.

5. Ibid., pp. 125–38.

Cat. no. 15

1. Wick, *George Washington,* pp. 142–44.

2. For a discussion of the Great Seal, see pp. 240-41.

Cat. no. 16

1. The original Stuart portrait is unknown. It is thought to have been destroyed by Gilbert, who was not satisfied with it; see Fiske Kimball, "The Life Portraits of Jefferson and Their Replicas," *Proceedings of the American Philosophical Society* 88, no. 6 (December 1944): 513–14.

2. Bush, *Life Portraits,* pp. 59–61.

3. David Meschutt, "Gilbert Stuart's Portraits of Thomas Jefferson," *American Art Journal* 13, no. 1 (Winter 1981): 3–16.

4. For a discussion of stock prints of ships, see p. 241; for a discussion of the Great Seal, see pp. 240–41.

5. For more on Madison, see http://www.whitehouse.gov/history/presidents/jm4.html.

Cat. no. 17

1. For a discussion of engravers and printers, see Chapter 2 in this volume.

2. http://freemasonry.bcy.ca/symbolism/bees.html.

3. Ada Walker Camehl, *The Blue-China Book: Early American Scenes and History Pictured in the Pottery of the Time, with a Supplementary Chapter Describing the Celebrated China in the White House at Washington, D.C., and a Complete Checking List of Known Examples of Anglo-American Pottery* (New York: E. P. Dutton & Company, 1916), pp. 31–32.

4. For a discussion of the chain of states design, see p. 240.

5. For a discussion of the Great Seal, see pp. 240-41; for a discussion of the characteristics of Morris's eagle print, see cat. no. 20.

6. For more on Jefferson, see http://www.princeton.edu/~tjpapers/inaugural/infinal.html

Cat. no. 18

1. http://www.census.gov/prod/2000pubs/cff-4.pdf.

2. http://www2.census.gov/prod2/decennial/documents/1790a-02.pdf.

3. "A Letter to George Washington, President of the United States of America," *Connecticut Gazette,* October 30, 1789, p. 3.

Cat. no. 19

1. For L'Enfant, see http://gwpapers.virginia.edu/project/reviews/stinchcombe.html.

2. The plan was published in the *Universal Asylum and Columbian Magazine* (March 1792): 155.

3. *Massachusetts Magazine* (May 1792).

4. For the "official plan," see http://home.earthlink.net/~docktor/wmslogo.htm.

5. If the sixteen stars and stripes truly reflect the number of states in the Union, then this piece dates after the admittance of Tennessee on June 1, 1796.

6. For a discussion of the Great Seal, see pp. 240–41. A jug with identical printed decoration is known with the words "HERCULANEUM POTTERY LIVERPOOL" (B. 61.33) in the Bayou Bend Collection, gift of Miss Ima Hogg.

7. If it is indeed a Herculaneum example, it would have to date after that factory's establishment in 1796.

Cat. no. 20

1. For a discussion of the American flag, see p. 240.

2. For a discussion of the Great Seal, see pp. 240-41.

3. For more on Francis Morris, see cat. no. 17.

4. For a discussion of the chain of states design, see p. 240; see fig. 3.14 for fragment.

5. For an eagle with inscription, see cat. no. 17.

Cat. no. 21

1. For the history of the arms and Great Seal of the Commonwealth of Massachusetts, see www.sec.state.ma.us/pre/presea/sealhis.htm.

2. John Schultz, *Legislators of the Massachusetts General Court, 1691–1780: A Biographical Dictionary* (Hanover, N.H.: University Press of New England, 1997), p. 29.

3. Emma Nason, *Old Colonial Houses in Maine* (Augusta, Maine: Press of the Kennebec Journal, 1908), pp. 93–94.

4. http://www.mainegenealogy.net/2006/06/recorde-of-dresden-congregational.html.

5. *Kennebec Gazette* (Kennebeck, Maine), January 15, 1802.

6. Fannie Chase, *Wiscasset in Pownalborough* (Wiscasset, Maine, 1941), p. 305.

7. *The Lincoln County News* (Damariscotta, Maine), May 1, 1930.

8. Robert H. McCauley to S. Robert Teitelman, December 9, 1966, Object File, Winterthur.

Cat. no. 22

1. The second jug is in the collection of the Maine Historical Society in Portland.
2. Jonathan Gray, ed., *Welsh Ceramics in Context: Part 1* (Swansea: Royal Institution of South Wales, 2003), pp. 124–31.
3. Letter, Sally Sayward Barrell Keating Wood to her father, Nathaniel Barrell, December 7, 1804, Maine Historical Society, Blaisdell Collection.
4. For a detailed commentary on Sally Sayward Barrell Keating Wood, see S. Robert Teitelman, "Maine's Early Nineteenth-Century Barrell-Wood Family Jugs and the Remarkable Woman Who Made Them Great," in *Ceramics in America*, ed. Robert Hunter (Milwaukee, Wis.: Chipstone Foundation, 2005).
5 Ibid.

Cat. no. 23

1. *Poems by the Earl of Roscomon … Together with Poems by Mr. Richard Duke* (London: T. Tonson, 1717), p. 324.
2. One of the earliest known American references occurred on George Washington's birthday in 1783, when the toast "Success to the Honest Lover, Liberation to the Prisoner, Freedom to the Slave, Bread to the Poor, and Health to the Sick" was given at a dinner in Milton, Massachusetts (cited in the *Continental Journal*, Boston, February 13, 1783). The toast is even known to have been used in the slaveholding states of the American South in the nineteenth century; see "A standing Fourth of July toast, by a slaveholder, owning more than a hundred slaves: Health to the Sick, Honor to the Brave, Success to the Lover, and Freedom to the Slave," cited in J. B. D. de Bow, *De Bow's Review* 16, n.s., 2 (1854): 52.
3. Thomas Clarkson, *A Portrait of Quakerism*, vol. 1 (London, 1806), pp. 293–94.
4. William Cowper, "The Negro's Complaint: A Subject for Conversation and Reflection at the Tea Table," *The Gentleman's Magazine* (December 1793), cited in H. S. Milford, ed., *The Complete Poetical Works of William Cowper* (London: Henry Frowde, 1905), pp. 371–72.
5. Among the pieces is an English porcelain mug dated ca. 1850, illustrated in Sam Margolin, "'And Freedom to the Slave': Antislavery Ceramics, 1787–1865," in *Ceramics in America*, ed. Robert Hunter (Milwaukee, Wis.: Chipstone Foundation, 2002), p. 87.

Cat. no. 24

1. Robin Reilly, *Wedgwood*, vol. 1 (New York: Stockton Press, 1989), p. 114.
2. L. A. Compton, "Richard Westall RA: His Pictures on Our Pots," *Northern Ceramic Society Newsletter* 72 (December 1989): 10–12; Cowper, "Negro's Complaint," pp. 371–72.
3. Sharron D. Greene, "Oversize Staffordshire Jugs," *The Magazine Antiques* 149, no. 1 (January 1996): 192–201.
4. Ibid., p. 196; Roger Pomfret, "W(★★★)—The Case for Whitehead Re-Assessed," *Northern Ceramic Society Journal* 22 (2005–6): 111–36.
5. Martha Katz-Hyman, "Doing Good While Doing Well: The Decision to Manufacture Products that Supported the Abolition of the Slave Trade and Slavery in Great Britain," *Slavery and Abolition* 29, no. 2 (June 2008): 219–31.

Cat. no. 25

1. Frederick Leiner, *Millions for Defense: The Subscription Warships of 1798* (Annapolis, Md.: Naval Institute Press, 2000), p. 32.
2. *Columbian Centinel* (Boston), May 26, 1798.
3. The cities were Boston, Salem, Providence, New York, Philadelphia, Richmond, Norfolk, and Charleston.
4. *Federal Gazette & Baltimore Daily Advertiser*, September 18, 1798, quoted in Leiner, *Millions for Defense*, p. 35; *Dictionary of American Naval Fighting Ships*, vol. 4 (Washington, D.C.: Department of the Navy, 1969), p. 337.
5. Dudley Knox, ed., *Naval Documents Related to the Quasi-War Between the United States and France*, vol. 2 (Washington, D.C.: Government Printing Office, 1935–38), p. 60.
6. Leiner, *Millions for Defense*, p. 52.

Cat. no. 26

1. This version is No. 105 in Robert H. McCauley, *Liverpool Transfer Designs on Anglo-American Pottery* (Portland, Maine: Southworth-Anthoensen Press, 1942), p. 96. The other is No. 106 in the same volume.
2. *Columbian Centinel* (Boston), March 23, 1799, quoted in Eugene Ferguson, *Truxton of the Constellation* (Baltimore: Johns Hopkins University Press, 2000), p. 171.
3. This jug is thought to have been made at the Herculaneum Pottery, as the print of the Great Seal that appears below the spout is also found on a jug with the inscription "HERCULANEUM POTTERY" (see cat. no. 12).
4. Charles Dexter Cleveland, ed., *A Compendium of American Literature* (A. S. Barnes & Co., 1859), p. 203; see http://www.potw.org/archive/potw233.html.

Cat. no. 27

1. Prior to the Revolution, American ships were protected from the Barbary pirates by the British navy and by the tribute Great Britain paid to the Barbary states. After the Revolution, this protective umbrella was lifted.
2. Quoted in Frank Lambert, *The Barbary Wars: American Independence in the Atlantic World* (New York: Hill and Wang, 2005), pp. 125–26.
3. McCauley, *Liverpool Transfer Designs*, pp. 96–97, no. 107; Christina Nelson, "A Selected Catalog of the Liverpool-Type Historical Creamwares and Pearlwares in the Henry Francis du Pont Winterthur Museum" (Master's thesis, University of Delaware, 1974), p. 55.
4. John Garraty and Mark Carnes, eds., *American National Biography*, vol. 17 (New York: Oxford University Press, 1999), pp. 821–22.
5. That jug is in the collection of the Maine Historical Society and is illustrated in Laura F. Sprague, "Liverpool-Type Pitchers Decorated for Portland," *American Ceramic Circle Bulletin* 5 (1986): 29.
6. McCauley, *Liverpool Transfer Designs*, p. 82, no. 45; Nelson, "Selected Catalog," p. 55.
7. *Documents Official and Unofficial, Relating to the Case of the Capture and Destruction of the Frigate Philadelphia* (Washington, D.C.: John T. Towers, 1850), p. 6.

Cat. no. 28

1. Quoted in *The Naval Monument* (Boston: Abel Bowen, 1816), p. 1.
2. McCauley, *Liverpool Transfer Designs*.
3. Both illustrations are copyrighted November 25, 1815, by A. Bowen.
4. Quoted in Nelson, "Selected Catalog," p. 39.
5. A. W. Coysh and R. K. Henrywood, *The Dictionary of Blue Printed Pottery, 1780–1880*, vol. 1 (Woodbridge, Eng.: Antique Collectors' Club, 1982), p. 40.

Cat. no. 29

1. The *Constitution* was one of the original six frigates authorized by Congress in 1794. She was designed by Philadelphia shipwright Joshua Humphreys; built at Hartt's Shipyard in Boston; launched on October 21, 1797; and served in the Quasi-War with France (1798–1800), the Tripolitan War (1801–5), and the War of 1812 (1812–15). In 1830 the *Constitution* was almost decommissioned and scrapped but public sentiment, fueled by Oliver Wendell Holmes's poem "Old Ironsides," saved her. Preserved in Boston, she remains the oldest commissioned ship in the U.S. Navy.
2. *Naval Monument*, p. 12.
3. Tyrone Martin, *A Most Fortunate Ship: A Narrative History of Old Ironsides* (Annapolis, Md.: Naval Institute Press, 1997), p. 157.
4. "Biographical Notice of Captain Isaac Hull," *Analectic Magazine* (March 1813): 270.
5. *Naval Monument*, p. 83.
6. "The Constitution in close action with the Guerrière" is based on an illustration drawn by M. Cornè and engraved by A. Bowen; "The Second View of Com. Perry's Victory" is based on an illustration drawn by M. Cornè and engraved by W. B. Annin; see *Naval Monument*, pp. 12, 83.

Cat. no. 30

1. *Analectic Magazine* (March 1813): 276.
2. Ibid., opp. p. 266.

Endnotes

3. Nine portraits from *Analectic Magazine* appear on ceramics. As some of the images were not illustrated in the monthly issues of the magazine but were included in the bound volumes, it is assumed that the later editions are the source for all the images. Christina Nelson, "Transfer-Printed Creamware and Pearlware for the American Market," *Winterthur Portfolio* 15, no. 2 (Summer 1980): 102–5.

Cat. no. 31

1. *Naval Monument*, dedication.
2. Alice Morse Earle, *China Collecting in America* (1902; reprint, Rutland, Vt.: Charles E. Tuttle, 1973), p. 163.
3. Quoted in *Naval Monument*, p. 90.
4. Donald Hickey, *The War of 1812: A Short History* (Chicago: University of Illinois Press, 1995), pp. 38–39.
5. *Naval Monument*, p. 155.
6. Hickey, *War of 1812*, pp. 56–59.
7. The image under the spout is based on the frontispiece, which was drawn by J. R. Penniman and engraved by W. B. Annin. "The First View of Com. Perry's Victory" is based on an engraving by W. B. Annin after a painting by Michele Cornè and appears after p. 82. "Com. Macdonoughs Victory on Lake Champlain" is based on an engraving by William Hoagland after a painting by Michele Cornè and appears after p. 144.
8. Robin Reilly, *Wedgwood: The New Illustrated Dictionary* (Woodbridge, Eng.: Antique Collectors' Club, 1995), p. 364.
9. Ibid., p. 115.

Cat. no. 32

1. Edgar Stanton Maclay, *A History of American Privateers* (New York: Burt Franklin, 1899), p. 506.
2. "News," *Geographical and Military Museum* (Albany, N.Y.), April 25, 1814.
3. Maclay, *History of American Privateers*, p. 275.
4. "Shipping News," *Baltimore Patriot*, June 19, 1816.
5. Maclay, *History of American Privateers*, p. 356.
6. "News," *Essex Register* (Salem, Mass.), March 12, 1814.
7. Ibid., February 15, 1815; "News," *Northern Whig* (Hudson, N.Y.), April 15, 1817.
8. Pomfret, "W(★★★)," pp. 113, 133.

Cat. no. 33

1. A fusilier is a soldier armed with a flintlock musket, known in French as a *fusil*.
2. The Boston Fusiliers were granted a charter by Massachusetts governor and signer of the Declaration of Independence, John Hancock, on July 4, 1787; Fusilier Veterans Association, *A Historical Sketch* (Cambridge, Mass.: Press of Murray and Emory Co., 1914), pp. 2–3.
3. Fusilier Veterans Association, *Historical Sketch*, pp. 3–10.
4. The exact design of the flag is unknown, but it includes the shield of the coat of arms of Massachusetts.
5. The phrase "to conquer or to die" has been attributed to several military leaders, including that ancient foe of Rome, Hannibal. It was also used by George Washington in his General Orders of July 2, 1776; see *Oxford Dictionary of Quotations*, p. 804.
6. The phrase is credited to Aesop, who used it in his fable "The Four Oxen and the Lion," but it was also used by American patriots, beginning with John Dickinson in *The Liberty Song*, which was first published in 1768; see John Bartlett, *Familiar Quotations* (New York: Little, Brown, & Co., 1992), p. 336.
7. This story appears as early as 1877, when it is mentioned in an article in a now-untitled newspaper of November 18, 1877 (photocopy in Object File, Winterthur) and is related in greater detail in McCauley, *Liverpool Transfer Designs*, p. 59.

Cat. no. 34

1. The print of the militiamen and a similar version of the Great Seal also appear on the jug in cat. no. 17 with other prints that are signed by Francis Morris of Staffordshire.
2. Noble Cunningham Jr., *The Inaugural Addresses of President Thomas Jefferson, 1801 and 1805* (Columbia: University of Missouri Press, 2001), p. 5.
3. David Heidler and Jean Heidler, eds., *Encyclopedia of the War of 1812*

(Santa Barbara, Calif.: ABC-CLIO Inc., 1997), pp. 167–68.

Cat. no. 35

1. See Chapter 3 in this volume and figs. 3.15, 3.16.
2. For the system of flags, see http://www.wirral.gov.uk/LGCL/100006/200073/670/content_0001101.html.
3. Brown and Lockett, *Made in Liverpool*, cat. nos. 181, 183.
4. A. S. Davidson, *Marine Art & Liverpool: Painters, Places & Flag Codes, 1760–90* (Wolverhampton, Eng.: Waine Research Publications, 1986), pp. 30–31, 58–60.
5. For a discussion of stock prints of ships, see p. 241.

Cat. no. 36

1. http://www.liverpool.gov.uk/Leisure_and_culture/Parks_and_recreation/Parks_and_gardens/St_Nicholas_Church/index.asp.
2. Brown and Lockett, *Made in Liverpool*, p. 125, cat. no. 192.

Cat. no. 37

1. Annie Haven Thwing, *The Crooked & Narrow Streets of the Town of Boston, 1630–1822* (Boston: Marshall Jones, 1920), pp. 5, 7.
2. Sir Leslie Stephen and Sir Sidney Lee, *Dictionary of National Biography*, rev. ed. (Oxford: Oxford University Press, 1937–38).

Cat. no. 38

1. Thomas Knox, "Boston Light House," *Massachusetts Magazine; or, Monthly Magazine of Knowledge* (February 1, 1789): 70.
2. Justin Winsor and Clarence F. Jewett, *The Memorial History of Boston: Including Suffolk County, Massachusetts, 1630–1880*, vol. 3 (Boston: J. R. Osgood and Co., 1881), p. 187.

Cat. no. 39

1. For the charts, see http://celebrating200years.noaa.gov/welcome.html.
2. See Smith, *Guide to Liverpool Herculaneum*, pl. 60. The jug is credited to Peabody Essex Museum, Salem, Massachusetts.
3. *United States Gazette*, May 16, 1807.
4. *Newburyport Herald*, August 4, 1807.
5. *England Palladium*, September 22, 1809, November 24, 1809; *Newburyport Herald*, November 24, 1809, June 15, 1810; *Baltimore Price-Current*, November 18, 1809.
6. For a further discussion of this print, see cat. no. 62.
7. McCauley, *Liverpool Transfer Designs*, pp. 126–27, pl. 32; and David Arman and Linda Arman, *Anglo-American Ceramics, Part I: Transfer-Printed Creamware and Pearlware for the American Market, 1760–1860* (Portsmouth, R.I.: Oakland Press, 1998), p. 139.

Cat. no. 40

1. John K. Moulton, *Captain Moody and His Observatory* (Falmouth, Maine: Mount Joy Publishing, 2000).
2. Laura F. Sprague, "Liverpool-Type Pitchers Decorated for Portland," *American Society Bulletin* 5 (1986): 39.
3. Ibid.

Cat. no. 41

1. Family history related in Northeast Auctions Catalogue, Portsmouth, N.H., August 20, 2006, lot 794.
2. W. Carew Hazlitt, *The Livery Companies of the City of London* (New York: MacMillan & Co., 1892), pp. 619–22; http://www.shipwrights.co.uk/history.htm.
3. Eric R. Delderfield, *Introduction to Inn Signs* (Newton Abbot, Eng.: David & Charles, 1969), pp. 59–60.
4. Based on similarities in the style of painting, the scroll border at the rim, and the flourish beneath the inscription, several other jugs can be attributed to the same hand or workshop; these include "Success to the Alexander" at the Mariners Museum and "The Fisher" at Peabody Essex Museum.

Cat. no. 42

1. The *Patapsco* was the second of two subscription ships built in Baltimore and was named after the river on which the port city stands. She protected convoys of American merchant ships during the Quasi-War with France and

was sold in 1801 after the war ended; see Leiner, *Millions for Defense*, p. 91.

2. "News," *The Federal Gazette* (Baltimore), June 20, 1799.

3. The mate to this jug has the same image and the initials "MDR." It survives in the Herbert and James Barnett families of Baltimore; see Leiner, *Millions for Defense*, opp. p. 52. This jug was previously in the collection of Breckinridge Long (1881–1958), assistant Secretary of State under President Franklin D. Roosevelt.

4. David Drakard, *Printed English Pottery: History and Humour in the Reign of George III, 1760–1820* (London: Jonathan Horne, 1992), p. 98.

Cat. no. 43

1. David Fitz-Enz, *Old Ironsides: Eagle of the Sea* (Latham, Md.: Taylor Trade Publishing, 2004), p. 13.

2. Thwing, *Crooked and Narrow Streets*, sec. 4.

3. Ibid., p. 208.

4. "News," *The Argus* (Boston), February 26, 1793.

5. "News," *American Apollo*, March 1, 1793.

6. *A Report of the Record Commissioners of the City of Boston, Containing The Statistics of the United States Direct Tax of 1798, as Assessed on Boston* (Boston: Rockwell and Churchill, 1890), p. 72.

7. Advertisement, *The Democrat* (Boston), May 26, 1804.

8. Allen Chamberlain, *Beacon Hill: Its Ancient Pastures and Early Mansions* (Boston: Houghton Mifflin Co., 1925), p. 220.

9. Ibid., p. 255.

Cat. no. 44

1. Karl Marquardt, *The 44-Gun Frigate USS Constitution: "Old Ironsides"* (Annapolis, Md.: Naval Institute Press, 2005), p. 120.

2. Davida Tenenbaum Deutsch and Betty Ring, "Homage to Washington in Needlework and Prints," *The Magazine Antiques* 119, no. 2 (February 1981): 402–19, fig. 17; and New-York Historical Society, acc. no. 1941.106 http://emuseum.nyhistory.org/code/emuseum.asp.

3. For a discussion of the chain of states design, see p. 240.

4. For a discussion of the Great Seal, see pp. 240-41.

5. Paine, "Eulogy," p. 118.

Cat. no. 45

1. Frederic Howay, *Voyages of the "Columbia" to the Northwest Coast, 1787–1790 and 1790–1793* (Boston: Massachusetts Historical Society, 1941), p. vi.

2. Ibid., p. 146.

3. *Ship Columbia Register*, National Archives, Washington D.C., quoted in Francis Cross and Charles Parkins Jr., *Captain Gray in the Pacific Northwest* (Bend, Oregon: Maverick Publications, 1987), p. 184.

4. Howay, *Voyages of the "Columbia,"* pp. 150–51.

5. Ibid., pp. 447, 308 n.

6. Cross and Parkins, *Captain Gray*, p. 188.

7. Charlestown (Massachusetts) Vital Records, p. 504.

8. The mate is in the Peabody Essex Museum. This is not the only jug made for a crewmember of the *Columbia*; Alice Morse Earle records a jug decorated with a view of the vessel that was made for S. Yendell; see her *China Collecting*, p. 155.

9. *New England Historical and Genealogical Register*, vol. 73 (Boston: New England Historical and Genealogical Society, 1919), p. 156; vol. 57, p. 206.

10. McCauley, *Liverpool Transfer Designs*, no. 57.

Cat. no. 46

1. "Coppered" refers to the fact that the hull was sheathed in copper plates, which helped preserve the wood from worms and barnacles and make the ship faster; Advertisement, *Daily Advertiser* (New York), November 2, 1802.

2. *Lloyd's Register, Underwriter's Register of Shipping for the Years 1803–9* (Reprint; Farnborough, Eng.: Gregg International Publishers, 1969).

3. Starks is first recorded as master in an October 29, 1802 notice in the *New-York Gazette* and is also listed as master in the Lloyd's registers from 1803 until 1808.

4. Advertisement, *Mercantile Advertiser* (New York), January 24, 1803; Advertisement, *Chronicle Express* (New York), May 7, 1804; Advertisement, *New-York Gazette* (New York), December 21, 1802.

5. Robert Davison, *Isaac Hicks: New York Merchant and Quaker, 1767–1820* (Cambridge: Harvard University Press, 1964), pp. 91–92, 99.

6. *The Farmer's Cabinet* (New York), November 24, 1803.

7. Spencer Tucker and Frank Reuter, *Injured Honor: The Chesapeake-Leopard Affair* (Annapolis, Md.: Naval Institute Press, 1996), p. 45.

8. The jugs with the portrait of the *Orozimbo* and the *Orestes* are both impressed "HERCULANEUM." Smith, *Guide to Liverpool Herculaneum*, pl. 47. S. Robert Teitelman, "THE OROZIMBO: A Peabody Crown Jewel," *Peabody Museum of Salem Antiques Show Catalogue* (1990): 17–19.

9. Personal communication, Pat Halfpenny and Peter Hyland, and Pat Halfpenny and Robin Emmerson, November 28, 2008.

10. The jug decorated with a portrait of the *Venilia* (see cat. no. 48) was almost certainly painted in Liverpool and is in an entirely different style from the portraits in this group.

Cat. no. 47

1. Certificate of Registry No. 372 for the Ship *Orestes*, National Archives, Washington, D.C.

2. Insurance Company of North America Marine Blotter, 1805–6, Policy 14801, CIGNA Archives.

3. Eliza Starbuck Barney Genealogical Record, Nantucket Historical Association, http://www.nha.org/library/barneyinfo.html; The Marine Society of the City of New York, 1769–1969, http://www.sunymaritime.edu/StephenBluceLibrary/pdfs/marinesocofnyc-findingaid.pdf.

4. Barney Genealogical Record.

Cat. no. 48

1. *Independent Chronicle and the Universal Advertiser* (Boston), July 19–23, 1798; *The Courier* (Boston), June 26, 1799; *Columbian Centinel* (Boston), October 12, 1799; *The Courier of New Hampshire* (Concord), May 31, 1800; *New-York Price-Current*, March 14, 1801.

2. Amended Catalogue Entry, Skinner's Auction Company, Boston, 1991.

3. The portrait of Caleb Bates (Charles Devlin, Amsterdam, 1800–1810); Mary Bates (unknown artist, Boston, ca. 1820); and other household objects including a watercolor of the Bates coat of arms, several Chinese export porcelain watercolors, and a Chinese export porcelain teaset are in the collection of Concord Museum, Concord, Massachusetts, acc. no. 1991.25–30.

4. *Alphabetical List of Ship Registers, District of Boston, Massachusetts, 1801–1810* (Boston: National Archives Project, 1939), p. 556.

5. The jug is in the collection of the Bostonian Society, Boston, Massachusetts, acc. no. MB 513.

Cat. no. 49

1. Certificate of Registry No. 308, December 15, 1795, National Archives, Washington, D.C.

2. Ibid., No. 111, March 11, 1801.

3. Advertisement, *Daily Advertiser* (New York), November 27, 1795, December 11, 1795.

4. Certificate of Registry No. 305, November 13, 1797; Certificate of Registry No. 610, November 19, 1804, National Archives, Washington, D.C.

5. *Lloyd's Register*; "Shipping News," *Baltimore Price Current*, August 6, 1803; "Shipping News," *Evening Post* (New York), March 10, 1804; "Shipping News," *Commercial Advertiser* (New York), June 25, 1804; Advertisement, *New-York Gazette*, October 22, 1805.

6. Advertisement, *New-York Gazette*, October 22, 1805; Hyland, *Herculaneum Pottery*, p. 170.

7. Kenneth Charlton, "James Cropper (1773–1840) and Agricultural Improvement in the Early Nineteenth Century," *Transactions of the Historic Society of Lancashire and Cheshire* 112 (1961): 67; Clement Jones, *Pioneer Shipowners* (Liverpool: Charles Birchall & Sons, Ltd., n.d.), p. 16.

8. Greene, "Oversize Staffordshire Jugs," pp. 192–201.

9. It was illustrated in *Old China Magazine* (December 1901).

Cat. no. 50

1. Everett S. Stackpole, *Old Kittery and Her Families* (Lewiston, Maine: Press of Lewiston Journal Company, 1903), p. 410.

Endnotes

2. *Lloyd's Register 1803–9; Lloyd's Register 1807; Lloyd's Register 1812.*
3. Brock Jobe, *Portsmouth Furniture* (Hanover, N.H.: University Press of New England, 1993), pp. 204–6.
4. Robert Follett, Will, September 9, 1815, York County (Maine) Probate Records, No. 6005.
5. Inventory of Mercy Follett, appraised October 4, 1852, probated March 7, 1853, York County (Maine) Probate Records, No. 6002.
6. Stackpole, *Old Kittery*, p. 410.

Cat. no. 51

1. *Ship Registers and Enrollments of Newport, Rhode Island, 1790–1939*, vol. 1 (Providence: Rhode Island State Archives, 1941), p. 48.
2. Ibid.; *Newport Mercury*, July 26, 1803.
3. The *Aurora* traveled between Rhode Island and New York on an almost monthly basis, making one voyage in a very quick 17 hours; see "Shipping News," *Greenleaf's New York Journal*, April 23, 1794.
4. The *Aurora* carried no fewer than 23 desks and other pieces of furniture from Newport to New York in 1791 alone; see Joseph Ott, "Rhode Island Furniture Exports," *Rhode Island History* 36 (February 1977): 10.
5. Brock Jobe and Myrna Kaye, *New England Furniture: The Colonial Era* (Boston: Houghton Mifflin, 1984), pp. 12–14.
6. "Rhode Island School of Design Museum Notes" (1989): 24.
7. Diana Edwards, *Wedgwood and Contemporary Manufacturers* (Woodbridge, Eng.: Antique Collectors' Club, 1994), pp. 266–67.
8. A creamware platter and soup plate are decorated with a print of the *Wilmington*, ca. 1795 (Winterthur Museum, acc. no. 1959.585, 1964.1176).

Cat. no. 52

1. Hazard Powers (1764–1832) and Hannah Powers (1760?–1845).
2. Elizabeth Janoski, "Hazard Powers: Sailor and Settler," *The Susquehanna County Independent*, November 12, 1987, pp. 1, 20.
3. Advertisement, *Connecticut Gazette* (New London), August 21, 1799; Advertisement, *Windham Herald*, March 16, 1810.
4. Correspondence, Patricia Kile to Winterthur Museum, August 13, 1999, Object File, Winterthur.
5. Arman and Arman, *Anglo-American Ceramics*, p. 177.
6. Janoski, "Hazard Powers."

Cat. no. 53

1. "News," *Connecticut Journal* (New Haven), August 3, 1785.
2. "Wilmington, (Delaware) January 11"; see http://www.msa.md.gov/megafile/msa/specol/sc4800/sc4872/001283/pdf/m1283–1157pdf.
3. "Shipping News," *Pennsylvania Packet* (Philadelphia), May 1, 1786.
4. "Shipping News," *Pennsylvania Mercury* (Philadelphia), September 19, 1789.
5. "News," *The Daily Advertiser* (New York), July 10, 1789; "News," *Federal Gazette* (Philadelphia), June 28, 1790.
6. Benjamin Ferris, *History of the Original Settlements on the Delaware* (Wilson and Heald, 1846), p. 232.
7. Marianne Wokeck, *Trade in Strangers: The Beginning of Mass Migration to North America* (University Park, Pa.: Pennsylvania State University Press, 1999), pp. xix–xx, 175.
8. "Shipping News," *Pennsylvania Packet* (Philadelphia), May 1, 1786; "Shipping News," *New-York Price-Current*, April 21, 1810.
9. Advertisement, *American Watchman* (Wilmington, Del.), June 1, 1811; "News," *Poulson's American Daily Advertiser* (Philadelphia), April 11, 1812.
10. There was no information found on No. 257 in Delaware.

Cat. no. 54

1. Cited in Mae Schulze, "A Ship Called *Wilmington*," *Delaware Antiques Show Catalogue* (1965): 63.
2. Ibid.
3. Ibid.
4. "Shipping News," *Pennsylvania Packet* (Philadelphia), May 1, 1786; "Shipping News," *New-York Price-Current*, April 21, 1810.
5. "Foreign Intelligence," *Pennsylvania Mercury* (Philadelphia), April, 23, 1791. Poolbeg is an anchorage near Dublin, Ireland.
6. "Pelosi's Marine List," *New-York Packet*, July 28, 1791.
7. Advertisement, *The Federal Gazette* (Philadelphia), September 19, 1791.

8. Advertisement, *The Federal Gazette* (Philadelphia), September 10, 1791.
9. "Shipping News," *The Federal Gazette* (Philadelphia), December 10, 1791.
10. "Shipping News," *Dunlap's American Daily Advertiser* (Philadelphia), June 29, 1792.
11. "News," *Massachusetts Spy* (Worcester), June 27, 1793.
12. Benjamin Ferris, *History of the Original Settlements on the Delaware* (Wilson and Heald, 1846), p. 232.
13. Schulze, "Ship Called *Wilmington*," p. 63.
14. "Shipping News," *Philadelphia Gazette*, October 13, 1796.
15. "Shipping News," *The Diary; or, Loudon's Register* (New York), July 25, 1797.
16. Drakard, *Printed English Pottery*, pp. 125–26.
17. The bowl is in the Winterthur Museum collection.
18. Schulze, "Ship Called *Wilmington*," p. 67.

Cat. no. 55

1. "News," *Daily Advertiser* (New York), June 28, 1803. *Ship Registers and Enrollments of Providence, Rhode Island, 1773–1933*, vol. 1 (Providence: Rhode Island State Archives, 1941), p. 832.
2. *Ship Registers and Enrollments of Providence*, p. 832.
3. Ibid.
4. Death Notices, *Rhode-Island American* (Providence), January 16, 1821. W. W. Chapin, "The Aborn Family Genealogy," undated manuscript, Rhode Island Historical Society, pp. 28–29; James Arnold, *Vital Record of Rhode Island, 1636–1850*, vol. 14 (Providence: Narragansett Historical Publishing Company, 1905), p. 457. There seems to be some discrepancy about Aborn's death date; his obituary puts it on June 21, 1820; see Arnold, *Vital Record*, vol. 13, p. 103.

Cat. no. 56

1. See Northeast Auctions, Portsmouth, N.H., August 18–19, 2000, lot 280.
2. See Teitelman notes, Object File, Winterthur.
3. A good example is a set of three canvases that depict the *Ulysses*, *Brutus*, and *Volusia* of Salem, Massachusetts, attributed to George Ropes. The first shows the vessels departing from port on February 21, 1802; the second illustrates the ships caught in a fierce snowstorm on the night of February 22; and the third shows the ships wrecked on the beach at Cape Cod on the morning of February 23; see Peabody Essex Museum, acc. nos. M2363, M2362, M2368.

Cat. no. 57

1. Two of these jugs were in the Teitelman Collection (see Appendix II, 97, 140), and the fourth jug was sold by James Julia Inc., Fairfield, Maine, August 29, 2007, lot 805.

Cat. no. 58

1. The name is spelled Mackinet, Mackenit, Maganett, Mackenett, Macknet, sometimes with various spellings in the same legal document.
2. S. F. Hotchkin, *Ancient and Modern Germantown, Mount Airy, and Chestnut Hill* (Philadelphia: Ziegler & Co., 1889), p. 153.
3. Deed Book, D1, vol. 15, p. 127, Philadelphia City Archives (1775) describes Heath as "Inholder."
4. Deed Book, D9, p. 493, Philadelphia City Archives.
5. For "Revolutionary Service of Captain John Markland," *The Pennsylvania Magazine of History and Biography*, see http://www.archive.org/stream/pennsylvaniamaga09histuoft.
6. For images and history, see http://www.brynmawr.edu/iconog/gtn/6019g.htm.
7. http://www.ushistory.org/germantown/upper/greentree.htm.
8. For a discussion of the Great Seal, see pp. 240–41.

Cat. no. 59

1. http://www.coopers-hall.co.uk/coopers/.
2. For a description of the coat of arms, see http://www.heraldicmedia.com/site/info/livery/livcomps/coopers.html.
3. Kenneth Kilby, *The Cooper and His Trade* (London: John Baker, 1971).
4. Information generously supplied by Marshall Scheetz, journeyman cooper, Colonial Williamsburg.

5. Kenneth Kilby, *The Village Cooper* (Aylesham, Eng.: Shire Publications, 1998), p. 18.

6. Other examples can be found in the Willett Collection of Popular Pottery, Brighton Museum, DA 328211, DA 328594.

Cat. no. 60

1. Benjamin L. Carp, "Fire of Liberty: Firefighters, Urban Voluntary Culture, and the Revolutionary Movement," *William and Mary Quarterly* (October 2001).

2. *Continental Journal,* June 13, 1776, p. 2.

3. Communication from descendants of Joseph Lovering, August 6, 2007; see also Francis S. Drake, *Tea Leaves* (Boston: A. O. Crane, 1884).

4. Zachariah G. Whitman, *The History of the Ancient and Honorable Artillery Company* (Boston: John H. Eastburn, 1842), p. 347.

5. *Massachusetts Mercury*, November 12, 1799, p. 4.

6. Stephanie Schorow, *Boston on Fire* (Beverly, Mass.: Commonwealth Editions, 2003), p. 9.

7. http://www.auroraregionalfiremuseum.org/handtubexpo/handtubs_&_musters.html.

8. *The Massachusetts Centinel*, November 4, 1789, p. 59.

9. A similar painted example inscribed "THE PROPERTY OF ENGINE Nº. 2" is in the Robert McCauley Collection at the Smithsonian Institution (63.150). Printed versions include an example at the Bostonian Society (1971.71.10) and the Philadelphia Museum of Art (1940.16.113)

10. For a discussion of the Great Seal, see pp. 240-41.

Cat. no. 61

1. E. McClung Fleming, "From Indian Princess to Greek Goddess: The American Image, 1783–1815," in *Winterthur Portfolio III*, ed. Milo M. Naeve (Winterthur, Del.: Henry Francis du Pont Winterthur Museum, 1967), pp. 37–66.

2. Boleslaw and Marie-Louise D'Ortange Mastai, *The Stars and the Stripes: The American Flag as Art and as History* (New York: Alfred A. Knopf, 1973), p. 84.

3. "Three Liverpool Pitchers," *Bulletin of the Pennsylvania Museum* 18, no. 74 (February 1923): 9–11; Smith, *Illustrated Guide to Liverpool Herculaneum*, p. 56.

4. Wick, *George Washington,* pp. 138–41.

5. Ibid., p. 37.

6. For a discussion of the Great Seal, see pp. 240-41.

7. For a discussion of Masonic symbols, see p. 240.

8. For similar hand-painted inscriptions, see cat. nos. 46, 47, 55, and 73.

Cat. no. 62

1. A pair of such plates was in the S. Robert Teitelman Collection (see Appendix II).

Cat. no. 63

1. E. McClung Fleming, "The American Image as Indian Princess, 1765–1783," in *Winterthur Portfolio II*, ed. Milo M. Naeve (Winterthur, Del.: Henry Francis du Pont Winterthur Museum, 1965), pp. 65–81.

2. Anthony Ray, *English Delftware Pottery in the Robert Hall Warren Collection, Ashmolean Museum, Oxford* (Boston: Boston Book & Art Shop, 1968), p. 129.

3. For an identical print, see cat. no. 72.

4. Geoffrey A. Godden, *Godden's New Guide to English Porcelain* (London: Sterling Publishing Co., Inc., 2004), p. 202.

Cat. no. 64

1. For a discussion of the Great Seal, see pp. 240-41.

2. For a discussion of stock prints of ships, see p. 241.

3. Hugh Honour, *The Golden Land: European Images of America* (New York: Pantheon Books, 1975), pp. 89, 109.

4. Stephen Phillips, *Ship Registers of the District of Newburyport, Massachusetts, 1789–1870* (Salem: Essex Institute, 1937), p. 10.

Cat. no. 65

1. The documentation relating to the ancillary trade of engraver is scarce, as trade directories were not regularly produced. James Kennedy, engraver, appears in the following: Parson & Bradshaw, *Staffordshire Directory* (1818); *Pigot and Co's London & Provincial New Commercial Directory for 1822–23*; *Pigot and Co's National Commercial Directory for 1828–29, 1830,* and *1835*; and William White, *History Gazetteer and Directory of Staffordshire* (1834).

2. For a discussion of Masonic symbols, see p. 240.

3. http://74.125.45.104/search?q=cache:EQbBln4ngmoJ:www.answers.com/topic/freemason+freemason+American+members+1820&hl=en&ct=clnk&cd=3&gl=us.

4. For a discussion of the Great Seal, see pp. 240-41.

Cat. no. 66

1. John Carson, *Bristol Pottery, 1784–1972,* http://www.authorsonline.com.

2. For images, see http://www.kalendar.demon.co.uk/pountjdfifield.htm.

3. Information from Karin Walton, Curator of Applied Art, Bristol Museums & Art Gallery.

4. See Appendix II.148

5. For a discussion of the Great Seal, see pp. 240-41.

Cat. no. 67

1. For a discussion of the Great Seal, see pp. 240-41.

2. http://www.blacksmithscompany.org.uk/Pages/History/History_Home.htm. A resurgence in the craft has expanded the company's activities in recent years, but during the 1800s they were relatively inactive.

3. http://www.stoningtonhistory.org/archiv6.htm.

Cat. no. 68

1. Marc Leepson, *Flag: An American Biography* (New York: Thomas Dunne Books, 2005), p. 21.

2. Ibid., p. 22.

3. Ibid., pp. 55–57, 77.

4. Ibid., p. 58.

5. John Papworth, *An Alphabetical Dictionary of Coats of Arms Belonging to Families in Great Britain and Ireland* (1847; reprint, Baltimore: Genealogical Publishing Co., 1965), p. 385.

Cat. no. 69

1. W. M. Beauchamp, "Rhymes from Old Powder-Horns. II," *The Journal of American Folklore* 5, no. 19 (October–December 1892): 284–90.

2. See cat. nos. 7–12 for Washington subjects.

3. See cat. no. 45 for a similar design.

Cat. no. 70

1. James L. Mooney, *Dictionary of American Naval Fighting Ships* (Washington, D.C.: Department of the Navy, 1977), pp. 95, 366.

Cat. no. 71

1. *Columbian Centinel* (Boston), May 25, 1791.

2. *Providence Gazette and Country Journal*, March 10, 1792.

3. Samuel Morison, *The Maritime History of Massachusetts, 1783–1860* (Boston: Northeastern University Press, 1979), p. 96; National Park Service, *Salem: Maritime Salem in the Age of Sail* (Washington, D.C.: Department of the Interior, 1987), p. 96.

4. *Greenleaf's New York Journal*, February 18, 1795.

5. *Philadelphia Gazette & Universal Daily Advertiser*, February 24, 1795.

Cat. no. 72

1. http://www.heraldnet.com/article/20071118/LIVING05/711180002.

2. *Pennsylvania Gazette*, May 22, 1766, p. 2.

3. For an identical print, see cat. no. 63.

4. Godden, *New Guide*, p. 202.

Cat. no. 73

1. Henry Wadsworth Longfellow, *The Courtship of Miles Standish and Other Poems* (1858; reprint, New York: BiblioLife, 2009).

2. For a teapot celebrating the repeal of the Stamp Act, see cat. no. 3.

3. Priscilla Jones, *Alden Family Notebook,* Penobscot Marine Museum Library, Searsport, Maine.

4. The jug and plate were acquired from an Alden descendant in 1983 along with a watercolor portrait of David as well as his magistrate's journal.

Appendix I

Robin Emmerson

The Jonathan Aborn Invoice

September 1802

"Invoice of sundry Merchandise shipped on board the Patterson, Jonathan Aborn Master, bound for New York, by order and on account of risk of John Innes Clark Esq & to him consigned by Michael Richardson & Co., Merchants Liverpool."

The 200 crates of earthenware on board the *Patterson* contained approximately 110,000 pots from the Herculaneum Pottery Company. It is not possible to give an exact count because although the items are generally listed in dozens, a potter's dozen was not necessarily 12. Pieces that held liquid, such as mugs, jugs, and bowls, were traditionally counted according to how many pints one dozen of them would hold. In other words, one-pint jugs were counted 12 to the dozen, but two-pint jugs were counted 6 to the dozen, and half-pint mugs 24 to the dozen. To count the pots you therefore need to know how many of the dozens were "mugs 24" rather than "mugs 12," which was usually recorded by the clerk, but not always. The price per dozen was normally the same whether it was for 24 halfpint mugs or 12 one-pint ones. As long as the clerk counted the overall number of dozens, he would get the price right. As a result, he occasionally neglected to specify which dozens were which size.

The system of potters' dozens has a certain weird logic, but in practice it was even more complex. The minimum wholesale prices of earthenware were set periodically by a group of leading Staffordshire potters in an attempt to prevent mutual underselling. This means there was a standard price for a dozen creamware jugs, set at 1s.6d in 1796. The easiest way for a potter to circumvent this agreement and undersell his competitors was to make larger ware for the same price. When you bought a dozen Spode "one-pint" jugs, you received 12, but each jug actually held 1½ pints, as the more scrupulous, but less aggressive, firm of Wedgwood noted in 1807.[1] The sizes of chamber pots, bowls, wash basins, and teapots had already grown so much by January 1796 that new maximum sizes had to be set: 12s (formerly a pint) could now be a 1½ pints; 18s (formerly ⅔ of a pint) could now be one pint; and 24s (formerly ½ pint) could now be ¾ of a pint. Reality, however, had evidently already overtaken these figures, for only three months later it was agreed that all these wares were "not to exceed in Measure, double their Denomination." In other words, 12s could conceivably hold two pints.[2]

About half of all the pots in the 1802 Aborn invoice (some 55,000) were tablewares—that is, dinnerware. Nearly 24,000 were teawares (a term that included coffeeware, though few were specifically listed for coffee), and nearly 19,000 were hollowwares. The types of decoration—or lack thereof—tended to go with function. The dinnerware was invariably plain creamware or had just a painted edge. The hollowware was mostly plain creamware. Some of the teaware was plain creamware, but most had some sort of decoration added. Enameling (onglaze painting) was confined to teaware apart from a few mugs and jugs. More than half of all the teaware was enameled. Painting before glazing was likewise confined to teaware and bowls. Ware that was dipped in colored clay and then lathe-turned, known as coloredware, was confined to hollowware ranging from chamber pots to pepper pots. The only wares printed in blue before glazing were some 750 items of teaware. The only items printed onglaze, described as copperplate, were jugs and mugs, more than 3,000.

The relative prices are interesting. Plain creamware teapots were 3s. or 4s. 6d. a dozen. Those painted before glazing were 5s. and 7s. a dozen, but some painted on the glaze were only 4s. 8d. a dozen. Similarly, plain creamware cups and saucers were 1s. 3d. a dozen, while those painted under the glaze and on the glaze were both the same price, at 2s. 3d. a dozen. This is surprising since the extra firing required for onglaze decoration should have made these more expensive. The clue is in their description as "common enamelled," which was trade jargon for substandard ware, "seconds," and "thirds." Only this low quality can account for their price. It also explains why there is so much more onglaze painted ware than one would expect, compared with the ware painted or printed before glazing.

The most striking feature of the Aborn shipment is also the most typical of the trade: the preponderance of pots that were either plain creamware or had just a painted edge—78 percent of the consignment. By contrast the pieces with onglaze prints constituted just 3 percent.

It is important for museums and collectors to realize that the relative proportions of the different types of wares that have survived intact are virtually in inverse proportion to their original share of the market. The reason is simple. Although the more decorative pieces were likely to be carefully used, treasured, and handed down, the plainer pieces for everyday use were broken and thrown away, with archaeologists therefore finding many in the trash pit.

1. Leonard Whiter, *Spode: A History of the Family, Factory, and Wares from 1733 to 1833* (London: Barrie & Jenkins, 1970), p.63.

2. Arnold R. Mountford, "Documents Relating to English Ceramics of the 18th and 19th Centuries," *Journal of Ceramic History* 8 (1975): 11.

Invoice of sundry Merchandize shipped on board the Patterson, Jonathan Aborn Master, bound for New York, by order and on account & risk of John Innes Clark Esqr. & to him consigned by Michael Richardson & Co. Merchants Liverpool

1802						£	s	d	
Sept.	3	John Clark for 150 Tons Coal @ 11/3.		84	7	6.			
		Extra Cartage		6	7	6.			
						90	15		
	5	Herculaneum Pottery Company for 200 Crates of							
		Earthenware marked C. No. 1 @ 200 — 913-16-7.							
		Discount 12½ per Cent — 114-4-7.		799	12	"			
		Crates & Covers		48	18	8.			
		Straw		20	"	"	868	10	8
	16	Edward & Hyper Morall for 6 Casks Paris white							
		marked A No. 16·18·23·24·34·35.							
		neat C. qr. lb 63-0-5 @ 6/. per Cwt. 18-18-3.							
		Casks @ 5/. each 1-10-"		20	8	3			
		Discount 4 per Cent		"	16	3.	19	12	
	28	Thomas Walker & Maltby & Co. for 11 Casks Spanish Brown							
		marked C No. 1 @ 11 —							
		neat C. qr. lb 86-2-13 @ 5/. 21-13-"							
		Eleven Casks @ 6/. each. 3-6-"		24	19	"			
		for 25 Casks dry white Lead marked C. No. 1 @ 25.							
		neat C. qr. lb 131-2-7. @ 42/.		276	5	8.			
		for 5 Casks red Lead marked C. No. 1 @ 5.							
		neat C. qr. lb 40-0-17 @ 30/.		60	4	6			
		Entry, Duty and shipping Charges		5	2	"	366	11	2
							1345	8	10

Charges

	£	s	d		£	s	d
Coal Sufferance.	"	1	"				
Duty Entry & Towns Duty on Coal.	8	6	7	"			
do do Earthenware	10	3	4.				
do do Paris white	"	10	6.				
Bills of Loading	"	2	6.				
Commission on Purchase of the above £1345-8-10 } @ 2½ per Cent	33	12	9		130	17	1.
Total Cash.					£ 1476	5	11.

Errors Excepted

Liverpool 28th Septr. 1802.

P. pro: Michael Richardson & Co.

Josh. Jas. Wells

carried over

Aborn invoice, from the John Innes Clark Invoice Book, 1801–18, Providence, Rhode Island. Document 714, Joseph Downs Collection of Manuscripts and Printed Ephemera, Winterthur Library.

136

Amount of Invoice bro.t over £			1476 5 11

Deduct

Discount off spanish. Brown 2½ p. cent — · 12 6

do — off white Lead 2/- . 13 3 —

do — off red Lead — 1/. . 2 — —

15 15 6

Commission on £15-15-6 @ 2½ p. cent — · 7 11 · 16 3 5

Total amount of the Pattersons Cargo on Cash Terms £ 1460 2 6.

Errors Excepted.

Liverpool 28 Sept. 1802.

p. pro Michael Richardson &Co.

Jas.t Jas.t Wells. —

Herculaneum 5 Sept. 180[8]

Mess.rs M.t Richardson &Co.

Bo.t of the Herculaneum Pottery Co.

C

No.					
1	40 Dozen Plates 1/5 Soups. C.C.		1/4		2 13 4
2 a 10	9 Crates same as No. 1				24
11	40 Doz. Plates 1/4 Soups. C.C.		1/4		2 13 4
12 a 20	9 Crates same as No. 11				24
21	72 Doz. Round Trifles. C.C.		1/.		3 12 ..
22 a 28	7 Crates same as No. 21				25 4 ..
29	122 doz. Muffins 7 In. C.C		10..		5 1 8.
30	same as No. 29				5 1 8.
31	224 doz. Muffins 6 In C.C		8		7 9 4.
32	same as No. 31.				7 9 4
33	190 doz. Muffins 130.60 3.6 In C.C. 6.8				5 5 ..
34	18 dozen Oval Dishes Roy.d 10.12.14.16.18.20. In 2/-4/-6/-10/-15/-24 ..				6 12 ..
35	6 doz. Round Bakers 10.11.12 In 3/-4/-6/-			1 6 ..	
	6 do. Oval Dishes 10.12.14.16 In 2/-4/-6/-14.			1 6 ..	
	10 do Bowls 4 b.		1/10	18 4	3 12 4
	Carried forward — £		£ 122 14 ..	

137C.

No			£ s d	
	Brought forward			122 14
No. 36.	7½ doz. Salads oval 10.11.12.13.14 in. 21-10-12/-15/-18/-		4 - 14 - 6	
	16 do Bakers Round 7.9.10.11.12 in. 7/6-11/-8/-11-91-		4 - 0 - 6	8 15
37	30 doz. Chambers 3.4 CC 16.14	1/8	2 - 10 -	
	11½ do Bowls 12-24 do	1/10	1 - 1 - 1	3 11
38	21 Doz. Chambers 4&6 CC	1/8	1 15	
39	An assorted crate particulars at foot of the Invoice			5 7 6
40 & 41	ea 40 doz. Royal Plates 1/5 Soups	1/4		5 6 8
42	8 doz. Plates 1/4 Soups Royal	1/4	- 10 - 8	
	10 do Twifflers & Muffins		8 - 9	
	12 do Plates Twifflers & Muffins Green Edge		1 - a -	
	6 do Cups & Saucers End London	2/3	13 - 6	
	9 Teapots 18. 5 ea. 9 Sugars 24. 3½ ea. do		6 - 4½	
	9 Creams 30. End		1 - 6	
	1½ doz. Bowls 12-24 do		6 - -	
	12 doz Jugs & mugs 4.6.12 4.8.11 Copperplate		8 - -	
	2 do Cups & Saucers CC. Lon.	1/3	2 - 6	
	2 do do Do Irish	1/6	3 - -	
	9 Teapots 18. Sugars 24 & Creams 30. CC		1 - 6	
	4 doz. Chambers 4 & 6	1/8	6 - 8	
	1 do hand Basons 4.6	1/10	1 - 10	
	4 do Bowls 12-24	1/10	8 - 4	
	5 do Mugs 6.12 CC	1/6	7 - 6	
	3 do Jugs 4-6 do	1/6	4 - 6	
	½ do Ewers 4	2/6	1 - 3	5 10 10
43	Same as No 42			5 10 10
44	Same as No 42. Blue Edge instead of Green Edge		-	5 10 10
45 @ 54	10 crates same as No 44			55 8 9
55 @ 58	4 crates same as No 42			22 3 6
59	6 doz. Plates 1/4 Soups Royal	1/4	- 8 -	
	4 do Twifflers & Muffins		3 - 6	
	2 do Cups & Saucers. Lon. CC	1/3	2 - 6	
	2 do do do Irish do	1/6	3 - -	
	9 Teapots 18. Sugars 24 & Milks 30 do		1 - 8	
	Carried forward		£ 18 - 8	£ 141 14

138.

C	Brought forward	£ ̶ 18 ̶ 8	241 14 1½	
No 59. Continued	4 doz. Chambers 3. 6 ̶ C. C.	1/8	̶ 6 ̶ 8.	
	4 do Bowls 12.24 Do	1/10	7 ̶ 4.	
	1 do hand Basons 4. 6 Do	1/10	1 ̶ 10.	
	5 do Mugs 6.12 Do	1/6	7 ̶ 6.	
	3 do Jugs 4.6 Do	1/6	4 ̶ 6	
	½ do Ewers. 4 Do	2/6	1 ̶ 3.	
	6 do Cups & Saucers End London	2/3.	13 ̶ 6.	
	9 Teapots 18. 3/6. 9 Sugars 24. 2/8 Do	̶	6 ̶ 2	
	9 Creams 30 Do	̶	1 ̶ 6.	
	2 Sets Teaware Enameled Fluted	2/6	5 ̶ ̶	
	12 doz Jugs & mugs 4.6.12 Copperplate	8 ̶ ̶	4 1 11	
60 a 78	19 Crates same as No 59	̶	77 16 5.	
79	6 doz Plates Royal ¼ Soups ̶ C. C.	1/4	̶ 8 ̶ ̶	
	4 do Twifflers & Muffins 6 in Do	̶	̶ 3 ̶ 4	
	4 Bakers Round. 9.11 in	̶	1 ̶ 1.	
	4 doz. Chambers 4. 6	1/8	6 ̶ 8.	
	4 do Bowls 12.24	1/10	7 ̶ 4.	
	1 do Hand Basons 4	1/10	1 ̶ 10	
	3 do Jugs 4.6	1/6	4 ̶ 6	
	2 do Mugs 6.12	1/6	3 ̶ ̶	
	2 do Cups & Saucers London C. C.	1/3	2 ̶ 6.	
	2 do do Irish do	1/6	3 ̶ ̶	
	9 Teapots 18. Sugars 24. & Creams 30 Do	̶	1 ̶ 6.	
	12 Jugs & mugs Copperplate 4.6.12	̶	8 ̶ ̶	
	2 Sets Teaware Blue. Printed, Fluted & Topt. Consisting of 6 Cups & Saucers. 1 Teapot 1 Sugar. 1 Cream & Cake Plate a 5/10	}	̶ 11 ̶ 8.	
	2 Sets Teaware common Enamel'd Fluted	2/7	̶ 5 ̶ 2	
	3 do Joyp. do & Coffee ware do	4/	̶ 3 ̶ ̶	
	6 do Cups & Saucers End. London	2/3.	13 ̶ 6	
	9 Teapots 18. 3/6. 9 Sugars 24. Do 2/8	̶	6 ̶ 2.	
	9 Milks 30 Do	̶	1 ̶ 6.	
	1½ doz. Bowls 12.24 Do	1/10	2 ̶ 9.	4 14 6.
80 a 90	11 Crates same as No 79	̶	51 19 6.	
	Carried forward	£ ̶ ̶	£ 380 6 5	

140 C.

				£	380.65
N° 91	Same as N° 79 only Soap, Tea, & Coffee Ware excluded				4.11.6
92	Same as N° 91				4.11.6
93	8 doz. Plates ¼ Soups Royl. C.C		1/4	10.8.	
	2 do Suppers	D°	1/2	2.4.	
	8 do. Twifflers & Muffins 6 In.	D°		6.8.	
	4 Bakers In.	D°		1.1.	
	2 doz. Chambers In.	D°	1/8	3.4	
	1 d° Bowls	D°	1/10	1.10	
	1 d° Hand Bowls	D°	1/10	1.10	
	1½ d° Jugs	D°	1/6	2.3.	
	1½ d° mugs	D°	1/6	2.3.	
	4 Sauce Boats	D°		1.	
	18 Mustards, Peppers, & Salts			1.9	
	8 doz. Cups & Saucers com. Enamel'd Irish. 2/9.			1.9.	
	18 Teapots 18. Sugars 24. & Creams 30. D°			5.3	
	1½ Doz. Bowls	D°	1/10	2.9.	
	4 Doz. Jugs & mugs B.& W.			12.	
	2 Sets Cups & Saucers consisting of 6 Cups & Saucers				
	1 Teapot 18. – 1 Sugar 24 & 1 Cream 30. Best enam			8.	
	-d'd Fluted Basket Pattern				45.
94 a 111	18 Crates Same as N° 93				76.10.
112	30 doz. Plates ⅕ Soups Green Edge		2/.	3.	
	6 do Twifflers	D°	1/6.	9.	
	6 do. Muffins 6 In. D°		1/2.	7.	
	16 Dishes oval In. D°			12.1	
	6 Bakers round In. D°			2.	
	6 Salads oval In.			5.2.	4.15.3
113 a 121.	9 Crates same as N° 112				42.17.3
122	30 doz. Mugs. 24.12.6 C.C 12 to dozen			2.12.6	
	5 doz. Jugs 4. D° D°			7.6	3.
123	24 doz. Plates ¼ Soups Blue edge		2/.	2.8.	
	10 do. Twifflers & Muffins In D°			13.10.	
	4 Salads In. D°			3.	
	8 Round Bakers In. D°			3.	
	20 Dishes In. D°			14.10.	4.2.
	Carried forward			£	524.19.

141

				£		£	524	19.7
C.	Brought forward							
No 124	36 doz. Twifflers — Green edge	1/6		2.14.				
	32 do. Muffins 6.7 m. do 1/2. 1/4.			2. 1.		4	15	
125.	6 doz. Plates Blue edge	2/.		12.				
	5 do. Twifflers & Muffins — do			6.10				
	2 do painted Bowls	4/.		8.				
	3 do. Do Do & Saucers	4/6		13.6				
	3 Do. Do — Cups & Do Lon.	2/3.		6.9				
	12 Teapots & 18			5.				
	6 doz. Plates C.C.	1/4		8.				
	5 do. Twifflers & Muffins — Do			4.6				
	6 do Cups & Saucers — Do	1/3		7.6.				
	1 do Chambers — Do	1/8		1.8				
	3 do Bowls 12.24 — Do	1/10		5.6.				
	1 do Jugs 12. — Do	1/6		1.6.				
	3 do — do Ribband	3/.		9.				
	6 Teapots 18. C.C.			1.6		4	11	3.
126	Same as No 125.					4	11	3.
127	6 Doz. Plates Blue Edge	2/.		12.				
	5 Do. Twifflers & Muffins — do			6.10				
	2 Do Bowls painted	4/.		8.				
	3 do Cups & Saucers Irish do	2/9.		8.3				
	3 Do. Do London do	2/3.		6.9				
	12 Teapots 18. do			5.				
	6 doz. Plates C.C.	1/4		8.				
	5 Do. Twifflers & Muffins 6.7 m.			4.6.				
	3 do Cups & Saucers C.C.	1/6		4.6				
	1 do Chambers — Do	1/8		1.8				
	2 do Bowls 24 — Do	1/10		3.8				
	2 do Jugs 6.12. — Do	1/6.		3.				
	4 do — Do Ribband	3/.		12.				
	6 Teapots 18. C.C.			1.6.		4	5	8
128 a 139.	12 Crates same as No 127.					51	8	0.
	Carried forward			£		£	594	10.9

142

C.

				£		£	594	10.9
		Brought forward						
No. 140	12 doz	Jugs 6.12 Color'd	3/.	1.16.-				
	12 Do	Mugs 6.12.24 Do.	3/.	1.16.-				
	8½ Do	Tumblers — Do	3/.	1.5.6				
	3 Do	Mustards — Do	4/.	.12.-				
	10 Do	Peppers & Salts Do	3/.	1.10.-				
	8 Do	Chintz Jugs 6.12	3/.	1.4.-				
	8 Do	Do — Mugs 6.12.	3/.	1.4.-				
	1 Do	Do — Cans —	..	.3.-				
	1 Do	Do — Tumblers.		.3.-				
	10 Do	Colour'd Jugs & Mugs & Chamber Joys	4/.	1.-.-				
	1 Do	Do — Cans		.3.-	10	16.6		
141	16 Doz.	6.6 Jugs 4.6.12.	1/6	1.4.-				
	12 Do	Colour'd Mugs. 6.12.24.36	3/.	1.16.-	3	-.-		
142	16 Doz.	Paint'd Bowls	4/.	3.4.-				
	6 Do	Do Creams	4/.	1.4.-				
	7 Do	Do Teapots 9.18	7/.	2.9.-	6	17.-		
143	16 Doz.	Bowls 6 6.6	1/10	1.9.4				
	8 Do	Basons. 2 gall & 1 gall Do	1/10	14.8				
	4 Do	Dishes 12.13.14 — Do		.19.-				
	3 Do	Chambers 2 Do	1/8	.5.-				
	2 Do	Sauce Boats 2 size Blue Edge —		.7.-	3	15.-		
144	12 Doz.	Chambers 2 S.S	5/8	4.8.				
	4 Do	Jugs gall Do.	1/6	.6.-				
	4 Do	Ewers 2 — Do.	2/6	.10.-				
	12 Do	Carved Mugs 6.6.24 Do. —	2/6	1.10.-	2	13.6		
145	21 Doz.	Second Plates — 6.6 —	1/2.	1.4.6.				
	5 Do	Do Twifflers Do	10d.	4.2				
	12 Do	Do Muffins 5.6.7 Do	—	.7.-				
	10 Do	Do best Plates 6.6	1/4.	13.4	2	9.-		
146	9 Doz.	Chambers 4.6.12. 6.6 —	1/8	15.-				
	3 Do	Bowls. 24.30 — Do.	1/10	5.6				
	3 do	Poringers 24. 6.6	1/8	5.-				
	6 Do	Jugs & Mugs 12. Do	1/6	.9.-				
	6 Teasets	Best End. Different patterns —	3/6	1.1.-				
	2 Do	Blue printed fluted & Topt	5/.	.10.-				
	10 Do	Com. Enamel'd ea consist'g of 6 cups & Saucers						
		1 Bowl 24. 1 Teapot 18. 1 Sugar 24. & 1 Cream 30	4/.		4	56		
		Carried forward			£	628	12	

			£	628	7	3
	Brought forward					
No 147	6 Dozen Plates Flats brown line					
	2 Do Do Soups Do					
	4 Do Twifflers & Muffins 7 In Do					
	18 Dishes 10·12·14·16·18·20 & 24 In Do					
	2 Gravy Dishes 20 & 22 In Do					
	4 Bakers 8·10·12 In Do					
	2 Salads 10·11 In Do					
	1 Large Fish Drainer Do					
	1 Do Cheese Toaster Do					
	6 Fruit Dishes 8 In Do					
	4 Do Baskets & Stands 2 large size Do					
	2 Vegetable Dishes 12 In Do					
	4 Covered Do 12 In Do					
	2 Soup Tureens & Ladles 10 & 12 In Do					
	4 Sauce Do Complete Do					
	6 Pickles Do					
	12 Custard Cups Do					
	1 Butter Tub & Stand Small Do	8·8·				
	4 Jugs Fluted Best Ena 3·4·6·12	·12·	9			
148	16 Doz black glaze Teapots 12·18·24	3/6	2 16			
149	18 Do Red Do Do 12·18	4/9	4 5 6			
150 & 151	2 Crates same as No 149		8 11			
152	60 Doz Cups & Saucers Lon. Ena	a 2/3	6 15			
153	Same as No 152		6 13			
154	41 Doz Hand Basons C.C	1/10 3·15·2				
	5 Do Mugs 12 Do	1/6 ·7·6	4 2 8			
155	50 Doz Cups & Saucers com Ena Irish	2/9	6 17 6			
156	Same as No 155		6 17 6			
157	40 Doz Plates 1/5 Soups C.C	1/4	2 13 4			
158	28 Doz Royal Plates & Soups C.C	1/4 1·17·4				
	20 Do Twifflers & Muffins Do	·18·	2 15 4			
159	Same as No 93		4 5			
160	18 Teasets Fluted best Ena Rose Pattern	4/6 4·1·				
	24 Do Do Do Greens spreig	4/ 4·16·				
	6 Do Do Do yellow border	4/3 1·5·6	10 2 6			
	Carried forward	£	£ 704	3	7	

144

C.	Brought forward	—	£		£ 704	37
Nº 161.	34 doz. Jugs C.C. 12.3.14 2.3.4	1/6	2	11		
	60 Setts Toy Teaware com. Enºd	1/.	3	..	5 11	..
162	27 Doz. Jugs 2.3.4.6 C.C.	1/6	2	0 6		
	20 Dº. Cups & Saucers London com. Enº	2/3.	2	5	4 5 6	
163	16 Doz. Jugs 2.3.4.6 C.C.	1/6	1	14		
	20 Dº. Cups & Saucers Lon. com. Enamel'd	2/3	2	5	4 4	..
164	15 Doz. Soup Plates	1/4	1	..		
	25 Dº. Twifflers	1/.	1	5	2 5	..
165	Same as Nº 164				2 5	..
166	8 Doz. Cups & Saucers Lon. Blue Print'd Fluted Sept		1	8		
	4 Dº. Bowls & Saucers. 36. — Dº Dº	9/.	1	16		
	2 Dº. Coffee Cups 36 Dº Dº	8/.		16		
	1 Dº. Teapots — 18. Oval Dº		1	4		
	1 ½ Dº. Sugars 18 Dº Dº	24/.	1	12		
	1 Dº. Creams 24 Dº Dº			12		
	2 Dº. Coffee Pots 4.6 Dº Dº	14/.	1	4		
	2 Dº. Bowls 24 — Dº Dº	8/.		16	10 8	..
167.	24 Doz. Cups & Saucers Lon. com. Enº & Fluted	3/3	3	18		
	2½ Dº. Teapots 18 Dº Dº	9/.	1	2	6	
	2 Dº. Sugars 24 Dº Dº	9/.		18		
	3 Dº. Bowls 24 Dº Dº	5/.		15		
	2 Dº. Creams 4 Dº Dº	5/.		10	7 3 6	
168.	50 Doz. Cups & Saucers Irish C.C.	1/6.			3 15	..
169 @ 172	4 Crates same as Nº 162.				15	..
173	40 Doz. Cups & Saucers, & Bowls & Saucers 36. C.C. 20 1/6 20 2/6				4	..
174	36 Doz. Basons 3.4.6. C.C. 8.15.8	1/10			3 6	..
175	38 Doz. Hand Basons 3.4.6 C.C. 10.16.12	1/10			3 9	..
176	34 Dº. Hand Basons & Bowls 3.4.6 C.C. 10.14.10	1/10			3 2 4	
177	40 Doz. Plates & Soups Blue & green edge	2/.			4	..
178 180	3 Crates same as Nº 177.				12	..
	Carried forward		£ £ 788	18

259

145

C					£	788	18	T
		Brought Forward		£				
N⁰ 181	72 Doz. Twiflers Blue & Green Edge	1/6				5	8	~
182	50 Doz Supplies Blue & Green Edge	1/9				4	7	6
183	180 Doz. Muffins ¹⁵⁶·²⁴ 6·7 m. D⁰					10	14	~
184	228 D⁰ — d⁰ — 6 m __ D⁰	1/2				13	6	~
185	18 Doz. oval Dishes ⁴·⁴·⁴·³·²·¹ 10·12·14·16·18·20 m D⁰ 3/- 6/- 10/- 15/- 21/- 30/-					9	13	-
186	60 Doz. cups & Saucers Lon. Com. En⁰ — 2/3					6	15	~
187	Same as N⁰ 186					6	15	~
188	50 doz cups & Saucers Fr. com En⁰ 2/9					6	17	6
189	Same as N⁰ 188					6	17	6
190	30 Doz. Bowls En⁰	4/-				6	~	~
191	30 Doz. Bowls ²⁰ ⁶ Sugars & Creams En⁰					6	12	~
192	11 Doz. Teapots & Coffee Pots Com En⁰		3	17	~			
	3 D⁰ — D⁰ perped D⁰		1	19	~	5	16	~
193	13 Doz. Teapots — C. C	4/6				2	18	6
194	37 Doz. Jugs ³⁴ & Mugs ³ 24. C. C	1/6				2	15	6
195	6 Doz — Jugs ²·²·² 2·4·12 Common En⁰	4/-	1	4	~			
	20 D⁰ — D⁰ Brick work ²·²·⁶·⁶·¼ 2·3·4·6·½	3/-	3	~	~			
	3 D⁰. Creams 30 Com. En⁰	4/6	..	18	~	4	16	~
196	Same as N⁰ 195					4	16	~
197	15 Doz. Jugs Copperplate ²·³·⁶·⁴ 2·3·4·6.	4/-	3	~	~			
	12 D⁰ — D⁰ Brick work ²·²·³·³·² 2·3·4·6·12	3/-	1	16	~			
	3 D⁰ Creams 30. Com. En⁰	4/-	..	12	~	5	8	~
198	26 Doz. Jugs ¹⁸·⁸ 4·5·2 Brick work	3/-	3	18	~			
	10 D⁰ — D⁰ 6. Copperplate & En⁰	4/-	2	~	~	5	18	~
199	32 Doz. Chambers 3.	1/8	2	13	4			
	40 D⁰ — Muffins 6 m.	8⁰	1	6	8	4	~	~
200	22 Doz. Coffee Pots Red Glaze	4/9				5	4	6
						913	16	T
	Crates & Covers		48	18	8			
	Straw		20	~		68	18	8
		£	~	~	£	982	15	3

Turn over ——

260

146

Particulars of N.º 39.

8 Doz. Plates ¼ Soups C.C.	1/4	-10-8
8 D.º Twifflers & Muffins 6 m. D.º		7--
1 D.º Chambers 4 & 6 - D.º		-1-8
1 D.º Basons 4-6 - D.º		1-10
1 Ewer & Bason 4 D.º		2-6
2 Doz. Bowls 12-24-30 D.º		3-8
2 D.º Jugs & Mugs 3-4-6-12 D.º		3--
8 D.º Plates Green edge ¼ Soups		16--
6 D.º Twifflers & Muffins 6 m. - D.º		10-8
13 Dishes 9-11-14-16-18 In. D.º		8-3
6 Bakers 9-11-13 In. D.º		-3-8
2 Salads 13 In. D.º		2-6
2 Sauce Tureens Complete D.º		-3--
4 D.º - Boats 2 size - D.º		-1-4
3 Teasets Best En.d Different Patterns 3/4		-10--
1 Blue printed Fluted 1 Toilet - D.º		5-6
2 Doz. Cups & Saucers Lon. Com. En.d		4-6
2 D.º D.º Fish D.º		5-6
21 Teapots 18 Sugars 24 & Creams 30 D.º		-6-3 £57-6

S. ROBERT TEITELMAN COLLECTION

Patricia A. Halfpenny and Ronald W. Fuchs II

In this appendix we hope to fulfill the cherished desire of S. Robert Teitelman that his life's collection be fully documented in some permanent way. He thought it important that each piece be seen with all its decorations, if possible, and agreed that an appendix to the detailed catalogue entries would be an acceptable solution.

For lack of any other logical classification, the collection is shown in the order of Bob's acquisitions. The documentation includes his initials followed by the year and number of acquisition, such as SRT 98.1. A gap in sequential numbering may occur if Bob sold a piece, gave

it to an appropriate institution, or made a purchase that was not related to creamware for the American market.

The objects that follow were dispersed following Bob's death, and we are grateful to all who have helped to re-create this visual record. Many items were transferred for sale, to be enjoyed by future generations of collectors, and we thank Ron Bourgeault, Northeast Auctions, for his generous donation of images of those pieces, which were expertly photographed and documented by Andrew Davis. We also thank photographers Gavin Ashworth and Laszlo Bodo for their involvement and contributions to the project.

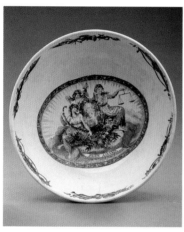 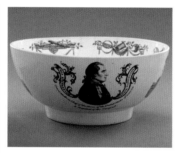 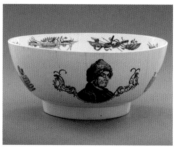 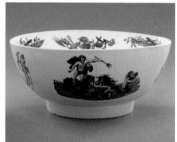

1. Bowl, creamware printed in black, Staffordshire or Liverpool, printed in Liverpool, 1798–1810.
Diam 9⅞ in. (251 mm), H 4¼ in. (108 mm)
Interior: portrait "JOHN ADAMS, President of the United States of America" and trophies on interior rim (see cat. no. 7); exterior: prints including "HIS EXCELLENCY GENERAL WASHINGTON" and "BENJn. FRANKLIN L.L.D. F.R.S"; see cat. nos. 10, 13. SRT 57.1

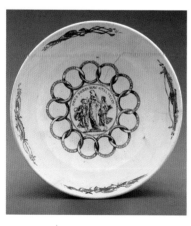 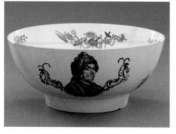 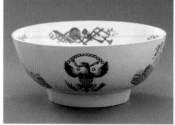 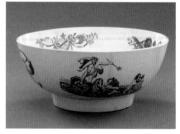

2. Bowl, creamware printed in black, Staffordshire or Liverpool, printed in Liverpool, 1795–1810.
Diam 8⅞₆ in. (225 mm), H 3¾ in. (95 mm)
Interior: allegory of Peace, Liberty, and Plenty with trophies on interior rim (see cat. no. 7, App. 1, 21); exterior: prints including an adaptation of the Great Seal of the United States and portrait of Benjamin Franklin. SRT 59.1

3. Jug, creamware printed in black, painted in enamels, Staffordshire, probably printed by F. Morris, Shelton, 1800–1815.
H 7⅞ in. (200 mm)
On one side: stock print of three-masted ship flying the American flag and pennant inscribed "SUCCESS TO TRADE" and two bundles, one inscribed "WB/TX/No 4/For America"; on the other side: print seen at cat. nos. 17, 34; beneath spout: allegory of Fame; traces of gilding and inscription. SRT 60.1

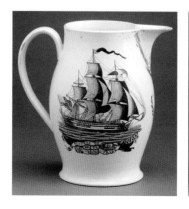 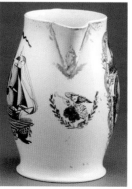 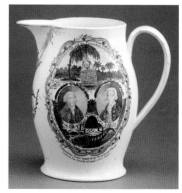

4. Jug, creamware printed in black, painted in enamels, Staffordshire, probably printed by F. Morris, Shelton, 1802–15. H 10⅑₆ in. (255 mm) On one side: print and poem "The Tythe Pig"; on the other side: scene inscribed "HARVEST HOME"; beneath spout: adaptation of the Great Seal of the United States inscribed "Peace, Commerce, and honest Friendship, with all Nations. Entangling Alliances with none. JEFFERSON/ Anno Domini 1802"; below handle: allegory of Fame. SRT 60.3

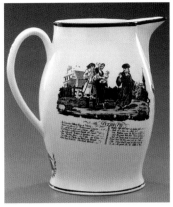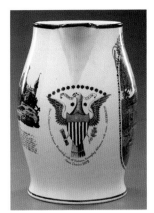

5. Jug, creamware printed in black, painted in enamels, probably Staffordshire, ca. 1800. H 10¹¹⁄₁₆ in. (272 mm) On one side: ship and sailor scene "POOR JACK"; on the other side: ship and sailor scene "TOM TRUELOVE GOING TO SEA"; below spout: design "COME BOX THE COMPASS"; to the left is a sailor heaving a lead. SRT 60.4

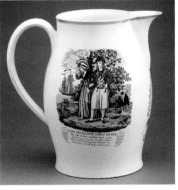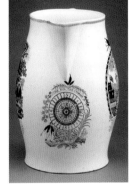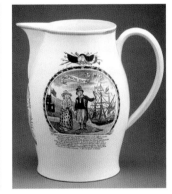

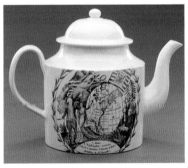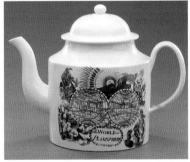

6. Punch pot, creamware printed in black, Staffordshire, probably printed by F. Morris, Shelton, 1800–1810. H 6¾ in. (168 mm) On one side: print of the east coast of North America (see cat. no. 20); on the other side: image entitled "The WORLD in/ PLANISPHERE"; the cover is modern. SRT 61.1

7. Soup plate, creamware printed in black, probably made in Staffordshire and printed in Liverpool, ca. 1778. Diam 9¹¹⁄₁₆ in. (245 mm) Allegorical cartoon "A Picturesque View of the State of the Nation for February 1778"; see cat. no. 4. SRT 61.2

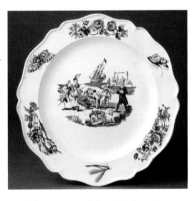

8. Jug, creamware printed in black, painted in enamels, Staffordshire, probably printed by F. Morris, Shelton, 1804–15. H 8¾ in. (222 mm) On one side: print "Success to AMERICA whose MILITIA is better than Standing ARMIES" (see cat. no. 34); on the other side: stock print of three-masted ship flying the American flag and pennant; beneath spout: adaptation of the Great Seal of the United States with the American eagle framed by the inscription "Peace. Commerce. And honest Friendship with all Nations. Entangling Alliances with none. JEFFERSON/ Anno Domini 1804." SRT 61.4

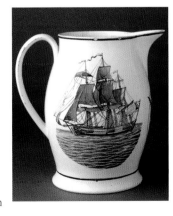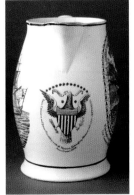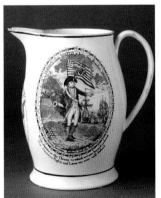

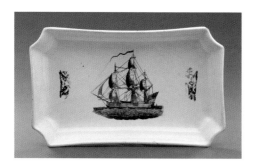

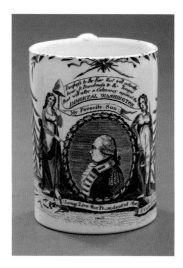

9. Dish, creamware printed in black, painted in enamels, impressed "WEDGWOOD" and "1," Staffordshire, probably 1875–1900. L 11½ in. (292 mm), W 7 in. (178 mm) Painted stock print of three-masted ship flying the American flag; vignettes of two birds, typical of Colonial Revival taste; see App. 55, 56. SRT 61.5

10. Mug, creamware printed in black, signed "F. Morris" for Francis Morris, printer, Shelton, Staffordshire, ca. 1800. H 3⅞ in.(98 mm) Portrait of Washington inscribed "Deafness to the Ear that will patiently/hear, and Dumbness to the Tongue/that will utter a Calumny against the/ IMMORTAL WASHINGTON"; see cat. no. 9. SRT 61.6

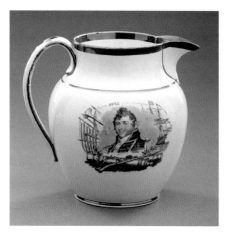

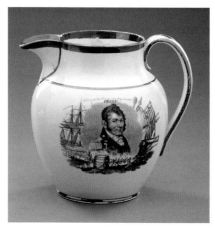

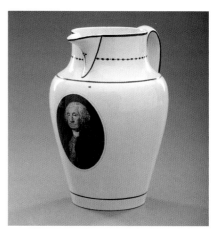

11. Jug, creamware printed in black, Staffordshire, 1816–20. H 7³⁄₁₆ in. (183 mm) On one side: portrait "Captain HULL of the Constitution" (see cat. no. 30); on the other side: portrait of Commodore Oliver Hazard Perry and inscription "We have met the Enemy; and they are ours!/PERRY"; below are naval trophies; both portraits from David Edwin engravings in the *Analectic Magazine* (March 1813/ December 1813). SRT 61.7

12. Jug, pearlware printed in black, base impressed "HERCULANEUM 4" for Herculaneum Pottery, Liverpool, 1800–1808. H 7¹⁵⁄₁₆ in. (202 mm) Portrait of George Washington, see cat. no. 14, App. 15. SRT 63.1

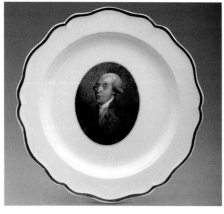

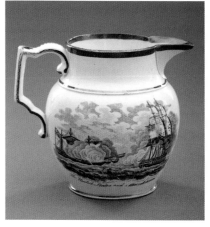

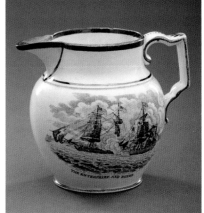

13. Plate, creamware printed in black, probably Herculaneum Pottery, Liverpool, 1809–17. Diam 10 in. (254 mm) Center with printed portrait of a man; similar examples are entitled "Madison." SRT 63.3

14. Jug, pearlware printed in black, signed "Bentley Wear & Bourne Engravers & Printers Shelton Staffordshire," Staffordshire, 1815–20. H 4⅝ in. (117 mm) Both sides printed with scenes of War of 1812 naval battles; "The United States and Macedonian." and "THE ENTERPRISE AND BOXER." SRT 63.4

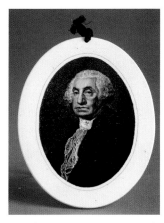
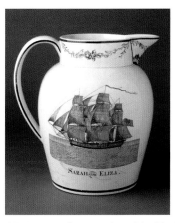

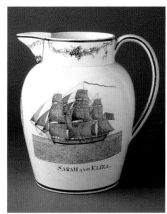

15. Plaque, creamware printed in black, Herculaneum Pottery, Liverpool, 1800–1808. H 5 in. (120 mm), W 4⅟₁₆ in. (103 mm)
Stipple engraving portrait of Washington after Gilbert Stuart's 1796 unfinished portrait (the "Athenaeum" portrait); printed version published by London engraver William Nutter, January 1798; see cat. no. 14. SRT 63.5

17. Jug, pearlware printed in black, painted in enamels, base impressed "HERCULANEUM" for Herculaneum Pottery, Liverpool, 1796–1805. H 10⅜ in. (263 mm)
On both sides: stock print of American ship with painted inscription "SARAH and ELIZA."; beneath spout: painted initials "JTW"; the *Sarah & Eliza* was built in 1803 in Nobleborough, Maine, and sailed until at least 1808, making several voyages between New York and Liverpool. SRT 63.7

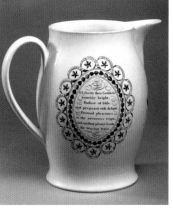
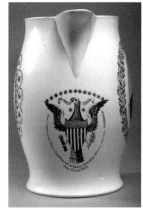
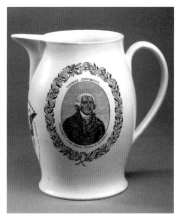

18. Jug, creamware printed in black, painted in enamels, print signed "F. Morris, Shelton," Staffordshire, 1802 10. H 10⅟₁₆ in. (256 mm)
On one side: portrait of Thomas Jefferson and inscription "THOMAS JEFFERSON" above and "PRESIDENT of the United States of AMERICA"; on the other side: poem beginning "O Liberty thou Goddess"; beneath spout: adaptation of the Great Seal of the United States with inscription "Peace, Commerce, and honest Friendship, with all Nations. Entangling Alliances with none. JEFFERSON/ Anno Domini 1802"; see cat. no. 17. SRT 63.8

16. Plaque, creamware printed in black, Herculaneum Pottery, Liverpool, 1801–8. H 5 in. (120 mm), W 4⅟₁₆ in. (103 mm)
Stipple engraving portrait of Thomas Jefferson. SRT 63.6

19. Mug, creamware painted in enamels, gilded, probably Liverpool, 1795–1800. H 6 in. (152 mm)
Two floral sprays flanking 15-star American flag with sheaf of wheat tied around base of the staff. SRT 63.9

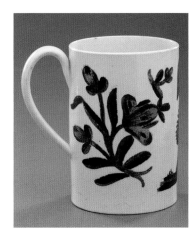
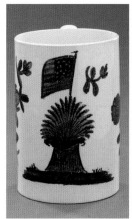
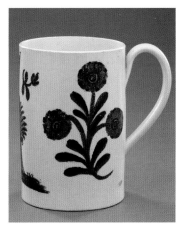

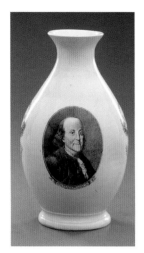 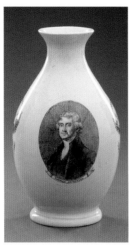 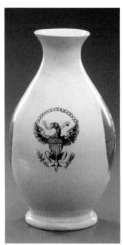 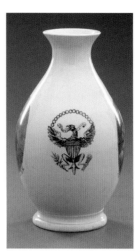

20. Bottle, creamware printed in black, probably Staffordshire, 1875–90. H 9¼ in. (235 mm)
On one side: portrait of Benjamin Franklin; on the other side: Thomas Jefferson; both titled in sans-serif letters, with an adaptation of the Great Seal of the United States.
SRT 63.10

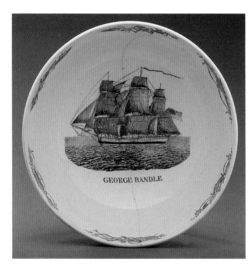 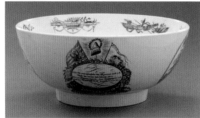 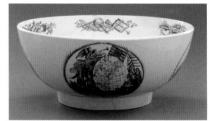
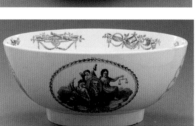 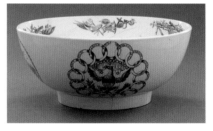

21. Bowl, creamware printed in black, painted in enamels, probably Herculaneum Pottery, Liverpool, 1800–1807. Diam 11⅜ in. (289 mm), H 4¹³⁄₁₆ in. (122 mm)
Interior: stock print of American ship entitled "GEORGE BANDLE" with trophies at rim; exterior: prints including an adaptation of the Great Seal of the United States, portrait "JOHN ADAMS,/President of the United States," map of the east coast of the United States, and a poem; see cat. no. 7. SRT 63.11

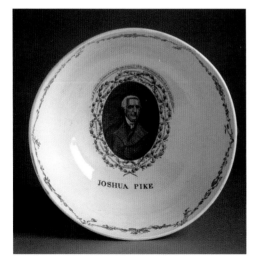 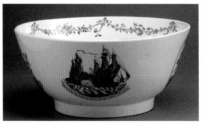 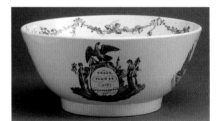
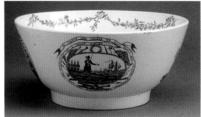 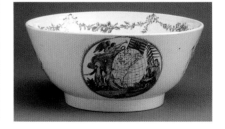

22. Bowl, creamware printed in black, Staffordshire or Liverpool, 1801–10. Diam 11¼ in. (286 mm), H 5 in. (125 mm)
Interior: portrait "THOMAS JEFFERSON PRESIDENT OF THE UNITED STATES OF AMERICA."; painted inscription "JOSHUA PIKE."; exterior: map of east coast of the United States; battle scene between *L'Insurgent[e]* and the *Constellation*; medallion with inscription "PEACE/PLENTY/and/INDEPENDENCE"; and portrait of George Washington; see cat. nos. 5, 26, 60, 71, App. 35 (for companion jug). SRT 63.12

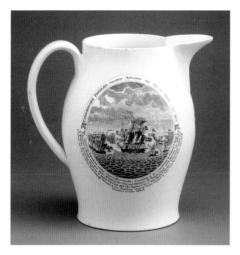
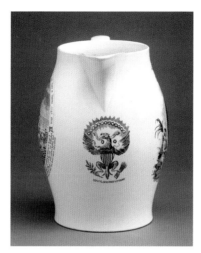
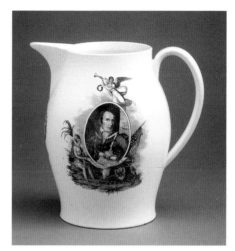

23. Jug, creamware printed in black, inscribed "HERCULANEUM POTTERY" for Herculaneum Pottery, Liverpool, 1805–7.
H 9 in. (229 mm)
On one side: scene "COMMODORE PREBLES SQUADRON ATTACKING THE CITY OF TRIPOLI Aug 3 1804."; on the other side: portrait "COMMODORE PREBLE"; beneath spout: adaptation of the Great Seal of the United States inscribed "HERCULANEUM POTTERY"; see cat. no. 27. SRT 63.13

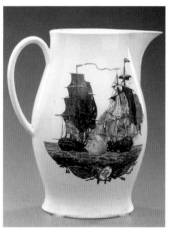
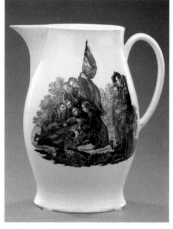
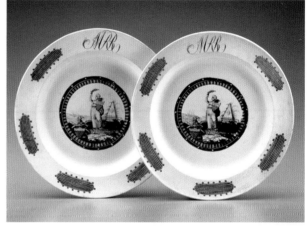

24. Jug, creamware printed in black, probably Staffordshire, possibly printed by Sadler and Green, Liverpool, 1785–90.
H 10½ in. (267 mm)
On one side: scene depicting the death of General Wolfe; on the other side: scene of two frigates, one with a British flag, in close combat; border of naval trophies and cartouche with initials "GR." SRT 63.14

25. Two plates, creamware printed in black, impressed "HERCULANEUM 7" for Herculaneum Pottery, Liverpool, 1800–1807. Diam 10⅛ in. (257 mm)
Center: Columbia holding an American shield and olive branch; pyramid is inscribed "SACRED TO THE/memory of/WASHINGTON"; made for Matthew and Ruth Rogers, Long Island, married 1797; see cat. no. 62. SRT 63.16 & 63.2

26. Mug, pearlware printed in red, probably Staffordshire, ca. 1815.
H 2½ in. (64 mm)
Printed with an adaptation of the Great Seal of the United States and banner inscribed "MAY SUCCESS ATTEND OUR/AGRICULTURE TRADE AND/MANUFACTURES." and "A PRESENT FOR MY DEAR GIRL." SRT 63.17

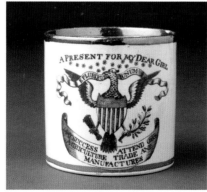
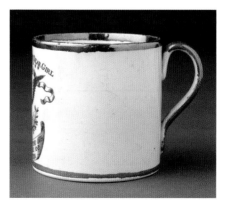

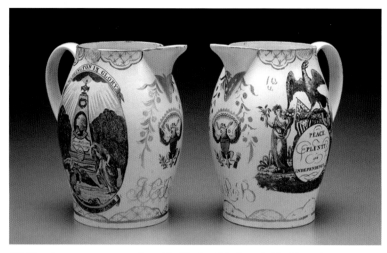

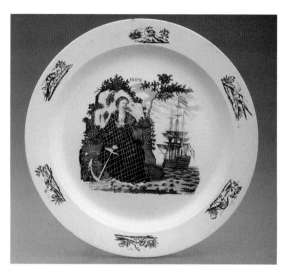

27. Two jugs, creamware printed in black, gilded, probably Herculaneum
Pottery, Liverpool, 1800–1810. H 8¹¹⁄₁₆ in. (220 mm)
On one side: printed "PEACE, PLENTY AND INDEPENDENCE."; on
the other side: memorial to George Washington "WASHINGTON IN
GLORY./AMERICA IN TEARS."; beneath spout: adaptation of the Great
Seal of the United States and painted initials "JEPB." SRT 64.2 & 64.3

30. Plate, creamware printed in black, painted in
enamels, probably Staffordshire, 1800–1810.
Diam 9¾ in. (246mm)
Rim: Six vignettes of birds; center: allegorical
figure of Hope with an American ship. SRT 64.8

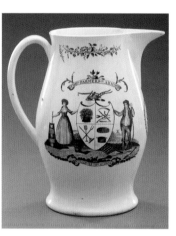

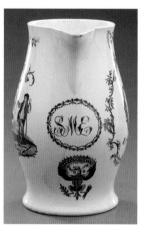

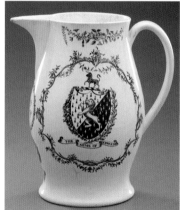

28. Jug, creamware printed
in black, painted in
enamels, probably
Herculaneum Pottery,
Liverpool, 1796–1805.
H 11 in. (278 mm)
On one side: coat of arms
inscribed "THE ARMS OF
EDWARDS"; on the other
side: print inscribed "THE
FARMERS ARMS.";
beneath spout: adaptation of
the Great Seal of the
United States and painted
initials "SME." SRT 64.5

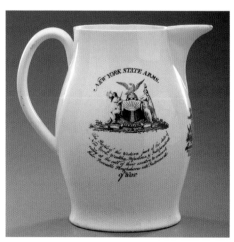

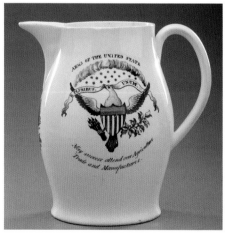

29. Jug, creamware printed in black, probably Staffordshire, ca. 1810. H 7⅞ in. (200 mm)
On one side: print "NEW YORK STATE ARMS"; on the other side: adaptation of the Great Seal of the United States;
inscribed below, "May success attend our Agriculture Trade and Manufactures."; beneath spout: print and inscription "WHEN
THIS YOU SEE/ REMEMBER ME." SRT 64.6

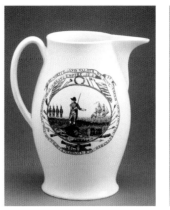
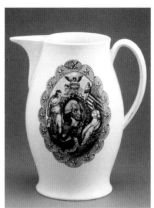

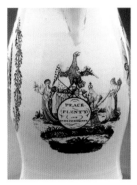

31. Jug, creamware printed in black, gilding, probably Staffordshire, 1800–1810. H 11 in. (280 mm)
On one side: seated allegorical figure of Liberty and inscription "May COMMERCE flourish."; on the other side: Apotheosis of Washington "ASCENDING TO GLORY"; below spout: "PEACE/PLENTY /and/INDEPENDENCE"; see cat. no. 71. SRT 64.9

32. Jug, creamware printed in black, Staffordshire or Liverpool, 1795–1810. H 9¹¹⁄₁₆ in. (246 mm)
Both sides show prints of George Washington (see cat. nos. 5, 69). SRT 64.10

33. Bowl, creamware printed in black, Staffordshire or Liverpool, 1798–1810. Diam 11 in. (278 mm), H 4¾ in. (121 mm)
Interior: portrait of George Washington; exterior: prints including portrait "JOHN ADAMS, President of the United States of America" and two portraits of George Washington (see cat. nos. 5, 7, 9, 13). SRT 64.13

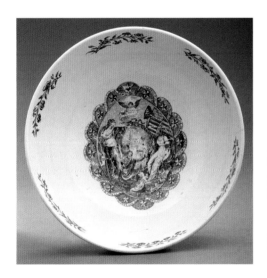
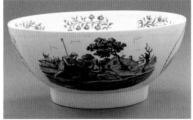
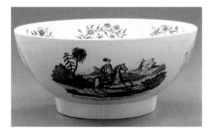
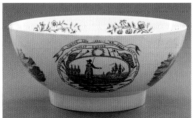
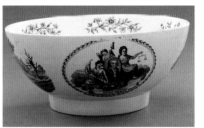

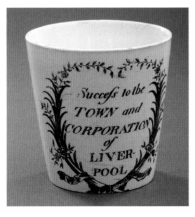
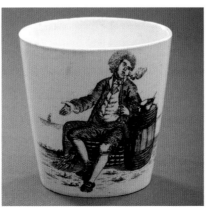

34. Beaker, creamware printed in black, Liverpool, 1790–1800. H 3⁵⁄₁₆ in. (85 mm)
On one side: printed inscription "Success to the TOWN and CORPORATION of/LIVER-POOL"; on the other side: seated man smoking a pipe. SRT 65.1

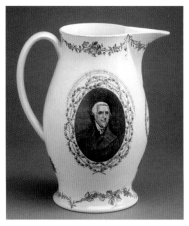 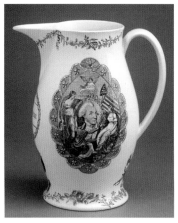 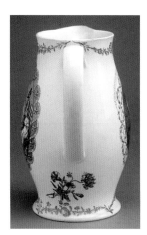 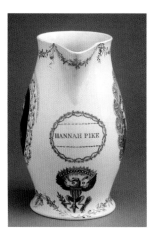

35. Jug, creamware printed in black, Staffordshire or Liverpool, 1801–10. H 10⅛ in. (257 mm)
On one side: portrait of Thomas Jefferson in a chain of states and inscribed THOMAS JEFFERSON, PRESIDENT OF THE UNITED STATES OF AMERICA"; on the other side: commemorative portrait of Washington; beneath spout: painted "HANNAH PIKE" and printed adaptation of the Great Seal of the United States; see cat. no. 69; companion to App. 22. SRT 65.3

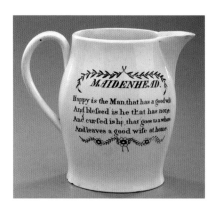 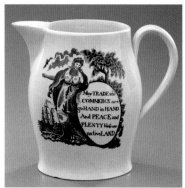

36. Jug, creamware printed in black, probably Liverpool, ca. 1800. H 5 in. (127 mm)
On one side: poem "Maidenhead"; on the other side: allegorical figure of Commerce. SRT 65.4

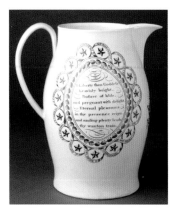 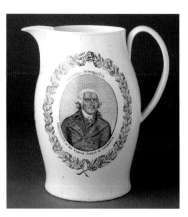

37. Jug, creamware printed in black, Staffordshire, probably printed by F. Morris, Shelton, 1801–9. H 9 in. (229 mm)
On one side: portrait "THOMAS JEFFERSON" and "PRESIDENT of the United States of AMERICA"; on the other side: poem beginning "O Liberty thou Goddess!"; beneath spout: stock print of three-masted ship flying the American flag; see cat. no. 17. SRT 65.5

38. Jug, creamware painted in enamels, Staffordshire or Liverpool, probably painted in Liverpool, 1790–1805. H 9⅛ in. (232 mm)
One of two presentation jugs (see cat. no. 21 for full description); this example painted beneath the spout with "THE GIFT OF JAMES PATTERSON."
SRT 66.2

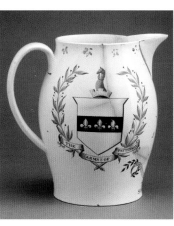 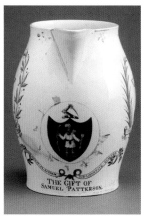 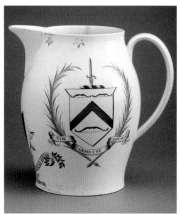

 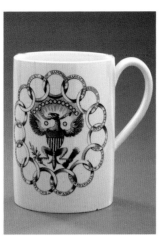

39. Mug, creamware printed in black, probably Herculaneum Pottery, Liverpool, 1796–1800. H 6⅛ in. (156 mm) On one side: adaptation of the Great Seal of the United States; on the other side: allegories of Liberty, Peace, and Plenty; both prints within a chain of states. SRT 66.3

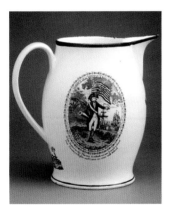 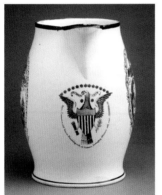

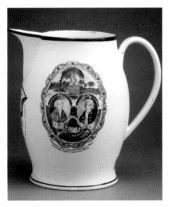 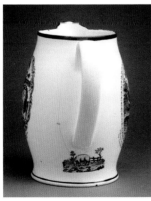

42. Jug, creamware printed in black, painted in enamels, Staffordshire, probably printed by F. Morris, Shelton, 1801–10. H 11¼ in. (286 mm) On one side: print "The Memory of WASHINGTON and the Proscribed PATRIOTS of AMERICA"; on the other side: "Success to AMERICA whose MILITIA is better than Standing ARMIES"; beneath spout: adaptation of the Great Seal of the United States with inscription "Peace, Commerce, and honest Friendship, with all Nations. Entangling Alliances with none. JEFFERSON"; see cat. nos. 17, 34. SRT 67.1

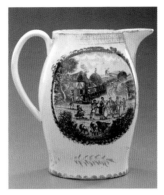 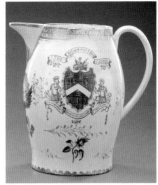

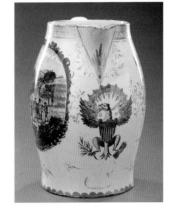

40. Jug, creamware printed in black, gilding, probably Herculaneum Pottery, Liverpool, England, 1796–1810. H 10 in. (255 mm) On one side: print "THE BLACKSMITH'S ARMS"; on the other side: village harvest scene; beneath spout: adaptation of the Great Seal of the United States, traces of gilded initials. SRT 66.5

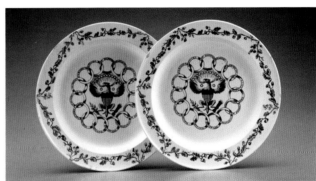

41. Two plates, creamware printed in black, probably Herculaneum Pottery, Liverpool, 1796–1807. Diam 9⅞ in. (251 mm) Rim: garlands of oak leaves and acorns; center: adaptation of the Great Seal of the United States within a chain of states. SRT 66.6 & 67.4

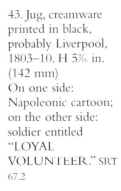 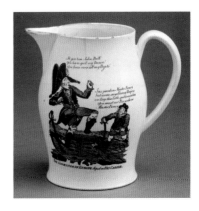

43. Jug, creamware printed in black, probably Liverpool, 1803–10. H 5⁵⁄₁₆ in. (142 mm) On one side: Napoleonic cartoon; on the other side: soldier entitled "LOYAL VOLUNTEER." SRT 67.2

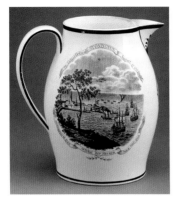
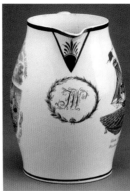
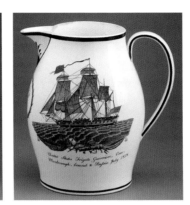

44. Jug, creamware printed in black, painted in enamels, probably Herculaneum Pottery, Liverpool, 1818–25.
H 8⅞ in. (225 mm)
On one side: print "The Gallant Defence of Stonington. August 9ᵗʰ 1814"; on the other side: scene "United States Frigate Guerriere, Com./ Macdonough, bound to Russia July 1818."; below spout: painted initials "TW." SRT 67.5

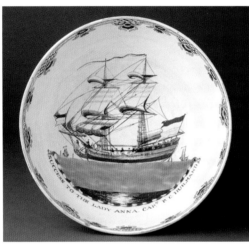
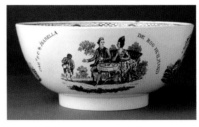
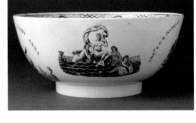
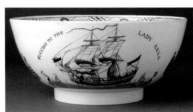
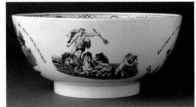

45. Bowl, creamware printed in black, painted with enamels, Liverpool, ca. 1785. Diam 10⅝ in. (270 mm), H 4½ in. (114 mm)
Interior: painted portrait of ship flying the Dutch flag "SUCCESS TO THE LADY ANNA, CAPT. P.C. HUILMAND"; exterior: similar painted portrait "SUCCESS TO THE LADY ANNA" and printed tea party scene with inscription "CAPT P.C. & JSABELLA DE ROO HUILMAND." SRT 67.6

46. Jug, creamware printed in black, painted in enamels, inscribed "F. Morris" for printer Francis Morris, Shelton, Staffordshire, 1795–1810.
H 8¼ in. (210 mm)
On one side: portrait of Washington and inscription beginning "Deafness to the Ear that will patiently hear"; on the other side: stock print of American ship; beneath spout: adaptation of the Great Seal of the United States; see cat. no. 9. SRT 68.1

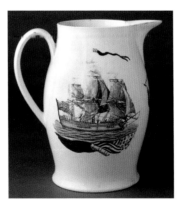
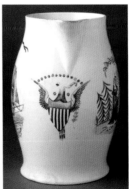
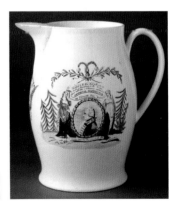

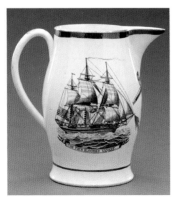
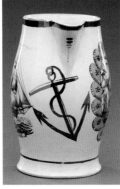
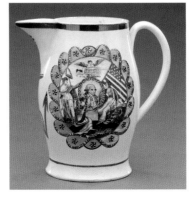

47. Jug, creamware printed in black, Staffordshire, 1815–20.
H 8¼ in. (210 mm)
On one side: stock print of three-masted ship flying the American flag "THE TRUE BLOODED YANKEE."; on the other side: Washington memorial; beneath spout: anchor painted in pink lustre; see cat. nos. 32, 69. SRT 68.3

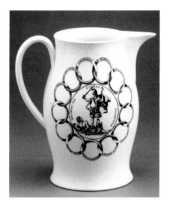
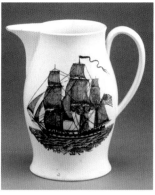
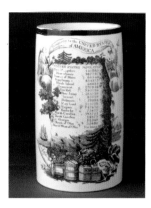
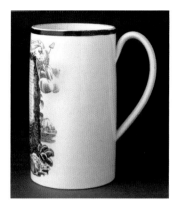

48. Jug, creamware printed in black, painted in enamels, Staffordshire or Liverpool, 1795–1810. H 7¼ in. (184 mm)
On one side: seal of the Commonwealth of Virginia; on the other side: stock print of an American ship. SRT 68.4

49. Mug, creamware printed in black, probably Staffordshire, 1790–95. H 6⅛ in. (156 mm)
Print titled "Prosperity to the UNITED STATES OF AMERICA" and inscribed with the 1790 census; see cat. no. 18. SRT 69.1

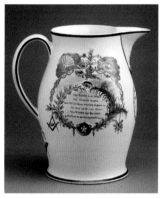
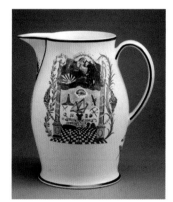
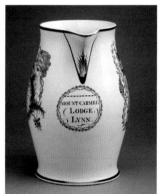
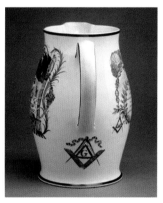

50. Jug, creamware printed in black, probably Herculaneum Pottery, Liverpool, 1807. H 10⅝ in. (270 mm)
On one side: Masonic print; on the other side: Masonic poem; beneath spout: painted inscription "MOUNT CARMEL LODGE, LYNN."; beneath handle: Masonic symbols; On April 29, 1807, Brother T. Atwell received thanks from the Lodge "for the pair of very elegant Pitchers, which he this evening presented to us." SRT 70.1

51. Jug, creamware printed in black, painted in enamels, probably Staffordshire, ca. 1930. H 9¼ in. (235 mm)
On one side: three-masted ship flying the American flag with painted inscription "SHIP CAROLINE"; on the other side: "The Shipwright's Arms"; beneath spout: adaptation of the Great Seal of the United States and the painted name "JAMES LEECH"; similar examples commissioned for sale by Hill-Ouston of Birmingham, England in 1930. SRT 70.2

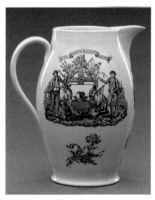
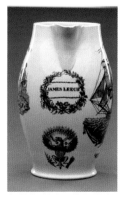
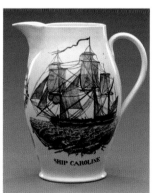

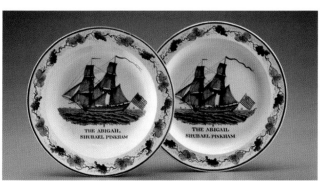

52. Two plates, creamware printed in black, painted in enamels, probably Staffordshire, ca. 1796. Diam 10 in. (254 mm)
Rim: painted floral border; center: stock print of brigantine flying the American flag and a pennant; beneath: painted inscription "THE ABIGAIL SHUBAEL PINKHAM"; the *Abigail* was built in Hanover, Mass. in 1790; Pinkham was master 1795–97; the ship sailed to Liverpool in 1796, returning with 115 crates of earthenware. SRT 71.2 & 98.3

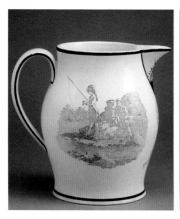 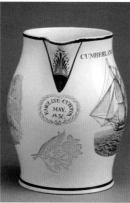 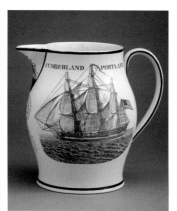

53. Jug, pearlware printed in green, painted in enamels, probably Herculaneum Pottery, Liverpool, 1830. H 9½ in. (241 mm)
On one side: stock print of three-masted ship "CUMBERLAND of PORTLAND"; on the other side: pastoral riverscape; beneath spout: "EMELINE-CURTIS MAY 1830"; the ship was built in Cumberland, Maine, in 1793 and sank off Cape Cod in 1843. SRT 71.3

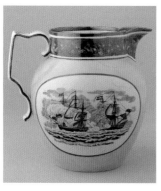 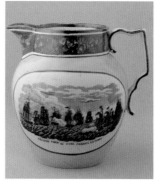

54. Jug, creamware printed in black, enamel ground and lustre rim, printed by Bentley Wear & Bourne, Shelton, Staffordshire, 1815–20. H 8 in. (203 mm)
On one side: scene titled "The CONSTITUTION in close action with the GUERRIERE"; on the other side: scene titled "SECOND VIEW OF COM. PERRY'S VICTORY"; both prints with "Bentley Wear & Bourne Engravers & Printers, Shelton, Staffordshire"; see cat. no. 29. SRT 72.4

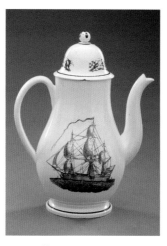 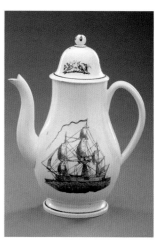

55. Coffeepot, creamware printed in black, painted in enamels, base impressed "Wedgwood & Co.," Staffordshire, probably 1875–90. Diam 5 in. (127 mm), H 9⅝ in. (244 mm)
Printed and painted on both sides with stock prints of three-masted ships flying the American flag; cover printed with birds; prints match those on App. 9 and 56; the impressed mark was used by the Wedgwood Unicorn & Pinnox Works, Tunstall, from 1860. SRT 73.1

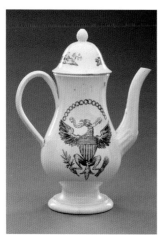 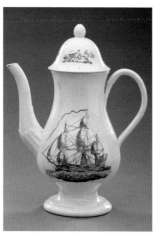

56. Coffeepot, creamware printed in black, Staffordshire, probably 1875–90. Diam 4¾ in. (121 mm), H 9⅞ in. (251 mm)
On one side: stock prints of three-masted ships flying the American flag; on the other side: adaptation of the Great Seal of the United States; cover: prints of birds; the prints of the ship and birds match those on App. 9 and 55. SRT 73.2

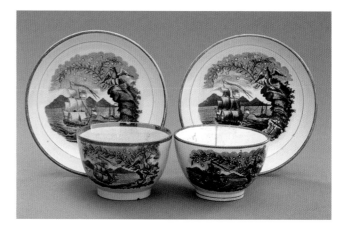

57. Two cup and saucers, pearlware printed in black, Staffordshire, 1820–30. Diam (cup) 3½ in. (89 mm), H (cup) 2¼ in. (57 mm), Diam (saucer) 5⅜ in. (137mm)
Thought to depict the steamboat *Clermont* and three-masted ship *Cadmus*. SRT 73.3 & 73.4

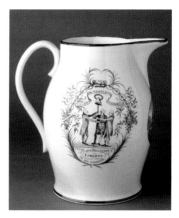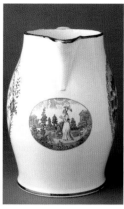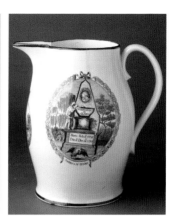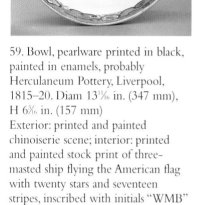

58. Jug, creamware printed in black, Staffordshire, 1800–1810. H 10⅝ in. (270 mm)
On one side: three men, probably Washington, Adams, and Jefferson, stand in a circle and hold a staff with liberty cap, inscribed "UNION to the PEOPLE of AMERICA"; below, "CIVIL and RELIGIOUS/ LIBERTY/ TO ALL MANKIND"; on the other side: memorial to George Washington "WASHINGTON/ IN/ GLORY" and "AMERICA IN TEARS." SRT 74.1

59. Bowl, pearlware printed in black, painted in enamels, probably Herculaneum Pottery, Liverpool, 1815–20. Diam 13¹¹⁄₁₆ in. (347 mm), H 6³⁄₁₆ in. (157 mm)
Exterior: printed and painted chinoiserie scene; interior: printed and painted stock print of three-masted ship flying the American flag with twenty stars and seventeen stripes, inscribed with initials "WMB" and "SHIP FRANKLIN." SRT 75.1

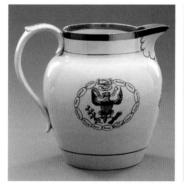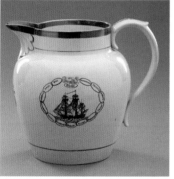

60. Jug, drabware printed in purple, Staffordshire, 1816–20. H 8 in. (203 mm)
Each side with an adaptation of the Great Seal of the United States surrounded by a chain of oval links, each containing the name of a War of 1812 hero. SRT 76.2

61. Jug, creamware printed in black, probably Staffordshire, 1810–20. H 10⅝ in. (270 mm)
On one side: portrait titled "WASHINGTON"; on the other side: adaptation of the Great Seal of the United States; beneath spout: painted initials "TEF" framed in silver lustre heart; see App. 144 with same portrait, entitled "HIS GRACE THE DUKE OF LEINSTER." SRT 76.3

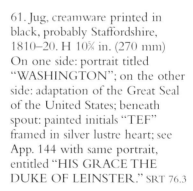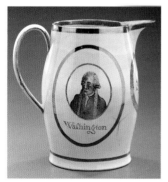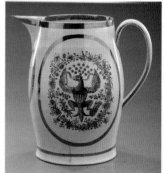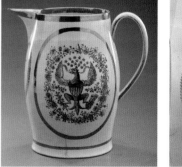

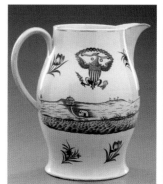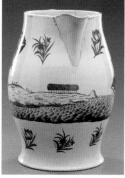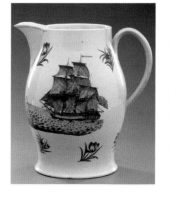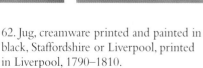

62. Jug, creamware printed and painted in black, Staffordshire or Liverpool, printed in Liverpool, 1790–1810.
H 13 in. (331 mm)
On one side: painted view of coast beneath printed representation of the Great Seal of the United States; on the other side: stock print of three-masted ship flying an American pennant and flag with fifteen stars and fourteen stripes. SRT 76.4

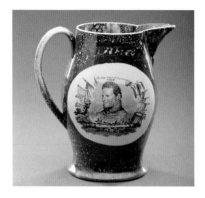
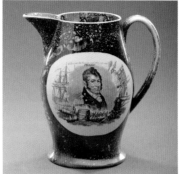

63. Jug, pearlware printed in black, Staffordshire, 1815–20. H 7¹⁵⁄₁₆ in. (202 mm)
On one side: print inscribed "We have met the Enemy and they are ours!/PERRY" (for Oliver Hazard Perry); on the other side: print inscribed "Be always ready to die for your country/PIKE" (for Zebulon Pike); portraits of War of 1812 heroes Perry and Pike from the *Analectic Magazine* (1813/1814). SRT 76.5

64. Teapot, creamware printed in black, impressed "WEDGWOOD & CO." for Ralph Wedgwood, Burslem, Staffordshire, and Ferrybridge, Yorkshire, 1780–1800. H 6¼ in. (159 mm)
Prints and inscriptions including "KEEP WITHIN COMPASS AND YOU SHALL BE SHURE, TO AVOID MANY TROUBLES WHICH OTHERS ENDURE"; "THE END OF THE/UPRIGHT MAN/IS PEACE"; and "THE/VIRTUOUS WOMAN/IS A CROWN TO HER/HUSBAND." SRT 76.6

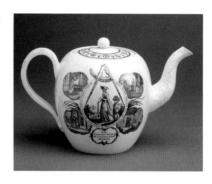
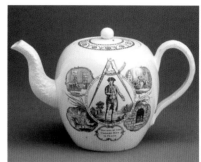

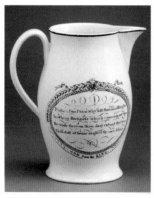
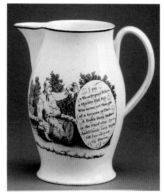
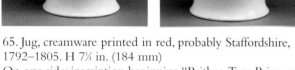

65. Jug, creamware printed in red, probably Staffordshire, 1792–1805. H 7¼ in. (184 mm)
On one side: inscription beginning "Prithee, Tom Paine, why wilt thou meddling be In others Business which concerns not thee" and "GOD Save the KING"; on the other side: man astride barrel labeled "Old Stingo"; poem beginning "I am/a Hearty good fellow/a thirsty Old Sot." SRT 77.1

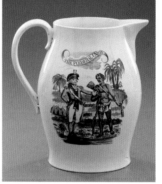
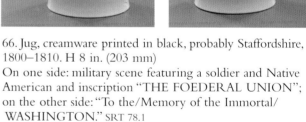

66. Jug, creamware printed in black, probably Staffordshire, 1800–1810. H 8 in. (203 mm)
On one side: military scene featuring a soldier and Native American and inscription "THE FOEDERAL UNION"; on the other side: "To the/Memory of the Immortal/WASHINGTON." SRT 78.1

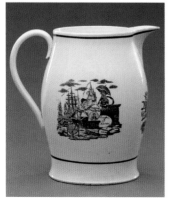
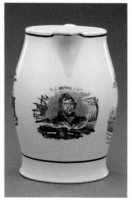
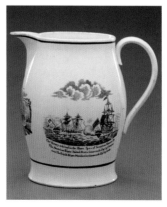

67. Jug, creamware printed in red, probably Staffordshire, 1815–20. H 9 in. (229 mm)
On one side: marine battle inscribed "the Victory achieved in the Short Space of Seventeen Minutes by the American Frigate United States Commanded by Cap Decatur/over the British Frigate Macidonian Commanded by Cap Carder."; on the other side: allegorical scene celebrating "VIRTUE/&/INDUSTRY" and the relationship between "Europe/&/America"; beneath spout: portrait "Major Genl BROWN Niagara" taken from the *Analectic Magazine* (April 1815). SRT 78.3

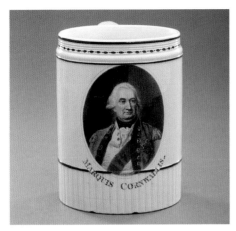

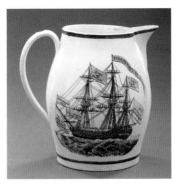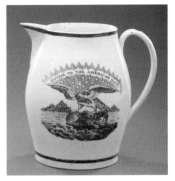

69. Jug, creamware printed in red, probably Staffordshire, 1810–20. H 7¾ in. (187 mm)
On one side: American eagle perched on recumbent British lion and inscribed "SUCCESS TO THE AMERICAN NAVY!"; on the other side: three-masted man-of-war *Columbia* and inscription "We will not give up the Ship"; flags inscribed with patriotic slogans including "Democracy! Conscription Embargo. War!", "Peace, Religion Prosperity!", and "The NAVY and Free Trade." SRT 79.2

68. Mug, pearlware printed in black, impressed on the base "HERCULANEUM 9" for Herculaneum Pottery, Liverpool, ca. 1800. H 5¹³⁄₁₆ in. (148 mm)
Print of General Charles Cornwallis entitled MARQUIS CORNWALLIS." SRT 78.4

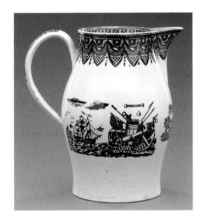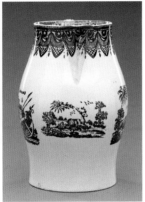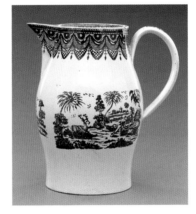

70. Jug, pearlware printed in greenish-black, Staffordshire, Yorkshire, or Northeast England, 1800–1820. H 9⅜ in. (238 mm)
On one side: Indian Princess and stag in a landscape; on the other side: three-masted ship and naval accoutrements. SRT 79.3

71. Jug, creamware printed in black, Staffordshire or Liverpool, 1817–25. H 8¾ in. (225 mm)
On one side: stock print portrait "JAMES MONROE President of the United States of America." (see App. 74 for similar print of man labeled "I. BAKER") ; on the other side: battle between British and American ships "The MACEDONIAN & the UNITED STATES"; beneath spout: adaptation of the Great Seal of the United States. SRT 79.4

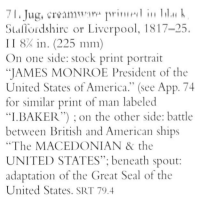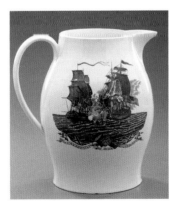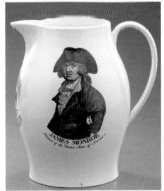

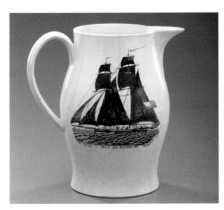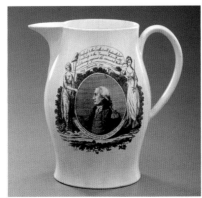

72. Jug, creamware printed in black, probably Liverpool, 1795–1805. H 9⅜ in. (238 mm)
On one side: portrait of Washington and inscription beginning "Deafness to the Ear, that will patiently hear" (see cat. no. 9); on the other side: two-masted ship flying the American flag and ribbon inscribed "[COMM] ERCE TRADE and PEACE ALL NATIONS JOYS INCREASE." SRT 80.2

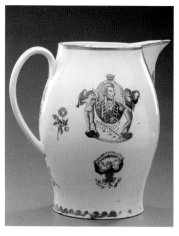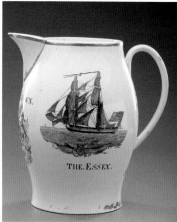

73. Jug, creamware printed in black, painted in enamels, gilding, probably Herculaneum Pottery, Liverpool, 1799–1805.
H 13¼ in. (335 mm)
On one side: stock print of brig with gun ports, flying the American flag with sixteen stars and fifteen stripes entitled "THE ESSEX"; on the other side: portrait of Horatio Nelson "ADMIRAL LORD NELSON"; above is a plan of the "BATTLE of the NILE" and an adaptation of the Great Seal of the United States; beneath spout: painted inscription "S E Brown" and print of the Cooper's Arms; see cat. no. 59. SRT 80.5

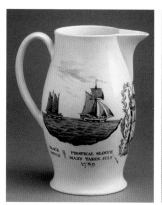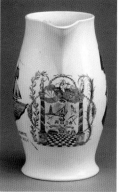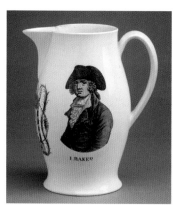

74. Jug, creamware printed in black, painted in enamels, probably Liverpool, ca. 1789. H 9½ in. (241 mm) On one side: seascape painted with two-masted vessel flying the American flag on the left; larger sloop on the right entitled "BLACK/ PATCH" and "PIRATICAL SLOOPE MARY TAKEN JULY 1789"; on the other side: stock print portrait "I.BAKER" (see App. 71 for similar print); beneath spout: printed Masonic imagery; see cat. nos. 25, 26. SRT 80.6

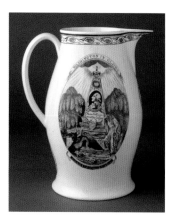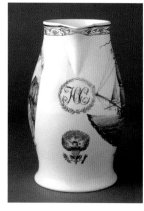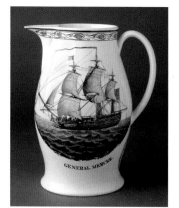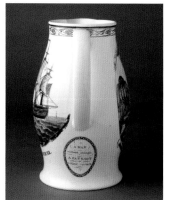

75. Jug, creamware printed in black, painted in enamels, probably Herculaneum Pottery, Liverpool, 1800–1807.
H 10‰ in. (268 mm)
On one side: painted ship portrait "GENERAL MERCER"; on the other side: memorial inscribed "WASHINGTON IN GLORY./AMERICA IN TEARS" (see cat. no. 8); beneath spout: painted "HC" above printed adaptation of the Great Seal of the United States; beneath handle: cartouche inscribed "A MAN without example A PATRIOT without reproach"; the *General Mercer* was a three-masted ship built in 1799 in Hudson, N.Y.; sailed primarily to Liverpool; Alexander Coffin was owner and master 1799–1801; "HC" was probably a relative. SRT 80.7

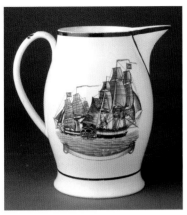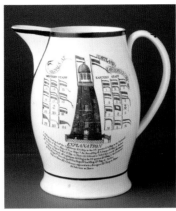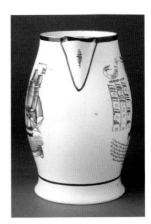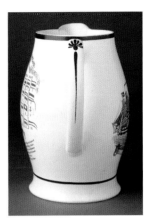

76. Jug, creamware printed in black, painted in enamels, probably Staffordshire, ca. 1807. H 9¼ in. (235 mm)
On one side: a view of the Portland Observatory; on the other side: two three-masted ships passing at sea, the larger named "WASHINGTON" and flying the American flag; both vessels fly American pennants and house flags with the letter "W"; see cat. no. 40. SRT 80.8

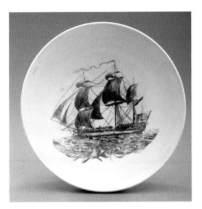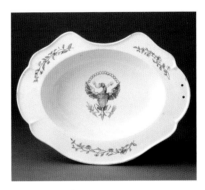

77. Bowl, creamware printed in black, Staffordshire or Liverpool, 1790–1800.
Diam 7 in. (178 mm), H 3 in. (76 mm)
Interior: stock print of British vessel; exterior: naval and other maritime prints and a version of the popular rhyme beginning "When this you see remember me." SRT 81.1

78. Shaving basin, creamware printed in black, probably Staffordshire, 1875–1925. L 11 in. (278 mm), W 8¼ in. (210 mm), H 1⅞ in. (45 mm)
Center: adaptation of the Great Seal of the United States; three floral sprays on the rim. SRT 81.2

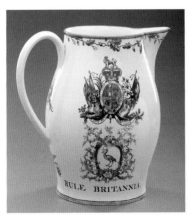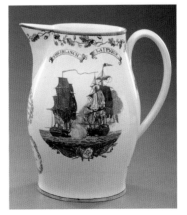

79. Jug, creamware printed in black, probably Herculaneum Pottery, Liverpool, 1798. H 12⅞ in. (327 mm)
On one side: naval battle of 1795 commemorating British ship "THE BLANCH" taking French ship "LA PIQUE" in the West Indies; on the other side: arms of Great Britain above emblem of the City of Liverpool and inscription "RULE BRITANNIA"; beneath spout: "WILLIAM AND SUSANNAH PENDLETON LIVING IN NEW YORK 1798" and a version of the popular rhyme "When this you see remember me." SRT 81.3

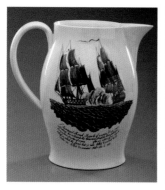 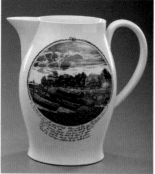

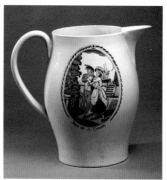 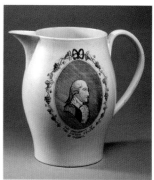

80. Jug, creamware printed in black, probably Staffordshire, ca. 1800. H 10⅝ in. (270 mm)
On one side: French ship *L'Insurgant [sic]* and victorious American ship *Constellation*, February 12, 1799, with full details in inscription beneath; on the other side: logging scene and verse beginning "Our Mountains are cover'd with imperial Oak, Whose roots like our liberties ages have nourish'd" and ending "For neer shall the Sons of Columbia be slaves; While the Earth bears a plant or the Sea rolls its waves"; see cat. no. 26 for similar subject. SRT 81.4

81. Jug, creamware printed in black, probably Liverpool, 1790–1800. H 9⅜ in. (238 mm)
On one side: portrait of Washington "THE PRESIDENT OF/THE UNITED STATES/OF AMERICA"; on the other side: sailor and lass "JACK ON A CRUISE." SRT 82.1

82. Dessert mold, creamware printed in black, probably Herculaneum Pottery, Liverpool, 1797–1801.
L 7⁷⁄₁₆ in. (191 mm), H 3⅛ in. (79 mm)
Design of the Prince of Wales; exterior: printed on both sides with a version of the Great Seal of the United States; inscription "JOHN ADAMS, PRESIDENT" and image of three-story building with inscription "JAMES BRYDEN, FOUNTAIN INN"; that Baltimore inn opened in 1773; Bryden was innkeeper 1795–1808. SRT 82.2

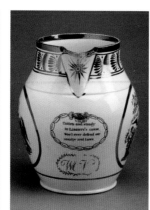 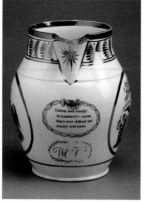 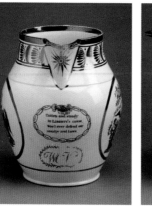

83. Jug, pearlware printed in purple, gilding, Staffordshire, 1815–20. H 9½ in. (241 mm)
On one side: cartouche inscribed "New York PEACE PLENTY and INDEPENDENCE" and banner inscribed "MAY THE TREE OF LIBERTY EVER FLOURISH"; on the other side: cartouche inscribed "SUCCESS to the UNITED STATES of AMERICA"; beneath spout: "United and steady/in LIBERTY'S cause, Wee'l ever defend our country and Laws" and gilded initials "WCV." SRT 82.3

84. Jug, pearlware printed in black, painted in enamels, Staffordshire, 1815–20.
H 6½ in. (165 mm)
Both sides: printed and painted eagle perched on cannon, surrounded by American flag and foliage, with inscriptions "ARMS OF THE UNITED STATES" and "E PLURIBUS UNUM"; beneath spout: "FREE TRADE AND SAILORS RIGHTS"; see cat. no. 70. SRT 82.4

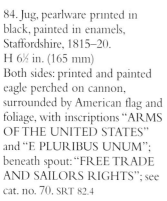 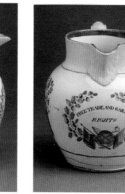 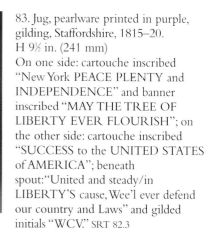

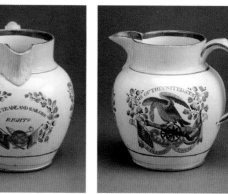

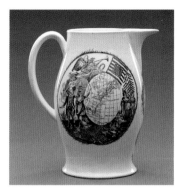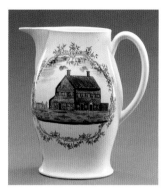

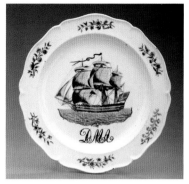

85. Jug, creamware printed in black, painted in enamels, probably Herculaneum Pottery, Liverpool, ca. 1800. H 9⅙ in. (233 mm)
On one side: printed cartouche containing painted two-story brick building; on the other side: map of the east coast of North America (see cat. no. 20); beneath spout: painted "JOSEPH/SMITH"; above is a printed adaptation of the Great Seal of the United States. SRT 82.5

86. Plate, creamware printed in black, painted in enamels, probably Herculaneum Pottery, Liverpool, 1796–98. Diam 10 in. (254 mm)
Center: stock print of three-masted ship flying the American flag and pennant with female figurehead, with initials "DMA" for David and Mercy Alden, painted in black script; see cat. no. 73. SRT 83.3

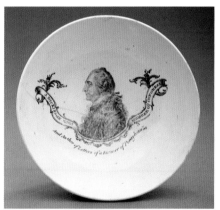

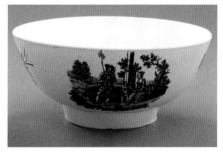

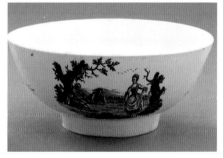

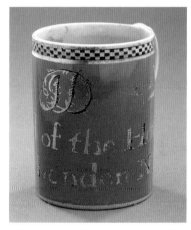

87. Bowl, creamware printed in black, probably Liverpool, 1785–1800.
Diam 7⅙ in. (79 mm), H 3 in. (77 mm)
Interior: printed portrait of William Henry Drayton but inscribed "J. DICKINSON ESQR. MEMBER OF CONGRESS" and "Author of Letters of a Farmer of Pennsylvania"; exterior: stock prints of two pastoral scenes and two floral sprays. SRT 83.4

88. Mug, pearlware with gilt, probably Liverpool, ca. 1795.
H 3¾ in. (98 mm)
Blue slip ground, inscribed in gilt "JD\Landlord of the Hotell New London No. 12." SRT 83.5

89. Jug, creamware printed in black, probably Herculaneum Pottery, Liverpool, 1809–12.
H 7¾ in. (197 mm)
On one side: portrait and poem beginning "Hail Columbia happy land Hail ye patriotic band" and "And Maddison our favorite toast Republicans behold your chief"; on the other side: apotheosis of Washington (see cat. no. 12); beneath spout: adaptation of the Great Seal of the United States. SRT 84.1

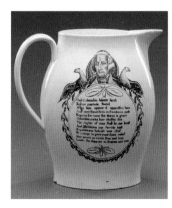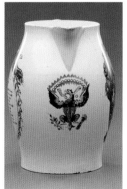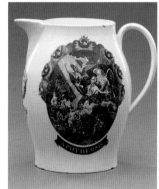

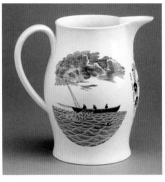 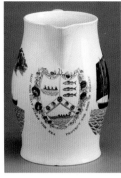 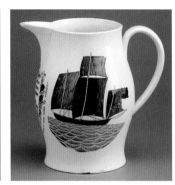

90. Jug, creamware printed in black, painted in enamel, probably Staffordshire, 1790–1820. H 7⅞ in. (200 mm)
On one side: three-masted ship flying British flag; on the other side: single-masted fishing boat; beneath spout: shield depicting fishing boats and fish, inscribed "MAY GOD THAT RULES THE SEA PROTECT THE SONS OF FISHERY." SRT 84.2

91. Jug, creamware printed in black, painted in enamels, probably Herculaneum Pottery, Liverpool, ca. 1800. H 10½ in. (267 mm)
On one side: stock print of three-masted frigate flying the American flag and pennant entitled "BOSTON FRIGATE"; on the other side: map of east coast of North America (see cat. no. 20); beneath spout: painted initials "LW" above printed adaptation of the Great Seal of the United States; the *Boston* was a subscription ship built by the citizens of Boston; given to the U.S. Navy in preparation for Quasi-war with France; burned in 1814 as Washington, D.C. fell to the British. SRT 84.3

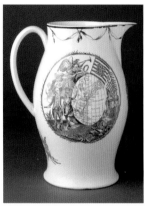 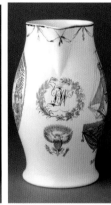 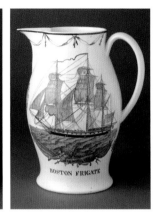

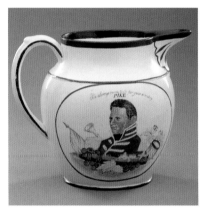 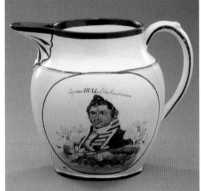

92. Jug, pearlware printed in black, painted in enamels, Staffordshire, 1815–20.
H 5⁷⁄₁₆ in. (138 mm)
On one side: printed and painted portrait of military officer with inscription "Be always ready to die for your country PIKE" (for Zebulon Pike); on the other side: printed and painted portrait of naval officer with inscription "Captain HULL of the Constitution" (for Isaac Hull); portraits from the *Analectic Magazine* (1814/1813); see cat. no. 30. SRT 84.4

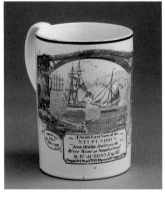 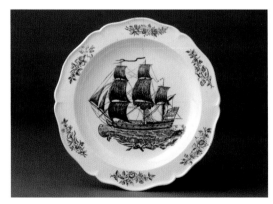

93. Mug, creamware printed in black, probably Sunderland, 1793–1800. H 5 in. (127 mm)
Iron bridge over the Wear River at Sunderland; interior: molded frog. SRT 84.5

94. Plate, creamware printed in black, painted in enamels, probably Herculaneum Pottery, Liverpool, 1796–1800. Diam 5¹¹⁄₁₆ in. (170 mm)
Rim: floral sprays; center: stock print of three-masted ship flying the American flag with fifteen stars and stripes. SRT 85.1

95. Jug, creamware printed in black, painted in enamels, gilt, probably Herculaneum Pottery, Liverpool, ca. 1800. H 10 in. (255 mm)
On one side: stock print of three-masted ship flying the American flag; on the other side: map of the east coast of North America (see cat. no. 20); beneath spout: inscription "SUCCESS TO THE INFANT NAVY OF AMERICA" above an adaptation of the Great Seal of the United States; see cat. no. 60. SRT 85.3

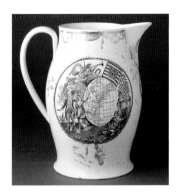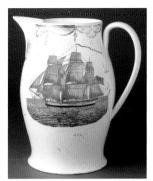

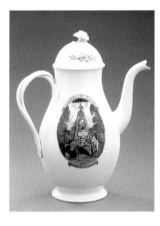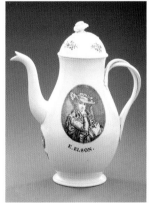

96. Coffeepot, creamware printed in black, impressed "WEDGWOOD" for Josiah Wedgwood, Staffordshire or Ralph Wedgwood, Ferrybridge, Yorkshire, 1800–1810. Diam 6½ in. (165 mm), H 12⁵⁄₁₆ in. (314 mm)
On one side: memorial to George Washington inscribed "WASHINGTON IN GLORY. AMERICA IN TEARS" (see

cat. no. 8); on the other side: printed portrait of young woman with painted inscription "E.ELSON"; beneath spout: adaptation of the Great Seal of the United States. SRT 85.4

97. Jug, creamware painted in enamels, probably Staffordshire, 1810–25.
H 9⁵⁄₁₆ in. (233 mm)
Both sides: painted scenes depicting a disaster at sea; beneath spout: painted initials "EEC"; see cat. no. 57.
SRT 85.5

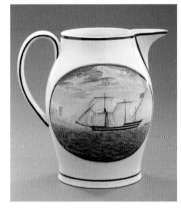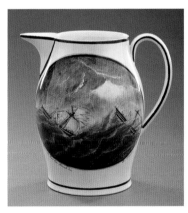

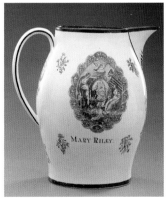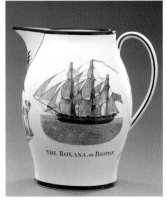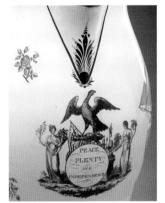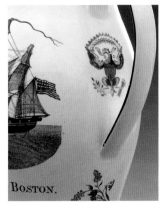

98. Jug, creamware printed in black, painted in enamels, probably Herculaneum Pottery, Liverpool, 1806–24. H 12¾ in. (324 mm)
On one side: stock print of three-masted ship flying an American pennant and flag with sixteen stars and fifteen stripes inscribed "THE ROXANA, OF BOSTON"; on the other side: memorial to George Washington and inscription "MARY RILEY."; beneath spout: "PEACE PLENTY and INDEPENDENCE"; beneath handle: adaptation of the Great Seal of the United States; two ships of this name sailed out of Boston, one from 1806–24, the other from 1812–24. SRT 85.6

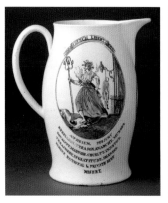

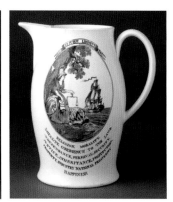

99. Jug, creamware printed in black, painted in enamels, probably Staffordshire, 1793–1800. H 7¼ in. (184 mm) On one side: print and inscriptions depicting "BRITISH LBERTY"; on the other side: print and inscriptions depicting "FRENCH LBERTY"; beneath spout: "WHICH IS THE BEST." After "The Contest," by Rowlandson after Lord George Murray, January 1, 1793. SRT 86.1

100. Jug, creamware printed in black, painted in enamel, Staffordshire, 1800–1810. H 8 in. (203 mm) On one side: print titled "HIBERNIA" with design and inscriptions celebrating the commerce of Ireland; on the other side: stock print of three-masted ship flying the American flag and inscribed "SUCCESS TO TRADE" with two bundles, one inscribed "WB/ TX/ No 4/ For America."; beneath spout: allegorical depiction of "HOPE"; see cat. no. 34. SRT 86.2

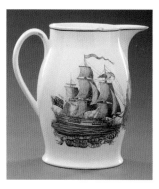

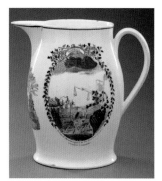

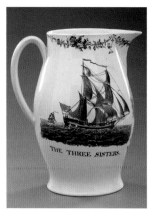
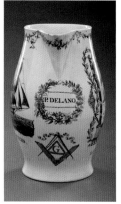
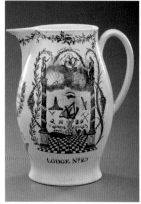

101. Jug, creamware printed in black, painted in enamels, probably Liverpool, possibly Staffordshire, 1797–1800. H 9½ in. (241 mm) On one side: stock print of ship flying the American pennant and flag with fifteen stars and fourteen stripes with inscription "THE THREE SISTERS"; on the other side: Masonic chart and "LODGE #25"; beneath spout: Masonic symbol and the name "P. DELANO"; see cat. no 25; in 1796–97 Peleg Delano was captain of the *Three Sisters*, which wrecked off Cape Cod; this jug is one of several supposedly made to commemorate the rescue of the crew. SRT 86.4

102. Jug, creamware printed in black, painted in enamels, probably Herculaneum Pottery, Liverpool, 1815–20. H 10⅞ in. (276 mm) On one side: stock print of three-masted frigate flying the American flag and pennant with painted inscription "FRANKLIN"; on the other side: stock print of three-masted frigate flying the American flag and pennant with painted inscription "INDEPENDENCE"; beneath spout: adaptation of the Great Seal of the United States and an Irish harp printed above painted name "MARY SINET"; the ships were built in 1814 and 1815 for the U.S. Navy. SRT 86.5

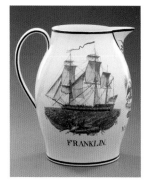
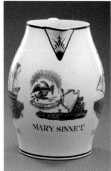
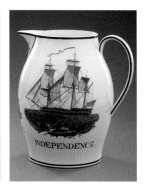

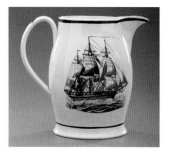
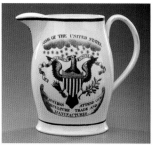

103. Jug, creamware printed in black, Staffordshire, 1815–20. H 7¾ in. (197 mm) On one side: adaptation of the Great Seal of the United States entitled "ARMS OF THE UNITED STATES" and banner inscribed "MAY SUCCESS ATTEND OUR/ AGRICULTURE TRADE AND/ MANUFACTURERS"; on the other side: stock print of three-masted ship flying the American flag; see cat. no. 32. SRT 86.6

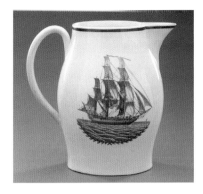 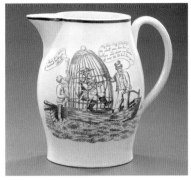

104. Jug, creamware printed in red, Staffordshire or Liverpool, ca. 1815. H 8 in. (203 mm)
On one side: satirical print depicting British triumph at the defeat of Napoleon with inscriptions including "A Present from Waterloo by Marshalls Wellington Blucher"; on the other side: stock print of three-masted ship flying the American flag and pennant. SRT 87.2

105. Jug, creamware printed in black, painted in enamels, probably Herculaneum Pottery, Liverpool, ca. 1800. H 8½ in. (216 mm)
On one side: portrait of clergyman; on the other side: stock print of three-masted ship flying the American flag with fifteen stars and sixteen stripes and an American pennant entitled "BETSEY"; beneath spout: painted inscription "A PRESENT FROM A FRIEND TO THE REVD. ANDREW ELIOT" and printed adaptation of the Great Seal of the United States; Eliot was a Boston minister active in the early temperance movement. SRT 87.3

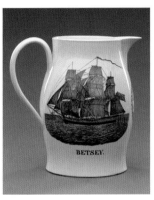 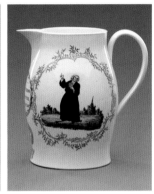

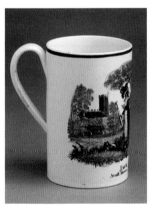 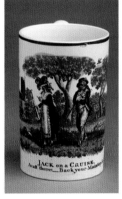 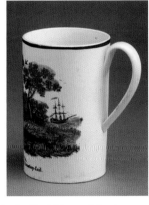

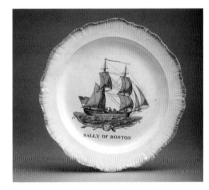

106. Mug, creamware printed in black, painted in enamels, Staffordshire or Northeast England, ca. 1800. H 5¼ in. (133 mm)
Sailor following a woman, inscribed "JACK on a CRUISE. Avast there!- Back your Maintop-sail." SRT 88.1

107. Plate, pearlware printed in black, painted in enamels, probably Staffordshire, ca. 1800. Diam 9⅜ in. (238 mm)
Center: stock print of brig flying the American flag with thirteen stars and stripes and painted inscription "SALLY OF BOSTON." SRT 88.2

108. Jug, creamware printed in black, probably Staffordshire, ca. 1800. H 7⁷⁄₁₀ in. (189 mm)
On one side: print "PEACE PLENTY AND INDEPENDENCE" including adaptation of the Great Seal of the United States; on the other side: two frigates, one with the British flag, in close combat. SRT 88.3

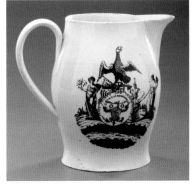 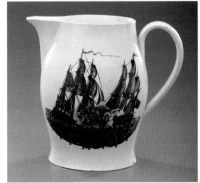

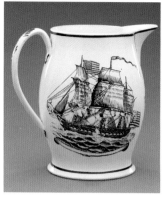

109. Jug, creamware printed in black, probably Herculaneum Pottery, Liverpool, 1796–1810. H 7¹⁵⁄₁₆ in.(202 mm)
On one side: printed scene inscribed with rhyme "JACK SPRITSAIL COMING ON SHORE"; on the other side: stock print of three-masted ship flying two American flags, one with twenty-six stars and thirteen stripes and the other with seventeen stars and thirteen stripes, and an American pennant; beneath spout: stock print of three-masted ship inscribed "SUCCESS TO THE WOODEN WALLS OF OLD ENGLAND." SRT 88.4

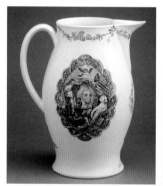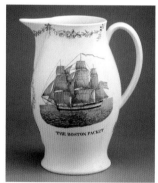

110. Jug, creamware printed in black, painted in enamels, probably Herculaneum Pottery, Liverpool, ca. 1800.
H 11½ in. (292 mm)
On one side: printed and painted stock print of three-masted ship flying the American flag and pennant with inscription "THE BOSTON PACKET"; on the other side: memorial to George Washington (see cat. no. 69); beneath spout: adaptation of the Great Seal of the United States with painted initials "NJF" above. SRT 88.5

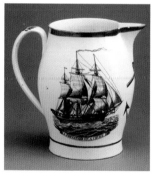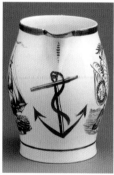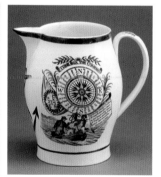

111. Jug, creamware printed in black, Staffordshire, 1815–20. H 7⅜ in. (187 mm)
On one side: stock print of three-masted ship flying the American flag and ribbon inscribed "A PRIVATEER ON A CRUISE"; on the other side: designs relating to a compass rose with inscriptions including "COME BOX THE COMPASS"; beneath spout: anchor painted in pink lustre; see cat. no. 32. SRT 88.6

112. Bowl, creamware printed in black, painted in enamels, probably Liverpool, ca. 1789. Diam 11⅞ in. (301 mm), H 5⅜ in. (137 mm)
Interior: printed and painted stock print of three-masted ship flying American pennant and flag with thirteen stars and stripes and inscription "SUCCESS TO JOSEPH MOUNTFORT 1789"; exterior: maritime views, maritime mythological subject, and sailor prints "JEMMY'S FAREWELL" and "JEMMY'S RETURN"; Mountfort was a sea captain, participant in the Boston Tea Party, and lieutenant in the Revolutionary War. SRT 89.1

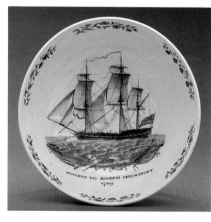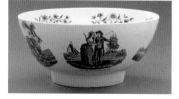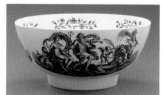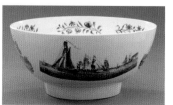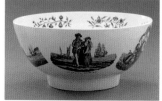

113. Jug, creamware printed in black, painted in enamels, Staffordshire or Liverpool, 1795–97. H 9⅞ in. (251 mm) Both sides: printed and painted crossed military trophies and American and French flags hung with banner inscribed "THE UNION OF THE TWO GREAT REPUBLICS"; a similar jug is reported to be dated 1796. SRT 89.3

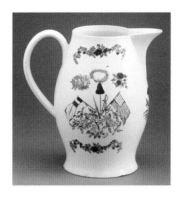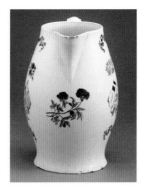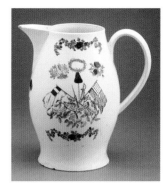

114. Jug, creamware printed in black, probably Herculaneum Pottery, Liverpool, 1796–1810. H 9⅝ in. (244 mm) On one side: portrait of sailor's lass with verse "RETURNING HOPES"; on the other side: sailor taking leave with verses "Song of JEMMY'S FAREWELL Auld Robin Grey"; beneath handle: inscription "Jno. & POLLY/ ROONEY." "RETURNING HOPE" appears on a plate impressed "HERCULANEUM." SRT 90.2

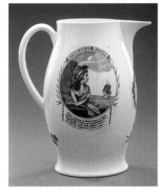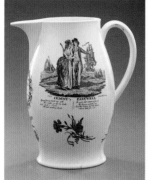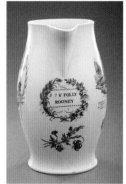

115. Bowl, creamware printed in black, painted in enamels, probably Herculaneum Pottery, Liverpool, ca. 1800. Diam 10¾ in. (273 mm), H 4 %6 in. (116 mm) Interior: three-masted ship flying American flag with fifteen stars and stripes and painted inscription "PIGOU"; exterior: prints depicting George Washington (see cat. nos. 5, 7), portrait of "BENJn. FRANKLIN L.L.D. F.R.S." in his fur cap, and an adaptation of the Great Seal of the United States; the *Pigou*, a three-masted ship built in 1789, sailed out of Philadelphia, was active in the China Trade, and was seized by the French in 1794 and 1798 and by the British in 1810. SRT 90.3

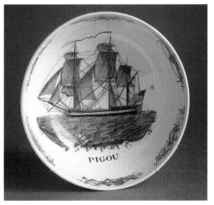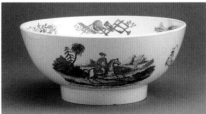

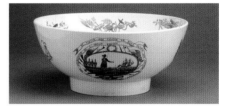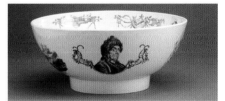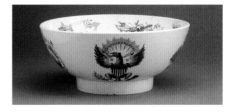

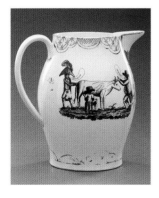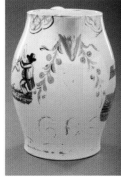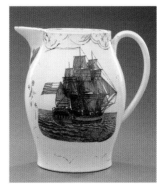

116. Jug, creamware printed in black, gilding, probably Herculaneum Pottery, Liverpool, 1807–9. H 8 in. (203 mm) On one side: version of cartoon known as "A Picturesque View of the Nation" (see cat. no. 4); the cow (Commerce) is milked by "Jefferson" while "Bunoparto" and "John Bull" pull at either end; on the other side: stock print of three-masted ship flying American flag with fifteen stars and sixteen stripes and pennant. SRT 91.2

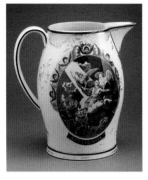
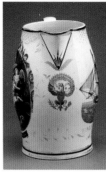
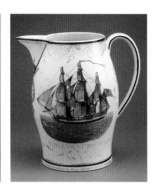

117. Jug, creamware printed in black, painted in enamels, gilt, probably Herculaneum Pottery, Liverpool, ca. 1794. H 10¹³⁄₁₆ in. (275 mm)
On one side: memorial to George Washington "APOTHEOSIS" (see cat. nos. 12, 50); on the other side: printed and painted stock print of three-masted ship flying the American flag and pennant with figurehead of a man in military uniform, inscribed WILLIAMNEWBURYPOR[T]" in gold; beneath spout: adaptation of the Great Seal of the United States and faint traces in gold of "William Pickett; Pickett was captain of the *William* in 1794 when she sailed to St. Petersburg, Russia, returning with a cargo of hemp. SRT 91.3

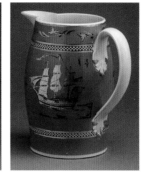

118. Jug, pearlware painted in black, gilded, Liverpool, 1796. H 8¹⁄₁₆ in. (229 mm)
Blue slip ground and painted design in black and gold of three-masted ship flying the American flag; beneath spout: painted inscription "Ebenezer B. Ward Salem, N.E. 1796" for Ebenezer Butler Ward, who became a member of the Marine Society at Salem, September 27, 1792 and died July 12, 1805 in Salem, age forty-six. SRT 91.4

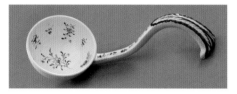

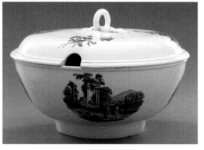
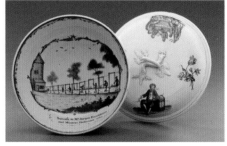

119. Covered punch bowl and ladle, creamware printed and painted in black, probably Liverpool, 1785. Diam 11¹¹⁄₁₆ in. (296 mm), H 7¹⁄₁₆ in. (195 mm)
Interior of bowl: painted scene of ropewalk inscribed "Success to Mr. Jergen Barckhoren/ and Misters. Fieliesien 1785"; exterior: landscape scenes; cover: prints of drinking scenes. SRT 91.8

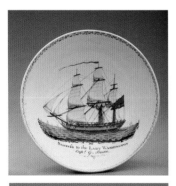

121. Jug, creamware printed in black, Staffordshire, printed by T. Fletcher, Shelton, ca. 1800. H 6¹³⁄₁₆ in. (173 mm)
On one side: central design of three men holding staff of liberty with inscriptions "UNION to the PEOPLE of IRELAND" and "CIVIL and RELIGIOUS LIBERTY TO ALL MANKIND"; on the other side: Irish harp and inscription "TUNED to FREEDOM/ FOR OUR COUNTRY"; beneath spout: man declares "Erin go Bragh" (Ireland Forever). SRT 92.2

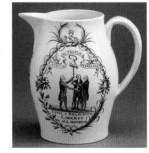

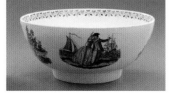
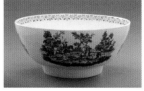

120. Bowl, creamware printed in black, painted in enamels, Liverpool, ca. 1786. Diam 11¾ in. (298 mm), H 5 in. (127 mm)
Interior: three-masted ship flying the American pennant and flag with thirteen stars and fourteen stripes and inscription "Success to the LADY WASHINGTON Capt. G. Burr."; exterior: sailor's farewell and return and farmyard and hunting scenes. SRT 92.1

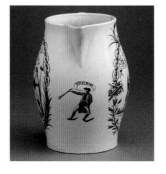
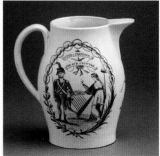

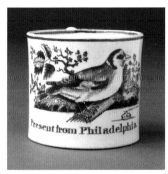

122. Mug, pearlware printed in blue, probably Staffordshire, ca. 1820. H 2⅜ in. (60 mm) Design of bird on a branch and inscribed "Present from Philadelphia." SRT 92.4

123. Bowl, creamware printed in black, overpainted in enamels, probably Herculaneum Pottery, Liverpool, 1796–1800
Diam 9⅞ in. (251 mm), H 4¼ in. (108 mm)
Interior: stock print of three-masted ship flying American flag; six naval and military trophies printed on interior rim; exterior: printed portrait of Washington above scroll inscribed "HIS EXCELLENCY GENERAL WASHINGTON"; below, inscription "Commander in Chief of the Forces of the United States of America/ & President of the Congress"; above image, painted "COLUMBIA'S FAVORITE SON"; above scroll, printed portrait of Franklin "BENJn. FRANKLIN L.L.D. F.R.S"; below scroll, inscription "Born at Boston in New England,17 Jan.1706"; printed cartouche with painted inscription "Health to the Sick;/ Honour to the Brave;/ Success to the Lover;/ and Freedom to the/ Slave"; printed American eagle facing left holding banner inscribed "E PLURIBUS UNUM" with American shield on breast, clasping olive branch in left talon and arrows in right; two stars flanking head and arch of thirteen stars and rays over his head; see cat. nos. 10, 23. SRT 93.1

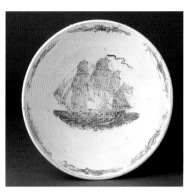

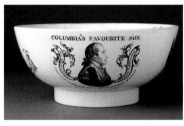

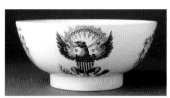

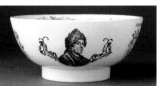

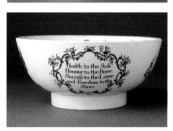

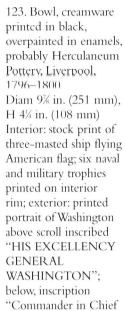

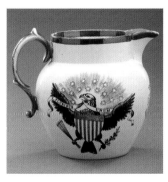

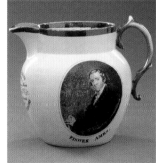

124. Jug, pearlware printed in black with pink lustre, Wood & Caldwells Manufactory, Burslem, Staffordshire, ca. 1810. H 5¼ in. (133 mm)
On one side: oval portrait of seated man above inscription "FISHER AMES" (a Massachusetts businessman); on the other side: adaptation of the Great Seal of the United States, eagle facing left holding ribbon inscribed "E PLURIBUS UNUM." beneath arch of rays and fifteen stars; American shield on its breast, arrows in left talon and olive branch in right; under spout: printed inscription "HENSHAW & JARVES/ Importers of/ Earthen & China Ware/ Boston/ from Wood & Caldwells/ Manufactory/ BURSLEM, STAFFORDSHIRE." SRT 94.1

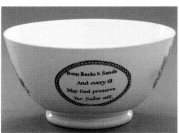

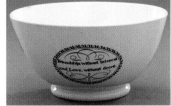

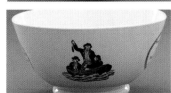

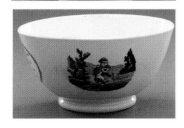

125. Bowl, creamware printed in black, Liverpool or Staffordshire, 1815–20. Diam 7⅛ in. (181 mm), H. 3½ in. (89 mm)
Interior: compass rose with banner inscribed "Come Box the Compass"; exterior: oval medallion and inscription "friendship without Interest./ And Love without deceit"; figure of man fording a stream carrying on his back a woman with basket on her head; oval medallion with inscription "From rocks & Sands/ And every ill/ May God preserve/ the Sailor still"; figure of sailor in rowboat with lead line. SRT 94.2

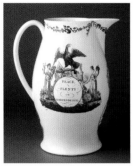 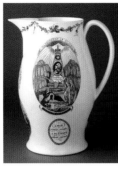 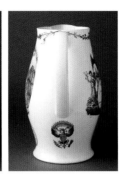 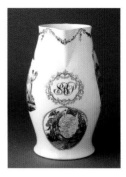

126. Jug, creamware printed in black, probably Herculaneum Pottery, Liverpool, 1800–1810. H 12⅞ in. (327 mm) On one side: memorial to George Washington inscribed "WASHINGTON IN GLORY AMERICA IN TEARS" and "A MAN without example A PATRIOT without reproach" (see cat. no. 8); on the other side: design inscribed "PEACE PLENTY and INDEPENDENCE" (see cat. no. 71); beneath spout: map of the east coast of North America (see cat. no. 60) and painted initials "SRP"; beneath handle: adaptation of the Great Seal of the United States. SRT 94.4

127. Jug, creamware printed in black, painted in enamels, gilding, probably Liverpool, 1794. H 10¹¹⁄₁₆ in. (272 mm) On one side: printed and painted stock print of three-masted frigate flying American flag and pennant and inscription "SUCCESS TO THE FORTITUDE/ OF CHARLESTOWN"; on the other side: pastoral landscape; beneath spout: painted "ER" and "1794"; the *Fortitude* was built in Charlestown, Mass., in 1785. SRT 94.5

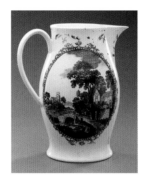 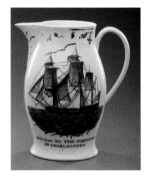

128. Mug, creamware printed in black, Staffordshire or Liverpool, ca. 1800. H 6¹⁄₁₆ in. (54 mm) Banner containing poem written by Adam Treat Paine in 1798, "ADAMS and LIBERTY," beginning "YE sons of Columbia, who bravely have fought." SRT 94.10

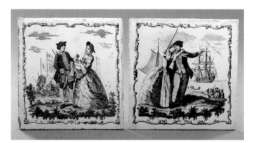

129. Tiles, tin-glazed earthenware printed in black by John Sadler, Liverpool, 1757–61. H 5 in. (127 mm), L 5 in. (127 mm) Design depicting a sailor's farewell and return. SRT 94.6 & 95.1

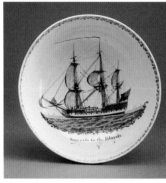

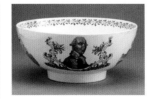 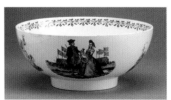 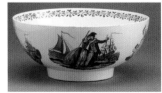

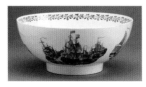

130. Bowl, creamware printed in black, painted in enamels, Liverpool, 1782–88. Diam 9½ in. (241 mm), H 4 in. (102 mm) Interior: painted portrait of three-masted ship with ten guns, flying the British flag and inscription "Success to the Blayds" (a slave ship built in 1782); exterior: naval images including portrait of "SR. G. BRIDGES RODNEY. BT. REAR ADMIRAL OF ENGLAND," sailor's farewell and return, and a naval battle. SRT 95.2

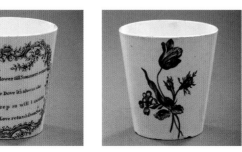 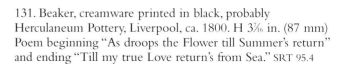

131. Beaker, creamware printed in black, probably Herculaneum Pottery, Liverpool, ca. 1800. H 3⁷⁄₁₆ in. (87 mm) Poem beginning "As droops the Flower till Summer's return" and ending "Till my true Love return's from Sea." SRT 95.4

132. Jug, creamware printed in black, painted in enamels, probably Staffordshire, 1800–1810. H 11 in. (280mm) On one side: print depicting Hope in a seascape with three-masted ship flying two American flags and a pennant; on the other side: printed and painted

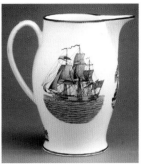 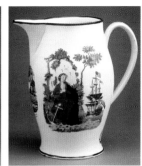

stock print of three-masted ship flying the American flag with fifteen stars and fourteen stripes and a pennant; beneath spout and handle: sailor's farewell and return. SRT 95.6

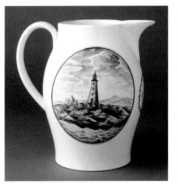 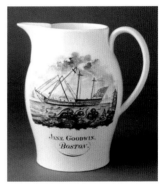

133. Jug, creamware printed in black, painted in enamels, Staffordshire or Liverpool, painted in Liverpool, 1795–1805. H 9 in. (229 mm) On one side: painted portrait of three-masted ship flying the American flag with foremast set into place with inscription "JANE GOODWIN, BOSTON"; on the other side: painted scene of Boston lighthouse; beneath spout: painted initials "CLG"; see cat. no. 38 for the mate. SRT 95.7

134. Jug, creamware, Staffordshire or Liverpool, 1795–1805. H 9 in. (228 mm) Undecorated jug with baluster-shape body and strap handle. SRT 96.1

135. Jug, creamware printed in black, painted in enamels, probably Herculaneum Pottery, Liverpool, ca. 1800. H 11⅝ in. (295 mm) On one side: sailor with quadrant and inscription "We have had a good Observation to day And I hope we shall make the Land To morrow"; on the other side: stock print of

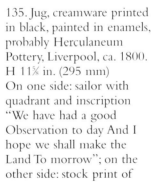 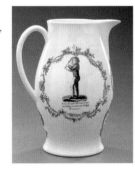 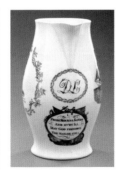 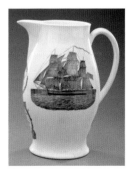

three-masted ship flying the American flag and pennant; beneath spout: painted initials "DL" and inscription "FROM ROCKS & SANDS AND EV'RY ILL, MAY GOD PRESERVE THE SAILOR STILL"; beneath handle: adaptation of the Great Seal of the United States. SRT 96.3

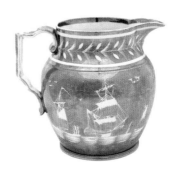 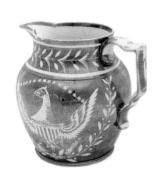

136. Jug, pearlware with silver lustre resist, Staffordshire, ca. 1815. H 9⅞ in. (251 mm) On one side: adaptation of the Great Seal of the United States; on the other side: two merchant vessels on a calm ocean; beneath spout: an anchor. SRT 96.5

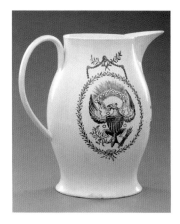
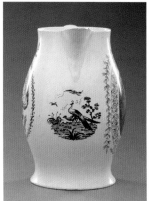
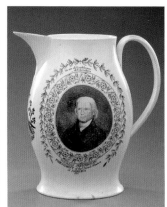

137. Jug, creamware printed in black, Staffordshire or Liverpool, 1801–8. H 10⅙ in. (256 mm) On one side: portrait of Thomas Jefferson and inscriptions "We are all Republicans all Federalists" and "THOMAS JEFFERSON PRESIDENT of the United States of AMERICA 1801"; on the other side: adaptation of the Great Seal of the United States; beneath spout: vignette of a pair of peacocks. SRT 97.1

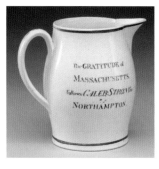
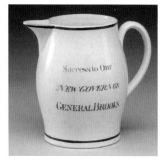
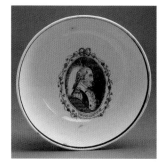
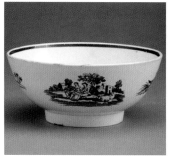

138. Jug, creamware printed in black, probably Staffordshire, ca. 1816. H 5⅜ in. (137 mm)
On one side: "The GRATITUDE of MASSACHUSETTS, Follows CALEB STRONG to NORTHAMPTON"; on the other side: "Success to Our NEW GOVERNOR GENERAL BROOKS." SRT 97.3 (2008.15 Historic Deerfield, bequest of S. Robert Teitelman; photograph by Penny Leveritt)

139. Bowl, creamware printed in red, probably Staffordshire, 1790–1800. Diam 6⅞ in. (162 mm), H 2⅝ in.(67 mm)
Interior: portrait of George Washington and inscription "THE PRESIDENT OF THE UNITED STATES"; exterior: two pairs of birds and pastoral vignettes. SRT 98.1

140. Jug, creamware printed in black, painted in enamels, probably Liverpool, 1810–25. H 8¹⁵⁄₁₆ in. (228 mm)
On one side: stock print of brig flying an American pennant and American flag with sixteen stars and stripes; on the other side: painted with double portrait of the brig in a stormy sea titled "When the First Sea Struck Her" and "the Second" graphically showing the disaster, also with painted initials "EEC"; see cat. no. 57. SRT 98.2

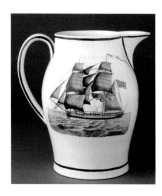
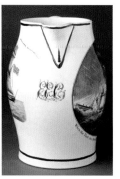
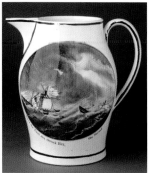

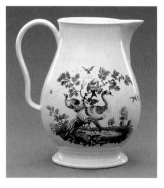

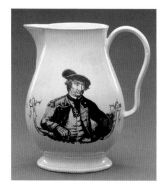

141. Jug, creamware printed and painted in black, Staffordshire or Liverpool, probably decorated in Liverpool, 1775–90. H 8¼ in. (210 mm)
On one side: portrait titled "MAJOR GENERAL ISRAEL PUTNAM"; on the other side: pair of exotic birds; beneath spout: painted "W-Walker"; Putnam led American troops to victory at the Battle of Bunker Hill. SRT 98.4

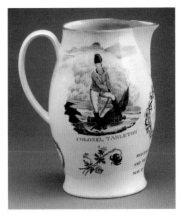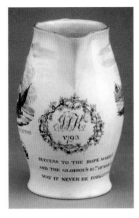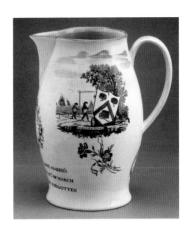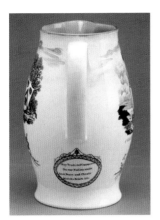

142. Jug, creamware printed in black, painted in enamels, probably Liverpool, 1793. H 9⁹⁄₁₆ in. (243 mm)
On one side: arms of the ropemakers; on the other side: portrait titled "COLONEL TARLETON"; beneath spout: initials "JSK" and "1793" together with inscription "SUCCESS TO THE ROPE MAKER'S AND THE GLORIOU'S 10ᵀᴴ. OF MARCH MAY IT NEVER BE FORGOTTEN"; below handle: inscription beginning "May Trade and Commerce" and ending "Bless the British Isle"; the view of Tarleton, a British General in the American Revolution, is after a portrait by Joshua Reynolds. SRT 98.5

143. Jug, creamware printed in black, Liverpool, 1793–1800. H 7⅞ in. (200 mm)
On one side: image of Louis XVI at the guillotine titled "MASSACRE OF THE FRENCH KING" and inscription "La Guillotine, the Modern Beheading Machine, at Paris, Jany 20ᵗʰ. 1793"; on the other side: scene "Marie Ann Charlotte La Corde, assassinating Marat, the French Regicide in his own house"; both prints with illegible engraver's signature and "Liverpool." SRT 99.2

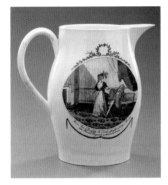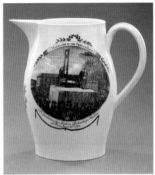

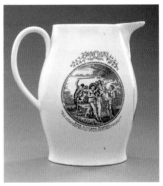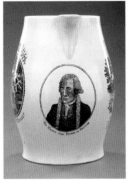

144. Jug, creamware printed in sepia, probably Staffordshire, 1800–1820. H 9 in. (229 mm)
On one side: image "SAILORS JOYFUL RETURN"; on the other side: image "THE LOVERS PARTED" both with appropriate verses; beneath spout: portrait "HIS GRACE THE DUKE OF LEINSTER"; see App. 61 for similar portrait titled "WASHINGTON." SRT 99.3

145. Jug, pearlware printed in black, painted in enamels, probably Herculaneum Pottery, Liverpool, 1830. H 9½ in. (241 mm)
On one side: portrait of side-wheel steamship inscribed "WILMINGTON & PHILADELPHIA"; on the other side: stock print of three-masted ship flying American flag with sixteen stars and thirteen stripes; beneath spout: painted inscription "Capt H Read. Wilmington, Del. 1830" and vignette of three men in a rowboat. SRT 99.7

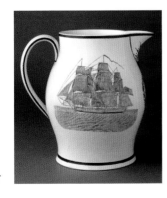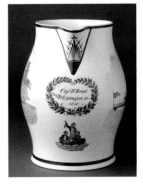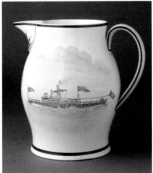

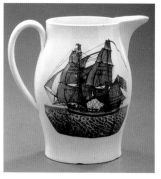
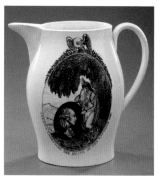

147. Tankard, creamware printed in orange, probably Herculaneum Pottery, Liverpool, 1815–20. H 6 in. (152 mm) Portrait titled "JAMES LAWRENCE ESQR. Late of the United States Navy" after print published in the *Analectic Magazine* (February 1814). SRT 2000.2

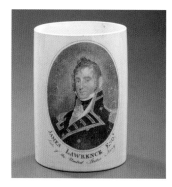

146. Jug, creamware printed in black, Staffordshire or Liverpool, 1800–1810. H 5⅞ in. (149 mm)
On one side: memorial to George Washington inscribed "AMERICA LAMENTING THE DEATH OF HER FAVORITE SON"; on the other side: stock print of three-masted ship flying the American flag. SRT 2000.1

148. Jug, pearlware printed in black, painted in enamels, painted on base "Bristol Pottery 1819" for Bristol Pottery, 1819. H 10⁷⁄₁₆ in. (266 mm)
See cat. no. 66 for almost identical jug; this example with addition of an American flag in Liberty's hands; said to have descended in the family of Isaac Hull. SRT 2000.3

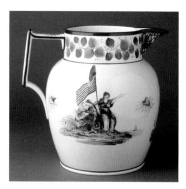
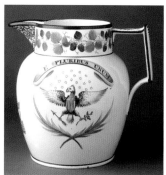
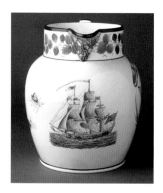
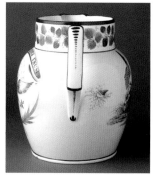

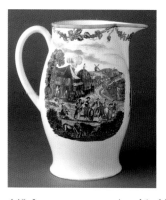

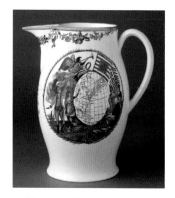

149. Jug, creamware printed in black, painted in enamels, probably Herculaneum Pottery, Liverpool, 1799. H 9⅝ in. (244 mm)
On one side: map of the east coast of North America (see cat. no. 20); on the other side: scene of harvest celebration; beneath spout: painted "TJ" and "1799." SRT 2000.4

150. Plaque, enameled copper, printed and signed "J. Sadler Liverp." for John Sadler, Liverpool, ca. 1760. H 7⅛ in. (180 mm), W 5¾ in. (146 mm) (including frame)
Portrait of William Pitt, sitting, inscribed "The Right Honble. WM. PITT Esqr./ One of His Majesty's principle Secretaries of State/ And One of His most Honble. Privy Council." SRT 2001.1

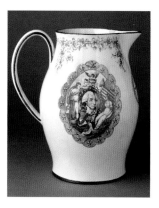

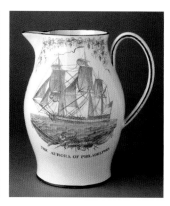

151. Jug, creamware printed in black and painted in enamels, Staffordshire or Liverpool, On one side: ship flying the American flag with painted inscription "The Aurora of Philadelphia"; on the other side: portrait of Washington framed with the chain of states (see cat. no. 69); under spout: "Henry Stephens"; the *Aurora* was built in 1792 and Stephens was master 1795–98. SRT 2001.2

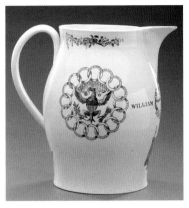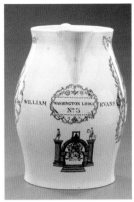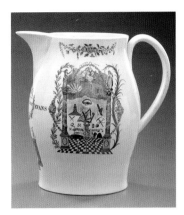

152. Jug, creamware printed and painted in black, possibly Herculaneum Pottery, Liverpool, ca. 1800. H 11⅜ in. (288 mm)
On one side: Masonic imagery; on the other side: adaptation of the Great Seal of the United States encircled by a chain of sixteen states; beneath spout: painted "WILLIAM EVANS" and "WASHINGTON LODGE/ No. 3" above Masonic insignia of the Royal Chapter of England; beneath handle: Masonic set square; see cat. no. 25. SRT 2001.3

153. Jug, creamware printed and painted in black, possibly Staffordshire, 1791–1810. H 10 in. (255 mm)
On one side: two-story house with trade sign hanging from gable end; on the other side: allegorical scene "May COMMERCE Flourish"; beneath spout: painted "JOSIAH & MARY/ MERICK"; Dr. Josiah and Mary Myrick lived in Newcastle, Maine. SRT 2001.4

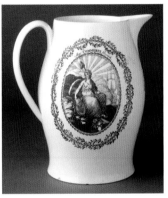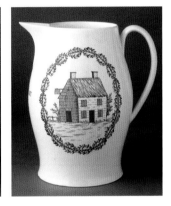

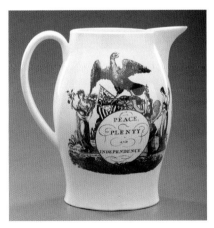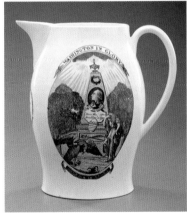

154. Jug, creamware printed in black, probably Herculaneum Pottery, Liverpool, ca. 1800.
H 9¼ in. (235 mm)
On one side: "PEACE, PLENTY AND INDEPENDENCE";
on the other side: Washington memorial "WASHINGTON IN GLORY" (see cat. no. 8); beneath spout: printed "May America/ never want Artillery/ to defend/ her rights"; see cat. no. 71. SRT 2001.5

155. Jug, creamware printed in black, Staffordshire or Liverpool, 1780–1800. H 8¹¹⁄₁₆ in. (220 mm)
On one side: allegorical representation of Ireland inscribed "ARM'D FOR YOUR DEFENCE" and vignette advocating "Free Trade"; on the other side: scene after Robert Hancock's engraving of "La Cascade" by Watteau. SRT 2002.3

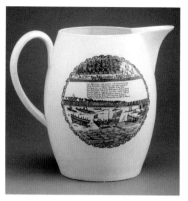 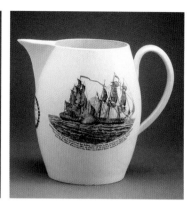

156. Jug, creamware printed in black, possibly Herculaneum Pottery, Liverpool, ca. 1800. H 9¾ in. (223 mm)
On one side: maritime victory of the American *Constellation* over the French *L'Insurgent[e]*, February 19, 1799, with details of the engagement; on the other side: landscapes and verse beginning "Our Mountains are cover'd with Imperial Oak" and ending "For ne'er shall the Sons of Columbia be Slaves/While the Earth bears a Plant, or the Sea rolls its Waves"; beneath spout: "SUCCESS TO THE WOODEN WALLS OF AMERICA"; see cat. no. 26. SRT 2002.4

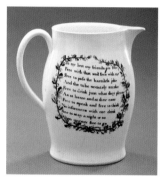 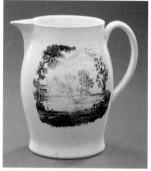 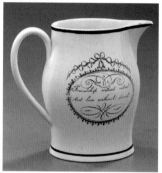 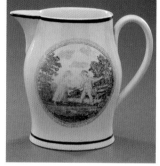

157. Jug, creamware printed in black, Staffordshire or Liverpool, 1800–1820. H 5¾ in. (146 mm)
On one side: verse beginning "To my best my friends are free"; on the other side: badly transferred rural scene. SRT 2004.1

158. Jug, creamware printed in black, Staffordshire or Liverpool, 1800–1820. H 4¾ in. (120 mm)
On one side: elegantly framed motto "Friendship without interest And love without deceit"; on the other side: children at play. SRT 2004.2

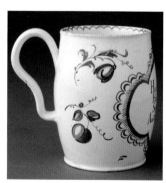 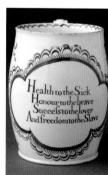 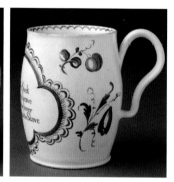

159. Mug, creamware painted in red enamel, Staffordshire or Derbyshire, 1770–80. H 3¾ in. (95 mm)
Inscribed "Health to the Sick Honour to the brave Success to the lover And freedom to the slave"; sides painted with flowers and cherries often associated with the Cockpit Hill factory in Derby; see cat. no. 23 for similar inscription. SRT 2005.1

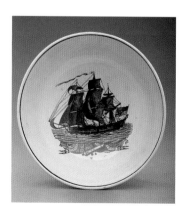 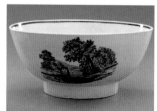 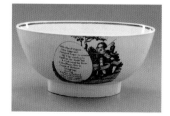 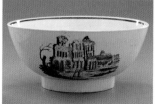

160. Bowl, creamware printed in black, Staffordshire or Liverpool, 1800–1820. Diam 9⅝ in. (244 mm)
Interior: stock print of ship and title "SUCCESS TO TRADE"; exterior: rural landscapes and print of a portly man smoking alongside a verse beginning "With a Pipe of Virginia How happy I am." SRT 2005.2

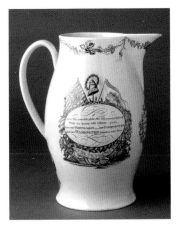 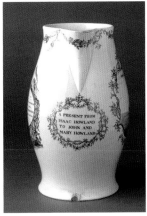 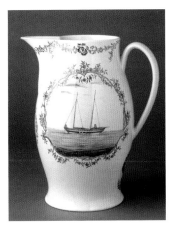 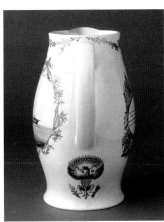

161. Jug, creamware printed in black, painted in enamels, probably Liverpool, ca. 1800.
On one side: verse memorializing Washington (see cat. no. 13); on the other side: printed cartouche containing painted sailing boat; front:
"A PRESENT FROM ISAAC HOWLAND TO JOHN AND MARY HOWLAND"; beneath handle: adaptation of the Great Seal of
the United States. SRT 2005.4

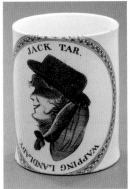 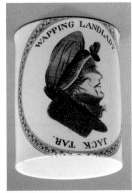 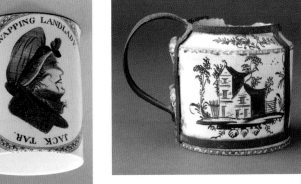

162. Mug, creamware printed in black, Staffordshire
or Liverpool, 1800–1820
Printed with portrait of a man titled "JACK TAR";
when reversed the portrait appears to be of a
woman and is titled "WAPPING LANDLADY";
Wapping is an area in the London docklands. SRT
2005.7

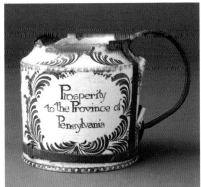 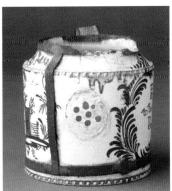

163. Remains of a teapot, creamware painted in enamels, Staffordshire or
Yorkshire, 1770–85. H 3½ in. (88 mm)
On one side: inscription believed to be unique "Prosperity to the Province of
Pensylvania"; on the other side: a naively painted building; the question was
asked "When is a teapot not a teapot: When it has no spout, no cover, a hole in
the base, and a make-do handle?" SRT 2006.1

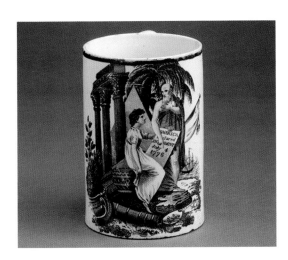

164. Mug, creamware printed in black, Staffordshire or Liverpool, ca.
1800. H 4⅞ in. (123 mm)
Figures in a classical landscape with tablet inscribed, "AMERICA declared
INDEPENDENT July 4 1776." SRT 2007.1

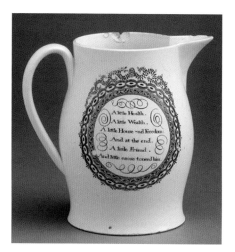
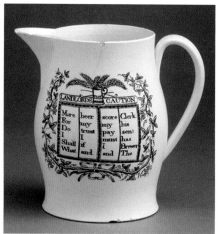

165. Jug, creamware printed in black, Staffordshire or Liverpool, 1800–1820. H. 5¾ in. (127 mm) On one side: verse beginning "A little Health A little Wealth"; on the other side: a puzzle called "LANDLORD'S CAUTION" to be read vertically from bottom right-hand corner. SRT 2007.10

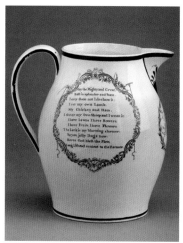
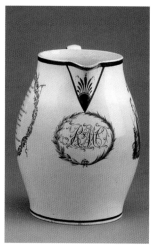
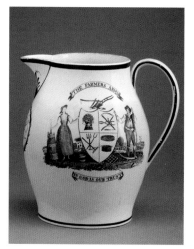

166. Jug, creamware printed in black, painted in enamels, probably Liverpool, 1800–1820. H 8 in. (203 mm) On one side: traditional "FARMERS ARMS"; on the other side: a version of the usual accompanying verse beginning "May the Mighty and the Great Roll in splendor and in State"; beneath spout: painted "R&MC." SRT 2007.12

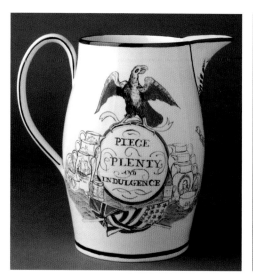
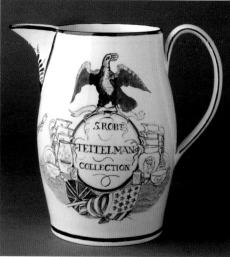
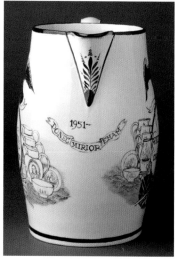

167. Jug, creamware painted in enamels, signed on base "ME" for Michelle Erickson, Yorktown, Virginia, 1999. H 9¼ in. (235 mm) A jug specially commissioned by S. Robert Teitelman and made by Michelle Erickson to celebrate his lifetime of enjoyment collecting pottery. The design is based on his favorite "Peace, Plenty, and Independence" print (see cat. no. 71); on one side: circular medallion with painted "S. ROBT./ TEITELMAN/ COLLECTION" surmounted by an American eagle and supported by rows of jugs and mugs; on the other side is a play on words that sums up his collecting: "PIECE/ PLENTY/ AND/ INDULGENCE"; beneath the spout: "1951" above his Latin motto: "DONEC MIRIOR EMAM (Until I Die, I will Buy)." SRT 99.11

GLOSSARY OF MARITIME TERMINOLOGY

Brig: A vessel with two masts (known as the foremast and mainmast) that are square-rigged (having four-sided sails hung from horizontal spars hung perpendicular to the keel of the ship). There is also a fore-and-aft sail (triangular or trapezoidal sails hung parallel to the keel of the ship) known as a spanker, which is attached to a boom on the first course mainmast.

Brigantine: A vessel with two masts (known as the foremast and mainmast), the foremast square-rigged (four-sided sails hung from horizontal spars hung perpendicular to the keel of the ship) and the mainmast carrying fore-and-aft sails (triangular or trapezoidal sails hung parallel to the keel of the ship), and sometimes carrying a square topsail or topgallant sail.

Cannon: Cannon were described by the weight of the solid iron cannonballs that they fired; for instance a 12-pound cannon fired cannon balls that weighed 12 pounds. The largest naval cannon commonly available in the late eighteenth and early nineteenth centuries were 36 pounders.

Frigate: A warship with three masts that are square-rigged (four-sided sails hung from horizontal spars hung perpendicular to the keel of the ship). Frigates carried between 22 and 44 guns, and typically had a single gun deck.

Master: The individual in command of a merchant ship.

Privateer: A private warship that is authorized by the government to attack an enemy's shipping during a time of war. The owners, captains, and crew of privateers were often motivated as much by profit as by patriotism, as they were rewarded with money that came from the sale of the vessel and its cargo.

Schooner: A vessel with masts that are fore-and-aft-rigged (triangular or trapezoidal sails hung parallel to the keel of the ship). Schooners in the eighteenth and early nineteenth centuries typically had two masts, though three- and even four-masted schooners were built. Schooners sometimes carry square topsails above the fore-and-aft rigged sails.

Ship: A term commonly applied to any vessel, but technically a ship has three masts that are square-rigged (four-sided sails hung from horizontal spars hung perpendicular to the keel of the ship). They could also be referred to as a "full-rigged ship."

Ship-of-the-line: A large and powerful warship with three masts that are square-rigged (four-sided sails hung from horizontal spars hung perpendicular to the keel of the ship). Ships-of-the-line had two to three gun decks and 64 to 144 guns. The name comes from the line-of-battle, a common naval tactic of the eighteenth century in which warships maneuvered into a single-file line in order to bring the greatest weight of broadside guns to bear on an enemy's ships.

Sloop: A small vessel with a single mast that is fore-and-aft-rigged (triangular or trapezoidal sails hung parallel to the keel of the ship). Sloops sometimes carry square topsails above the fore-and-aft rigged sails.

Subscription ship: A warship built by the citizens of U.S. port cities that were loaned or given to the U.S. Navy during the Quasi-War with France. The ships were funded by subscriptions from citizens, thus the name.

Selected Bibliography

Analectic magazine, comprising original reviews, biography, analytical abstracts of new publications, translations from French journals, and selections from the most esteemed British reviews. Philadelphia: M. Thomas, 1813–20.

Arman, David, and Linda Arman. *Anglo-American Ceramics, Part I. Transfer-Printed Creamware and Pearlware for the American Market, 1760–1860.* Portsmouth, R.I: Oakland Press, 1998.

Bradley, H. G., ed. *Ceramics of Derbyshire, 1750–1975.* London: Gilbert Bradley, 1978.

Brown, E. Myra, and Terence A. Lockett, eds. *Made in Liverpool: Liverpool Pottery & Porcelain, 1700–1850.* Liverpool: National Museums & Galleries on Merseyside, 1993.

Carson, John. *Bristol Pottery, 1784–1972.* http://www.authorsonline.com.

Cox, Alwyn, and Angela Cox. *Rockingham Pottery and Porcelain, 1745–1842.* London: Faber and Faber, 1983.

Cunningham, Noble E., Jr. *The Image of Thomas Jefferson in the Public Eye: Portraits for the People, 1800–1809.* Charlottesville: University Press of Virginia, 1981.

Davidson, A. S. *Marine Art & Liverpool: Painters, Places & Flag Codes, 1760–90.* Wolverhampton, Eng.: Waine Research Publishing, 1986.

Detweiler, Susan Gray. *George Washington's Chinaware.* New York: Harry N. Abrams, 1982.

Drakard, David. *Printed English Pottery: History and Humour in the Reign of George III, 1760–1820.* London: Jonathan Horne, 1992.

———, and Paul Holdway. *Spode Transfer-Printed Ware, 1784–1833.* Woodbridge, Eng.: Antique Collectors' Club, 2002.

Edwards, Diana. *Neale Pottery and Porcelain.* London: Barrie & Jenkins, 1987.

Ewins, Neil. "Supplying the Present Wants of Our Yankee Cousins: Staffordshire Ceramics and the American Market, 1775–1880." *Journal of Ceramic History* 15 (1997): 76.

Fleming, E. McClung. "The American Image as Indian Princess, 1765–1783." In *Winterthur Portfolio II*, edited by Milo M. Naeve, 65–81. Winterthur, Del.: Henry Francis du Pont Winterthur Museum, Inc., 1965.

———. "From Indian Princess to Greek Goddess: The American Image, 1783–1815." In *Winterthur Portfolio III*, edited by Milo M. Naeve, 37–66. Winterthur, Del.: Henry Francis du Pont Winterthur Museum, Inc., 1967.

Fowble, E. McSherry. *Two Centuries of Prints in America, 1680–1880.* Charlottesville: University Press of Virginia, 1987.

Gray, Jonathan, ed. *Welsh Ceramics in Context: Part 1.* Swansea: Royal Institution of South Wales, 2003.

Greene, Sharron D. "Oversize Staffordshire Jugs." *The Magazine Antiques* 149, no. 1 (January 1996): 192–201.

Griffin, John D. *A Celebration of Yorkshire Pots.* Nottingham, Eng.: Northern Ceramic Society, 1997.

———. *The Leeds Pottery, 1770–1881.* 2 vols. Leeds, Eng.: Leeds Art Collections Fund, 2005.

Halfpenny, Pat, ed. *Penny Plain, Twopence Coloured: Transfer Printing on English Ceramics.* Stoke-on-Trent: City Museum and Art Gallery, 1994.

Hickey, Donald. *The War of 1812: A Short History.* Chicago: University of Illinois Press, 1995.

Hyland, Peter. *The Herculaneum Pottery: Liverpool's Forgotten Glory.* Liverpool: Liverpool University Press/National Museums Liverpool, 2005.

Katz-Hyman, Martha. "Doing Good While Doing Well: The Decision to Manufacture Products that Supported the Abolition of the Slave Trade and Slavery in Great Britain." *Slavery and Abolition* 29, no. 2 (June 2008): 219–31.

Lambert, Frank. *The Barbary Wars: American Independence in the Atlantic World.* New York: Hill and Wang, 2005.

Lawrence, Heather. *Yorkshire Pots and Potteries.* London: David & Charles, 1974.

Leiner, Frederick. *Millions for Defense: The Subscription Warships of 1798.* Annapolis, Md.: Naval Institute Press, 2000.

Lloyd's Register, Underwriter's Register of Shipping, 1764–1881. Reprint, Farnborough, Eng.: Gregg International Publishers, 1969.

Lockett, Terence A., and Patricia A. Halfpenny. *Creamware & Pearlware: The Fifth Exhibition from the Northern Ceramic Society (18 May–7 September 1986, Stoke-on-Trent City Museum and Art Gallery).* Stoke-on-Trent: City Museum and Art Gallery, 1986.

Magid, Barbara H. "Commemorative Wares in George Washington's Hometown." In *Ceramics in America*, edited by Robert Hunter, 2–39. Milwaukee, Wis.: Chipstone Foundation, 2006.

———. "Robert H. Miller, Importer: Alexandria and St. Louis." In *Ceramics in America*, edited by Robert Hunter, 143–62. Milwaukee, Wis.: Chipstone Foundation, 2008.

Margolin, Sam. "'And Freedom to the Slave:' Antislavery Ceramics, 1787–1865." In *Ceramics in America*, edited by Robert Hunter, 80–109. Milwaukee, Wis.: Chipstone Foundation, 2002.

Martin, Tyrone. *A Most Fortunate Ship: A Narrative History of Old Ironsides.* Annapolis, Md.: Naval Institute Press, 1997.

McCauley, Robert H. *Liverpool Transfer Designs on Anglo-American Pottery.* Portland, Maine: Southworth-Anthoensen Press, 1942.

Mooney, James L. *Dictionary of American Naval Fighting Ships.* Washington, D.C.: Department of the Navy, 1959–.

Moulton, John K. *Captain Moody and His Observatory.* Falmouth, Maine: Mount Joy Publishing, 2000.

The Naval Monument. Boston: Abel Bowen, 1816.

Nelson, Christina. "A Selected Catalog of the Liverpool-Type Historical Creamwares and Pearlwares in the Henry Francis du Pont Winterthur Museum." Master's thesis, University of Delaware, 1974.

———. "Transfer-printed Creamware and Pearlware for the American Market." *Winterthur Portfolio* 15, no. 2 (Summer 1980): 93–119.

Pomfret, Roger. "W(★★★)–The Case for Whitehead Re-Assessed." *Northern Ceramic Society Journal* 22 (2005–6): 111–36.

Price, E. Stanley. *John Sadler: A Liverpool Printer.* West Kirby, Eng.: By the author, 1948.

Roberts, Gaye Blake. "Printing in Liverpool: The Association between Wedgwood and Sadler and Green." *Northern Ceramic Society Journal* 14 (1997): 49–50.

Scottish Rite Masonic Museum of Our National Heritage. *Masonic Symbols in American Decorative Arts.* Lexington, Mass.: By the museum, 1976.

Smith, Alan. *The Illustrated Guide to Liverpool Herculaneum Pottery, 1796–1840.* New York: Praeger Publishers, 1970.

Sprague, Laura. "Liverpool-Type Pitchers Decorated for Portland." *American Ceramic Circle Bulletin* 5 (1986): 26–41.

Teitelman, S. Robert. "Maine's Early Nineteenth-Century Barrell-Wood Family Jugs and the Remarkable Woman Who Made Them Great." In *Ceramics in America*, edited by Robert Hunter, 8–19. Milwaukee, Wis.: Chipstone Foundation, 2005.

———. "THE OROZIMBO: A Peabody Crown Jewel." *Peabody Museum of Salem Antiques Show Catalogue* (1990): 17–19.

———. "Unraveling the Mystery behind the 'Merick' Jug: An English Creamware Jug for the American Market, circa 1791 to 1810." *Catalogue of Antiques and Fine Art* (January 2003): 276–79.

Wick, Wendy C. *George Washington, An American Icon: The Eighteenth-Century Graphic Portraits.* Washington, D.C.: SITES/National Portrait Gallery, 1982.

Works Progress Administration. *Ship Registers and Enrollments of Newport, Rhode Island 1790–1939.* Providence: Rhode Island State Archives, 1941.

INDEX

Index

Within this Family Vault,
Lie Interred,
it is to be hoped never to rise again,
The Star Chamber Court
Ship Money — Excise Money.
& all Imposts without Parliament.
The Act de Hæretico Comburendo.
Hearth Mon — Gener Warrants.
And
which tended to alienate the Affections of
Englishmen to their Country!

THE REPEAL. — or the Funeral

Over the Vault are placed two Skeleton Heads, Their elevation on Poles, and
the dates of the two Rebellion Years, sufficiently shew what Party they espoused, and
in what cause they suffered an ignominious Exit.

to three farthings, an important sum
and 71 declare the minority which so